DATA CENTERS
EDGES OF A WIRED NATION

Edited by Monika Dommann, Hannes Rickli, Max Stadler
Lars Müller Publishers

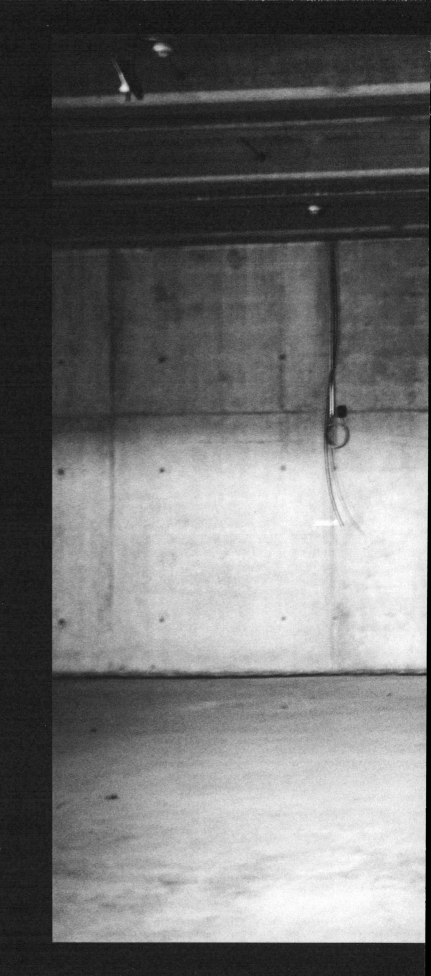

Data center construction site, Switzerland, February 2019. (© Andrea Helbling)

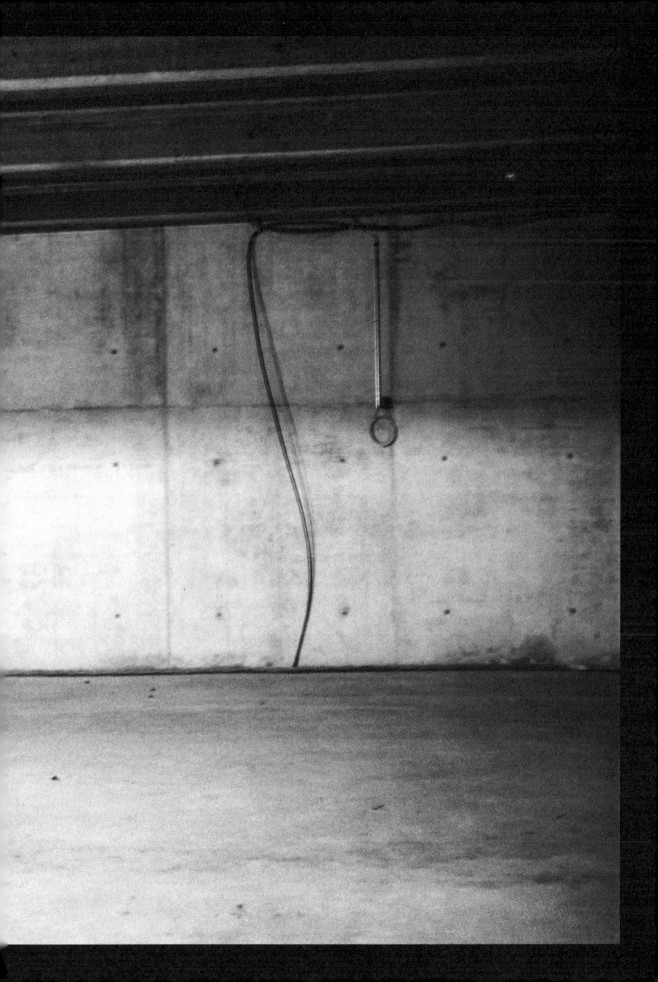

Introduction

**Monika Dommann
Max Stadler**

**Photos by
Andrea Helbling**

Digital infrastructures are not only unobtrusive, inconspicuous, and usually hidden from view; they're also fast-moving. The spring of 2018, when work on this book began, was dominated by a media scandal: the political misuse of technology and data in connection with Cambridge Analytica. At the time that our research concluded in spring 2020, COVID-19 was defining the guiding questions for the media and the politics of technology: Are "tracing apps" legitimate technology for containing COVID-19 or are they the precursors of a new techno-authoritarianism? Will the pandemic strengthen the omnipotence of Amazon? Has the "digital divide" been extended to our home offices, when the premise of "essential services" is employed to determine who can or must stay home, and who must inevitably expose him- or herself to an increased risk of infection by the virus on construction sites, in supermarkets, in hospitals, or for the purpose of maintaining critical IT infrastructure?

In between (and now almost forgotten again) were the trade war between the United States and China, the discussion about whether to break up "big tech" by means of regulations, the fear that 5G could make people ill, anti-"techsploitation" protests and Google walkouts (including in Zurich), the fear of digital surveillance, of facial recognition, of unbridled AI, and the pressing question of whether the boundaries between private and public affairs in business and government are being redrawn behind closed doors.

When such terms as revolution, transformation, and disruption make the rounds globally and dominate the talk of "digitalization," the historical backgrounds and contours—the underlying material cultures, political contexts, and everyday realities—tend to disappear from view. A look at the infrastructures in the immediate neighborhood, a visit to the places where we live and work, at addresses around us, can help to ground these concepts and bring infrastructure back into play.

So it's necessary to go there. One local starting point for such an approach is the inner workings of the Milchbuck Tunnel Fig.1 , parts of which run beneath the Irchel campus of the University of Zurich: 1,820 meters long, planned in the 1950s and finally built between 1976 and 1985 as a conduit between the outskirts and the downtown area. We encounter endless corridors and caverns, cable shafts and concrete corridors. In the distance, the muffled din of car engines is heard. Running through the side tunnels are high-voltage cables, low-voltage cables, and fiber optic cables: from A to B, to the airport, to the surrounding area.

Somewhere inside a red cabinet that's easily overlooked (we almost missed it), there is also a "fiber optic node" through which some of the data traffic to and from Zurich is handled Fig. 2 . It has long been known that such structures, the critical points of data transfer, are of social, economic, and even national importance. Since the early 2000s, the term "critical infrastructures" has been adopted for this cornerstone of contemporary society.[1] Broadly speaking, this new attention to infrastructures (a term derived from the language of railway construction in the nineteenth century, where it was launched as a counter-concept to the superstructure built above it)[2] has resulted from an altered perception of the world after 2000.

Terrorism, the proliferation of cyberattacks, and the risks of climate change or environmental emissions precipitating natural disasters or flooding, with the potential to disrupt data transmission channels and damage infrastructures, were now increasingly regarded as tangible threats. "Today's critical infrastructure resilience policies have to address diverse and complex shock events," as a recent OECD briefing stated.[3] At the same time, the demand for the permanent availability of these structures, which in many respects have become "mission-critical," has risen since the 1980s and has accelerated with the spread and commercialization of digital networks and the Internet in particular.[4] Not least, the economic significance of critical infrastructures has also increased, and with it the realization that without resilient infrastructures there can be no "business continuity." The more a company makes use of IT in its operations, the more important it is to ensure a smooth workflow, as a Swiss IT disaster recovery manual from the early 2000s emphasized.[5]

Researching Infrastructure

The fact that infrastructures such as bridges, dams, tunnels, and even "centers of calculation"[6] are highly political entities that shape the way states coexist, manage their economies, and engage in their activities is an insight that has also emerged in science and technology studies (STS), cultural anthropology, sociology, and the history of science and technology. Since at least as far back as the controversies surrounding the bridges and parkways of New York city planner Robert Moses, a new branch of research has emerged that focuses on the study of infrastructure. Moses' low-slung bridges were "political" because they produced a "social effect" in terms of "technical arrangement"—because they prevented buses from transporting the poor black population from the city to the beaches.[7] Although

1 See, for example (regarding the background as well): Myriam Dunn Cavelty and Kristian Søby Kristensen, eds., *Securing 'the Homeland': Critical Infrastructure, Risk, and (In)Security*, New York, 2008. Such concerns were notably manifested in the US "National Infrastructure Protection Plan": see Department of Homeland Security, *National Infrastructure Protection Plan*, Washington, DC, 2006; on Switzerland, see, for example: *Critical Infrastructure Protection: Focal Report 1*, CRN Report, Zurich, 2008.

2 On this, cf. Dirk Van Laak, "Der Begriff 'Infrastruktur' und was er vor seiner Erfindung besagte," *Archiv für Begriffsgeschichte* 41, no. 1 (1999), pp. 280–99.

3 OECD, *Good Governance for Critical Infrastructure Resilience*, OECD Reviews of Risk Management Policies, Paris, 2019, p. 13.

4 Among other things, a series of blackouts, software failures, and network outages—in short, "crises in communication"—raised awareness in the early 1990s of the susceptibility of the increasingly digital telecommunications networks to disruptions. In August 1990, for example, in the New York City area, an outage (not an isolated case) reportedly "left at least 200 data centers in the dark and caused some 24 companies to declare disasters and move to hot sites." See Johanna Ambrosio, "Fallout from the New York Blackout," *Computerworld* 24, no. 43 (October 29, 1990), p. 110.

5 Ulrich Moser, *Der IT-Ernstfall – Katastrophenvorsorge*, Rheinfelden, 2003, p. 6. Moser also alluded to 9/11, but even more so to the legal provisions that made disaster prevention—"preparedness"—necessary: corporate law, privacy, insurance regulations, banking regulations, Basel II, the Swiss Code of Obligations, default clauses, and new corporate security standards such as ISO 17799 (then recently introduced).

6 On the early (and rather metaphorical) attention given to "centers of calculation," see Bruno Latour, *Science in Action: How to Follow Scientists and Engineers Through Society*, Cambridge, MA, 1987.

7 Langdon Winner, "Do Artefacts Have Politics?" *Daedalus* 109, no. 1 (1980), pp. 121–36; Bernward Joerges, "Do Politics Have Artefacts?" *Social Studies of Science* 29, no. 3 (1999), pp. 411–31.

this story later turned out to be a kind of modern urban legend, the debates surrounding the New York bridges were extremely conducive to the emergence of a new field of research dealing with the relationship between technology, space, and power. If the criticism of infrastructure at the time came in the wake of technocracy and high-modernism—a critique of "large-scale, high-technology systems" (Winner)—the stakes have multiplied since then. In recent years, a (re)politicization of the way we deal with infrastructure can be observed. This is in view of the fact that many (public) infrastructure projects from that period are now decaying, that they have to be "maintained" by people,[8] that the heated debate about privatizing infrastructure since the 1980s has gained new topicality,[9] and that an awareness has emerged of the extent to which they are interconnected with global regimes of exploitation and ecological destruction.[10] Because these findings do not appear in the epic narratives of technological progress, there has recently been a veritable explosion of projects that, in dense and historically informed studies, have turned their attention to the nodes and hubs of infrastructures such as dams, department stores, highways, export processing zones, ports, shipping routes and telecommunications networks.[11]

This book positions itself in the field of infrastructure research and examines the spaces, hinges, and edges along which the data streams of the recent past and present are concentrated. It deals with data centers, databases, blockchain installations, and fiber optic cables, as well as with the work of law firms, the activities of corporations, and the actions of government institutions that contribute to the creation, maintenance, and regulation of digital infrastructures. Switzerland serves us as a research subject, as a solvent, if you will, to expose those locally, nationally and transnationally operating technological linkages that are involved in the creation and maintenance of digital infrastructures. These socio-technical conglomerates shape the functioning of the economy, politics, law, and society, and they are also changing our understanding of key concepts of modernity such as the nation, major distinctions such as private and public, and (in view of new technological possibilities) notions of people's agency.

The first objective of the research project documented in this book is to identify and make visible such new edges of digital Switzerland. This approach further suggests itself because digital infrastructures blend very discreetly into the landscape and tend to remain inconspicuous. Making them visible therefore entails illuminating all those practices that are, typically for good reasons, carried out discreetly in the background during the sale, planning, construction, maintenance,

8 On "maintenance," see in particular Andrew L. Russell and Lee Vinsel, "After Innovation, Turn to Maintenance," *Technology and Culture* 59, no. 1 (2018), pp. 1–25; on IT specifically, see, for example, Rebecca Slayton and Brian Clarke, "Trusting Infrastructure: The Emergence of Computer Security Incident Response, 1989–2005," *Technology and Culture* 61, no. 1 (2020), pp. 173–206.

9 See, for example, The Foundational Economy Collective, *Foundational Economy: The Infrastructure of Everyday Life*, Manchester, 2018.

10 See, for example, Deborah Cowen, *The Deadly Life of Logistics: Mapping Violence in Global Trade*, Minneapolis, 2014; Laleh Khalili, *Sinews of War and Trade: Shipping and Capitalism in the Arabian Peninsula*, London, 2020; Rahul Mukherjee, *Radiant Infrastructures: Media, Environment, and Cultures of Uncertainty*, Durham, NC, 2020.

11 See, for example, Paul Edwards, "Infrastructure and Modernity: Force, Time, and Social Organization in the History of Sociotechnical Systems," in *Modernity and Technology*, edited by Thomas J. Misa, et al, Cambridge, MA, 2003, pp. 185–225; Lisa Parks and Nicole Starosielski, eds., *Signal Traffic: Critical Studies of Media Infrastructures*, Urbana, IL, 2015; Nicole Starosielski, *The Undersea Network*, Durham, NC, 2015; Keller Easterling, *Extrastatecraft: The Power of Infrastructure Space*, London, 2016; Ashley Carse, "Keyword: Infrastructure – How a Humble French Engineering Term Shaped the Modern World," in *Infrastructures and Social Complexity*, edited by Penny Harvey, et al, New York, 2017, pp. 27–39; Vladan Joler, et al., *Critical Cartography of the Internet and Beyond: Unofficial Blueprints*, Novi Sad, 2018; Christine Folch, *Hydropolitics: The Itaipu Dam, Sovereignty, and the Engineering of Modern South America*, Princeton, NJ, 2019; Dara Orenstein, *Out of Stock: The Warehouse in the History of Capitalism*, Chicago, 2019.

and regulation of those infrastructures. In order to explore these intricate interactions, we have necessarily adopted an approach that involves multiple perspectives from a methodological point of view. The photographs in this book, taken by Andrea Helbling and Marc Latzel, who accompanied us in our explorations, had a central heuristic function—as had the soundscapes recorded by the artist Hannes Rickli, whose interest in the material manifestations of computing proved a key element in the coming together of this book.[12] Even if little is superficially visible (or audible) at the edges (cables, racks, emergency power generators, destroyed hard disks, noise; only scattered individuals, often just traces of human presence such as empty tables, beverage cans, or leftover food), the site visits guided us to the technical realms and social environments that define and maintain digital infrastructures. Through our visits to selected places in Switzerland, the visual documentation by Andrea Helbling and Marc Latzel, the ethnological investigation of the different technical cultures involved and, finally, the analysis of historical strata, the local, national, and global as well as the material and virtual entanglements of these "centers" are revealed. This book, then, is a snapshot of a few selected places, actors, and their histories involved in digital Switzerland, as observed between 2018 and 2020. This is why the book is called *Data Centers*—even though it does not deal with "data centers" in the strict technical sense.

Computing Centers/Data Centers

The recent history of the data center begins around the turn of the millennium, parallel to the increasing urgency of infrastructural "availability," "preparedness," and "resilience." Even in the German-speaking world, the term "data center" has since increasingly supplanted the term *Rechenzentrum* ("computing center"), which had been in use since the 1950s and initially simply referred to "large-scale computer facilities"—a building or part of a building with one or more digital computers, peripherals, offices, air conditioning, potted plants, and carpets Fig. 3 .

Half office, half engine room, a "center" in the literal sense, the original computing center was a product of the postwar decades, of big government and big business, of technocracy, hierarchy, and optimism about progress. It was also (or still) a workplace for many:[13] not least for the numerous (as a rule) women who were busy there with "data entry" and the like, or (in rare cases) harboring doubts about their employer (be it IBM, Siemens, PTT, Standard Radio & Telephon Zürich, etc.), as the chapter on those "worlds of paper" by former programmer and writer Emil Zopfi explains. Like

12 Hannes Rickli, in parallel to co-editing this book, has been developing an exhibition on the interplay of technology, art and history in relation to data centers, which will open in the fall of 2020 (in Zurich) on the book and progress on the exhibition intersected at many points, mutually shaping each other in the process.
13 On this, see Mar Hicks, *Programmed Inequality: How Britain Discarded Women Technologists and Lost Its Edge in Computing*, Cambridge, MA, 2017; Ute Hoffmann, *Computerfrauen. Welchen Anteil haben Frauen an der Computergeschichte und -arbeit?* Munich, 1987.

Fig. 3

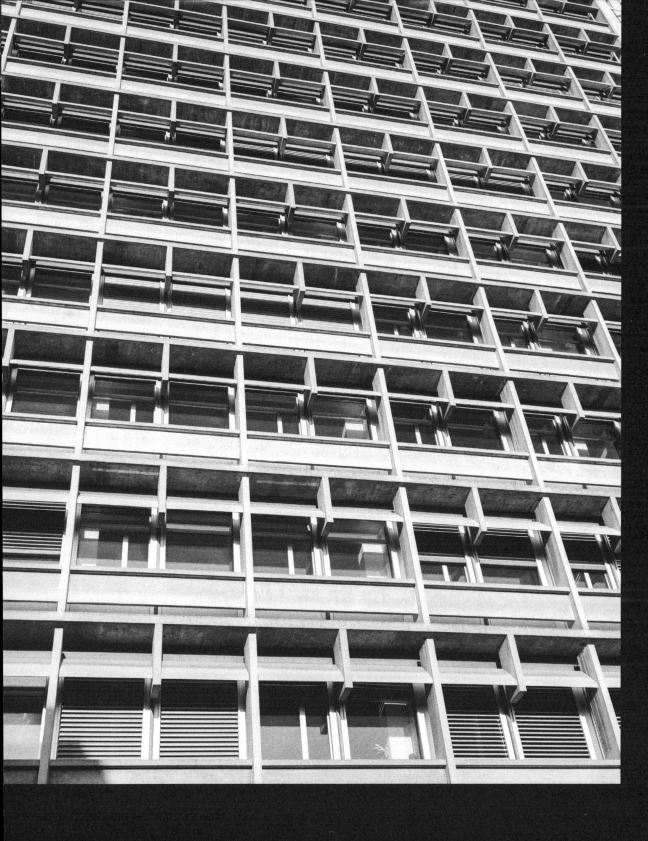

Fig. 4

the perpetually "invisible" computer workers, many of these former telecommunications players have disappeared from the collective memory, as have the ideals they had embodied—the common good, democratic oversight, or "humane" capitalism—and once professed, however imperfectly.

The Swiss PTT's former Electronic Computing Center (Elektronisches Rechenzentrum or ERZ, built in 1967) may stand in here for this forgotten history of the recent past. It is located on the grounds of the PTT's erstwhile Technology Center in Ostermundigen Fig. 4 , next to the historic "R&D skyscraper," where a rooftop bar and start-ups have recently taken up shop. Anyone wandering through the empty (and asbestos-ridden) offices of the computing center today will encounter remnants: cubicles that were installed there at some point; "focus" modules, into which one could withdraw to think; a few orphaned floppy disks that recall an earlier moment when Switzerland dreamed of becoming a "hub" of information—a hub of "electronic markets." [14] Switzerland, like other countries, could not afford to miss the connection to the "infosphere," the "data highways," and "decentralized global data networks," it was said at the time, with reference to corresponding policy decisions being made in the United States and the European Union.[15] It was then, in the course of liberalization of the telecommunications market in the 1990s, that ERZ PTT also met its ultimate demise.

When people talk about data centers today, they're usually referring to something else: highly functional purpose-built structures that enclose very, very many servers, actual "server farms." [16] This does not mean that legacy mainframe systems have disappeared altogether. The mainframes declared obsolete decades ago are still in use, though they are now often "virtualized." Swisscom, the partially privatized successor to PTT, for example, migrated certain applications as recently as 2019, including TERCO (Telephone Rationalization with Computers), a "large-scale project" initiated in the 1960s.[17] Yet, driven by streaming services, social media, big data, "infrastructure as a service" (IaaS) and other such means of outsourcing (as opposed to in-house solutions), the trend in recent decades has shifted toward server concentration with 99.999 percent "availability." [18] (At the ERZ PTT, a system of "shifts" still prevailed at first.) In 1994, the United Parcel Service (UPS) Windward Data Center in Alpharetta, Georgia, reportedly became the first Tier IV data center with a doubly redundant power supply, backup servers, contingency planning, increased security measures, and so on.[19] The dot-com boom and the expansion of e-commerce, as well as the catastrophic experiences of the attack on the World Trade Center (2001) and Hurricane Katrina (2005), amplified the trend toward

14 Stefan Zbornik, "Elektronische Märkte in der Schweiz: Die Zeit läuft ab!," in *Management Zeitschrift* 62, no. 1 (1993), pp. 89–94.
15 See, for example, Beat Schmid, "Der Übergang in die Informationsgesellschaft," in *Mut zum Aufbruch. Eine Wirtschaftspolitische Agenda für die Schweiz*, edited by David de Pury, Heinz Hauser, and Beat Schmid, Zurich, 1995, pp. 18–21; and see, for example, the (critical) take in *Deregulierung des Gemeinwohls. Telekommunikation als Markt der Märkte* (Themenheft), *Zoom. Kommunikation & Medien* 48, no. 7 (1996).
16 On this expression, which began circulating in the mid-1990s, see, for example, Robert F. Sullivan, "Alternating Cold and Hot Aisles Provides More Reliable Cooling for Server Farms," *Site Infrastructure White Paper* (2000), p. 1; or Kristina Shevory, "Cultivating Server Farms," *The New York Times* (October 25, 2006).
17 See "Swisscom hat die Mainframes abgeschaltet," *Computerworld* (May 14, 2019), https://www.computerworld. ch/technik/business-it/swisscom-mainframes-abgeschaltet-1709829.html?page=1_mainframe-as-a-service. This is not an isolated incident: the Zurich-based company LzLabs (https://www.lzlabs.com/), for example, specializes in moving mainframe-based systems into the cloud. The COVID-19 crisis in April 2020 also brought this persistence to mind, when many US government agency systems based on COBOL, a programming language from the 1950s, collapsed when hundreds of thousands of people attempted to file unemployment claims. On this, see, for example, Mar Hicks, "Scapegoating COBOL?" (May 1, 2020), https://marhicks.com/videos/cobol.html (retrieved July 3, 2020).
18 Pitt Turner, John Seader, and Kenneth G. Brill, "Industry Standard Tier Classifications Define Site Infrastructure Performance," *Site Infrastructure White Paper* (2005).
19 According to industry consultant Kenneth G. Brill, who is often referred to as "the father of the data center industry." On Windward, see Turner et al 2005, p. 1. Consulting and certification organizations such as 7×24 Exchange and the Uptime Institute were formed in the early 1990s, with a run-up in the 1980s. The first Tier IV-certified data center in Switzerland was established in 2014, operated by Swisscom, the successor to PTT.

data centers with a high degree of "resilience," appropriate security precautions, and discreet, inconspicuous architectures.[20] Nevertheless, the high visibility of quasi-monopoly platforms such as Amazon, Google/Alphabet, Alibaba, Baidu and Tencent, as well as their considerable carbon footprint, have increasingly caused data centers to come under the scrutiny of the media (and academia) in recent years. Estimates suggest that by 2017 there were more than 8.6 million data centers of various types around the world—small and large, private and public.[21] In addition to the standardization of security requirements and specific business models (such as IaaS)—again driven by Facebook, Google, Amazon, Salesforce, etc.)—a trend toward "hyperscale" data centers has also been observed since the mid-2000s; in this regard, the 500 mark was passed by the end of 2019.[22] According to current estimates, 38 percent of all "hyperscale" facilities are located in the United States, 10 percent in China, just under 10 percent in the UK and Germany, 7 percent in Japan, and the rest scattered around the world.[23]

China in the Basement

The proliferation of studies on digital infrastructures such as fiber optic networks, data centers and cryptocurrencies (or blockchain and high-performance computing installations) has reminded us of the critical importance of these infrastructures and has also given new topicality to the question of the political dimension of these supposedly purely technical artifacts. Who owns, who controls, and who benefits from these infrastructures? How sustainable are they? Do they undermine democracy?[24]

Much of what we know about digital infrastructures originates in the public communication of the IT industry in Silicon Valley: for example, the concept of neutral "platforms," the stock images of deserted server halls, and the associated idea of a "cloud" without borders or a physical location.[25] To this day, indeed, the success story of the Silicon Valley region continues to shape historical approaches to computerization, digitalization, automation, and the high-tech industry. The well-known and repeatedly recycled stories include ARPANET, the invention of HTTP at CERN, and the degeneracy of the anarchical origins of the Internet. The stories then proceed via the dot-com bubble into the "commercial web" of the 2000s. In turn, narratives of digital Europe (and of Switzerland as well) lean towards a certain declinism. As is well known, the course has long been set elsewhere.[26]

The fact that this image is historically incomplete and not quite up to date became particularly evident to us during a visit to Eastern Switzerland: a computing center on a

20 See, for example, Frank Patalong, "Wackelt das Web?" *Der Spiegel* (July 22, 2002), https://www.spiegel.de/netzwelt/web/worldcom-konkurs-wackelt-das-web-a-206309.html (retrieved July 3, 2020). "Since the WTC attack, US companies have been opting for duplicate structures," the article said. This security awareness also has a deeper history, of course. While Swiss banks, for example, were initially proud to display their computers in shop windows in downtown Zurich, concerns about such practices began to emerge by the late 1960s.

21 Cynthia Harvery, "Data Center," *Datamation* (July 10, 2017), https://www.datamation.com/data-center/what-is-data-center.html (retrieved July 3, 2020).

22 In 2015, there were just 259. See Thomas Barnett, Jr. et al., "Cisco Global Cloud Index (2015–2020)," 2016, https://www.cisco.com/c/dam/m/en_us/service-provider/ciscoknowledgenetwork/files/622_11_15-16-Cisco_GCI_CKN_2015-2020_AMER_EMEAR_NOV2016.pdf (retrieved July 3, 2020). The term "hyperscale" is a bit ambiguous. Although "hyperscale" data centers are generally large, "scale" refers mainly to scalability, i.e. a maximum degree of modularity, potential for automating operations, etc.

23 https://www.datacenterknowledge.com/cloud/analysts-there-are-now-more-500-hyperscale-data-centers-world (retrieved July 3, 2020).

24 The academic literature on this ranges from Nick Srnicek, *Platform Capitalism* (Cambridge, 2016) to Shoshana Zuboff, *The Age of Surveillance Capitalism* (London, 2019) to Evgeny Morozov, "Socialize the Data Centers!" *New Left Review* 91 (2015), pp. 45–66.

25 Cf. the critical treatment in Tung-Hui Hu, *A Prehistory of the Cloud*, Cambridge, MA, 2015; and Jennifer Holt and Patrick Vonderau, "'Where the Internet Lives': Data Centers as Cloud Infrastructure," in *Signal Traffic: Critical Studies of Media Infrastructures*, edited by Lisa Parks and Nicole Starosielski, Urbana, IL, 2015, pp. 71–93.

26 The GAIA-X cloud project launched in Germany in autumn 2019, for example, is a concrete reaction to such concentrations of power and technological "dependencies." "Europe," it says, "faces the following challenge: firstly, maintaining its liberal and socially cohesive economic and societal model in the face of increasing dependence on critical digital technologies (e.g. for obtaining, exchanging, and analyzing data) and oligopoly tendencies in the platform economy; secondly, positioning that model in a context of international competition." See (German) Federal Ministry for Economic Affairs and Energy (BMWi), "Project GAIA-X: A Federated Data Infrastructure as the Cradle of a Vibrant European Ecosystem" (2019), p. 6, https://www.bmwi.de/Redaktion/EN/Publikationen/Digitale-Welt/project-gaia-x.html (retrieved July 3, 2020).

greenfield site, just 10 km outside St. Gallen, operated by a power company founded during World War I. The PR pictures show cows, behind them picturesque mountains. "Swissness" is emphasized, as is the effort to create "future-proof IT infrastructures" for the region's small and medium-sized enterprises. The whole scene is rounded off with a cheese cellar next to the computing center, the cheese dairy making exemplary use of the waste heat from the computing center, thus contributing to energy efficiency and environmental compatibility.

The visit to the computing center, which was still under construction Fig. 5 , led us in new directions. Here, too, it was noticeable that the data center was built as an extension of existing older infrastructures. The data center was built next to an electrical substation whose history goes back to the beginnings of electrification and railway construction. The fact that this time-honored power company is entering the data center business is also significant from the perspective of economic history—not least because it points to the persistence of well-funded, traditional companies in the new economy, in this case the power industry, which is striving for diversification. This layering of digital infrastructures on top of older infrastructures, be it along ancient maritime routes, along undersea cables, along railways, roads, high-voltage lines, or gas pipelines, is inherent in many infrastructures[27]—because cables can usually be laid more easily where roads, rails, or pipes have already been laid, both in terms of practical and legal considerations: right-of-way.[28]

When we visited the construction site in the winter of 2017/18, however, we came across not only historical sediments of infrastructure, but also clues in the basement that point to the growing importance of that other, new Silicon Valley, the "capital of hardware": Shenzhen, the first special economic zone of the People's Republic of China.[29] The heart of the facility, an optical switching and networking platform, ensures that the incoming and outgoing streams of luminous data get to where they are supposed to go. The ultra-bandwidth light-wave switch was manufactured and installed by Huawei, a company founded in 1987. Along with Nokia / Alcatel-Lucent, Ericsson, Cisco, and ZTE, Huawei is now one of the global market leaders in network technology and mobile communications.[30] Huawei has been operating in Switzerland since 2008, with offices in Dübendorf, Liebefeld, and Lausanne. We became aware of this silent testimony to Swiss-Chinese relations shortly before the escalation of the trade war between the United States and China in the spring of 2018 (when the company name Huawei also became a veritable political epithet in Switzerland). The proliferation (and prev-

27 Or, as in the case of the first fiber optic cable connecting St. Gallen and Geneva in the mid-1980s: inside a concrete pipeline built between 1921 and 1924 by the Swiss Confederation as a "job creation measure" (the fiber optics themselves came from Japan at the time, from the Fujikura company). See B. Peyer, "Digitale Kommunikation. Glasfaser-Kabelnetz der PTT im Aufbau," *Schweizer Ingenieur und Architekt* 104, no. 17 (1986), pp. 404–06, esp. p. 406.

28 On this, see, for example, Ingrid Burrington, "How Railroad History Shaped Internet History," *The Atlantic* (November 24, 2015), https://www.theatlantic.com/technology/archive/2015/11/how-railroad-history-shaped-internet-history/417414/ (retrieved July 3, 2020); and ibid., "A Network of Fragments," *The Atlantic* (December 8, 2015), https://www.theatlantic.com/technology/archive/2015/12/a-network-of-fragments/419469/ (retrieved July 3, 2020). There is also a tendency to install data centers inside former factories and the like, the real estate of the industrial age; on this, see: Graham Pickren, "The Factories of the Past Are Turning into the Data Centers of the Future," *Imaginations* 8, no. 2 (2017), pp. 22–29; Kate Jacobson and Mél Hogan, "Retrofitted Data Centres: A New World in the Shell of the Old," *Work Organisation, Labour & Globalisation* 13, no. 2 (2019), pp. 78–94.

29 Representative of this discourse is, for example: Matthias Müller, "Shenzhen – Chinas Hauptstadt der Hardware," *Neue Zürcher Zeitung* (April 1, 2019), https://www.nzz.ch/wirtschaft/shenzhen-chinas-hauptstadt-der-hardware-ld.1448786 (retrieved July 3, 2020). For further details, see, for example, *Learning from Shenzhen: China's Post-Mao Experiment from Special Zone to Model City*, edited by Mary Ann O'Donnell, Winnie Wong, and Jonathan Bach, Chicago, 2017.

30 On this, see the chapter by Lena Kaufmann.

alence) of Chinese hardware has thus far received little attention in the typically US-centric research within STS and media studies. It is to be read as a consequence of new techno-geopolitical circumstances, though also as a result of the multinational economic interdependencies that the "open economy" of Switzerland has cultivated for decades, not only as an importer of digital infrastructures, but at times also, as the chapter by ethnologist Lena Kaufmann on the transnational activities of cable manufacturer Daetwyler AG points out, as a successful exporter of know-how.[31]

On-site visits thus heighten awareness of the *longue durée* of infrastructures and of their tendency to undermine nations, legal spaces, economic areas, and academic horizons of thought. The centers of data are complex entities. A closer look reveals, for instance, that the data center in Eastern Switzerland not only featured high tech from the Far East, but also the inconspicuous RJ45 connector accessories from Reichle & De-Massari, founded in 1964 as a PTT supplier in Wetzikon and now operating in China, Singapore, Poland, the United States, and elsewhere. In the basement, we came across a diesel emergency power generator reminiscent of a ship engine from the nineteenth century. In the electrical substation next to the computing center parking lot, one might find the insignia of traditional Swiss engineering companies such as Brown, Boveri & Cie., founded in the late nineteenth century. And suddenly the fiber optic cables hanging from the walls of the aforementioned company Daetwyler AG from Erstfeld catch one's eye (we had seen them previously in the Milchbuck tunnel)—the company's origins in wire and rubber processing are rooted in the mountainous canton of Uri in the early twentieth century; the company expanded into China in the 1990s. The emergence of transnational links in Switzerland's recent technological and economic history (for example, with Japan and later China) has so far hardly found its way into the historical narratives of Switzerland's "digitalization."

Edges of a Wired Nation: For an Extension of the History of Data Centers

It is precisely such historical complexities that this book aims to explore. It tells the story of places that became data centers. For this purpose, we've visited very different "centers": not always the newest, not always the largest, not always the most obvious. We've been in warehouses where computing antiquities from six or seven decades are piled up, at universities where discarded supercomputers serve as seats or stand unheeded in a corner; we have been in old, dysfunctional, and new data centers, to computer center construction sites, to museums, to exhibitions. We've

31 The fact that "Swiss electronics" didn't exist (anymore) or that "electronics ... kn[ew] no national boundaries," as Swiss National Councillor Ulrich Bremi put it in 1983, undoubtedly was a thoroughly traumatic experience, though. On this, see David Gugerli, "'Nicht überblickbare Möglichkeiten'. Kommunikationstechnischer Wandel als kollektiver Lernprozess, 1960–1985," *Preprints zur Kulturgeschichte der Technik* 15, Zurich, 2001.

met Microsoft Azure employees, retired data center directors, talked to electricity companies and politicians, visited archives and basements, visited Bitcoin bankers at their offices, and attended Huawei, Swisscom, and cryptocurrency events. Some traces have been lost, some have been followed up, others have mutated.[32] We were in the field a lot, but the basic tenor of this book is historical.

This book thus builds upon and expands the STS literature, which in the narrower sense revolves around the data center industry. Existing research focuses, for good reasons, primarily on the expansion strategies of Microsoft, Facebook, Amazon et al., on the corresponding regional political tactics of the host communities (be they in Sweden, Ireland, North Carolina, or—for the past year or two—in Switzerland as well), on the semantics of the "cloud," on the alleged weightlessness and locationlessness of the data center industry.[33] This book similarly draws upon local case studies, yet explores extended periods of time: some of them going back to the nineteenth century, others more recent. Additionally, in the spirit of an extended history of infrastructures, our investigation also includes actors and spaces that haven't received much attention thus far, such as component manufacturers and the role of law firms in the regulation of blockchain technologies, the activities of state agencies in the pursuit of industrial policy, be it on a local, regional, or national level, and areas of cooperation and conflict between the state, knowledge, and the economy in the development of digital infrastructures.

Many of the essays compiled here thus deal with a period of socio-technical upheaval, which likewise has received little attention in the historiography of Switzerland. This period began in the 1980s, intensified in the 1990s, and continues to the present day. Silvia Berger's essay deals with the post-1989 conversion of World War II and Cold War bunker architecture to data centers, using the Swiss "Fort Knox" as an example, a facility frequently stylized as "Europe's most secure data center." Giorgio Scherrer's study on the Centro Svizzero di Calcolo Scientifico (CSCS), the Swiss national high-performance computing center, vividly describes the transformation of Swiss technocratic elites since the 1980s, and how they played into the planning and naming of a national data center in Switzerland. Max Stadler's essay on the Swiss PTT's Electronic Computing Center traces the rise of this institution from the perspective of the history of technology and labor—and its fall in the wake of the deregulation of the telecommunications sector. Moritz Mährs and Kijan Espahangizi's study uses the example of the so-called Central Aliens Register (ZAR) to explore how database systems have influenced the formulation and development of policy (regarding foreign nationals) in Switzerland (and vice versa). In her study

32 During the course of the project, the object of investigation, the questions we were after, also shifted. Initially we mainly were interested in the media-driven notion that Switzerland could become a "data vault," that data was the new "gold" or the new banking secrecy, that Switzerland should not miss the connection to the "cloud." However, we were quickly confronted with the fundamental question of how this history of the edges of digital Switzerland could be told without resorting to narratives of revolution or disruption.

33 A considerable amount of literature has accumulated on this subject. See, for example, Vincent Mosco, *To the Cloud: Big Data in a Turbulent World*, Boulder, CO, 2014; Holt et al 2015, pp. 71–93; Louise Amoore, "Cloud Geographies: Computing, Data, Sovereignty," *Progress in Human Geography* 42, no. 1 (2016), pp. 4–24; Asta Vonderau, "Scaling the Cloud: Making State and Infrastructure in Sweden," *Ethnos* 84, no. 4 (August 8, 2019), pp. 698–718; ibid., "Technologies of Imagination: Locating the Cloud in Sweden's North," *Imaginations Journal of Cross-Cultural Image Studies* 8, no. 2 (2017), pp. 8–21; Mél Hogan, "Data Flows and Water Woes: The Utah Data Center," *Big Data & Society* 2, no. 2 (2015), pp. 1–15; Louise Amoore, *Cloud Ethics: Algorithms and the Attributes of Ourselves and Others*, Durham, NC, 2020; Mél Hogan, *The Data Center Industrial Complex*, Durham, NC, 2020 (forthcoming).

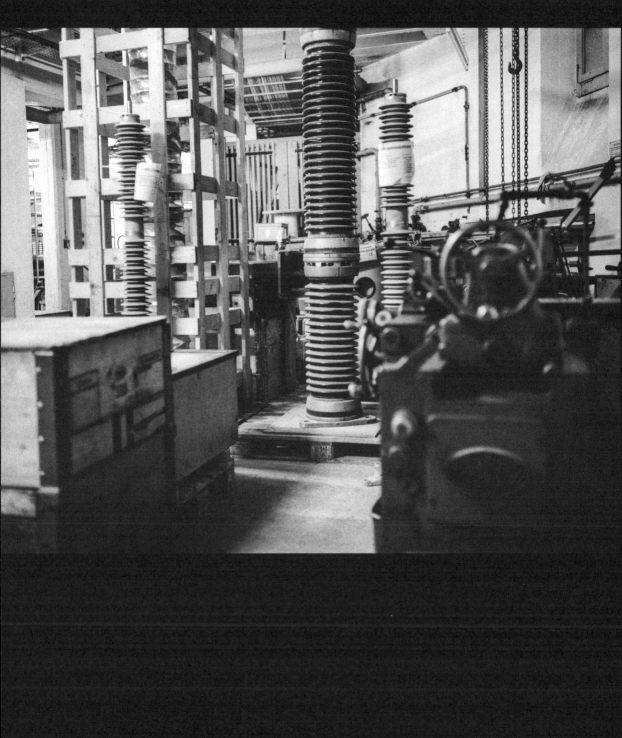

Fig. 6

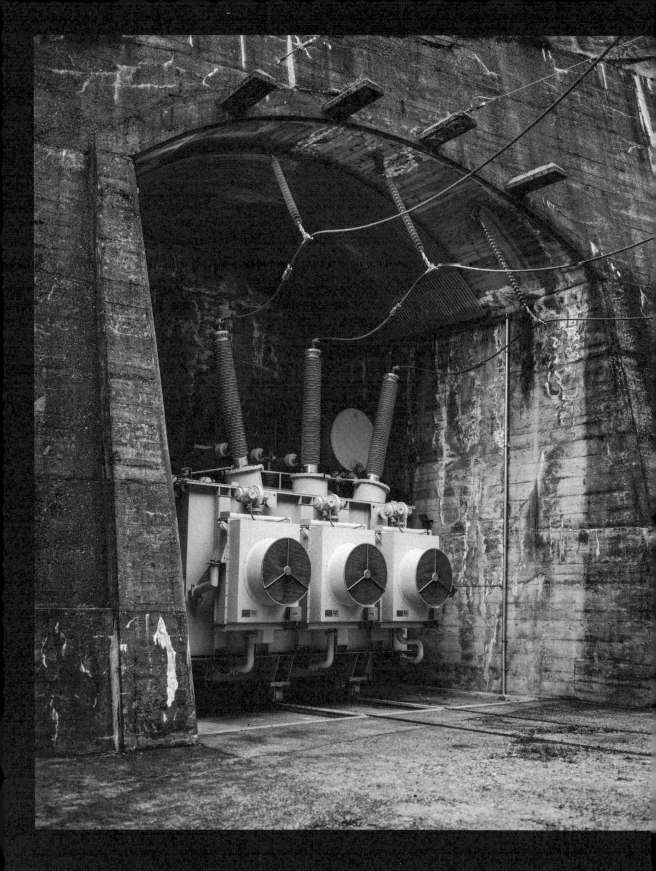

Fig. 7

on the "Crypto Valley" in Zug, Monika Dommann shows how a small town, by building upon the expertise of local commercial and tax law firms, is seeking to position itself internationally in the new field of blockchain technology following the decline of the local export and manufacturing industry. In a further chapter, she explores (with Max Stadler) the new dream of digital gold: the "mining" of cryptocurrencies—"crypto" gold—and its connection to socio-ecological conflict and alpine hydropower, or "white" gold Figs. 6,7 . Finally, Lena Kaufmann's chapter looks at some of the less conspicuous things: the routes taken by Daetwyler AG's cables on their way to China, and in exchange the arrival of Huawei employees in Switzerland. In addition, this volume contains essays by Sascha Deboni and Andrés Villa Torres on practices of data destruction and preservation; by Renate Schubert, Scherwin Bajka, and Fatih Öz on the energy issues surrounding data centers; and by Ioana Marinica and Renate Schubert, who designed a representative survey to explore the Swiss population's ideas and attitudes towards data centers.

A lot remains to be done, evidently: many traces, many places, many actors we've come across in the course of our investigations await their own historians: be they financial players such as Telekurs or the Schweizerische Kreditanstalt (now Credit Suisse), which began to exert pressure early on to demand better, faster information and communications infrastructure;[34] be they lobby organizations such as l'Association Suisse des Télécommunications (ASUT), established in 1975, which were up to something similar; or international actors such as SWIFT, the financial messaging service provider, which has maintained a data center in Thurgau since 2013.[35] Add to that the many, many minor players that are generally overlooked in accounts of the data center industry: architectural firms that have specialized in such high-tech spaces over the last two, three, or four decades, manufacturers of racks, cooling systems, accessories, plugs, and cables—"the power of inconspicuous things," as a commemorative publication by Daetwyler is titled with some justification.[36] And so on. A systematic survey of the current Swiss data center industry must in any case be left to future researchers.[37] This will require studies that critically examine, in view of political, economic, and legal factors, Switzerland's characteristics as a location for data centers and compare them to other countries.[38]

It may well be the case that our snapshot will itself very soon become a historical document. Tech giants such as Google and Microsoft as providers of data centers are gaining a foothold in Switzerland as well. That anyone can keep up, let alone have a say, whether in terms of infrastructure, hardware, or research, when so much liquid capital is in play, seems doubtful. When we

34 On the nexus of Swiss banks and computing, see David Gugerli, "Data Banking: Computing and Flexibility in Swiss Banks 1960–90," in *Financial Markets and Organizational Technologies*, edited by Alexandros-Andreas Kyrtsēs, London, 2010, pp. 117–36.

35 On this, see Stefan Keller, *Spuren der Arbeit. Von der Manufaktur zur Serverfarm. Reportage*, Zurich, 2020, pp. 165–83; and Susan V. Scott and Markos Zachariadis, "Origins and development of SWIFT, 1973–2009," *Business History* 54, no. 3 (2012), pp. 462–82.

36 Karl Lüönd and Christoph Zurflüh, *Die Kraft der unscheinbaren Dinge. 100 Jahre Dätwyler*, Zurich, 2015.

37 We soon found out that the question of how many computer centers there actually are in Switzerland is not so easy to answer, even if a census mentions some seventy-five facilities. See Switzerland Global Enterprise, "Data Centers in Switzerland: Fact Sheet 2019," https://www.s-ge.com/en/publication/fact-sheet-data-centers-switzerland (retrieved July 3, 2020). Secrecy and discretion apart, one reason for this is that the distinction between installations with networked computers and data centers in private and public institutions is quite fluid. The same applies to typologies: an American study from 2016, for example, assumes eleven different "space types." See Arman Shehabi et al, *United States Data Center Energy Usage Report*, Lawrence Berkeley National Laboratory, Report LBNL-1005775 (2016), p. 21. And in any case, not everything, not even most things, are in the "public" cloud yet—even if the term "data center" is now used almost synonymously with Amazon AWS, Microsoft Azure, and so on.

38 This is especially true in view of the assertions by location boosters that Switzerland is ranked third on the global Data Center Risk Index, on account of its legal framework, its "political stability," the quality and stability of its power supply, and because it has "one of the best information and telecommunications infrastructures in the world" (with only Iceland and Norway being better positioned in terms of "attractiveness.") See, for example, Switzerland Global Enterprise 2019.

Fig. 8

asked whether the data center where this "K" is found Figs. 8, 9 —the aforementioned national super-computing center CSCS—will really still be able to compete with Amazon Web Services in the foreseeable future, we received a cautious answer: maybe not.[39] It certainly is no coincidence that there are renewed calls for an entrepreneurial or developmental state.[40] Indeed, not least the big infrastructure players, though they already provide essential infrastructure—many people today regard the Internet as a kind of utility—tend to be unaccountable.

Seen in this light, the iconography of the contemporary data center—endless, sterile rooms full of server racks and devoid of people—certainly contains a kernel of truth. For what the future arrangement of state and tech will look like, whether it's in the style of the United States or China, or whether Europe will be able to follow its own path, is one of the pivotal questions of our age. One thing appears certain at the moment: the political and legal concepts of modernity, such as "nation," "territory," and "sovereignty," have long since caught up with the supposedly locationless and weightless new world of zeros and ones, that putative world beyond the "weary giants of flesh and steel," to use the term from John Perry Barlow's often-cited "A Declaration of the Independence of Cyberspace," authored in Davos in 1996.[41] When it comes to the Internet and digital infrastructure, researchers today are more likely to speak of "territorialization," "(Internet) nationalism," infrastructural "sovereignty," "knowledge extractivism," or even "weaponization."[42] Switzerland is playing a role here, not so much by means of hardware but, as always, if you like, via territorial software—the provision of its territory for the legal enshrinement of the transnational flow of data. Examples of this are the establishment of SWIFT in Thurgau in 2011/2013,[43] the registration of the Ethereum Foundation in Zug in 2014,[44] the registration of Facebook offspring Libra Networks S.à r.l. in Geneva in 2019,[45] and the rumored recent migration of "hyperscalers" to Switzerland in the wake of the EU's General Data Protection Regulation (GDPR).[46]

As the essays in this volume, each in its own way, show, the concept of the nation—where it ends, what services and regulations it is responsible for, and by what means it can assert these—has long been challenged by the emergence and proliferation of digital infrastructures. To be sure, the case studies in this book do show that the cultivation of (in this case) "Swissness" and the recourse to historical narratives in the context of digital infrastructures has enjoyed and continues to enjoy a veritable renaissance. Nevertheless, the increasing deterritorialization of data[47] and the proprietarization of protocols, resources, and know-how not only acutely raise the question of how much territorial power nations are retaining in the age of oligopolistically managed digital infrastructures. More than that, the question arises of whether and how this process will occur in the spirit of a good, democratic, and sustainable society; and whether and how the ninety-nine percent, the citizens, will be allowed to participate in shaping it. This is another reason why it is necessary to keep an eye on the edges of the digital world: this is where history was and is being made.

39 On this issue, the increasingly hegemonic dominance of "industry labs" in certain computationally intensive research areas, see, for example, Emma Strubell, Ananya Ganesh, and Andrew McCallum, "Energy and Policy Considerations for Deep Learning in NLP," ArXiv:1906.02243 [Cs.CL], 2019.

40 On this, see, for example, Mariana Mazzucato, *The Entrepreneurial State: Debunking Public vs. Private Sector Myths*, London, 2018.

41 See John Perry Barlow, "A Declaration of the Independence of Cyberspace," *Electronic Frontier Foundation* (February 8, 1996), https://www.eff.org/cyberspace-independence. In 2020, for example, a company based in Switzerland (SITA) was (reportedly) sued for the first time by the US Office of Foreign Assets Control for routing data via servers on US soil. See Eric Sandberg-Zakian, "OFAC $7.8M Settlement with Swiss Company Expands Tech Enforcement," *Bloomberg Law* (April 16, 2020), https://news.bloomberglaw.com/white-collar-and-criminal-law/insight-ofac-7-8m-settlement-with-swiss-company-expands-tech-enforcement (retrieved July 3, 2020). Concern regarding "transborder data flows" is not a new phenomenon per se, however. See, for example, OECD, *Transborder Data Flows and the Protection of Privacy*, Paris, 1979.

42 See, for example, Henry Farrell and Abraham L. Newman, "Weaponized Interdependence: How Global Economic Networks Shape State Coercion," *International Security* 44, no. 1 (2019), pp. 42–79; Norma Möllers, "Making Digital Territory: Cybersecurity, Techno-Nationalism, and the Moral Boundaries of the State," *Science, Technology, & Human Values* (online first) (2020), https://doi.org/DOI/10.1177/0162243920904436 (retrieved July 3, 2020).

43 On this, see Stefan Keller 2020, pp. 165–83.

44 Kanton Zug, Handelsregister: Stiftung Ethereum, https://zg.chregister.ch/cr-portal/auszug/auszug.xhtml?uid=CHE-292.124.800 (retrieved February 1, 2020).

45 Kanton Genf, Handelsregister: Libra Networks S.à r.l., https://ge.ch/hrcintapp/externalCompanyReport.action?companyOfrcId13=CH-660-1258019-8&ofrcLanguage=1 (retrieved February 1, 2020).

46 Christine Hall, "Google Building Cloud Data Centers Close to Swiss Banks," *DataCenter Knowledge* (May 8, 2018), https://www.datacenterknowledge.com/google-alphabet/google-building-cloud-data-centers-close-swiss-banks (retrieved July 3, 2020).

47 On this, see Paul Schiff Berman, "Legal Jurisdiction and the Deterritorialization of Data," *Vanderbilt Law Review* 71, no. 11 (2018), pp. 11–32.

On the Images in This Book: Infrastructural Landscapes and Procedures

Hannes Rickli

In their commissioned photographic studies, Andrea Helbling and Marc Latzel have taken different approaches to the inconspicuous nature of digital infrastructures. The black-and-white images by Andrea Helbling that accompany the introduction were taken without the tripod that the architectural photographer usually employs and were instead shot by hand as fleeting impressions. Rather than capturing quantifiable information about a specific situation, they are more a reflection of the sensations and atmospheres that surround us in these mostly uninhabited spaces: the tactile and olfactory qualities of concrete and steel, temperatures perhaps, the muffled sound of one's own footsteps on an old office carpet. Things that one finds striking and moving in a specific situation, but that are hard to place. In their raw and direct manner, the images, some of which are under- or overexposed on analog film, question the iconography of these technical realms which the mass media usually present to us as an ordered series of illuminated clean rooms free of extraneous objects.

Helbling has chosen a different approach in her color photo essay, which spans the entire book. In this, she "studies" the spaces and infrastructural edifices encountered in order to understand them visually.[1] She integrates them into their urban or rural landscapes, into the eras and cultures they represent.

In his photo reportage of digital industry, Marc Latzel examines procedures that are part of high-tech labor but are often forgotten: the intricacy and precision involved in the production of kilometers of fiber optic cable, which are later invisibly laid underground as an indispensable medium for distributing information, and the certified physical destruction of storage media in a shredder at the end of their life cycle.

[1]

On the concepts "studium" and "punctum," see Roland Barthes, *Camera Lucida*, New York, 1981.

Manno

A Superbrain for
Switzerland:
Techno-Nationalism,
Cold War Thinking,
and the Commodification
of High-Speed
Computing in the Making
of the First National
Supercomputer,
1985–1992

Giorgio Scherrer

Seven years can be a long time in the lifetime of an idea, especially if that idea involves a computer. Or worse: an expensive, cutting-edge supercomputer in a time of rapid technological progress. A time like the late 1980s and early 1990s, when high-performance computers could become outdated in a fraction of the time it took to agree on the details of their installation. So, when Switzerland's first national center for scientific supercomputing (Centro Svizzero di Calcolo Scientifico, CSCS) officially opened in 1992, its then state-of-the-art machine from the Japanese company NEC would be in need of replacement within only three years. The time from the Swiss government's proposal to build the center in 1985 until its realization, meanwhile, was seven years.

What follows is the story of those seven years and of what made them so long. It's the story of an idea—that of a strong, powerful computing machine for a small, ostensibly neutral country. And it's the story of how that idea changed almost beyond recognition in the turbulences of a period that saw the end of the Cold War and of US dominance in the computer industry as well as a rise of neoliberal ideas and right-wing populism. The history of the nationalist project that CSCS stood for will touch on all of these issues, notwithstanding the center's seemingly remote, idyllic siting in Ticino— the country's southernmost canton, known for beautiful lakes and hikeable mountains. Even there it proved impossible to install a gigantic supercomputer without getting caught up in all kinds of transnational trends, as we shall see. But local developments also had a significant impact on the making of CSCS. Indeed, how this grand project of Swiss scientific and industrial innovation ended up being located in a region that at the time had no university, far away from its parent institution in Zurich (the Federal Institute of Technology, ETH), is a question that's crucial to this story. It's a story that begins at its end: the official opening ceremony of the CSCS on October 1, 1992.

I Prologue: The Opening Ceremony

Imagine the following scene: on an autumn day in the small Swiss community of Manno, between railway tracks and a highway in a bulky building with the charm of a shopping mall, the light melody of Mozart's *Variations on a Minuet by Duport* is playing softly. Imagine speeches, a ribbon-cutting ceremony, and groups of visitors touring the new facility: Switzerland's first national center for scientific computing.[1] Everyone is in a celebratory mood—except the two men who made all of this possible, who aren't even there (or at least don't remember being there). These men, in the case of the CSCS, were the former ETH president, who'd had the idea of placing the center in Ticino, and the local member of parliament,

1

CSCS: Inauguration of CSCS Manno—October 1, 1992. Detailed Program (in Schärli, Research Archive).

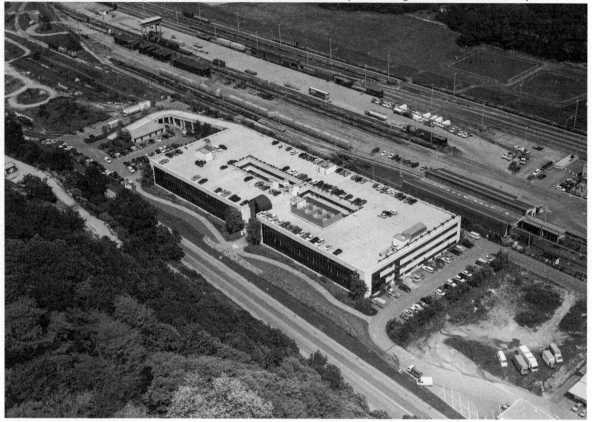

| Fig. 1 |

who had turned this idea into a reality in an exceptionally short time. But why weren't they there?

Hans Bühlmann, the former president, recalls no clear reason for his absence except the obvious one: he had stepped down as president (not in the happiest of circumstances) and resumed his post as a professor of mathematics two years earlier. The CSCS was his successor's project now: he had chosen its name, successfully installed his preferred candidate as its first director, and held the first speech of the day.[2]

Fulvio Caccia, the member of parliament (MP), doesn't remember whether he attended, but recalls many reasons for not doing so. For example, a year earlier, when the center had begun operating, the local government, in the name of which he had lobbied for CSCS to be established in Ticino, had refused to attend an exclusive tour of the facility, fearing political controversy shortly before the national election of October 1991. Caccia had taken this personally, since the controversy largely concerned charges of nepotism against him in the choice of the center's location.[3]

Still, both men were thanked numerous times in the inaugural speeches, including by the local state councillor who had earlier refused to visit the center. This contradiction is only one of many surrounding the history of the CSCS that are present in these speeches, hardly disguised by their celebratory tone and the musical intermezzos between them.

When the new president, Jakob Nüesch, praised the CSCS in his speech as "a lively example of how cultural barriers and prejudices can be overcome for an efficient collaboration," he referred to the unusual step of buying a Japanese computer from Nippon Electronics Corporation (NEC) for the CSCS, thereby ending a six-year period of dominance by its US competitor Cray at Switzerland's two Federal Institutes of Technology (ETH in Zurich and EPFL in Lausanne).[4] And yet, "cultural barriers and prejudices" would perhaps have been a more apt description of the relationship between proponents and opponents of placing the center in Ticino in the first place.[5] Indeed, what Nüesch called "a gesture of solidarity towards a promising region" and Giuseppe Buffi, the local councillor, called a commitment to "that Switzerland which prides itself on being multicultural and multilingual" was seen by many other *Ticinesi* as something else entirely: as a testimony to the lack of transparency—or, in Buffi's self-defense, the "maximal speed" and "maximal discretion"—with which the project had been realized.[6] This informal process drove a wedge into Ticino, creating the local variation of a larger conflict about how market-oriented and transparent bureaucracies should act, e.g. when deciding on the location of a cutting-edge piece of hardware.

2

Interview with Hans Bühlmann conducted for this publication (Scherrer July 12, 2018); Christoph Wehrli, "Überraschende Rücktritte aus der ETH-Leitung: Ankündigung des Präsidenten und eines Vizepräsidenten," *Neue Zürcher Zeitung* (March 20, 1990), p. 53.

3

Interview with Fulvio Caccia conducted for this publication (Scherrer July 26, 2018).

4

Speech by Jakob Nüesch ("Il centro Svizzero di Calcolo Scientifico. Una nuova realtà nel sistema informatico Svizzero") on October 1, 1992, p. 1 (in Schärli, Research Archive). At ETH there had been computer infrastructure from Control Data Corporation (CDC), from which Cray had emerged, since the 1960s. See Andrea Westermann, "Das Rechenzentrum," ETHistory 1855–2005, April 25, 2005, http://www.ethistory. ethz.ch/besichtigungen/

touren/vitrinen/dienstwege/ vitrine61/index.html (retrieved September 6, 2019). The switch to a Japanese machine was therefore a watershed moment, especially since it occurred at a delicate time of rising US-Japanese tensions regarding trade with high-end electronic products. (See Marie Anchorduguy, "Japanese-American Trade Conflict and Supercomputers," Political Science Quarterly 109, no. 1 (Spring 1994), pp. 61–75).

Symbolism aside, however, this machine also had actual tasks to fulfill. First the national task of helping Switzerland master the "transition from the industrial to the informational age," and second the global task of joining "an international network" of scientists and researchers to move beyond "an IT development with Swiss characteristics only."[7] Globalization to save the nation: yet another contradiction there. The CSCS's identity was contested, then, from its very start. And so was its history. In fact, Caccia, the MP, had already written an account of how the CSCS had ended up in Ticino, focusing on the local aspects of this story. It was an account addressed "to the friends who desire to know," published nowhere and yet omnipresent in many retellings of CSCS's origin story—from its first public appearance as a side note in a 1990 news story right up to CSCS's 25th anniversary celebration, when Caccia was tasked with presenting the institution's history while this time, the first director, Alfred Scheidegger, was absent.[8] Scheidegger had been invited, but with a standard letter—no personal invitation, no offer of speaking time, not even a paid train ticket, as he recalls—and so he had declined to go. Back in 1992, at the inauguration, Scheidegger had highlighted the CSCS's "broader function as a European institution."[9] Press coverage likewise focused on its role as "an international center of excellence"—a vision dominating public discourse at the time.[10] Today, in contrast, it's those who see it—in the tradition of Caccia—as a national symbol of lived federalism who are well on track to shaping the record of its past. The official book on the history of ETH, for example, speaks of a "decentralization serving regional policy purposes," one that constituted an "alien special use" of the supercomputer.[11]

The following account seeks to follow neither of these two paths. Rather, it argues that the three strands of this story—global, national, and local—are united by a simple question: How can, or rather, how should technology serve the nation? Indeed, in the story of CSCS, the national question of obtaining a supercomputer in order to ensure sovereignty and eco-

5

One would assume that the local councillor, Giuseppe Buffi, alluded to this conflict when arguing in his speech that "the story ... of the CSCS is one of friendship and misunderstandings." But one would assume wrongly. The misunderstandings, for him, were all in Ticino. With "undoubting bitterness" he decried the "mockery and suspicion," the "coldness, not to say indifference of our own surroundings" to the project.

6

"There are even those who believe that this center is at the origin of the political earthquakes that have marked our canton in the last two years," he lamented, referring to the rise of a populist party that had used charges of nepotism in the choice of the CSCS's location to stir anti-establishment sentiment among local voters. Speech by Giuseppe Buffi on October 1, 1992, p. 1, pp. 7–10 (in Schärli, Research Archive).

7

Speech by Nüesch on October 1, 1992, p. 2 (in Schärli, Research Archive).

6

Speeches by Nüesch, p. 3, and by Buffi, p. 4, p. 8, both on October 1, 1992 (in Schärli, Research Archive).

8

See Fulvio Caccia, *Memoriale sul Centro Svizzero di Calcolo Scientifico, Bellinzona*, September 30, 1991, p. 1 [unpublished account, obtained via the author]; an article on the inauguration in the local press (A.N., "Chiavi per l'apertura di un sogno," Gazzetta Ticinese (October 19, 1990), p. 13.); Fulvio Caccia, *CSCS 25th Anniversary: Retrospective of a Turbulent History*, October 25, 2016 [unpublished digital presentation, obtained via the author].

9

Speech by Alfred Scheidegger, *Calcolo scientifico di alto livello al CSCS. Effetti sociali ed economici*, October 1, 1992, p. 2 (in Schärli, Research archive).

10

Denise Jeanmonod ("Le plus puissant centre de calcul de Suisse inauguré," *Journal de Genève et Gazette de Lausanne* (October 2, 1992), p. 20) quoting Scheidegger; see also Gino Driussi ("Centre national de calcul à Manno: Du nouveau," *Journal de Genève* (October 12, 1990), p. 15), where it is called a "European IT center."

11

The formulation in the original German version is *"sachfremder Sondernutzen."* David Gugerli, Patrick Kupper, and Daniel Speich, *Die Zukunftsmaschine: Konjunkturen der ETH Zürich, 1855–2005*, Zurich, 2005, p. 353. Interestingly, the English version is vaguer, speaking only of a "regionally and politically pragmatic" solution. David Gugerli, Patrick Kupper, and Daniel Speich, *Transforming the Future: ETH Zurich and the Construction of Modern Switzerland 1855–2005*, Zurich, 2010, p. 307.

nomic survival in a world dominated by the Cold War quickly turned into a local question, namely of providing a supercomputer to express a government philosophy of paternalistic federalism (and of opposition to it). This question then shifted toward a global one, now framing the supercomputer as a product and the world as a market.[12] And yet, despite these transformations, a hidden continuity remained. The elites dominating those phases—the aging technocrats of Cold War nationalism with their rhetoric of need, the well-connected politicians of locally fragmented Switzerland pushing federalism, the new breed of market-oriented managers celebrating globalization and competition—may have changed drastically. But they all still relied on the state as a provider of electronic infrastructure.[13]

II Early Beginnings: The Construction of Necessity

It was the 1980s, and a fear was making its rounds among the Swiss scientific elite: the fear of their nation falling behind, not least and especially in computing.[14] According to a member of ETH's governing council, European (and thus also Swiss) technology was in danger "of being overtaken by the US and Japan."[15] The head of the federal office for science likewise propagated the need to "catch up in supercomputing with the more advanced countries."[16] "For ten years, the machines used here have been outdated," a 1988 radio report alleged.[17] Clearly, something had to be done.

Similar fears haunted other "advanced" nations. And so everywhere, things were indeed done. Japan started several public-private initiatives, in which big tech companies and the country's Ministry of Trade and Industry (MITI) collaborated on the development of experimental high-end technology, among them the *Japanese Super-Speed Computer Project* (or supercomputer consortium).[18] In the US, the *Defense Advanced Research Projects Agency* (DARPA), among other institutions, now sponsored a wide range of research activities—culminating in such initiatives as the 1989

12

While "nation" is understood differently on each level, the answer to the question remains similar in one regard: it sees technology—or, rather, high-end computer technology—as an element of infrastructure, i.e. something to be provided by the state, but not for the state's own use.

13

Those phases and elites, of course, overlapped at times. Therefore, after section II explores the early national strand of this story, III explores early interactions between national and global strands, while IV focuses on local aspects and V mainly on global ones.

14

For its effects, see Gugerli et al. 2005, pp. 353–57, or 2010, pp. 306–11.

15

The man was Ambros Speiser, head of research at the industry giant Brown, Boveri & Cie (after a merger part of ABB today), speaking in 1985, cited in: Gugerli et al. 2005, p. 336, or 2010, p. 291.

16

Urs Hochstrasser, "The National Initiative for Supercomputing in Switzerland," *Speedup Journal* 2, no. 1 (January 1988), p. 11.

17

This was in reference to ETH's computing center. Guido Stalder, "Neuer Supercomputer Cray X-MP," *Regionaljournal Zürich-Schaffhausen*, (June 13, 1988).

18

See Scott Callon, *Divided Sun: MITI and the Breakdown of Japanese High-Tech Industrial Policy, 1975–1993*, Stanford, 1995, pp. 18–23; Hiroshi Kashiwagi, "The Japanese Super-Speed Computer Project," *Future Generation Computer Systems* 1, no. 3 (1985), pp. 153–60.

Federal High Performance Computing (HPC) Program.[19] In both countries, however, the direct success of government resources in helping companies to develop better products was questioned both at the time and in retrospect. But the positive indirect effect that a growing pool of skilled computer specialists or increased access to supercomputers had on the economy was universally acknowledged. If there was a connecting thread behind all these initiatives, it was this: the belief that a nation's rate of technological innovation would directly translate into economic growth—and that innovation had to be enabled by the state.[20] Indeed, despite the prevailing free-market rhetoric of the time, it's doubtful that Cray's supercomputers, for instance, could have been developed without help from government agencies such as the National Security Agency (NSA).[21]

And Switzerland? What was done to preserve the *Denkplatz Schweiz* (Switzerland, place of thinking)?[22] Well, Switzerland, in the absence of supercomputer companies it could have supported, went about building its national supercomputing center—in order to support research relevant to the country's industry. This idea was long in the making, and two men were crucial to turning it into a parliamentary bill (passed in 1986), which secured funding for it. Both men were trained mathematicians who had made a career thanks to the emerging field of computer science. One by becoming a diplomat, Switzerland's first scientific attaché to the US and Canada and subsequently the director of the newly founded Federal Office for Science and Education. The other by becoming a professor of computer science at ETH and a high military official in the Swiss army in charge of computer simulations.

Urs Hochstrasser, the diplomat, had spoken of the need for a "national research center" with a "big electronic calculating machine" as early as 1959, in a report on the state of scientific research in Switzerland. In it he not only lamented the scarcity of scientific personnel in the Swiss bureaucracy, but also suggested that a "big calculating machine ...

19

See Alex Roland, and Philip Shiman, *Strategic Computing: DARPA and the Quest for Machine Intelligence, 1983–1993*, Cambridge, 2002, pp. 288–95. For a report expressing fears of losing leadership in the HPC sector, see Executive Office of the US President, and Office of Science and Technology Policy, "A Research and Development Strategy for High Performance Computing," November 20, 1987, https://science.energy. gov/media/ascr/pdf/program-documents/archive/Reports_leading_to_national_high_performance_computing_program. pdf (retrieved May 16, 2019).

20

In this context, supercomputers were seen as both "extremely useful tool[s] for the design of nuclear weapons and ballistic missiles" (Paul Freedenberg, *CoCom in a Period of Change*, Paper presented at a workshop of the Japan-US Joint Study Group on Trade, Finance and Technology, January 19–21, 1990, Hawaii. Cambridge, MA, 1992, p. 10 http://hdl.handle.net/1721.1/17083 (retrieved September 6, 2019) and as "technology driver[s]" (Anchordoguy 1994, p. 40). This (disputed) assumption, labeled "techno-nationalist" by historian David Edgerton, has also been used pejoratively to denounce government policies, particularly by Asian countries, that fund the development of new technologically advanced products. David Edgerton, "The Contradictions of Techno-Nationalism and Techno-Globalism: A Historical Perspective," *New Global Studies* 1, no. 1 (January 2007), pp. 1–10.

21

Albert Stahel, "Die Anatomie des mächtigsten Geheimdienstes der Welt," *Allgemeine Schweizerische Militärzeitschrift (ASMZ)* 168, no. 6 (2002), p. 30. See Anchorduguy 1994, pp. 40–43, for US investment generally and Daniel Okimoto, *Between MITI and the Market: Japanese Industrial Policy for High Technology*, Stanford, 1989, pp. 77–86, for a comparison with Japan.

22

A frequently used phrase to describe Switzerland as a place of innovation and ingenuity. It was used in the context of supercomputing by Carl August Zehnder, a computer science professor at ETH, on Swiss national radio. Stalder 1988.

23

Urs Hochstrasser, "Die Lage der technischen und naturwissenschaftlichen Forschung in der Schweiz," *Diplomatic Documents of Switzerland 1848–1975*, April 11, 1959, pp. 3–4 (quote 3), pp. 6–8, http://dodis.ch/30694 (retrieved June 25, 2019); see also Urs Hochstrasser, "Aus den Memoiren des ersten Wissenschaftsattachés der Schweiz," *Quaderni di Dodis* 1 (2012), p. 162.

24

Hochstrasser 1988, p. 9.

as part of a national research center could fulfill a very important function for the needs of Switzerland." He named nuclear technology as a key area for such a center's activities and suggested an institutional allocation close to ETH in Zurich.[23] At least the latter idea survived until such a center, the CSCS, was inaugurated in 1992. Why did it take so long, though? According to Hochstrasser himself, it had been "difficulties ... in the financing of such a project and in establishing convenient remote access to it" that had rendered his proposals unsuccessful.[24] Meanwhile, Carl August Zehnder, the professor, had begun harboring similar ideas: as early as the 1960s, he had been part of the electronic data processing commission (CICUS) of the Conference of Swiss Universities, a network of early computer specialists that, among other things, advised the universities on the state of their IT infrastructure.[25] By his account, he went to ETH planning to become a math teacher, but ended up as one of Switzerland's IT pioneers, studying at MIT for a while before leading the group coordinating access to ETH's data processors—first as a member of the university administration, then as a professor, mirroring the shift of computer science from an auxiliary to a full discipline.[26] This double function—as researchers and providers of computing infrastructure—created divisions among computer scientists in their attitude toward a national supercomputer. According to Zehnder, some felt that their discipline was about elegant concepts, not "number crunching," while others (including himself) foresaw needs in applied disciplines such as chemistry, physics, and engineering.[27] There, computer simulations were increasingly seen as a new way of gaining scientific knowledge alongside the established duo of theorizing and experimentation.[28] As a member of CICUS (as well as in his role as a General Staff officer in the Swiss militia army overseeing computer simulations of tank battles), Zehnder saw his role as putting computers to use for the nation, not just for his discipline. "I always spoke on behalf of Switzerland, not just of the computer scientists at ETH," he says today.[29]

25

For a self-description of CICUS's tasks, see CICUS (EDV-Kommission der Schweizerischen Hochschulkonferenz), *Schweizerische Hochschulplanung 1984–87: Spezialstudie Informatik,* Bern, September 12, 1983, p. 16.

26

Interview with Carl August Zehnder conducted for this publication (Scherrer and Stadler June 26, 2018); Andreas Nef, and Tobias Wildi, "Informatik an der ETH Zürich 1948–1981: Zwischen Wissenschaft und Dienstleistung," *Geschichte und Informatik* 17 (2009), pp. 28–31; see also another interview with Zehnder, David Gugerli, "Interview mit Carl August Zehnder," *ETHistory 1855–2005,* July 6, 2004, https://www.video.ethz.ch/speakers/ ethistory/952be1d4-773c-476a-9831-c1f2c835fe77.html (retrieved June 26, 2019).

27

Zehnder, speaking in a 2004 interview, said: "[the computing center in] Manno isn't for the computer scientists, but for the others," meaning the applied scientists. Gugerli 2004, 44'50".

28

This account, for example, appears in the government's 1985 report on the special measures bill (Bundesrat [Swiss Federal Council], "Botschaft über Sondermassnahmen zugunsten der Ausbildung und Weiterbildung sowie der Forschung in der Informatik und den Ingenieurswissenschaften vom 2.12.1985 (n. 85.071)," *Bundesblatt* 1, no. 5 (1986), p. 335, as well as in CICUS 1983, p. 3; on Swiss TV (Peter Lippuner, "Supercomputer Cray ETH Zürich," *Menschen Technik Wissenschaft* (September 9, 1988);

and in newspapers: Jean-Bernard Desfayes, "Psychodrame pour un superordi," *L'Hebdo* (April 1, 1991), pp. 39–40; Denise Jeanmonod, "Si Cray nous était conté...," *Gazette de Lausanne* (April 9, 1988), pp. 1–2.

29

Interview with Zehnder (Scherrer and Stadler June 26, 2018). His career profile makes him a perfect representative of the Swiss elite at the time—one that saw the nation's interest best served by a close entanglement of politics, academia, and private industry maintained by a militia system for military service and political representation. Male, academic, army officer, often (but not always) from an affluent family: prior to the 1990s, this was the typical profile of members of Switzerland's "tightly connected and homogenous" business elite. André Mach, Thomas David, Stéphanie Ginalski, and Felix Bühlmann, *Schweizer Wirtschaftseliten 1910–2010,* Zurich, 2017, p. 21 (quote), pp. 168–70.

It was in this spirit that the national supercomputer was initially planned. The need for it was formulated by men like Hochstrasser and Zehnder within the federal administration and the University Conference. Its formal realization as part of a parliamentary funding bill was then planned in what the government's accompanying report described as an "ad hoc working group"[30] of administration officials and university representatives—in other words, an informal gathering of influential men with the national interest in mind. Significantly, this group wasn't exclusively concerned with a national supercomputer, however. On the contrary, the latter was included as a minor element in a broad package designed to "overcome the state of emergency in computer science" by promoting IT education, computer access, and electronic research infrastructure. Of the 207 million Swiss francs of funding for these "special measures to support computer science and engineering," only 40 million were to be used for the supercomputer. The funding of more teaching positions and personal computer workplace stations was seen as more important and was more widely publicized. Why was that? For one, the broad scope of the bill ensured widespread support for what otherwise might have appeared to be an excessive amount of money devoted to a single machine—especially one that would soon be outdated again, as even Hochstrasser acknowledged.[31] For another, supercomputers were somewhat at odds with the latest developments in computer technology. Contemporary accounts, indeed, are all about the "decentralization" of computer infrastructure; in this context, a centralized supercomputer costing millions easily came across as an anachronism.[32] The need for such a piece of hardware, however prestigious, wasn't self-evident anymore. "In research," one justification for it went, "the calculating speed and storage capacity of workplace computers … don't suffice to solve complex tasks."[33]

The argument for the supercomputer was, like the argument for the whole package, clearly a techno-nationalist one. A boost of investments was needed to kick-start a catch-up to the big players, the US and Japan—using federal money to be distributed by, among others, Hochstrasser's office for science and education.[34] Additionally, in the face of "a quickly growing number" of supercomputing facilities abroad, the Swiss universities had to reduce their "serious backlog in this area" with a central-

30

Bundesrat 1986, p. 343.

31

Hochstrasser 1988, p. 9.

32

See Gugerli et al. 2005, pp. 348–57, or 2010, pp. 302–11.

33

From the government's report on the special measures bill (Bundesrat 1986, p. 368); for another example, see CICUS 1983, p. 13.

34

The money was to be distributed to academic institutions only, though there were other programs funding industrial research, if it was conducted in cooperation with a university and saw the private players pay half the project costs. Such cooperations were rare, and the government hoped that the "special measures" would help create the personnel and infrastructure needed for them. See Bundesrat 1986, pp. 350–52.

35

From the government's report on the special measures bill (Bundesrat 1986, pp. 368–70).

36

See the votes in the National Council and in the Council of States on June 20, 1986 (Bundesversammlung (Swiss Federal Parliament), "Informatik und Ingenieurwissenschaften: Sondermassnahmen," Amtliches Bulletin der Bundesversammlung 2 (1986), p. 436 [vote in the Council of States, June 20, 1986]; p. 1034 [vote in the National Council, June 20, 1986]).

37

From the debate in the National Council on March 3, 1986 (Bundesversammlung (Swiss Federal Parliament), "Informatik und Ingenieurwissenschaften: Sondermassnahmen," Amtliches Bulletin der Bundesversammlung 1 (1986), p. 2 [debate in the National Council, March 3, 1986]).

ized solution at ETH, where enough space for it would be available—and where, starting in 1987, Zehnder would be the vice president in charge of such services.[35] Correspondingly, in 1986, the bill was passed unanimously by parliament.[36] The expectations held of it are perhaps best summarized by the hopes of one MP for nothing less than a new man: "If I had to give this proposal a highbrow academic name, it would be this: *homo helveticus informatiatus ante portas.*"[37]

III The Cray Phase: A Time of Need

Did Switzerland actually need a national supercomputer? For most contemporaries, there was a clear answer to this: absolutely. In parliament it was called "a vital instrument to enable modern research that has a future." The whole package had been framed as a necessity, since "in the end we have no other choice but that of a strategy of technological advance." Even the Social Democrats, who more typically considered the "age of information" to be a threat to workers, acknowledged "the position of little choice that our industry, or better our whole society, is in" and limited their opposition to a little rant for the record.[38]

The need for such a machine was also seen by the people who were actually meant to use it. In 1987, an organization "with the objective of promoting vector and parallel computing in science and industry" was founded by representatives of various applied disciplines in science and industry, with the goal of "bringing together and informing those who are interested in the development of supercomputing in Switzerland."[39] Intended as a "forum of collaboration," its goal is best expressed by its name: Speedup. While some computer scientists continued to regard the "number crunching" business with dismay, the first editor of the *Speedup Journal* (speaking at a physics conference) outlined the organization's goal in the following, quite distinct terms: "academic and industrial research workers [should] always have at their disposal a system based on the current top-of-the-range number crunching computer."[40] But this new focus on speed posed problems as well, as Switzerland was about to learn.

For the question arose: *What* supercomputer should be bought with the 40 million francs from the special package? When it was passed, there was only one supercomputer in Switzerland: a Cray 1S, previously operated by Electricité de France and bought secondhand in 1985 by the EPFL in Lausanne, where it was mainly used by plasma physicists. It had 2,000 users and reached 80 percent of its production capacity within three months of taking up operations.[41] Researchers were happy with it, despite it not being

| Fig. 2 |

38

From the debates in the Council of States on June 5, 1986 (Bundesversammlung (Swiss Federal Parliament), "Informatik und Ingenieurwissenschaften: Sondermassnahmen," *Amtliches Bulletin der Bundesversammlung* 2 (1986), p. 280 [debate in the Council of States, June 5, 1986]) and the National Council on March 3, 1986 (Bundesversammlung 1986/1, pp. 5–6).

39

Roland Henzi, "Common Elements of the Various Disciplines in Computational Science: Talk at Symposium on Computational Physics," *Helvetica Physica Acta* 61 (1988), p. 55; Hochstrasser 1988, p. 8.

40

Still, his idea wasn't for supercomputers just to "bring new insight and discoveries in science," but also to contribute to "the better design of industrial products." Henzi 1988, pp. 55–56. The term "number crunching," meanwhile, seems to have been appropriated, suggesting a growing sense of self-consciousness among these new supercomputer users. This mirrors simultaneous developments in the US, where speed had become the central parameter at DARPA's Strategic Computing division, re-placing earlier visions of artificial intelligence. Roland and Shiman 2002, p. 296.

| Fig. 2 | The machine that redefined supercomputing and its public image: the iconic first Cray computer, here in the slightly updated 1S version purchased by EPFL in Lausanne. *(Cray 1S brochure,* 1979 © Courtesy of Computer History Museum & Cray Inc.)

a state-of-the-art machine. Reliability and usability, for them, were just as important as speed; without the former, the latter couldn't be put to use. Indeed, older models had the advantage of coming with tried and tested software, while newer ones could have "infancy troubles," as it was put at a Speedup conference.[42] Existing supercomputer users therefore tended to be less focused on the "latest generation" aspect that had been so important to the computer scientists and bureaucrats in making the case for its funding. The users wanted computer speed, but not at all costs, since they saw it as increasing exponentially anyway.[43] As one conference speaker put it: "the supercomputers of today will be the personal computers of tomorrow."[44]

This fact, though certainly known to the initiators of the special package, was, oddly, little discussed in the government report and parliamentary debate on it.[45] The supercomputer was sold to parliament as a one-time investment, when in fact it could only be the first of many supercomputers.[46] Indeed, when it was proposed to buy a second-generation Cray for ETH with the supercomputer money, the president of the ETH council vetoed the idea, arguing in 1987 that this couldn't be considered a supercomputer "of the latest generation."[47] Instead, in what was branded "an intermediary solution," both ETH and EPFL bought a Cray each (the X-MP in Zurich and the Cray 2 in Lausanne). At 21 million francs, the two machines came significantly cheaper than what the package would have provided (40 million), but the ease with which the money was found in the ETH budget is still striking, considering the fact that the report on the special measures bill had argued that "in the financial planning for both ETH institutions [ETH and EPFL], no credit for a supercomputer of the latest generation is planned for 1984–1987."[48] This raises the question: Why couldn't it, from the very start, be left to researchers and private companies to buy a supercomputer on their own budgets, should science or market needs require it? Part of the answer is that the perceived need for a Swiss supercomputer was originally rooted less in economic or scientific think-

41

Philippe Barraud, "A peine installé, le superordinateur Cray 1S frôle la saturation," *Journal de Genève* (June 24, 1986), p. 3, and Denise Jeanmonod, "Les Ecoles polytechniques suisses s'équipent des ordinateurs les plus puissants du marché," *Journal de Genève* (July 17, 1986), p. 7; for an overview of the history of supercomputing at EPFL, see Apolline Raposo de Barbosa, and Vincent Keller ("L'EPFL et les superordinateurs: Trente ans

d'histoire," *Flash informatique* 7 (2013), pp. 20–21), though beware of the factual errors in their account: e.g. it wrongly states that the special measures bill was passed in 1987 (correct: 1986) and that money from it was used to buy two Cray machines at ETH and EPFL in 1988 (in fact, other funds were used).

42

Hochstrasser 1988, p. 10–11.

43

For the visual representation of this belief, see the graph in Henzi 1988, p. 44.

44

Karl-Gottfried Reinsch, "Der Supercomputer und die wissenschaftliche Erkenntnis," *Helvetica Physica Acta* 61 (1988), p. 22.

45

Debate in the National Council on June 3, 1986 (Bundesversammlung 1986/2).

46

See Hochstrasser 1988, p. 9, for an implicit acknowledgment of this.

47

Ibid., pp. 10–11; confirmed in interviews with Zehnder (Scherrer and Stadler June 26, 2018) and Hans Bühlmann (from June 22, 2011, in Schärli, Research Archive).

48

From the report on the special measures bill (Bundesrat 1986, p. 370); for the price of the Cray computers, see Jeanmonod 1988.

ing than in considerations of national sovereignty: research could be (and had been) done on supercomputers outside Switzerland or in the private sector (e.g. on those of the potent pharmacological industry in Basel), but for the Swiss nation, it was important that the state also be able to provide such services—to ensure that they would be put to a national rather than private or multinational uses (for alliances could crumble and companies leave).

The two Cray machines fulfilled this purpose, because they not only corresponded to research needs, but were also easily turned into symbols of technological progress—due to their design, as it were. Originally introduced in the late 1970s and early 1980s, Cray machines had not only become near-synonymous with the term "supercomputer"; their visual appearance was iconic as well.[49] Weighing several tons and built in the shape of gigantic Cs, the Cray machines' stylish colors and peculiar forms were a vivid, even tangible manifestation of the otherwise abstract phenomenon of high-speed computing. The Swiss media eagerly picked up on it. "It is with the respect and prudence of the primitive in front of a bottle of Coca-Cola," as a 1986 article put it, "that one approaches 'the beast,' as it is called in EPFL's computing center."[50] However, the Crays' symbolic value aged even more quickly than their technological value. Referring to the much smaller successor model X-MP in 1988, a Swiss TV reporter remarked drily on its "modest exterior" that was "hardly bigger than a closet."[51] Indeed, despite their colorful leather upholstery and transparent elements (where the cooling fluid was prominently displayed), the Cray computers increasingly looked less like guarantors of a sovereign Swiss nation and more like gigantic toys for grown-up men in plain suits.[52] Supercomputers lost their initial visibility, then, even as their importance for research purposes continued to increase. This was part of a larger process: as Zehnder, the professor, recalls, in the 1950s and 1960s, computing machinery had proudly been shown off to passersby behind display windows, while ETH's Cray was installed underground.[53] Housing the national supercomputer miles away in Ticino was, in a way, a logical continuation of this disappearance of supercomputers from public perception. As was the design of its (Japanese) NEC machine: a group of plainly colored rectangular server stacks with opaque panels.[54]

Even with their public appeal in decline, the Cray machines snugly fit the sovereignty-centered Cold War mentality of the

Fig. 3

49

Lester Davis, "The Balance of Power: A Brief History of Cray Research Hardware Architectures," in *High Performance Computing: Technology, Methods and Applications*, edited by Jack Dongarra, Amsterdam, 1995, p. 121. The Cray 1 "defined the 'supercomputer' as a new kind of machine" (Thomas Haigh, and Paul Ceruzzi, *A History of Modern Computing*, Cambridge, MA, forthcoming, ch. 2).

50

The men building it (especially Seymour Cray) were also glorified: a 1998 book about these "technical wizards" was called *The Supermen* (Charles Murray, *The Supermen: The Story of Seymour Cray and the Technical Wizards behind the Supercomputer*, New York, 1997).

51

Hanspeter Bettler, "Neuer Supercomputer an der ETH," *Tagesschau* (June 13, 1988).

52

A whole TV show (Lippuner 1988) was devoted to the new Cray at ETH. Haigh and Ceruzzi (forthcoming, ch. 2) call the Cray 1 "the world's most expensive love seat."

53

Interview with Zehnder (Scherrer and Stadler June 26, 2018).

54

Press coverage on the CSCS was also more limited than that concerning the Cray machines and less focused on the computer.

55

Freedenberg 1992, p. 10.

50

Philippe Barraud, "A peine installé, le superordinateur Cray 1S frôle la saturation," *Journal de Genève* (June 24, 1986), p. 3.

Fig. 3
The plainly designed NEC SX-3:
marking the slow disappearance of
supercomputers from public per-
ception. (*CSCS Annual Report*, 1993
© CSCS)

Swiss elites who had bought them. Not only had these devices been devel-
oped with substantial assistance from US military agencies, they were also
considered, by NATO, to be strategic military goods "subject to an extremely
restrictive [export] control regime."[55] The latter was overseen by the Coordi-
nating Committee for Multilateral Export Control (CoCom) that had been
established in 1949 as part of an embargo policy towards the Communist
bloc.[56] Switzerland, though ostensibly neutral, had agreed to follow its rules
in a secret gentlemen's agreement from 1951 (formalized in 1987, when the
Swiss officially became a "trustworthy" non-CoCom country).[57] As far as Cray
computers were concerned, these rules meant that access to them was lim-
ited and a tight security protocol was implemented. In the case of the 1S, for
instance, citizens of Communist bloc states were forbidden from accessing
it.[58] For the X-MP and 2 there were also restrictions (chiefly regarding
security), though men like Zehnder went out of their way to argue that this
was less a military issue than an economic one of protecting company
secrets.[59] When a radio reporter remarked that the Cray X-MP was "protected
like a military secret," he replied that there had been "conditions" on its sale,
because "the supplier and its country, the US, have an interest in preventing
their products from just ending up anywhere."[60] The nonproliferation back-

56

See Robert Johnston, "U.S. Export
Control Policy in the High Perfor-
mance Computer Sector," *The Non-
proliferation Review* 5, no. 2 (Winter
1998), esp. pp. 46–47; Freedenberg
1992, p. 10–11.

57

Under the 5-K-provision of the
Export Administration Amendments
Act of 1985, countries outside Co-
Com but "comparable in practice"
to those within it could be treated
similarly. Freedenberg 1992,
pp. 24–25; Jan Stankovsky, and
Hendrik Roodbeen, "Export Con-
trols Outside CoCom," in *After
the Revolutions: East-West Trade
and Technology Transfer in the
1990s*, edited by Gary Bertsch,
Heinrich Vogel, and Jan Zielonka,
Boulder, 1991, pp. 81–85. For the
original Hotz-Linder agreement
from July 26, 1951, see Alfred
Zehnder, "Strictement confidentiel:
Notice pour le Conseiller fédéral
Petitpierre," *Diplomatic Documents
of Switzerland* 18, no. 105 (2001);
for context, Eric Flury-Dasein,
"Hotz-Linder-Agreement," *His-
torisches Lexikon der Schweiz*
(November 17, 2006), https://
hls-dhs-dss.ch/de/articles/
048308/2006-11-17/ (retrieved
June 26, 2019); André Schaller,
"Die Schweiz und das CoCom-
Embargo: Ist eine Änderung der
offiziellen Konzeption der schweiz-
erischen Aussenpolitik erforder-
lich?" *SVPW Jahrbuch* 28 (1988),
pp. 144–50.

58

This was publicly known and openly
admitted to by university officials,
though with a certain unease.
Barraud 1986.

59

This argument was made in Stalder
1988, Brigitte Honegger, "Genera-
tionensprung zum Supercomputer
an der ETH," *Schweizer Ingenieur
und Architekt* 106 (July 1988), p. 869,
and in an interview with Zehnder
(Scherrer and Stadler June 26, 2018).
The ETH president at the time,
Hans Bühlmann, confirmed signing
an agreement on such restric-
tions in an interview (Scherrer
July 12, 2018).

60

Stalder 1988.

ground of these restrictions had, however, been acknowledged by none other than the government itself in 1986: "Because such installations are also used for military purposes, there are export restrictions. Their loosening will have to be negotiated with the exporting countries."[61] In fact, US supercomputers were only ever exported if the host government had agreed "to assist the U.S. Government in policing how the machine is used."[62]

Still, it isn't wrong to stress the economic side of the Swiss deal: for global companies like Cray Corporation, money was the main motivator; they cared less about Soviet spies than about Japanese competitors.[63] And this mentality increasingly dominated the supercomputing world: while the focus had initially been more on designing revolutionary prototypes to be used chiefly by government facilities, supercomputers in the 1980s had become products of interest to private companies anywhere on the globe. As prototypes became products, questions of usability, software support, and compatibility were catching up to raw computing power in terms of their importance to market success.

When ETH bought the two Cray machines in 1988, both models—the X-MP and Cray 2—were already well-established (and thus "usable"), their acquisition mirroring not only the desires of scientists but also the changing realities in the increasingly global and commoditized field of supercomputing. The notion of buying an additional machine "of the latest generation"—a single machine to serve all Swiss universities—failed to take those realities into account. Still, the money was there. "We were sitting on a mountain of money and asked ourselves: What could we do with it?" the ETH president at the time, Hans Bühlmann, told me.[64] And so he came up with an idea. The only problem was: the money had an expiration date.

Fig. 4

IV Trouble in Ticino: The Supercomputer Goes South

Much is muddy and unclear about how the CSCS eventually ended up in Ticino. One thing, however, is certain: whose idea it was. It was that of a calm man with the charming accent of the Swiss mountain region of Graubünden and impressively bushy eyebrows, a man who believed in the necessity of ETH "opening [itself] toward the south."[65] Though a mathematician himself, Hans Bühlmann, who became ETH president in 1987, knew little about supercomputing; his world was that of complex pension systems, and he seems to have imported his field's predilection for efficiency and stable equilibria into his political work as head of ETH. Because it seemed like a waste of resources, he instinctively disliked the idea of alternating the acquisition of supercomputers between Zurich and Lausanne. He also sensed the reserva-

61

Federal Councillor Alphons Egli in the National Council debate on March 3, 1986 (Bundesversammlung 1986/1, p. 13).

62

Freedenberg 1992, p. 11.

63

The Undersecretary of Commerce for Export Administration at the time recalls: "An IBM engineer at a super-computer facility once remarked to the author that he was more worried about his new central processing unit falling into the hands of his rival at Fujitsu in Japan than he was about the Soviets getting hold of it." Freedenberg 1992, p. 20. On aggressive Japanese business tactics, see Anchorduguy 1994.

64

From an interview with Hans Bühlmann conducted for this publication (Scherrer July 12, 2018).

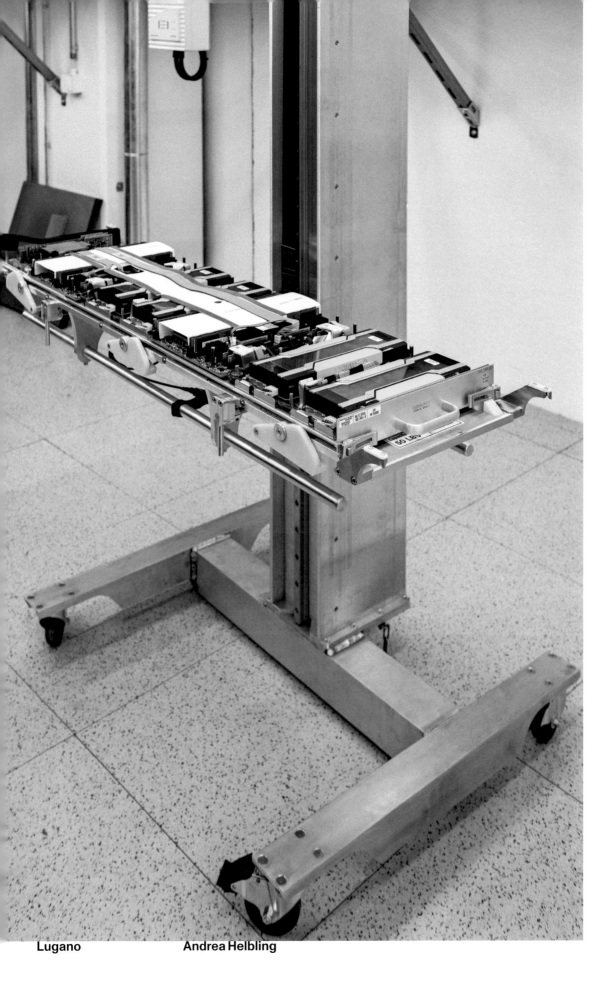

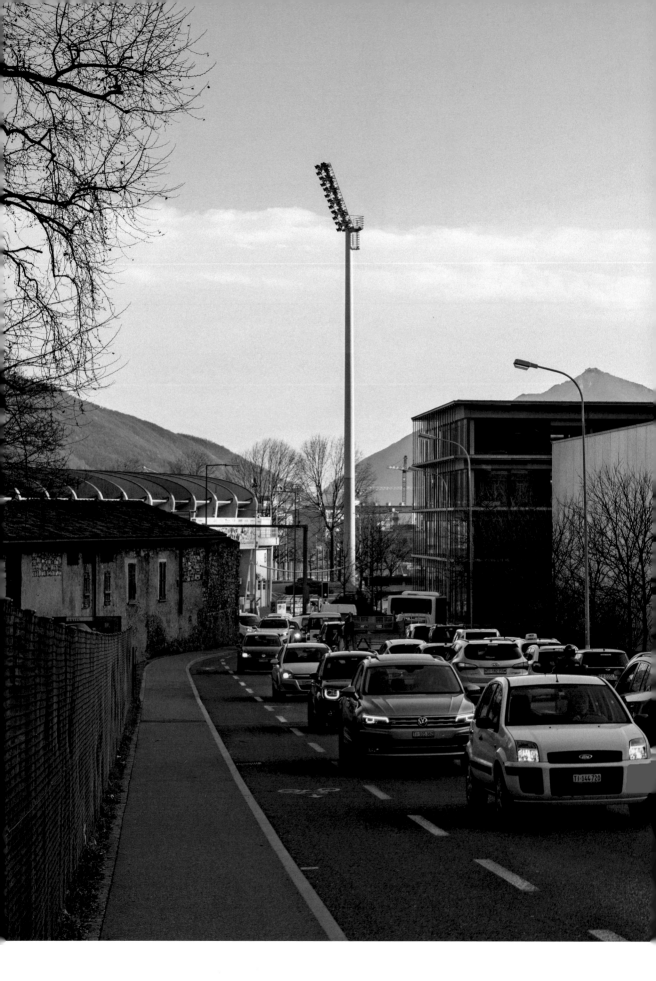

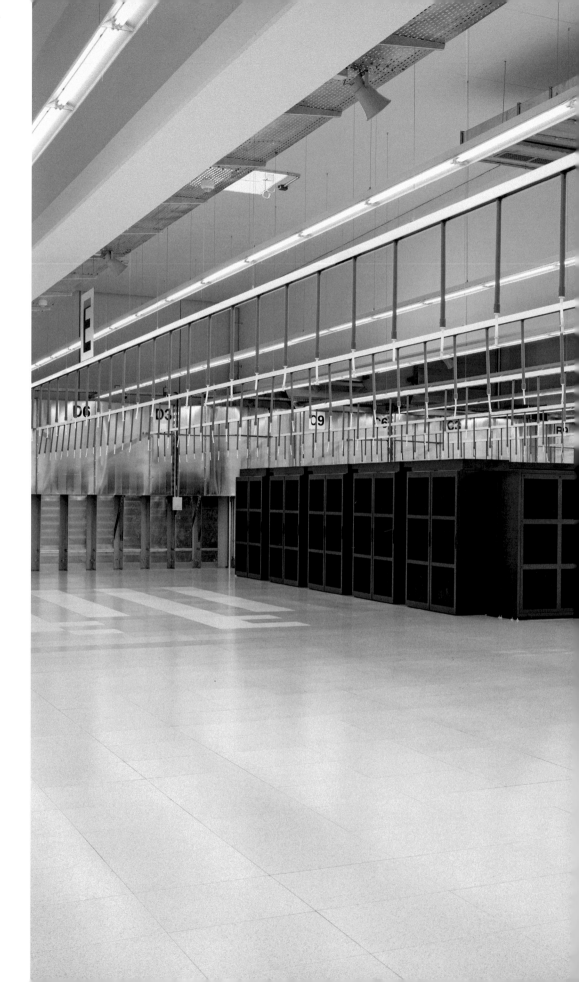

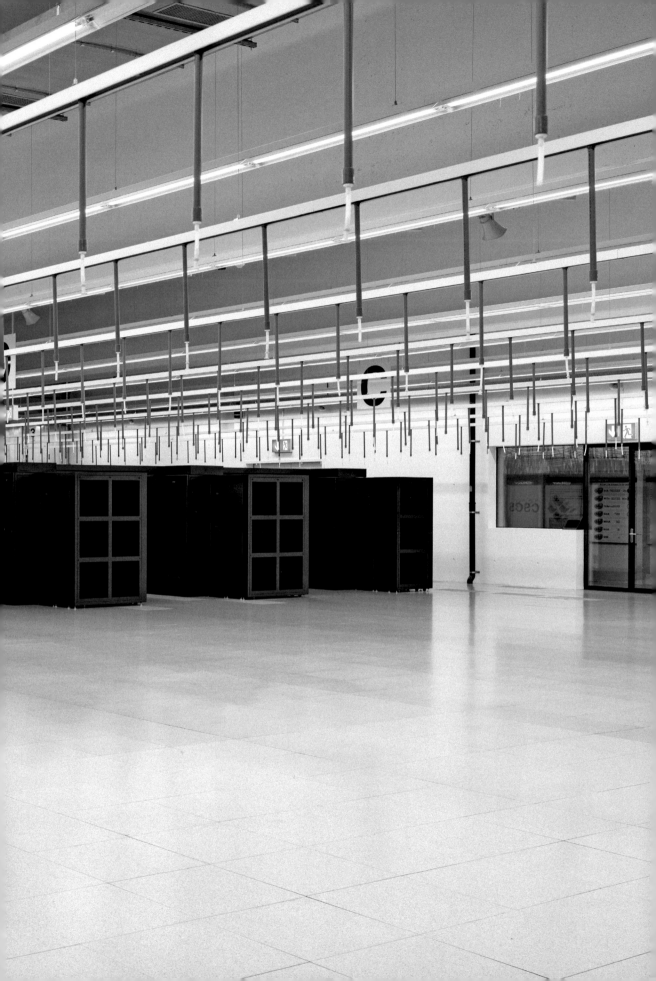

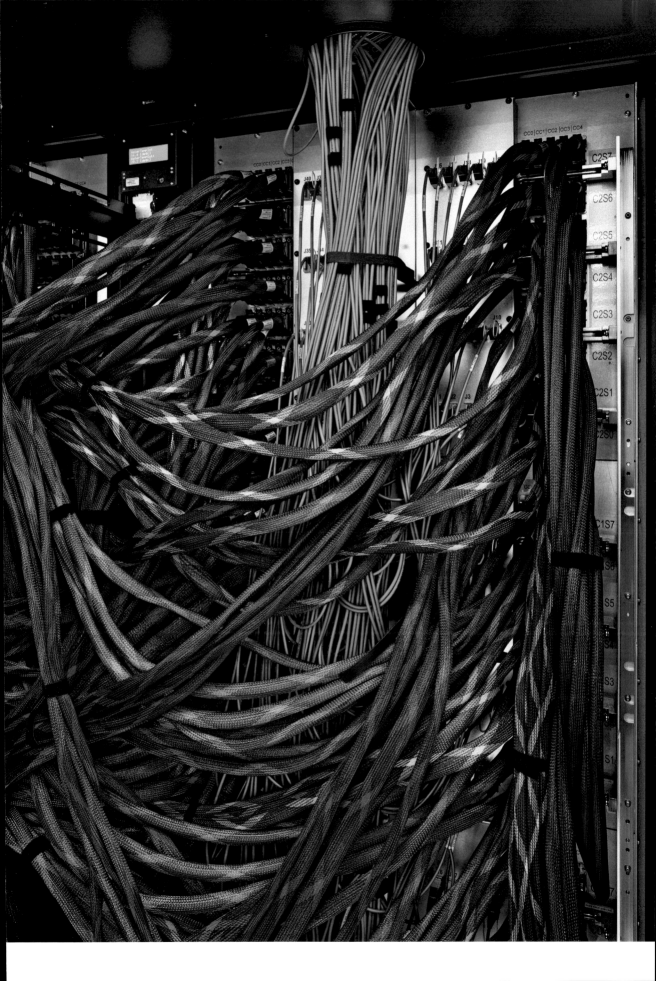

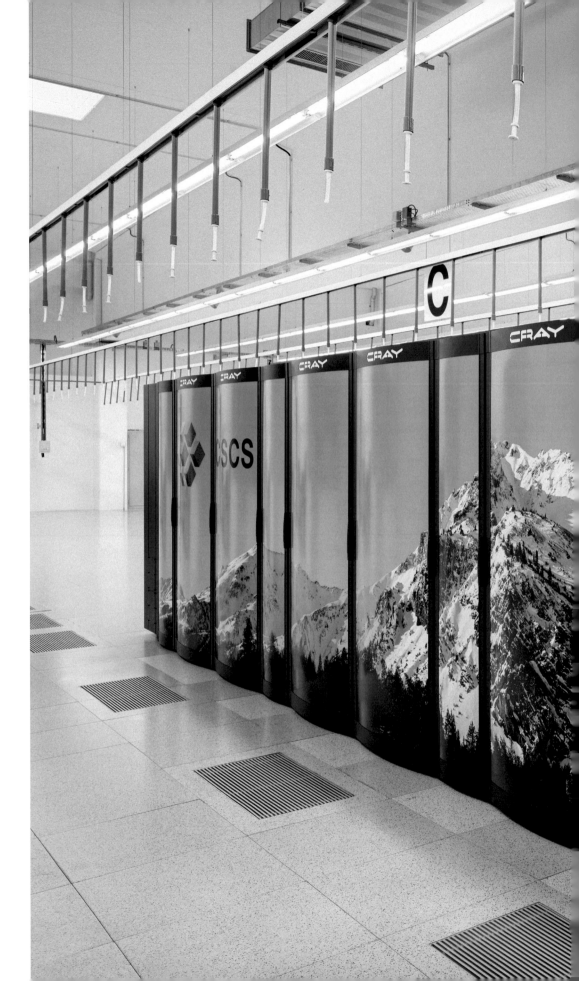

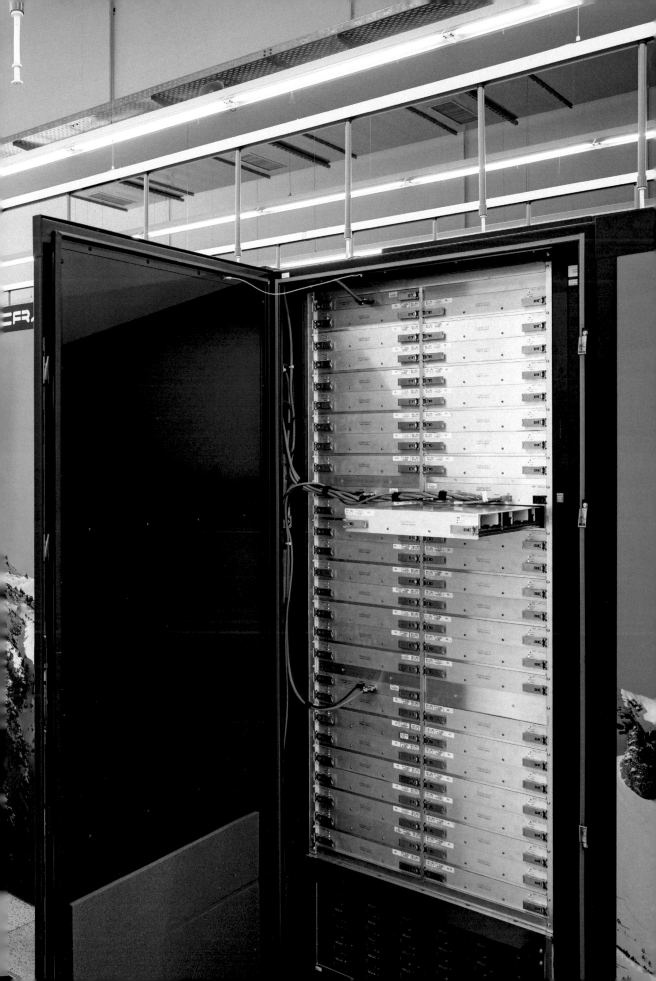

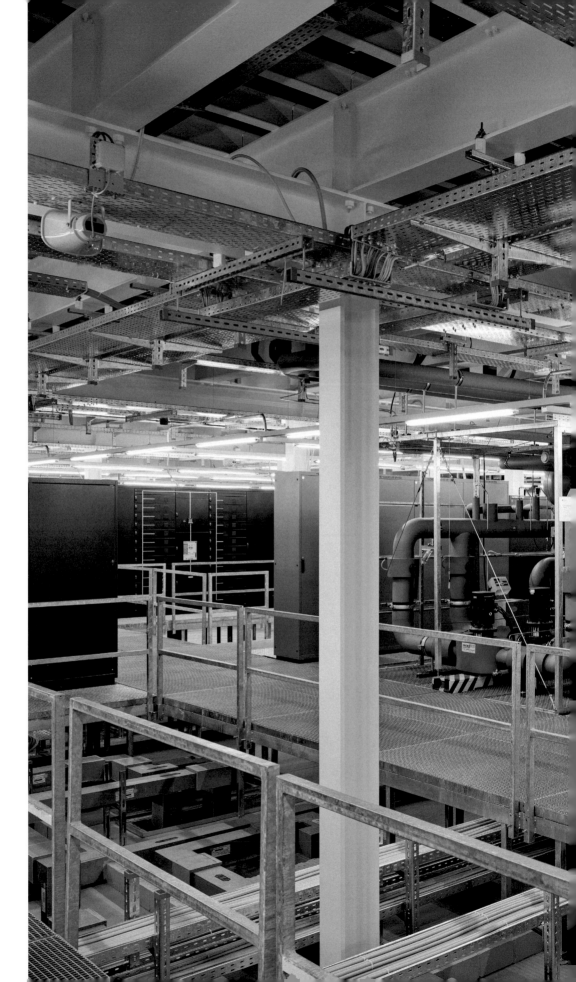

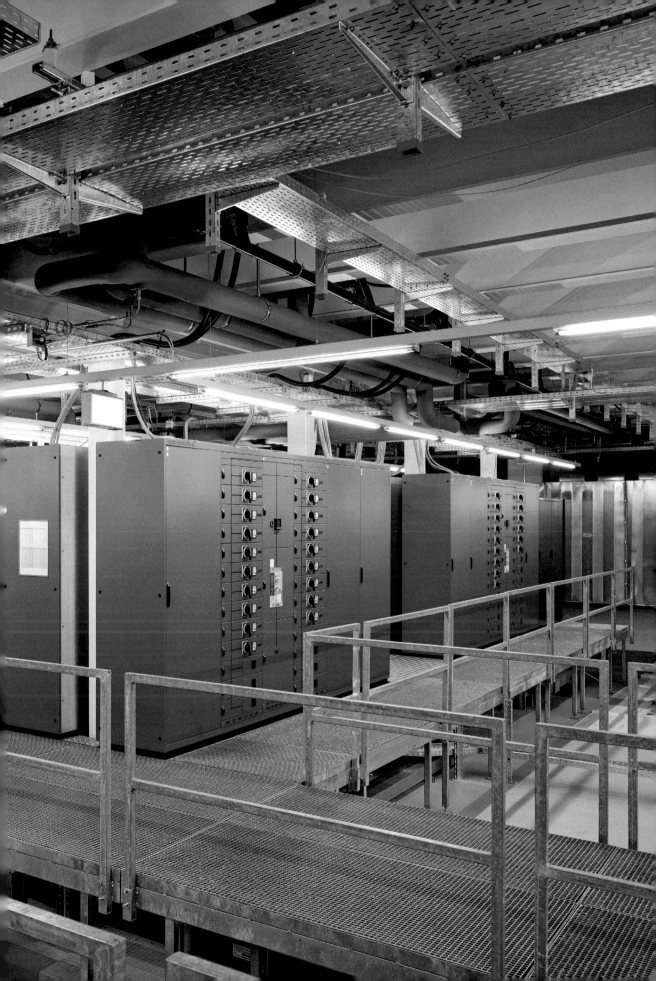

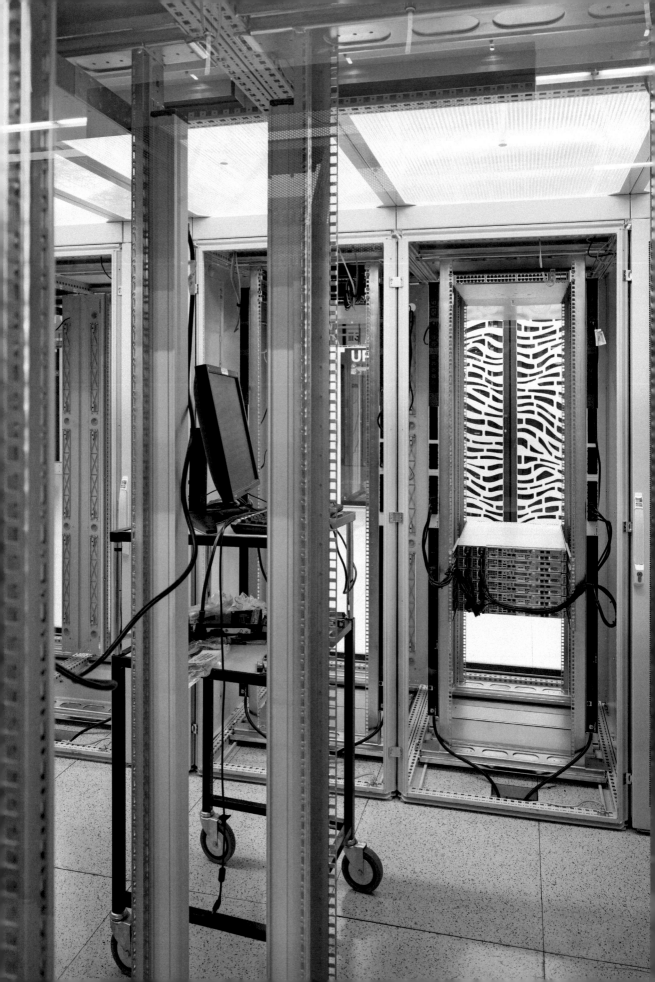

Fig. 4 The Swiss "primitives" and their toys worth multimillions: a celebration of ETH's newly bought Cray X-MP on Swiss National Television, 1988. (Hanspeter Bettler: Neuer Supercomputer an der ETH, *Tagesschau*, June 13, 1988 © SRF; Peter Lippuner: Supercomputer Cray ETH Zürich, *Menschen Technik Wissenschaft*, September 9, 1988 © SRF)

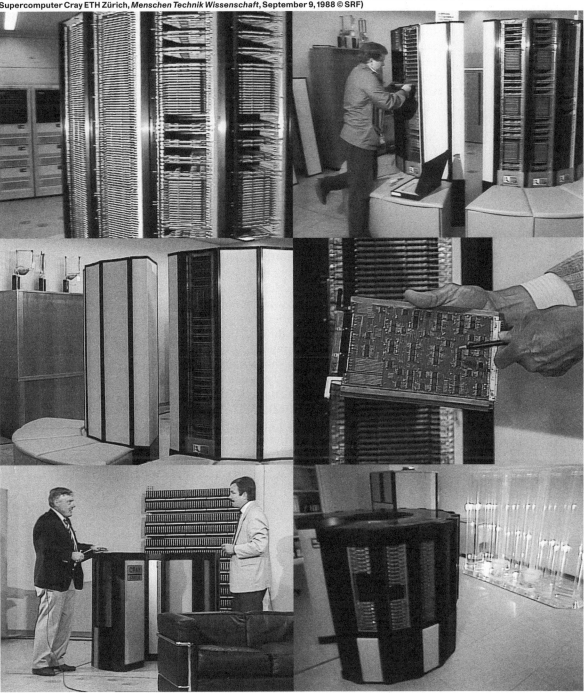

tions some ETH computer scientists had about "number crunchers." Sitting in his former office at ETH Zurich, he said that the interest in housing the national supercomputer at ETH wasn't resounding and that even the nearby Paul Scherrer Institute—an independent research center for nuclear energy research—had refused his offer to host it.[66] And then there was the deadline: if the money for the supercomputer wasn't used up by September 30, 1991—the expiration date set by parliament—it would be lost for good.

By Bühlmann's account, giving the supercomputer to Ticino was the perfect way out: Ticino's authorities had long been lobbying for some form of academic investment in their region; Bühlmann, in turn, could establish a bridgehead for scientific endeavors in the Swiss south, create a single national supercomputing center under ETH leadership while decentralizing university operations in accordance with the Swiss federalist spirit, and delegate some of the responsibility for its realization to local authorities. "If anyone could do it, it was the *Ticinesi*," he told me, referring to the tight schedule of under four years for building a new center from scratch, "because they really wanted it."[67] In theory, it was the perfect plan. In practice, not so much.

For starters, not everyone at ETH was against housing the supercomputer in Zurich. Zehnder, by now the university's vice president in charge of such projects, was not amused by the Ticino plans, to put it mildly. "It was a crazy idea," he told me. "I would have preferred it to be close to the users rather than far away. But in the end, I couldn't say anything except, 'Sorry—and at your orders.'"[68] What appeared crazy to him, though, was visionary to others. Case in point: Fulvio Caccia, the former Christian Democrat MP from Ticino, who openly admits that "those actually dealing with supercomputers wanted it close by" and not in Ticino, "in the desert," as they said. "It took Bühlmann to bring a broader perspective to the issue."[69] This symbolic element wasn't embraced by everyone. When asked by a TV reporter in September 1988 if putting the center in the south would be a "federalist concession"—to which the answer was yes—

65

From a speech held by Hans Bühlmann on October 2, 1989 at the inauguration of the Centro Stefano Franscini (in Schärli, Research Archive)

66

From an interview with Bühlmann (Scherrer July 12, 2018).

67

From an interview with Bühlmann (Scherrer July 12, 2018).

68

From an interview with Zehnder (Scherrer and Stadler June 26, 2018). According to Zehnder, space had already been reserved at ETH's computing center to host the supercomputer. Indeed, when the Ticino plans ran into trouble, he went as far as telling a local journalist, who was digging up dirt on the center, that hosting it in Zurich was still plan B. See Flavio Maspoli, "Per il Centro di manno l'ultimatum è per marzo," *Gazzetta Ticinese* (September 11, 1989), p. 8.

69

From an interview with Fulvio Caccia conducted for this publication (Scherrer July 26, 2018).

70

In Lippuner 1988.

71

This argument also appears in Antonio Antoniazzi, "ETH Rechenzentrum Manno," *DRS aktuell* (November 24, 1989); ETH Zürich, *Jahresbericht 1991*, Zurich, 1992, p. 25; [N.N.], "Il Consiglio federale favorevole al 'cervellone' in Ticino," *Gazzetta Ticinese* (December 5, 1989), p. 13.

Zehnder said no.[70] Rather, he and others argued, this was a strategic decision to better connect Switzerland to the universities and enterprises of northern Italy.[71] In 1989, even the government accounted for the decision to "install the computer in Ticino" in these terms: the "region offers unquestionable benefits (proximity to Italy, where there are extremely advanced industrial and scientific activities in the realm of high technology)."[72] This argument was consistent with the visions of the national supercomputer articulated by that point.

And yet, when Bühlmann had offered the supercomputer to Ticino, he had already departed from the techno-nationalist script that had been laid out in the bill of 1986. The bill and its proponents had framed the acquisition of a supercomputer as a question of national necessity, not of political volition. When this need was called into question by both the acquisition of the Cray machines and recent developments in supercomputing, Bühlmann repurposed the center as a federalist project, a "crystallization point"[73] at which to scientifically kick-start an underdeveloped region. This is what Caccia means by "broader perspective": combining policy objectives hitherto uncombined in order to reach goals otherwise unreachable. By doing that, however, the supercomputer was catapulted back into the realm of politics, which rendered the government's prior rhetoric of usefulness and need less credible (despite its somewhat desperate "proximity to Italy" argument). By this new political logic, the supercomputer, instead of responding to a global technological reality, was intended to shape its own local reality. This spirit is embodied by Caccia's belief that "if you create the possibilities, there will always be someone to make use of them."[74] Technological infrastructure, in this view, creates its users; supply creates demand, rather than responding to it. This is the opposite of the techno-nationalist insistence on catching up technologically to meet the allegedly unalterable needs of science and industry.

Caught between political visions and technological necessity, the previously little publicized process of establishing the national computing center became what one magazine called a "psychodrama for a supercomputer."[75] Most parts of this drama are disputed, but here is (to the extent it could be reconstructed) how it played out: in six acts and three intermezzi.

February 1988, ETH Zurich. A meeting is held, involving Bühlmann, Caccia, and Zehnder, among others. The topic: the university's

Fig. 5

Act 1

72

From the government response dated November 27, 1989 to the interpellations by Sergio Salvioni and Werner Carobbio (Bundesversammlung (Swiss Federal Parliament), "Interpellation Salvioni: Nationales Rechenzentrum im Tessin (n. 88.469)," and "Interpellation Carobbio: Supercomputer im Tessin (n. 89.497)," *Amtliches Bulletin der Bundesversammlung* 5 (1989), p. 2259, p. 2260). In it, the government also claims that "ETH urgently

73

ETH Zürich 1992, p. 25.

needed the space reserved for the supercomputer for itself," which is untrue according to Zehnder (Scherrer and Stadler June 26, 2018).

74

From an interview with Caccia (Scherrer July 26, 2018).

75

Desfayes 1991.

Fig. 5 From plan to reality: the unlikely emergence of the Swiss national supercomputing center in the small municipality of Manno with its Japanese NEC SX-3 on Swiss TV, 1989–1992. (Antonio Antoniazzi: ETH Rechenzentrum Manno, *DRS aktuell*, November 24, 1989 © SRF, Silvio Tarchini; Bruno Schärer: Rechenzentrum Manno, *Schweiz Aktuell*, October 1, 1992 © SRF)

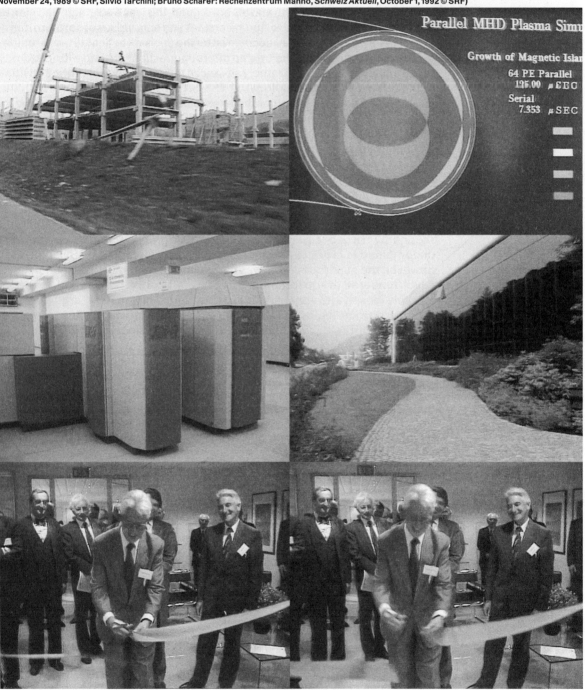

activities in Ticino. A project for a seminar center is decided upon and the possibility of another common project is alluded to. Whether the supercomputer is mentioned: unclear. Bühmann and Zehnder recall it; Caccia doesn't. (Or rather, Caccia offers conflicting accounts: in 1991 he wrote in a report that it was mentioned, but in 2010, 2016 and 2018 he insisted that it wasn't.)[76]

First Intermezzo: June 1988. An MP from Ticino files a parliamentary interpellation asking the government to build the national supercomputing center in his canton. Caccia, his colleague, insists that he knew nothing about it.[77]

Act 2

September 1988, Bern. Another meeting, this time with Caccia, Bühlmann, and Heinrich Ursprung, Bühlmann's boss as head of the ETH council.[78] The topic: the feasibility of creating a supercomputing center in Ticino. Thanks to a friend at ETH's computing center,[79] Caccia has advance knowledge of two major concerns: data transmission and the 1991 deadline. Thus prepared, he is able to present the men with solutions: the national transmission infrastructure is up to the task, Caccia's PTT (post and telecommunications agency) contacts assure him, and (incidentally) a local entrepreneur is in the process of building a large multipurpose facility that could be converted into a computing center in time. That building project, found through informal channels in under two weeks is the future site of CSCS in Manno.[80]

Act 3

September 1988 to May 1989. A working group including Caccia and Zehnder compiles a detailed study, assessing nine informally identified possible locations in Ticino. Manno, all members agree, is the only site both suited for a computing center and advanced enough for it to be completed in time. Without public bidding for developers, the plan is handed upwards for approval: first to ETH, then to the ETH council, and finally to the national government. Only one man isn't on board. Or at least that's how the legend goes.[81]

76

This paragraph is based on interviews with Bühlmann (Scherrer July 12, 2018; from June 22, 2011, in Schärli, Research Archive), Zehnder (Scherrer and Stadler June 26, 2018) and Caccia (Scherrer July 26, 2018; from September 21, 2010, in Schärli, Research Archive) and additional documents (Caccia 1991; ibid. 2016; a 2011 e-mail exchange between Zehnder and Martin Gutknecht, in Schärli, Research Archive).

77

The MP is Sergio Salvioni (Bundesversammlung 1989/5, pp. 2258–9); Caccia's statement is from an interview with him (Scherrer July 26, 2018).

78

The ETH council oversees the work of the two Federal Institutes of Technology in Zurich (ETH) and Lausanne (EPFL). At this meeting the president of EPFL, Bernard Vittoz, was also present.

79

Fiorenzo Scaroni, later involved in the establishment of CSCS as a project manager.

80

This paragraph is based on interviews with Bühlmann (Scherrer July 12, 2018) and Caccia (Scherrer July 26, 2018) as well as additional documents (Caccia 1991; ibid. 2016; Maspoli September 11, 1989).

81

This paragraph is based on the government response dated November 27, 1989 to the interpellations by Salvioni and Carobbio (Bundesversammlung 1989/5, p. 2259 and p. 2260) as well as additional documents (Caccia 1991; ibid. 2016) and interviews with Caccia (Scherrer July 26, 2018) and Zehnder (Scherrer and Stadler June 26, 2018).

Second intermezzo: May 1989. A supercomputing center also needs a supercomputer. A commission is thus established to find the right one. Its members: computer scientists, scientific users, and administrative computing center staff. Their criteria (among them novelty, in a strict reading of the special measures bill) will shape the center's future, yet aren't subject to public debate.[82]

Act 4

May to October 1989. Suddenly, there's trouble: the Manno site becomes the subject of an intricate legal battle, threatening to delay construction, and a local journalist digs up dirt on the project.[83] He speaks of an "insider … affair," of an important project being "subordinated to special interests" and "the laxness and inexperience, as well as the unwillingness to be transparent" on the part of Ticino's authorities.[84] If you believe Caccia, one man is behind all the "polemics, interventions, and court cases": Giugliano Bignasca, a local entrepreneur dubbed "the financier without a tie" by one magazine.[85] He'd like to host the supercomputer in one of his own building projects; whether his offer was in fact part of the initial evaluation is unclear.[86] What is clear, though: Bignasca seizes the opportunity to start a fight with Ticino's political establishment—a fight that he'll continue by founding his own newspaper in 1990 and a successful political party, the *Lega dei Ticinesi,* in 1991.[87] (One of its first national MPs would be the journalist critical of the Manno location.) Contrary to the prevailing story, however, Bignasca isn't the only one unhappy with the designated building. A Social Democratic MP from Ticino, for instance, files a parliamentary interpellation that criticizes both the project's lack of transparency and the building's use of "foreign prefabricated components."[88] Other newspapers question the "series of bureaucratic and legal mishaps" as well, arguing that Ticino is making *"una gran brutta figura"*—a very bad impression.[89] The critics are ultimately successful: citing legal and political concerns, the government decides to reevaluate the location of the supercomputer, this time with public bidding.[90]

82

This paragraph is based on documents (ETH Zürich, *Jahresbericht 1989,* Zurich, 1990, p. 81; Desfayes 1991, p. 40; a 2011 e-mail exchange between Zehnder and Martin Gutknecht, in Schärli, Research Archive), a research summary from 2011 (in Schärli, Research Archive), and Andreas Nef, Andrea Dudler, and Tobias Wildi, "Swiss Scientific Computing Center, Manno (CSCS)," *ETHistory 1855–2005,* July 28, 2005, http://www.ethistory. ethz. ch/rueckblicke/departemente/ dinfk/entwicklung/weitere_seiten/ cscs/index_EN/popupfriendly/ (retrieved June 26, 2019).

83

The problem was that the land in Manno belonged to the Swiss national railway (SBB), which had expropriated it in the 1970s to build a cargo railway station. A good portion of it was, however, never used, so SBB sold the right to build on it to a local entrepreneur, Silvio Tarchini. Now the original proprietors were suing the SBB for not ceding the land back to them. Additionally, there were also some formal problems with the building permit, and a local initiative demanding the creation of a public space on parts of the land. Flavio Maspoli, "A Manno ormai si danza al ritmo degli avvocati," *Gazzetta Ticinese* (September 8, 1989), p. 16; [N.N.], "Manno blocca il Centro di calcolo," *Libera Stampa* (June 15, 1989), p. 9; Antoniazzi 1989; interview with Fulvio Caccia from September 21, 2010 (in Schärli, Research Archive).

84

Maspoli September 8, 1989 and September 11, 1989. Flavio Maspoli, "Nessuno intende mandare il Centro di Calcolo in 'tilt,'" *Gazzetta Ticinese* (September 13, 1989), p. 12.

85

Caccia 1991; Bruno Giussani, "Le financier sans cravate," *L'Hebdo* (October 11, 1990), p. 51. In fact, Bignasca openly admitted that he'd informed the previous proprietors of the Manno land of their "right to demand a restitution" of the lands originally expropriated by SBB and had also filed a complaint with the canton's department of construction. Flavio Maspoli, "Presentata ieri a Lugano la soluzione Bioggio/ Bignasca per il futuro Centro di calcolo," *Gazzetta Ticinese* (November 9, 1989), p. 19; [N.N.],

"Centro di Calcolo contestata la licenza data a Tarchini," *Libera Stampa* (January 16, 1990), p. 4.

86

Caccia says yes, a newspaper report says that it was presented to authorities only in September 1989. Caccia 1991; a.car., "Berna ha ricevuto un progetto dettagliato sul Centro di Calcolo dei politecnici a Bioggio," *Libera Stampa* (September 9, 1989), p. 1.

Act 5 October 1989 to February 1990. Everything is changed, so that nothing changes. With thirty-seven options (including Bignasca's) newly evaluated, the legal case settled, and several new players (the Ministry of Finance, an independent engineering bureau) consulted, the result remains the same: ETH will rent the Manno location with the prospect of purchasing it later on.[91] Some credibility is gained, but time is lost.[92]

Third intermezzo: September 1990. Novelty trumps usability, Japan trumps the US, NEC trumps Cray: the evaluation of computer types ends with a clear recommendation. The NEC SX-3, not yet regularly installed anywhere at that point, wins the race after a call for offers in April. "Choosing it, we took a risk," a commission member admits some time later.[93]

Act 6 September 1991, Manno. A year before its official inauguration and a mere few days before parliament's deadline expires, the NEC is installed and the center begins operations. The new name—CSCS—marks a new era: parliament's "national high-performance calculator," the media's "national supercomputer," and Bühlmann's "National Computing Center" is now the "Swiss Center for Scientific Computing," a name chosen by the new ETH president, who was reportedly very proud of his idea.[94] In Ticino, meanwhile, they call the machine that embodies the hope of creating "a Ticinese Silicon Valley" by another name: *"cervellone"*—superbrain.[95]

87

Giugliano Bignasca (1945–2013) quickly became a polarizing figure in Ticino and beyond. A national MP and a Lugano city council member for a time, he was regularly criticized (and in some cases convicted) for dubious business practices, drug use, and anti-Semitic comments. While he polemicized against Ticino's political establishment constantly, he was very much a part of it, espousing politically what was good for his business. See

88

Interpellation filed by Carobbio on June 14, 1989 (Bundesversammlung 1989/5, p. 2259). Interestingly, though, Bignasca would use exactly this nativist aspect to publicly argue for the superiority of his solution. Maspoli November 9, 1989.

89

a.car., "Il Ticino sta facendo una brutta figura," *Libera Stampa* (September 13, 1989), p. 9.

90

See the government response dated November 27, 1989 to the interpellations by Salvioni and Carobbio (Bundesversammlung 1989/5, p. 2259 and p. 2260).

91

This would happen (with the approval of parliament) in 1993 for CHF 28.7 million. Bundesrat (Swiss Federal Council), "Botschaft über Bauvorhaben, Grundstücks- und Liegenschaftserwerb (Zivile Baubotschaft 1993) vom 26.5.1993 (n. 93.052)," *Bundesblatt* 2, no. 30 (1993), pp. 1365–70.

92

This paragraph is based on: ETH Zürich 1990, p. 81; the government response dated November 27, 1989 to the interpellations by Salvioni and Carobbio (Bundesversammlung 1989/5, p. 2259 and p. 2260); Antoniazzi November 24, 1989; Caccia September 30, 1991.

93

This paragraph is based on published (ETH Zürich, *Jahresbericht 1990*, Zurich, 1991, p. 99, and ETH Zürich 1992, p. 25; NEC (Nippon Electronics Corporation), *NEC Corporation 1899–1999: A Century of "Better Products, Better Services,"* Tokyo, 2002, pp. 214–15; Nef et al. 2005) and unpublished (a 2011 research summary and a 2011 e-mail exchange between Zehnder and Martin Gutknecht, in Schärli, Research Archive) material. The quote is from Desfayes 1991, p. 40.

Michele Andreoli, "Giugliano Bignasca," *Das Magazin* 34 (1991), pp. 6–10; Antonio Cortesi, "Bignasca und die anderen," *Tages-Anzeiger* (March 1, 2000).

94

Quotes e.g. in Bundesrat 1993, p. 1366 (quoting an earlier report); Desfayes 1991, p. 39; speech by Bühlmann on October 2, 1989, p. 2; ETH Zürich 1992, p. 25; the paragraph is also based on Caccia 1991; ibid. 2016 and an interview with Bühlmann (Scherrer July 12, 2018).

95

A.N., "Chiavi per l'apertura di un sogno," *Gazzetta Ticinese* (October 19, 1990), p. 13 (Silicon Valley); [N.N.], "Cervellone. Nominato il direttore," *Giornale del Popolo* (January 17, 1992), p. 15; [N.N.], "Per il supercomputer di Manno la prima direzione è europea," *Giornale del Popolo* (October 2, 1992), p. 23; October 2, 1992, a. ma., "In vista al cervellone," *Eco di Locarno* (October 5, 1991), p. 4 (cervellone).

V Marketing the supercomputer: A public institution in privatizing times

Neither before nor after his four years as the first director of CSCS did Alfred Scheidegger have anything to do with supercomputing. "Computer-specific know-how wasn't necessary for this position," he noted in an interview. "They were looking for someone with international experience and a business background," he told me, sitting in an oversized conference room at the offices of the biomedical venture capital investment firm he runs nowadays. A biochemist by training, Scheidegger had worked for the Swiss pharmaceutical industry in Japan before taking the job in Ticino. His main task as incoming director there: "The center had to be marketed," while dealing with "the vehement competition" between ETH's three computing centers in Zurich, Lausanne, and Manno. When asked about his noteworthy successes, he points to the SX-3's successor: he got it from NEC at no cost. "That was my coolest deal," he says (though the Japanese strategy of using dumping prices to capture markets may have helped).[96] He was, in short, a manager through and through.[97]

What Scheidegger embodied was in no way unique to this era: it was the early 1990s, and much like anywhere else, Switzerland's state bureaucracies (including ETH's) were captivated by the idea of running them like businesses.[98] "Management," "clients," "targets," "output," "performance": those were the words accompanying this shift to an ideology of new public management (NPM) that saw market principles as the antidote to alleged bureaucratic inefficiency. It was no coincidence that many of these concepts had their origin in the language of IT service providers, from where they spread to the rest of the administration.[99] While government agencies were privatized in Bern, at ETH in Zurich the "managerial revolution" reached its peak in 1995 with an ultimately unsuccessful "total quality management" reform led by none other than Scheidegger himself (who had by then left Ticino).[100] Unsurprisingly, then, Scheidegger's goal of bringing science and industry closer together by running the university like a company had already

96

For a case of NEC using dumping as a business strategy at MIT in the US, see Anchorduguy 1994, pp. 46–47.

97

From interviews with Alfred Scheidegger (Scherrer and Stadler June 27, 2018; another from July 20, 2011, in Schärli Research Archive).

98

See Sonia Weil, *25 Jahre New Public Management in der Schweiz: Zehn Gestalter erzählen*, Cahier de l'ID-HEAP 300, Lausanne, 2017, pp. 7–8; Daniel Speich Chassé, "Gab es in der Schweiz eine neoliberale Wende? Ein Kommentar," in *Staatlichkeit in der Schweiz. Regieren und verwalten vor der neoliberalen Wende*, edited by Lucien Criblez, Christina Rothen, and Thomas Ruoss, Zurich 2016, pp. 369–384.

99

Gugerli et al. 2005, pp. 378–85, or 2010, pp. 329–35.

100

Ibid. 2005, pp. 380–83, or 2010, pp. 330–33.

101

In 1994 he wrote an interesting op-ed in the Zurich daily *Neue Zürcher Zeitung*, presenting Japan as an exemplary case where economic competitivity was ensured through close cooperation between the state and industry. In it he also lamented the "traditional ivory tower syndrome of our universities here." Alfred Scheidegger, "Intensive Forschungskooperation in Japan: Sicherung der internationalen Wettbewerbsfähigkeit," *Neue*

Zürcher Zeitung (April 12, 1994), p. 34. His plan for industry cooperation even made it onto Swiss TV. Bruno Schärer, "Rechenzentrum Manno," *Schweiz Aktuell* (October 1, 1992).

102

On the internationalization of Swiss business elites in this period, see Mach et al. 2017, pp. 124–45.

Fig. 6

shaped his time at CSCS, where he aimed to "offer surplus capacity to industry" for money.[101] As he complained at the inauguration: "The use of the supercomputer as a tool for economic operations is sadly not yet evident enough to the leaders of [Swiss] private industry." In consequence, he sought out collaborations with companies from Japan and Russia. To the globally oriented business elite that he represented (and that was by now replacing the nationally minded old guard), the supercomputer's originally intended function of ensuring national sovereignty seemed antiquated.[102]

The CSCS, to Scheidegger's mind, "[wasn't] just important for research and economic development in our homeland," but also for the "integration of Switzerland into Europe."[103] Only two months after this statement, in December 1992, in one of the first big victories of the radical right in Switzerland, the Swiss people would, however, narrowly reject the proposal (supported by many scientists and economic interest groups) to join the European Economic Area (EEA). While Scheidegger would complain afterward that the decision harmed the CSCS's opportunities for participating in European projects,[104] the canton of Ticino had decisively contributed to it. (The canton voting against the EEA was a major success for Giugliano Bignasca's Lega dei Ticinesi that had led the local opposition against the proposal.)

It was a peculiar mix: the same movement and the same anti-establishment rhetoric that had emerged to criticize the lack of transparency in the choice of the CSCS's location—a classic pro-NPM argument—was now torpedoing the internationalist dreams of pro-NPM managers. And the same charge that had been leveled against Ticino's political establishment—nepotism—was now leveled by the Lega (and even parts of that very same political establishment) at Scheidegger and his boss, ETH president Jakob Nüesch.[105] It certainly looked a bit suspicious: not only had Scheidegger written his doctoral thesis with Nüesch at the University of Basel, they had also both worked for the same pharmaceutical company before joining ETH: Ciba-Geigy, today part of Novartis.[106] (Scheidegger insists that he was chosen meritocratically in a transparent process.) What's clear is that he very much shared Nüesch's vision of an "entrepreneurial university."[107] And it's striking how this vision—so different from the one of a federalist university promoting regional development—and its proponents were attacked in such similar

103

Speech by Scheidegger on October 1, 1992, pp. 1–2 (in Schärli, Research Archive); this European dimension was also noted by the local press: [N.N.] October 2, 1992.

104

In Gerhard Camenzind, "ETH-Computerzentrum mit Hochleistungsrechner: Zusammenarbeitsvertrag mit Japan," Tagesschau (March 13, 1993).

105

A CSCS collaborator from Ticino, who felt sidelined, claimed, for example, that the naming of Scheidegger as director was "a clear case of nepotism" (cited in a 2011 research summary, in Schärli, Research Archive). According to Scheidegger, many in Ticino (not just the Lega) would have preferred a local as director (Scherrer and Stadler June 27, 2018). Caccia, the MP, meanwhile, says Scheidegger was the "wrong choice" because he lacked

experience; he says he proposed another candidate, but ETH president Nüesch wasn't interested (Scherrer July 26, 2018).

106

Nüesch had been the head of pharmaceutical research, while Scheidegger had led a drug discovery project in Japan. For the dissertation, see Alfred Scheidegger, "Untersuchungen über die Cephalosporin C Biosynthese bei Cephalosporium Acremonium," PhD diss., University of Basel, 1984.

107

Cited in Lino Guzzella, "ETH Zurich Bids Farewell to Jakob Nüesch," ETH News (February 10, 2016), https://www.ethz.ch/en/news-and-events/eth-news/news/2016/02/abschied-von-jakob-nueesch.html (retrieved June 25, 2019). According to Scheidegger, he was first asked

in 1990 whether he'd be interested in the job as CSCS director (Scherrer and Stadler June 27, 2018). The official call for applications was published in Ticino in 1991 (Posti Federali, "Un/una dirigente per il Centro Svizzero di Calcolo Scientifico(CSCS)," Giornale del Popolo (October 16, 1991), p. 22).

| Fig. 6 | The CSCS as a European center: the opening ceremony in a local newspaper with the first director Alfred Scheidegger at left. (*Giornale de Popolo*, October 2, 1992, p. 23, Biblioteca Cantonale di Lugano)

GdP venerdì 2 ottobre 1992

Inaugurato ieri pomeriggio il centro scientifico svizzero

Per il supercomputer di Manno la prima direzione è europea

■ Il Centro svizzero di calcolo scientifico inaugurato ufficialmente ieri pomeriggio a Manno ha già cambiato nome: per gli oratori intervenuti ieri alla cerimonia di apertura, è diventato un centro «europeo» chiamato ad avere un ruolo di rilievo nell'integrazione della Svizzera in Europa per quanto riguarda la politica di ricerca.

Al taglio del nastro, Giuseppe Buffi accanto a Jakob Nüesch del Poli di Zurigo, al segretario di Stato Heinrich Ursprung e al direttore del CSCS Alfred Scheidegger nella foto di Jo Locatelli.

In questo senso si è espresso il direttore del CSCS, dott. Alfred Scheidegger, particolarmente orgoglioso di presentare finalmente il supercalcolatore, costato oltre 20 milioni di franchi, in grado di offrire alle università e alle industrie private 'svizzere un'altissima velocità di calcolo. Un «team» di 30 collaboratori in funzione 24 ore su 24 per sette giorni la settimana si occuperà del computer capace di eseguire la bellezza di 5 miliardi e mezzo di operazioni al secondo. In pratica ciò corrisponde all'addizione di tutti gli abitanti del Ticino effettuata 20mila volte al secondo...

Un servizio scientifico di calcolo ad altre prestazioni insomma che potrebbe aprire al Ticino prospettive interessanti, diventando un punto di riferimento europeo per quel che concerne i lavori di progetto nello sviluppo e nella ricerca applicata (fisica, matematica, chimica o biologia). Se le università svizzere già fanno capo al cervellone, il suo utilizzo come strumento di gestione non è purtroppo ancora abbastanza evidente per i dirigenti dell'industria privata, in particolare per le piccole e medie

aziende. L'ottimismo sembra regnare a Manno e il progetto del CSCS produrrà sicuramente le sinergie positive auspicate, integrandosi nel tessuto sociale ed economico del Cantone.

Il discorso europeo è stato cavalcato anche dal presidente del Politecnico federale di Zurigo, Jakob Nüesch che si è espresso sull'ubicazione del centro. Perchè costruirlo in Ticino, lontano dalle università ? « *Se oggi non esistono problemi di comunicazione,» –* ha detto Nüesch – *«la lontananza con gli atenei svizzeri potrebbe favorire un'autodinamica aperta a patto che venga opportunamente interpretato il ruo-*

lo del Centro. Ma vale anche come gesto di solidarietà nei confronti di un territorio assai promettente per la ricerca e la produzione».

Per il consigliere di Stato Giuseppe Buffi, l'apertura del centro di calcolo rientra nei momenti importanti per il Cantone. Frutto di trattative che risalgono al 1988 e alle quali aveva partecipato l'allora collega di lavoro Fulvio Caccia, l'arrivo del supercalcolatore è subito stato visto come una rivincita per ricucire un tessuto violentemente lacerato dall'affossamento del CUSI. Con il Politecnico di Zurigo si sono così ripresi quei contatti

universitari che si sono poi progressivamente concretizzati fino alla realizzazione del centro, rallentato da una fase di «smarrimento» politico quando la discussione sul contenitore stava per far dimenticare il contenuto.

Il Centro ora è in funzione e non sarà, ha concluso Buffi, una torre d'avorio o un'astronave misteriosa: sarà invece una base importante per dare al Ticino un solido credito nel campo delle realizzazioni universitarie. Dimenticando dunque le polemiche e le incomprensioni ma piuttosto vedendo nel centro un polo che irradia attorno a sè la forza del suo messaggio, trovando

ways: not by questioning their goals (no one in Ticino objected to those), but instead the allegedly untransparent processes by which they were realized.

Arguably, this likeness in what was being criticized (and how) suggests a hidden continuity between the nationally minded elites of the Cold War era and the globally minded ones of the 1990s. For despite the shift in rhetoric—from a military-like vocabulary of national sovereignty to a business vocabulary of international networking—the reasons advanced to give the CSCS legitimacy and purpose as an institution remained strikingly similar in the two periods. As far as state actors are concerned, the tone (and the speakers) changed more than what was actually said. In 1959, the report that first articulated the idea of a national computing center pointed to its potential to "take on some of the long-term research tasks necessary for maintaining Switzerland's economic position," since the private industry wasn't willing to cooperate to that end.[108] A 1983 CICUS report still argued that while the private sector was leading the way in computer research elsewhere, such "activities generally remain scarce ... in Switzerland; this is why it would be advisable especially in our country for the universities to play a major role in computer science research."[109] And in 1992, ETH president Jakob Nüesch argued that centers such as CSCS had to be part of global research networks, so that "our industry will come in contact with technologies of information and will be able to draw conclusions for adapting their products to the demands of the market."[110] In all these instances, it is a perceived failure or impossibility of the industry to innovate fast enough to remain competitive, which the state corrects by investing in research infrastructure such as a supercomputing center: risks are socialized, while rewards are privatized.[111]

Whenever the benefit to the industry is claimed to be direct—it can use the facility—or indirect—it profits from the results of research or a well-trained workforce—is of secondary importance, as is the fact that the "national industry" underwent drastic changes between 1959 and 1992. The point is that the national supercomputer drew its legitimacy from serving the (changing) interests of the private sector better than that sector itself, from responding better to long-term economic needs (especially in high-investment fields like high-speed computing) than the economy itself and from being a better crystallization point for regional IT development than anything in that region itself. This argument, stressing the need of a well-funded public IT infrastructure for an innovative private economy, links the various national, local, and global stages in the history of the supercomputing center. What separate them, meanwhile, are different ideas of the Swiss "nation": the sovereign, the federalist, and the globally connected.

108

Hochstrasser 1959, p. 7.

109

CICUS 1983, p. 3; see also p. 17.

110

Speech by Nüesch on October 1, 1992, p. 3 (in Schärli, Research Archive).

111

See Mazzucato 2013 for an exploration of such "entrepreneurial states."

Seen this way, even the infrastructure argument underwent changes: while it was initially "an essential element of [the] concept" to give all Swiss universities access to the center free of charge, this was later questioned in the face of financial difficulties.[112] While Zehnder, the professor, still insisted in 1988 that ETH's Cray X-MP would be available to researchers of private companies "only for very carefully selected projects" because "this isn't something you can rent like a car," the CSCS would subsequently try to be just that—something companies with enough money might rent.[113] Nevertheless, whether it marked distance or sought proximity to the private sector, the supercomputer remained a "national resource" even in the 1990s[114]—not as an antipode of the prevailing trend of NPM and privatization, but very much in line with it.

VI Epilogue: Afterlife

Summer 2018. A research team tasked with studying "digital infrastructures" in Switzerland undertakes a journey to find the nation's long outdated supercomputers. One of them (the Cray X-MP), it turns out, now serves as a bench in an ETH chemistry building. The other (the Cray 2) is gathering dust, we hear, in a remote corner of EPFL devoted to its history. On a hot day in July, we visit it in Lausanne: We stand around it, touching its red and yellow leather upholstery, its cold metal case, the empty container of cooling fluid, not really knowing what else to do. Time is merciless to everything, but especially to a supercomputer. It looks like a fancy, now long forgotten, prop. Through its transparent shell, you can see a few dead bugs lying on the processors once immersed in bubbling cooling fluid. In a nearby storage space, we unexpectedly find something else: the remnants of a decommissioned CSCS computer. (The center itself moved to a new location in Lugano, Ticino, in 2012 and is operating to this day.) The man showing us around is sure that somewhere he also has a part of the first machine there (the NEC SX-3). Though it had cost 23 million Swiss francs[115] and taken so much time, intrigue, and drama to install in Manno, it was outdated after only three years and had to be replaced as the CSCS's centerpiece. Our guide, an avid collector of computing antiquities, had been offered the whole machine for free. But lacking space, he had taken only one part, as a symbol of this quickly forgotten milestone in Swiss history. Now, however, he can't find it. The superbrain is gone.

112

Hochstrasser 1988, p. 9; parliamentary interpellation by MP Franco Cavalli filed on June 23, 1998 (Bundesversammlung (Swiss Federal Parliament), "Interpellation Cavalli: Schweizerisches Rechenzentrum in Manno, Zukunft? (n. 98.3276)," *Amtliches Bulletin der Bundesversammlung* 5 (1998), esp. p. 2257) and discussion on it on March 21, 2000 (Bundesversammlung (Swiss Federal Parliament), "Interpellation Cavalli: Schweizerisches Rechenzentrum in Manno, Zukunft?" *Amtliches Bulletin der Bundesversammlung* 1 (2000), esp. pp. 377–78).

113

The statement was made on Swiss radio. Stalder June 13, 1988. This mirrors a general shift in computer science from a division of labor to closer cooperation between industry and academia. Liebig 2006, pp. 123–24, describes this in her analysis of CICUS reports from 1983 to 2000.

114

Claudia Moor-Häberling, and Djordje Marič, "Centro Svizzero di Calcolo Scientifico (CSCS)," *Chimia* 49, no. 5 (May 1995), p. 124.

115

This price is for the machine only. Desfayes 1991.

Acknowledgments

First of all, I'd like to thank my interviewees—Carl August Zehnder, Hans Bühlmann, Fulvio Caccia, and Alfred Scheidegger—for their time. I am also indebted to Franziska Schärli, who generously allowed me to access the research archive she compiled for CSCS on its history and that Simone Ulmer at CSCS's Zurich offices made available to me. The visit to the Musée Bolo at EPFL was possible thanks to Yves Bolognini. David Gugerli provided useful input in the early stages of the project. Many thanks also go to the editors for helpful feedback on the manuscript.

Gondo

White Gold, Crypto Gold:
Alpine Hydropolitics

Monika Dommann
Max Stadler

Gondo? Readers may recall the Valais border town of Gondo from national and international headlines at the dawn of the twenty-first century. When a landslide destroyed a third of the village on October 14, 2000, sending thirteen villagers to their deaths, the disaster was broadcast to the world, triggering record donations to Swiss Solidarity.[1] It was not just nature that was involved in this tragedy—a "disaster of historic proportions," statistically speaking, much like the Valais floods of 1987 and 1993.[2] It was not just the mountain that came down with all its might into the valley after continuous heavy rainfall. It was the concrete piles that had been erected to protect against rockfall which, together with the boulders and scree, thundered down on the village and the Stockalperturm, a historic landmark. The damage totaled 70 million Swiss francs in the community of Gondo and 670 million Swiss francs in the region. With the help of SRG, the Swiss radio and television broadcaster, Swiss Solidarity was able to collect almost 76 million francs in donations after the accident. (Only the collection for the victims of the 2004 Indian Ocean tsunami brought in more.) Gondo received 14.8 million francs from Swiss Solidarity for the reconstruction of the village square, the construction of two new houses, and the renovation of the Stockalperturm, a seventeenth century storehouse and hostel that had once belonged to transit entrepreneur and paymaster Kaspar von Stockalper. In 2005, the rebuilt village center was ceremonially inaugurated.

In 2011, the mayor of Gondo, Roland Squaratti—who no longer lives in Gondo but in the next largest town, Brig-Glis—exuded optimism for the rebuilt village,[3] extolling the natural beauty of the Zwischbergen Valley to summer tourists. He also promised that the village with its two reservoirs would be able to produce clean "energy for the whole of Switzerland," emphasizing its potential for further expansion. This is how the village could return the favor to Switzerland: "clean energy as a thank-you" for the nation's support in the wake of the natural disaster. And clean energy as a form of aid to the "crisis in energy policy," the coming "electricity shortage" that Switzerland—after Fukushima and the abandonment of nuclear power—would now somehow have to address.[4]

Almost two decades after the accident, Gondo again caught the attention of the media. This time it was not a natural disaster that struck the village, but rather the prospect that hydroelectric power, or "white gold," as the people of Valais are fond of calling it, would bring new opportunities to the village of Gondo-Zwischbergen. In October 2017, the "Wallis" (Valais) regional program on Radio DRS reported for the first time that a crypto-mining start-up had been inquiring in Gondo.[5] Attracted by the lowest electricity prices in Switzerland—a side effect of an arrangement with the

1

See, for example, the documentary film *Als die Schweiz den Atem anhielt: Der Erdrutsch von Gondo*, directed by Fiona Strebel, produced by SRF, Switzerland 2001, aired on July 5, 2011, https://www.srf.ch/play/tv/katastrophen/video/als-die-schweiz-den-atem-anhielt-der-erdrutsch-von-gondo?id=8da43d6e-bcec-4e23-9e08-b74f9e20d2c2 (retrieved July 3, 2020).

2

I.e., statistically speaking, this kind of severe rainfall should have occurred far less frequently. See *Hochwasser 2000 – Les crues 2000. Ereignisanalyse/Fallbeispiele – Analyse des événements/Cas exemplaires*, Berichte des BWG (Bern, 2002), p. 11.

3

Als die Schweiz den Atem anhielt, 2011.

4

Roland Squaratti, "Gondo-Zwischbergen und die EES SA; Eine Erfolgsgeschichte," August 19, 2011, https://www.gondo.ch/downloads/Ansprache%20Einweihung%20Staumauer%20Sera%2019%208%202011%20_2_.pdf (retrieved July 3, 2020).

local electricity company, Energie Electrique du Simplon (EES)—the Valais-based company Alpine Mining from Martiny was interested in setting up a blockchain facility in the village. The Gondo community council and the start-up company agreed on a price of 0.09 francs per kilowatt-hour. Alpine Mining then installed a blockchain system or "crypto-mine" consisting of several hundred graphics cards in the empty civil defense facility. The object of desire: a digital currency called Ether.

Thomas Ludovic, the CEO of the start-up, stated in the radio broadcast in autumn 2017 that the facility consumed about 150 kW—about as much as a (Swiss) village of 400 to 500 people—and that, in addition to mining Ether, he also planned to establish a new currency on his own platform. The radio broadcast also mentioned another interested party that would use ten times as much electricity, which would require the community to invest in a new substation. Alpine Mining SA meanwhile reported (appropriately on blockchain-based social media platform Steemit, username @AlpineBlockchain): "[T]here is also the fact we are re-making history here, let me brievely [sic] explain ;-)."[6] The start-up alluded to the "gold rush" that had previously occurred in Gondo, in the 1890s, when the Parisian Société des Mines d'Or d'Helvétie settled there.[7]

This was the start of start of a minor media hype about a new crypto gold rush in Gondo. In the months that followed, the bourgeois *Neue Zürcher Zeitung*, the tabloid *Blick*, the commuters' newspaper *20 Minuten*, regional platforms, blog posts, and crypto news sites, among others, devoted reports to the digital mountain village in the Swiss Alps: at work there were modern gold miners, they said, who "[wore] neither tailcoats nor rags, but hoodies."[8] Even the American tech magazine *Wired* deemed the new gold rush in Gondo worthy of a report, including a lavish series of pictures: "The Cryptocurrency Rush Transforming Old Swiss Gold Mines."[9] The stories told were all about clean and cheap energy, the beneficial climate in the Alps (in

5
Priska Dellberg, "Warum Gondo auf das Blockchain-Geschäft hofft," Radio DRS (October 20, 2017), https://www.srf.ch/news/regional/bern-freiburg-wallis/blockchains-aus-dem-bergdorf-gondo-hofft-auf-die-digitalen-goldgraeber (retrieved July 3, 2020).

Marcel Gyr, "Ausgerechnet das Walliser Glückskette-Dorf Gondo stimmte am deutlichsten für 'No Billag' – neu setzt der entvölkerte Grenzort auf Blockchain," *Neue Zürcher Zeitung* (March 15, 2018), https://www.nzz.ch/schweiz/spendengelder-no-billag-und-kryptowaehrungen-ld.1366165; Roman Maas, "Grüne Start-ups und Gasriesen: Schweiz wird attraktiver Krypto-Standort," *BTC Echo* (April 4, 2018), https://www.btc-echo.de/gruene-start-ups-und-gasriesen-schweiz-wird-

6
AlpineBlockchain, "Finally back on Steemit with some news about our digital gold adventure," Steemit, October 23, 2017, https://steemit.com/life/@alpineblockchain/finally-back-on-steemit-with-some-news-about-our-digital-gold-adventure (retrieved July 3, 2020).

attraktiver-krypto-standort/; Helmut Stalder, "Das Bergdorf Gondo erlebt einen Krypto-Rausch – doch das Bauland für neue Firmen fehlt," *Neue Zürcher Zeitung* (April 9, 2018), https://www.nzz.ch/schweiz/krypto-rausch-in-gondo-gebremst-ld.1370601. (all retrieved July 3, 2020).

7
Hans-Peter Bärtschi, "Goldmine Gondo – Eine industriearchäologische Bestandesaufnahme," *Minaria Helvetica*, no. 16b (1996), pp. 29–81.

9
Michael Hardy, "The Cryptocurrency Rush Transforming Old Swiss Gold Mines," *Wired* (September 7, 2019), https://www.wired.com/story/cryptocurrency-gold-mines-gallery/ (retrieved July 3, 2020).

8
Cited in Thomas Bolzern, "Der digitale Goldrausch im Walliser Bergdorf," *20 Minuten* (May 17, 2018), https://www.20min.ch/story/der-digitale-goldrausch-im-walliser-bergdorf-154031188522; see also, for example, Priska Dellberg, "Gondo hofft auf die digitalen Goldgräber," *SRF* (October 20, 2017), https://www.srf.ch/news/regional/bern-freiburg-wallis/blockchains-aus-dem-bergdorf-gondo-hofft-auf-die-digitalen-goldgraeber;

10
Cf. Roland Barthes, *Mythen des Alltags*, Frankfurt am Main, 1988 [Paris 1957]. According to Barthes, myths are constructed from semiological chains, and they transform stories into natural states.

Fig. 1
"Have a good afternoon we let you appreciate this beautiful view in the mountains!" — Alpine Mining. (Instagram /@ alpinetechsa, May 17, 2018, Screenshot, April 16, 2020)

terms of cooling the facility), and a "revitalization" of Alpine valleys through digital gold and hydroelectric power as enablers of the digital future.

These media reports began to capture our interest. They seemed to contain particularly pointed (and, with the inclusion of a nineteenth century gold rush, particularly mythical)[10] stories of the kind we had already encountered in Switzerland's recent "digital" history. Indeed, the stories of the clean, white gold of the Alps and of high-tech infrastructures for peripheral regions had made their way not only into the buzz around Gondo, but also into Switzerland's most recent descriptions of itself as a digital economic area, as a "hub" of information flow,[11] as a "data vault,"[12] or as a country which, due to its cool alpine climate and inexhaustible energy supply, was particularly well-suited to the location of data centers. "Switzerland has the best possible environment for [the] mining process":[13] Alpine Mining SA was also happy to make use of this narrative and do its part to cultivate it. Anyone who got lost on their Instagram account would find not only photos of flashing LEDs and graphics cards and mining racks, but, above all, pictures of the natural environment: of lakes, dams, and waters tumbling down the mountains.

We wondered how this latest media hype surrounding the Zwischbergen Valley and the transit village of Gondo could be approached in terms of social history, environmental history, and the history of technology, and what stories might be lurking behind site propaganda and media reports.[14] That's why we made the journey to Gondo in summer 2018, on the trail of Alpine Mining and more than a few journalists. We began, much like tourists, by photographing the village and its hydroelectric and digital infrastructure. We were given a tour of the village by local authorities and spoke with employees of the Energie Electrique du Simplon SA (EES) electrical power station (which today belongs to the Alpiq Group, a pan-European energy services provider), a small EES shareholder, the community clerk, and a number of people who had moved to or away from the village. We studied old photos of Gondo, rummaged through

11

See, for example, Stefan Zbornik, "Elektronische Märkte in der Schweiz: Die Zeit läuft ab!" *in Management Zeitschrift* 62, no. 1 (1993), pp. 89–94, esp. p. 94.

12

asut, *Datentresor Schweiz*, Basel, 2012. The asut study had already drawn upon similar narratives, stating, for example: "the electricity mix is gaining in importance as a factor in site selection" and "Switzerland, in 9th place [in terms of sustainability] is also well-positioned, thanks to the large share of hydropower in domestic electricity production": ibid., pp. 26–27.

13

See the post from January 23, 2018, https://www.instagram.com/p/BeTPaVzjrwl/ or a similar one from December 29, 2017 (showing a little waterfall): "a source of water offering ecoresponsible electricity" [*sic*], https://www.instagram.com/p/BdSvhn_DXid/ (all retrieved July 3, 2020).

14

On these connections, see also in particular: Nick Lally, Kay Kelly, and Jim Thatcher, "Computational Parasites and Hydropower: A Political Ecology of Bitcoin Mining on the Columbia River," *Environment and Planning E: Nature and Space* (2019). The real and discursive mobilization of "climate" and "water" in the context of the data center industry is currently being subjected to intense examination. See, for example, Patrick Brodie, "Climate Extraction and Supply Chains of Data," *Media, Culture & Society*

Fig. 2
Gas station, Gondo, Valais, summer 2018. (© Hannes Rickli)

documents from the archives of the community and the electrical power station, looked back to the time of the concession agreement in the late 1940s, and leafed through the *Rote Anneliese*, "the critical voice of the Upper Valais," a left-wing newspaper whose critical interventions have escorted the canton's hydroelectric policy since 1973.[15]

Chocolate Coins as a Welcome Present

The distance from Zurich to Gondo is nearly 140 km as the crow flies. Yet the journey to the southern end of the Simplon Pass, to the border village with Italy, takes three-and-a-half hours. By train to Brig. Then by bus on the winding N9 over the Simplon Pass. Past Christian Menn's Ganter Bridge, which to some is a masterpiece of Swiss engineering and to others a memorial to the disfigurement of landscapes: In general, the "winterproof N9, which is part of the national highway network," as journalist Jürg Frischknecht complained in 1987, is "one of the blockiest stretches of road in the Alps, and one which, especially on the north side, soon runs only through avalanche galleries."[16] (The Ganter Bridge itself was opened in 1980 and was perfectly adapted to the sliding slopes by using flexible bearings.)[17] At the top of the pass, the route continues: past the old "hospice" built on Napoleon's orders, past the Simplon artillery range, and past the gigantic eagle from World War II, which commemorates Mountain Brigade 11. And finally in narrow serpentine curves down to the south.

Those who arrive in Gondo have, in a way, reached the end of the road. A smugglers' fountain celebrates the golden age of smuggling between Switzerland and Italy, the story of which is told in the 1936 novel *Joachim bei den Schmugglern*: "The valley is depopulating. The number of livestock and inhabitants is decreasing year by year, and the houses are falling into disrepair. Only a few families are able to survive," people were saying even then.[18] Today there are kiosks, three gas stations, a money exchange, and a few

Fig. 2

15

(2020); on water (as a coolant): Mél Hogan, "Data Flows and Water Woes: The Utah Data Center," *Big Data & Society* 2, no. 2 (2015), pp. 1–15; James Gilmore and Bailey Troutman, "Articulating Infrastructure to Water: Agri-Culture and Google's South Carolina Data Center," *International Journal of Cultural Studies* (2020).

16

Compare the website http://www.roteanneliese.ch/ as well as the retroactively digitized issues from 1974 to 1999 at https://www.e-newspaperarchives.ch. *Rote Anneliese* (a pun on *Analyse*, meaning "analysis"), the in-house magazine of "Kritisches Oberwallis" ("Critical Upper Valais," KO), first appeared in 1973 with an issue on the planned takeover of the Lonza chemicals group by Alusuisse.

17

René Walter, "Bemerkenswerte Spannbetonbrücken," *Schweizerische Bauzeitung* 96, no. 14 (1978), pp. 236–53, esp. p. 237.

houses, 57 percent of which are "second homes."[19] The Pension Bellevue with its café. The Stockalperturm seminar hotel, lavishly restored with Swiss Solidarity funds. And finally, the new community center on the village square built in 2015, surrounded by steep cliffs to the left and right. Several hundred cars and trucks rush past them every day. Since 2017, customs clearance is no longer carried out on site, but in Brig. Even for fresh bread, one has to drive all the way to Simplon Dorf, where the bakery is located. According to population statistics, the municipality has 77 inhabitants.[20] But when you walk through the streets at night, you hardly see any lights in the windows.

In the room where the local council meetings are held, we are welcomed by Paul Fux, a retired electrical engineer, veteran of water management, vice-communal president, and (also) a resident of Brig. On the walls are the coats of arms of long-established families (Escher, Lawiner, Squaratti, and so on). Placed in front of us are folders of documents: "Welcome to Gondo." Inside them are the usual tourist brochures: about the Simplon "Eco-Museum"; about cultural walks in the footsteps of Kaspar von Stockalper, the "Fugger of the Alps"; about trekking tours and kayaking weekends, and about panning for gold in the Zwischbergen Valley, guided by former customs officer Rolf Gruber, who has settled in Gondo. There's also a "Hydropower Excursions" brochure, which refers to the three local power plants, Gondo, Gabi, and Tannuwald, which were commissioned in 1952, 1958, and 1978, respectively.[21] Also included is a flood advisory notice from Hydro-Exploitation addressed to whitewater canoeists and potential gold-panners—it doubled as a voucher for a free visit to the Grande Dixence dam: "Don't risk your life ... CONSTANT DANGER."

And finally, to everyone's delight: a golden chocolate thaler the same size as the chocolate coins issued by the Swiss Heritage Society since 1946 to raise money for the preservation of local heritage and the environment.[22] The front of the thaler flaunted the logo of Alpine Mining: an abstract geometric mountain pattern, in an accentuated start-up look. On the

18

Hans Zullinger, *Joachim bei den Schmugglern. Eine Erzählung aus dem Simplongebiet*, Bern, 1936, p. 9.

19

Bericht zur Verwaltungsrechnung, 2012, p. 19, https://www.gondo.ch/ueber-die-gemeinde/gemeindefinanzen/ (retrieved July 3, 2020).

20

Kantonales Amt für Statistik Wallis, "Ständige Wohnbevölkerung nach Geschlecht, Staatsangehörigkeit und Gemeinde," https://www.vs.ch/de/web/acf/statpop. (retrieved July 3, 2020). The number of inhabitants peaked at 249 in about 1950, dwindling to 171 in 1980, then rapidly returned to late nineteenth century levels: 78 people in 2000, a figure which has remained constant since.

21

Georg Gruner, "Die Staumauer Serra am Grosswasser im Zwischbergental," *Schweizerische Bauzeitung* 71, no. 11 (1953), pp. 159–63; and "Simplon Storage Power Plant" (undated), https://www.alpiq.com/power-generation/hydropower-plants/storage-power-plants/simplon/ (retrieved July 3, 2020).

22

On this, see Madlaina Bundi, "Geld, Gold und Schokolade. Die Anfänge des Schoggitalers," *Heimatschutz/Patromoine* 109, no. 3 (2014), pp. 6–9. See also Madlaina Bundi's licentiate thesis: *Goldene Schokolade. Die Taleraktionen von Heimat- und Naturschutz 1946–1962*, Zurich, 2002.

Fig. 3
1893 "Gondo gold" / Alpine Mining
PR coins.

76

Fig. 3

reverse: the facsimile of a 20-franc coin from 1893. About twenty-five such coins were produced in the mint in Bern at that time, Paul Fux explained to us. These gold coins had been made from real gold—"Gondo gold"—which came from the surrounding mountains. It was excavated and processed by the Société des Mines d'Or d'Helvétie, which brought speculation and electricity and a lot of miners to the village until it went bankrupt again in 1897. After that, the mine shaft and the gold mill fell into disrepair.[23]

Knowingly or not, the PR stunt reflected the "metalism" that is widespread in the crypto scene: the unease with "central banks," with the state in general, the "politicization" of money, and so on.[24] (It is fitting that the Valaisans have the reputation of having always been freedom-loving and on their guard against the "Üsserschwyzer," the German-speaking inhabitants of the rest of Switzerland.) The analogy indeed is intentional: as is in principle the case with precious metals, the "supply" of Bitcoin is also limited (for technical and conceptual reasons). And like gold, Bitcoin, and derivatives, "alt-coins" are "mined." Unlike "fiat currencies," however (to quote the CEO of Alpine Mining),[25] they cannot be issued at will. And either form of "resource" exploitation, or this seemed to be the conceit of the chocolate coins, implies risk-taking, technological adventurism, and a pioneering spirit.

While the story of the brief Swiss gold rush in the late nineteenth century, along with the Alps, for which the company is named, was thus an essential part of Alpine Mining's image—nature, mountains, lakes—the history of modern hydroelectric power did not play a role in the marketing of the start-up. Yet that history also began at almost exactly the time when Gondo experienced its first and real "gold rush," in the 1890s, when it became possible to transport energy via high-voltage lines over long distances into the valley.[26] Subsequently, the large hydroelectric power projects in the Alps, their development as "reservoirs," came into being. Between 1920 and 1960, and particularly after World War II, the Valais Alps were developed on a large scale in terms of hydroelectric engineering. Dams were built, rivers straightened, and power stations built.[27] The driving forces behind these hydroelectric infrastructure projects were the large industrial enterprises set up in the valley from the late nineteenth century: those of the chemical industry (Lonza in Gampel in 1897, CIBA in Monthey in 1904) and the metal industry (Alusuisse in Chippis in 1908, which required large quantities of electricity for smelting aluminum).[28]

The "potential for hydrological expansion" in the Alps was soon considered "exhausted," however, and the construction of hydropower plants deemed unprofitable.[29] While nearly 100 percent of Switzerland's electricity was generated by hydroelectric power until about

23

Bärtschi 1996.

24

"Metalism," in turn, would be the notion that "money" ultimately reflects, or should reflect, the value of some commodity's market price rather than being determined by states, central banks, or the like. On this, see, for example, Zac Zimmer, "Bitcoin and Potosí Silver," *Technology and Culture* 58, no. 2 (2017), pp. 307–34; Lana Swartz, "What Was Bitcoin, What Will It Be? The Techno-Economic Imaginaries of a New Money Technology," *Cultural Studies* 32, no. 4 (2018), pp. 623–50; Stefan Eich, "Old Utopias,

New Tax Havens: The Politics of Bitcoin in Historical Perspective," in *Regulating Blockchain: Techno-Social and Legal Challenges*, edited by Ioannis Lianos, Philipp Hacker, Stefan Eich, and Georgios Dimitropoulos, Oxford, 2019, pp. 85–98.

25

Rick Nassar, "Is Crypto Mining Still Profitable? Alpinemining from Switzerland Thinks So," *Irish Tech News* (December 29, 2017), https://irishtechnews.ie/is-crypto-mining-still-profitable-alpinemining-from-switzerland-thinks-so/ (retrieved July 3, 2020).

| Fig. 4 |
Gondo Zentrale power plant,
corridor, summer 2018.
(© Monika Dommann)

| Fig. 4 |

1970, nuclear energy had long come to be seen as the energy of the future—even at Gondo Zentrale we came across an old brochure in the small archive that proclaimed exactly this: "L'énergie nucléaire est la solution de l'avenir."[30] Since then, Swiss electricity consumption has risen steadily—increasing six-fold between 1950 and 2010—and the share of hydropower in total generation has fallen steadily, to around 56 percent.[31] Then in May 2011, two months after the reactor accident at Fukushima, the Federal Council (with a female majority) announced Switzerland's withdrawal from nuclear energy. How this phase-out is to proceed, and what role hydroelectric power and alternative solar and wind energy are to play in it, is one of the most important and politically controversial issues of the present, particularly in Valais.[32]

 Meanwhile, on site in Gondo, an air of timelessness hovers over the power plants and reservoirs, as well as a hint of stolidity. This certainly was the impression gained during the first stop of our little tour organized by the villagers in the summer of 2018—during our visit to the Gondo Zentrale power plant, now operated by service provider Hydro-Exploitation, which provides the maintenance personnel. The heavy turbines seemed to date from the founding period of the power plant in the 1950s. The company names on the plaques on the turbines—Sécheron, Vevey, etc.—similarly

26

See, for example, William Weicker, "Zur Geschichte des Freileitungsisolators," in *Geschichtliche Einzeldarstellungen aus der Elektrotechnik*, vol. III, Berlin, 1932. For further details, see David Gugerli, *Redeströme. Zur Elektrifizierung der Schweiz 1880–1914*, Zurich, 1996, chapter 6.

27

See, for example, Damir Skenderovic, "Die Umweltschutzbewegung im Spannungsfeld der 50er Jahre," in *achtung: die 50er Jahre! Annäherungen an eine widersprüchliche Zeit*, edited by Jean-Daniel Blanc and Christine Luchsinger, Zurich, 1994, pp. 119–46; more generally: Marc D. Landry II, *Europe's Battery: The Making of the Alpine Energy Landscape, 1870–1955*, PhD dissertation, Georgetown University, 2013. Such projects met with local resistance almost immediately, as Skenderovic points out. On this, see also, for example, Erich Haag, *Grenzen der Technik. Der Widerstand gegen das Kraftwerkprojekt Urseren*, Zurich, 2004.

28

See, for example, Beat Kaufmann, *Die Entwicklung des Wallis vom Agrarzum Industriekanton*, Zurich, 1965.

29

For example, *Landschaftsschutz in der Schweiz 1982. Tätigkeit der SL* [Schweizerische Stiftung für Landschaftsschutz], Bern, 1982, p. 5; Patrick Kupper, *Atomenergie und gespaltene Gesellschaft. Die Geschichte des gescheiterten Projektes Kernkraftwerk Kaiseraugst*, Zurich, 2003, p. 53.

30

Énergie Nucléaire S.A., *Une contribution romande à l'étude de l'utilisation de l'énergie nucléaire*, Lausanne, 1958, preface, Archiv Zentrale Gondo.

31

Bundesamt für Energie, *Ausbaupotential der Wasserkraft*, Bern, 2004, p. 34.

32

This raised hopes in Gondo because, in the words of mayor Roland Squaratti, a "shortage of electricity" was feared, which would necessarily have to be made up for by hydroelectric power—"but this will require rethinking on a massive scale." See Roland Squaratti, "Gondo-Zwischbergen und die EES," 2011.

evoked tradition, the long history of Swiss mechanical engineering; in the side rooms, we discovered discarded insulators, antique measuring equipment, a shelf with dusty books: *L'épopée des barrages, Power Stations of Europe, Volume 1, Énergie Ouest Suisse, 1919–1944*, and so on. On the walls were black-and-white photographs from 1952, when the plant was connected to the grid: men posing in front of consoles in the control room. But appearances are deceptive. The turbines had only recently been replaced, and the old turbines from the 1950s had been shipped to Tanzania. The deserted command center and the digital gauges, some of them with IP addresses, with which the power plant had recently been outfitted, also belied the image of timelessness. The plant has been running "automatically" since 2016 and it's controlled from headquarters in Lausanne, the power plant employee told us.

| Fig. 5 |

This streamlining of the operation and maintenance of the power plant (renewal of the turbines, automation of the control system, and construction of the new Sera Dam in 2011) has led to a massive reduction in production costs, increased the efficiency of the power plant (more electricity for the same amount of water), and improved grid integration and stability.[33] These were obviously necessary investments, not least because European electricity prices had been in the doldrums for years—a *mauvaise conjoncture*, as the EES annual reports stated, below production costs.[34] "Wholesale prices," it was also stated at the inauguration of the new headquarters in September 2017, "remain below the production cost of hydropower."[35]

Mining in the Garage

We drove to the second stop of our little tour, the new Sera Dam, which was inaugurated in 2011. As local news reported, this was the first "new construction of a dam in Switzerland since 1989." The cost was 8.4 million francs.[36] The new Sera Dam was built by building contractor Werner Zenklusen, the mayor of the neighboring village of Simplon Dorf. Paul Fux explained the workings of the dam to us, we were awed by the engineering skills; and by the side of the road, we were once again handed flood warning leaflets, this time by two students as part of their summer job with Hydro-Exploitation. What we didn't know at the time was that the original plan was to build a new pumped-storage power station further up the mountain, not to cover the

33

Cf. "Inauguration of the Modernised Gondo Hydropower Plant in the Simplon Region," Alpiq media release (September 13, 2017), https://www.alpiq.com/alpiq-group/media-relations/media-releases/media-release-detail/inauguration-of-the-modernised-gondo-hydropower-plant-in-the-simplon-region/ (retrieved July 3, 2020). Production costs were able to be reduced from CHF 0.065 to 0.038 per kilowatt-hour.

Milliarde-Verlust-vor; Hansueli Schöchli, "Pikante Studie zur Wasserkraft," *Neue Zürcher Zeitung* (October 30, 2017), https://www.nzz.ch/schweiz/pikante-studie-zur-wasserkraft-ld.1325085 (all retrieved July 3, 2020).

34

(Cf. "Aktennotiz in Sachen EES," e-mail from Peter Bodenmann of May 15, 2020.)

36

"Eine Staumauer ist der Inbegriff der Wasserkraft," *Walliser Bote* (August 20, 2011), p. 5.

35

Énergie Électrique du Simplon SA, *Rapport Annuel 2015*, Brig, 2016, p. 5.

35

"Inauguration of the Modernised Gondo Hydropower Plant," 2017. Wholesale prices have somewhat recovered since. Note that these questions—such as the actual magnitude of production costs, the rentability of hydropower, and so on—are rather controversial. See e.g. Kurt Marti, "Die Strombranche gaukelte eine Milliarde Verlust vor," *Infosperber* (April 27, 2018), https://www.infosperber.ch/Umwelt/Strombranche-gaukelte-eine-

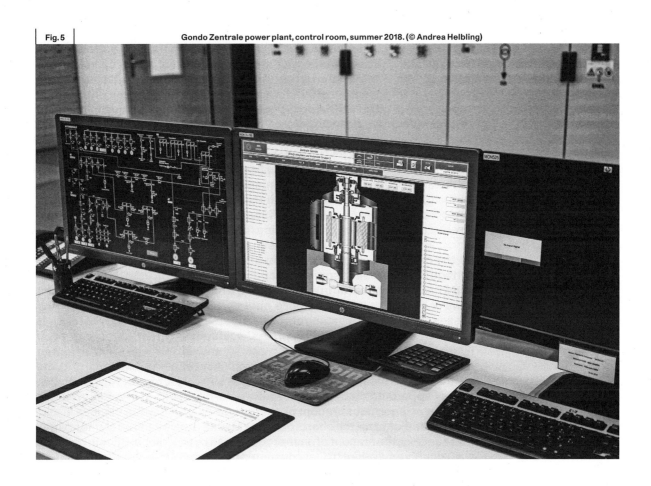

Fig. 5 · Gondo Zentrale power plant, control room, summer 2018. (© Andrea Helbling)

demand for electricity, but to arbitrage—to "refine cheap European electricity from nuclear and coal-fired power stations," as critical voices complained.[37] Not only that: in this scenario, the adjacent Laggintal valley, which had been included in the Inventory of Landscapes and Natural Monuments of National Importance (KLN) in 1979—for its "magnificent scenery and also for its botanical and faunal significance"—would have been partially flooded (by another 85-meter-high dam).[38] It did not come to that. (The village community was compensated accordingly.)[39] The fact that the disputes surrounding the waters of Gondo and the adjacent valleys actually go back decades is something we weren't aware of at the time. Nor did we imagine that further down in Domodossola, on the other side of the border with Italy, people were currently mobilizing against a new high-voltage line, the Interconnectore—an "extra-high-voltage direct-current connection" extending from Milan up into Switzerland.[40]

We had seen only one transformer station, further up the mountain—the next stop on our sightseeing tour—where the high-voltage lines (as well as some fiber optic cables) come in from Italy and go out to Switzerland. It buzzed in a monotone in front of us as we photographed the rows of insulators with our mobile phones. But the thought that virtual processes are handled by means of or via these material infrastructures, namely electricity trading, fluctuating prices, adjusted in fifteen-minute or even five-minute intervals, then didn't cross our minds. Nor was the truism that "Gondo" is but one element in a highly complex system—the electrical grid, the "mother of all critical infrastructures," as the industry is fond of saying—immediately apparent.[41] Even the fact that the "production" of cryptocurrencies requires an enormous amount of energy was only somewhat obvious in mid-2018 (hence, after all, the efforts of Alpine Mining to give itself an alpine image): that summer, the amount of energy consumed by the "global Bitcoin network" was roughly equivalent to that consumed by London. However, the true extent became apparent, or scandalized, only as the year progressed. By the end of the year, that amount of energy would nearly double again.[42] Only gradually did these elements coalesce into a single picture: attracted by media reports about a digital future for mountain regions, the deeper we drilled, the more we were confronted with rather traditional conflicts over resources. Indeed, on the basis of our discussions with community representatives and from reading

37

Kurt Marti, "SPO will Naturschutzgebiet unter Wasser setzen!" Rote Anneliese, no. 203 (2008), pp. 4–5, esp. p. 4.

38

Ibid., p. 4; Landschaftsschutz in der Schweiz 1982, 1982, p. 14; see also Bericht zur Verwaltungsrechnung, 2012, p. 24, https://www.gondo.ch/ueber-die-gemeinde/gemeindefinanzen/ (retrieved July 3, 2020).

39

Bericht zur Verwaltungsrechnung, 2013, p. 18, https://www.gondo.ch/ueber-die-gemeinde/gemeindefinanzen/. However, the envisioned Simplon Nature Park did not materialize either; see "Gondo: Nein zum Naturpark-Projekt aufgrund energiepolitischer Aspekte," radio rottu oberwallis (April 18, 2012), http://www.rro.ch/cms/gondo-nein-zum-naturpark-projekt-aufgrund-energiepolitischer-aspekte-54202. (all retrieved July 3, 2020).

40

CIPRA, "Strom frisst Landschaft," July 4, 2018, https://www.cipra.org/de/news/strom-frisst-landschaft; Terna, "380 kV Italy-Switzerland Interconnector," undated, https://www.terna.it/en/projects/public-engagement/interconnector-italy-switzerland.

41

Maik Neubauer, Das Europäische Hochspannungsnetz. Die Zukunft von Big Data und künstlicher Intelligenz in kritischen Infrastrukturen, Wiesbaden, 2020, p. 726.

42

See, for example, Christopher Schrader, "Bitcoin-Produktion verbraucht mehr Strom als die ganze Schweiz," Tagesanzeiger (November 12, 2018), https://www.tagesanzeiger.ch/digital/bitcoinproduktion-verbraucht-mehr-strom-als-die-ganze-schweiz/story/10669793 (retrieved July 3, 2020); Camilo Mora et al, "Bitcoin Emissions Alone Could Push Global Warming above 2° C," Nature Climate Change 8 (November 2018), pp. 931–33; "Mining Their Own Business," The Economist (February 9, 2019), p. 73; and Christian Stoll et al, "The Carbon Footprint of Bitcoin," Joule 3, no. 7 (2019), pp. 1647–61.

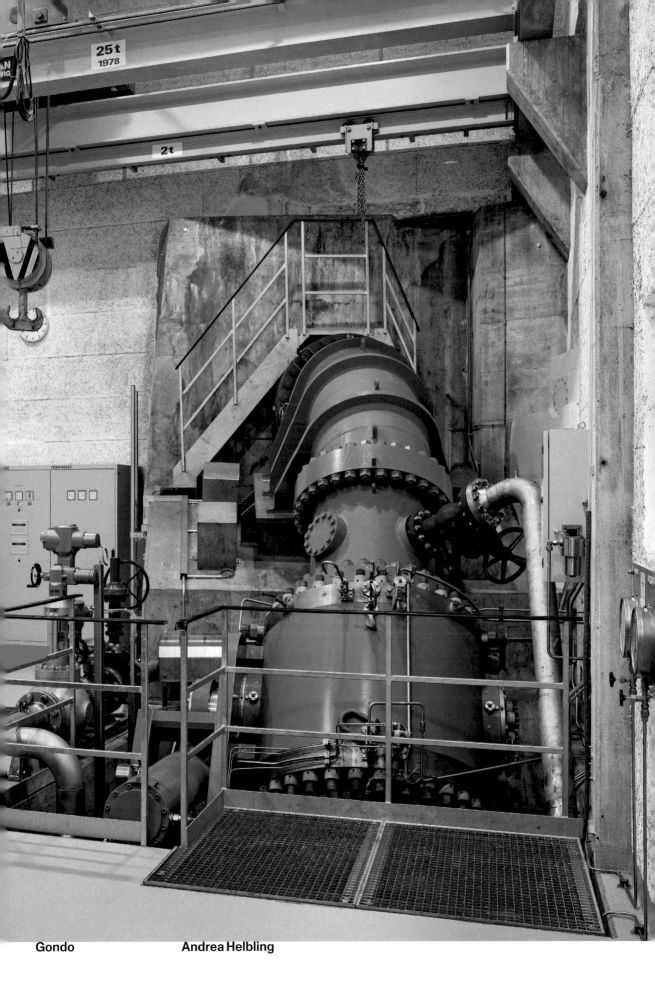

Gondo Andrea Helbling

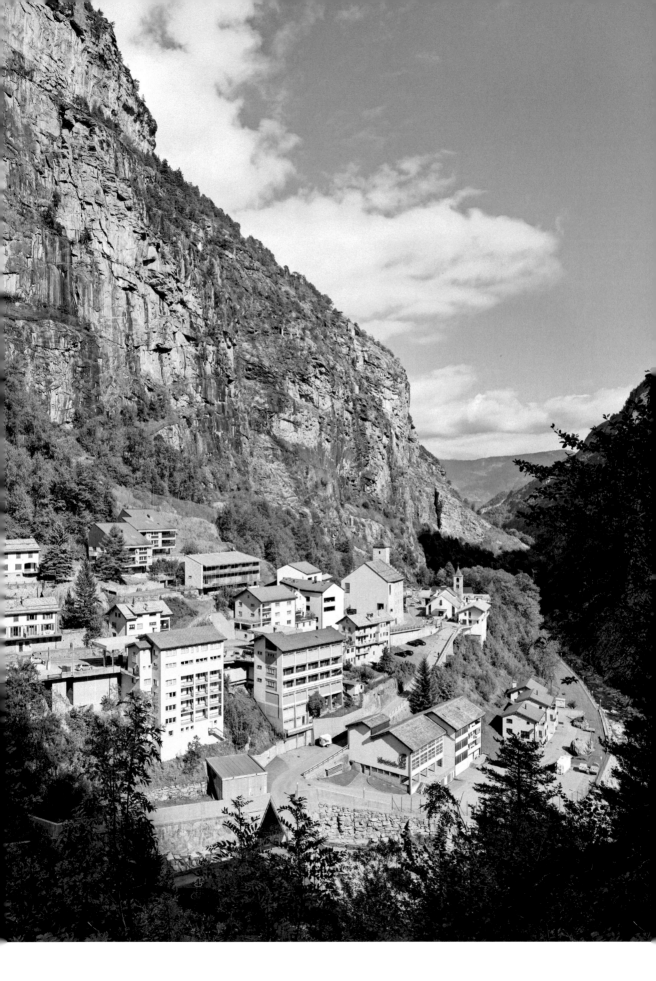

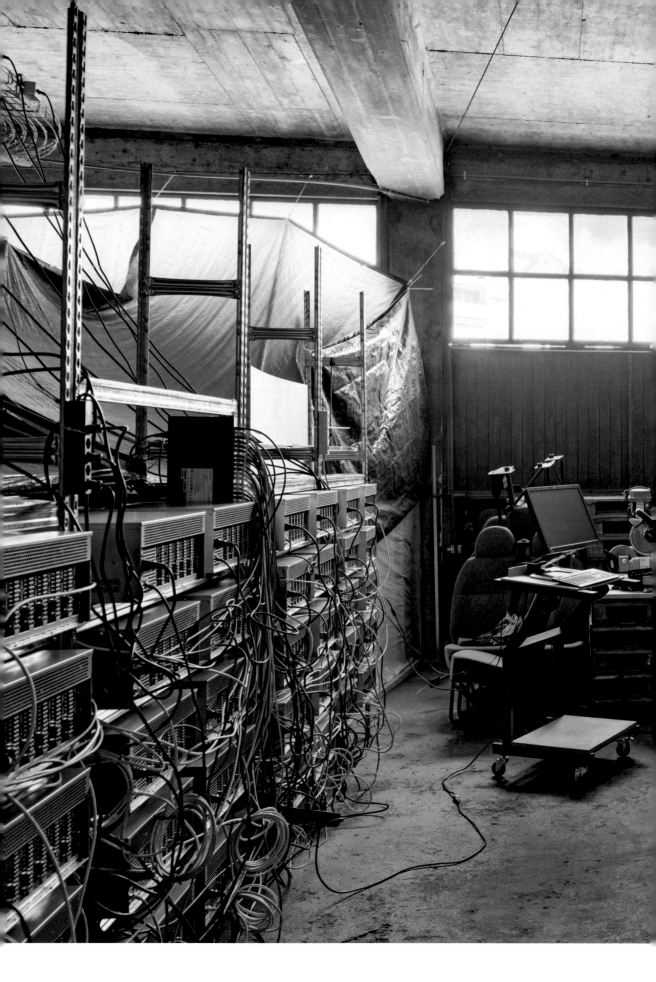

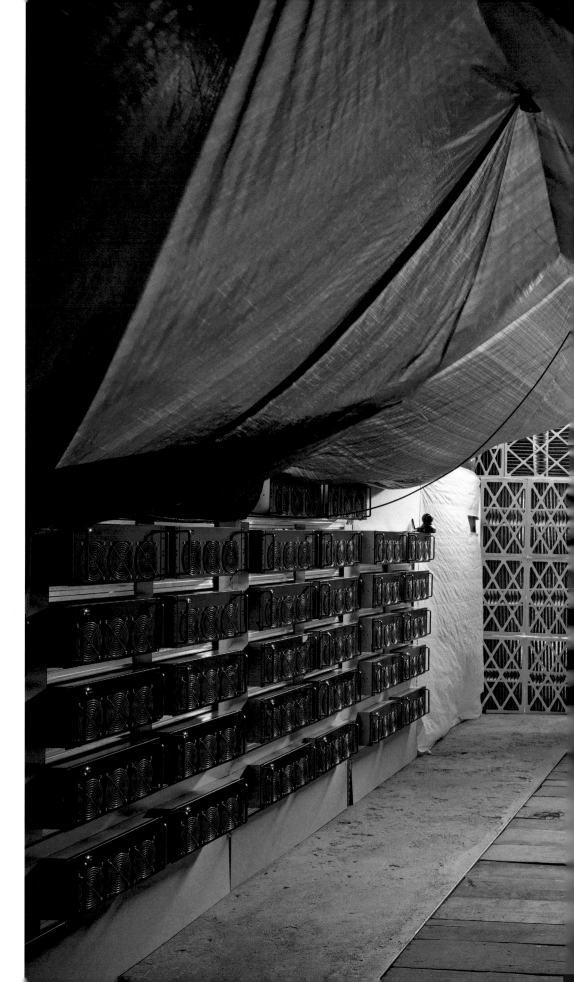

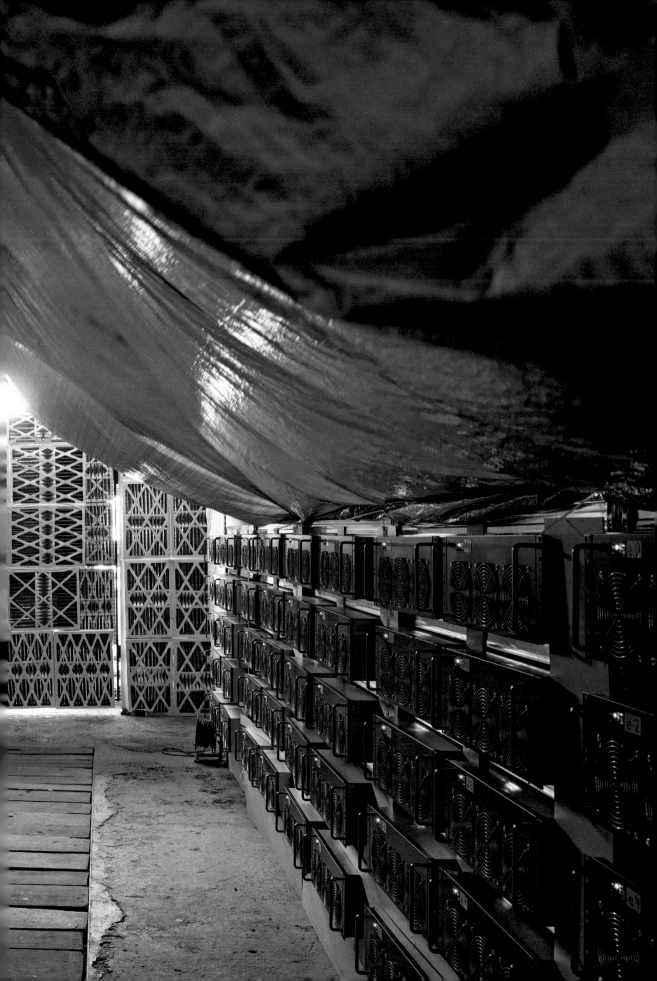

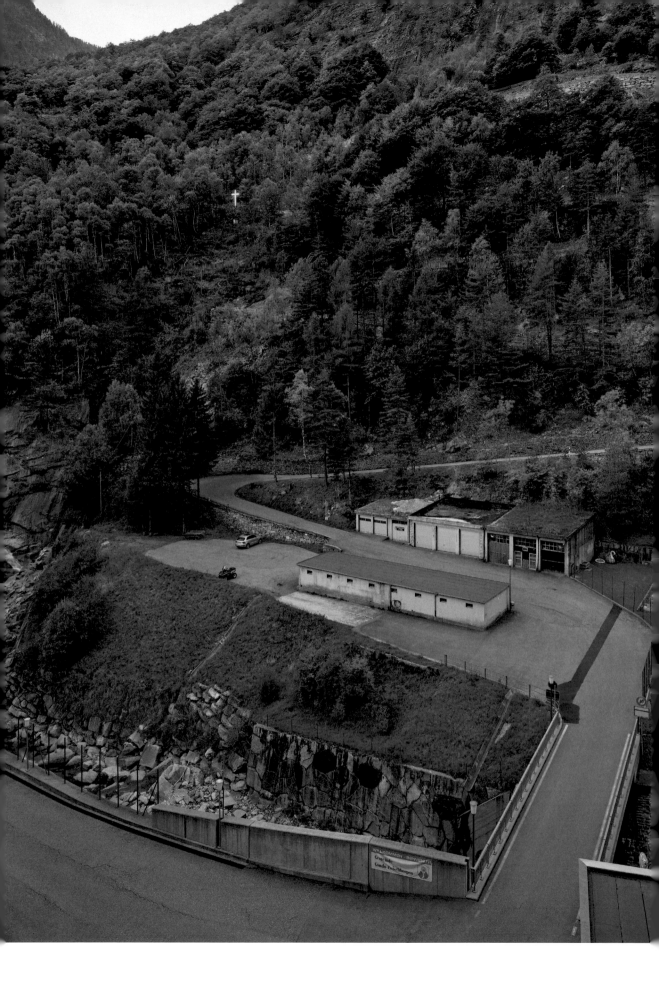

media reports, it had seemed evident from the start that the failure of the high-flying plans of Alpine Mining had in some way been due to the (not so benign) alpine environment, namely the avalanche or hazard zoning in the village.[43] After all, the whole village is wedged between the mountains and even the power station was built into the rock, as noted to us by Peter Seiler, whose family comes from the neighboring village of Simplon Dorf and who as a child had served as an altar boy in the churches of Gondo and Simplon Dorf in the summer. Although Mayor Squaratti already had envisioned a 500-square-meter "hall," according to the *Neue Zürcher Zeitung*, no building permit could be obtained for it, despite (or because of) the fact that since late 2017 "half a dozen cantonal offices" and a federal office had been working on the project. The preliminary assessment for rezoning ran aground in spring 2018.[44] Moreover, the capacity of the local substation was already exhausted; another one would have to be procured for several hundred thousand Swiss francs. But even that would take some time. The CEO of Swiss Alpine Mining expressed his displeasure in the media: "We're not prepared to wait six to eight months for a new transformer."[45]

Bad prospects, in other words, despite the favorable climate, for Alpine Mining and all other potentially interested crypto-mining companies in Gondo. In part, this is simply because a blockchain system ultimately consists of a collection of very, very many dedicated computers, which means that it requires not only power, but also space. Nearly 900 graphics cards or graphics processing units (GPUs) were in use in Gondo, which was rather rather modest.[46] Larger installations, such as those found in Mongolia or China's Sichuan province, where the majority of global "hash power" is concentrated—"industry" observers estimated in late 2018 that about 60 percent of all miners were (and still are) located there[47]—easily comprise tens of thousands of dedicated computers, typically so-called ASICs: Application-Specific Integrated Circuits. The hardware-related escalation in the field is of relatively

43

The proliferation of "conflicts of use" in connection with hazard zoning, zones where construction is prohibited, etc., has intensified in recent decades, fueled by increased awareness of "anthropogenic hazard potential." See, for example, Hans Kienholz, "Naturgefahren: Eine zunehmende Bedrohung?" in *Umbruch im Berggebiet. Die Entwicklung des schweizerischen Berggebietes zwischen Eigenständigkeit

und Abhängigkeit aus ökonomischer und ökologischer Sicht, edited by Ernst A. Brugger, Gerhard Furrer, Bruno Messerli, and Paul Messerli, Bern, 1984, pp. 563–88, esp. p. 585.

44

Stalder 2018; "Alpine Mining expandiert von Gondo nach Jokkmokk am Polarkreis," *1815.ch* (June 13, 2018), https://www.1815.ch/news/wallis/aktuell/alpine-mining/ (retrieved July 3, 2020).

45

"Cryptocurrency Miners Help Keep Tiny Swiss Village Alive," *Bitcoinist* (March 29, 2018), https://bitcoinist.com/cryptocurrency-miners-help-keep-tiny-swiss-village-alive/ (retrieved July 3, 2020).

46

Hardy 2019.

47

Christopher Bendiksen et al, *The Bitcoin Mining Network: Trends, Marginal Creation Costs, Electricity Consumption & Sources*, Coin-Shares Research (November 2018), p. 10. The number remained nearly constant; in late 2019, according to CoinShares Research, it was about 65 percent; see Christopher Bendiksen et al., *The Bitcoin Mining Network: Trends, Marginal Creation Costs, Electricity Consumption & Sources*, CoinShares Research

(December 2019), p. 9. Prior to that, that is, from 2008, when Bitcoin first saw the light of day, until the early 2010s, Bitcoin mining had still been a kind of hobby. (Back then, it was pretty much still possible to mine Bitcoin on a laptop.)

Fig. 6
"Crypto-mine," Gondo, interior view,
summer 2018. (© Max Stadler)

Fig. 6

recent origin. Around 2014, according to the scene's self-historization, the "industrial era" of Bitcoin production set in;[48] around 2014, this somewhat curious hobby had turned into a relatively capital- and know-how-intensive "industry." Why? Because the "mining" of Bitcoin and similar digital currencies is in principle based on making computationally and thus energy-intensive calculations in order to validate transactions. "Proof of work" is the name of the principle that was published in a white paper by the notoriously elusive figure of Satoshi Nakamoto in 2008.[49] The operator of a mine receives a kind of "reward" in the form of Bitcoin. The business model of "miners" is based on this, and because these calculations become more difficult, i.e. more computationally intensive, the more computers participate in this game (while the "reward" decreases), the more hardware or "hash power" has to be deployed.

 What we encountered in Gondo in the summer of 2018, in a disused garage and in the community's civil defense facility, was thus a kind of intermediate stage. Not a hobby anymore, not quite an "industry" yet: a dark shed, bluishly lit by the LEDs; along the walls there were still tools left by the previous user, and boxes with Chinese characters, from which Ethernet cables and other accessories protruded. In the middle: the improvised cooling system, an oversized fan, plus plastic sheeting draped around racks that were equipped with GPUs from Sapphire or AMD / Radeon. A frog had strayed into the cooling water. The Alpine Mining employee who was showing us around the garage was a bit skeptical and replied only hesitantly when asked when he had moved to Gondo: two months ago.[50]

 In other words, the blockchain installation in the disused garage was far from what would have been state of the art at the time.[51] But Alpine Mining was already working toward this goal. In mid-May 2018, Alpine Mining announced that although it would not be leaving Gondo, it would henceforth be focusing on a project in Sweden: "an international project of considerable magnitude."[52] The plan was to build a much, much larger data

48

Bendiksen et al, 2019, p. 2.

49

Satoshi Nakamoto, "Bitcoin: A Peer-to-Peer Electronic Cash System" (2008), https://bitcoin.org/bitcoin.pdf (retrieved February 1, 2020).

50

Officially, in 2017, the year Alpine Mining set up shop in Gondo, five newcomers were registered in Gondo. Five others left, none were born, and one person died. *Bericht zur Verwaltungsrechnung*, 2017, p. 12, https://www.gondo.ch/ueber-die-gemeinde/gemeindefinanzen/ (retrieved July 3, 2020).

51

To put this in perspective: whereas the facility in Valais drew about as much energy as the rest of the village, some "mines" today require as much electricity as a medium-sized town, or more. Indeed, at the time of our visit in the summer of 2018, a much larger facility was being built in Rapperswil-Jona, near Zurich, on a 3,000-square-meter site. See Demelza Hays, "Cryptocurrency Mining in Theory and Practice," *Crypto Research* (April 30, 2019),

52

https://cryptoresearch.report/crypto-research/cryptocurrency-mining-in-theory-and-practice/ (retrieved July 3, 2020).

53

"First Steps in Sweden," May 14, 2018, https://www.instagram.com/p/BixTCnLAMPH/ (retrieved July 3, 2020).

53

Many other data centers (Facebook's among them) were already located there, attracted by tax breaks, subsidies, lower electricity prices, etc. On this, see Asta Vonderau, "Scaling the Cloud: Making State and Infrastructure in Sweden," *Ethnos: Journal of Anthropology* 84, no. 4 (2019), pp. 698–718.

54

"Alpine Mining Becomes Alpine Tech!" March 20, 2019, https://www.instagram.com/p/BvObR_nAJI_/ (retrieved July 3, 2020).

center in the far north, not far from the "Node Pole."[53] And indeed, by mid-2018, Alpine Mining could be seen setting up a much larger "crypto-mine" on behalf of the Hong Kong-based "blockchain infrastructure" provider Diginex. Reportedly, this other, rather more professional-looking computing center cost 30 million dollars. And it involved not a few hundred GPUs, but tens of thousands, with Alpine Mining—soon duly rebranded as Alpine Tech[54]—reinventing itself in the process as a supplier of know-how in matters of managing large-scale, decentralized high-performance computing (HPC) installations.[55]

When we arrived in Gondo in the summer of 2018, the entire episode, in a way, thus had already run its course: the young entrepreneurs, the CEO, CTO, and whatever their titles were—the people who were supposed to revive the village—we never saw them ourselves, except for the one young man who was maintaining the facility. We only heard about them as rumors. They were said to be in Sweden. Or: the CEO had been spotted recently in the village square. A quick look at Instagram, meanwhile, revealed the young start-up's shift to the far north: where idyllic waters, dams, and plummeting streams in and around Gondo were once featured, heavy equipment in sub-Arctic terrain was now on view.[56] The crypto gold rush in Gondo was thus only short-lived.

In the Clutches of Hydroelectric Power

Unlike what Alpine Mining insinuates in its Instagram posts, the "natural environment" surrounding the Simplon site is anything but untouched. For centuries, temporary facilities and long-term infrastructures have been piling up there. In the "Eco-Museum" in Simplon Dorf, one can even trace the history of this superimposition of infrastructures, which dates back to the early modern era—the museum was set up (for this very purpose) in the late 1980s by folklorist Klaus Anderegg on behalf of the Swiss Agency for the Environment, Forests and Landscape (BUWAL).[57] In the seventeenth century, the Stockalperweg—transit entrepreneur and paymaster Kaspar von Stockalper's route over the Simplon Pass—served to transport salt, lead, gold, coal, and other resources and goods across the Alps; Napoleon's troops later marched across the Alps there.[58] The modern village of Gondo also owes its existence to this transit road; traditionally, the inhabitants of the Zwischbergen Valley were farmers.[59] The old gold mill from the nineteenth century, whose surroundings are still contaminated with mercury due to the amalgamation process used to extract gold, also bears testimony to a landscape that has been plundered since early modern times for the purpose of extracting raw materials.[60]

| Fig. 7 |

55

This was, in fact, quite a typical move for mine operators in the post-2018 crypto-depression: surviving players, such as Northern Bitcoin (turned "Northern Data"), soon refashioned themselves as "expert" providers of solutions, tending to an expansive, somewhat anarchically sprawling "high-performance" machine park. See, for example, https://northerndata.de/ (retrieved July 3, 2020).

56

See, for example, "How Do You Find Landscapes in #Sweden?" July 2, 2018, https://www.instagram.com/p/BkvIOf2gNgi/ (retrieved July 3, 2020).

57

On this, see Klaus Anderegg, "'Heimat' erfahrbar machen: Das Ecomuseum Simplon," *NIKE-Bulletin* 18, no. 2–3 (2003), pp. 4–11; and Niki Rhyner and Max Stadler, "Umbruch," in *cache 01: Gegenwissen*, Zurich, 2020.

58

Klaus Aerni, "Der Simplon als alpiner Lebensraum in Vergangenheit, Gegenwart und Zukunft," *Minaria Helvetica*, no. 16b (1996), pp. 3–22.

Fig. 7
1890s remains: gold mill piping.
From a report by Hans Peter
Bärtschi on industrial archaeology,
1995. (© ETH-Bibliothek Zürich,
Bildarchiv / Hans-Peter Bärtschi /
SIK_01-043919 / CC BY-SA 4.0)

Meanwhile, the opening of the Simplon Tunnel in 1906, then the longest railway tunnel in the world, would contribute to the plight of the small village of Gondo and the Zwischbergen Valley, because it diverted the traffic over the pass into the mountainous underground.[61] During World War II, a border fortification was built which gave the village not only that gigantic eagle monument, but also its first telephone line.[62] (There is still a military training area at the pass, which has been a cause for concern for a long time and recently as well, because "several tank howitzer target areas are located within a nationally protected landscape.")[63]

Finally, the construction of the N9 national highway from 1957 onward,[64] an infrastructure project intended to better connect the peripheral region to the rest of Switzerland, brought in trucks and motorized tourists and was thus a major encroachment on the surrounding area. The colossal Ganter Bridge mentioned above was completed in 1980. Since 2013, a new fiber optic cable also runs along the national highway, "connecting the buildings in Gondo" as well.[65]

The brief "crypto boom" in the small Valais mountain village in the early twenty-first century was in other words built upon old infrastructures and the interweaving of nature and technology, including the problems and tensions and conflicts over resources that went hand in hand with that—and will go hand in hand with it, because these will not diminish in the foreseeable future. On the contrary. The glaciers are already retreating—there are four in the territory of Gondo/Simplon that feed the plants: Rossboden, Hohmatta, Laggin, Holutrift.[66] And there is more change to come. The Swiss Water Management Association knows about these things: over the next few decades, climate change will noticeably shift, or flatten, "pumping profiles," for example (as things are and were, peak production is in summer); it'll create hundreds of new lakes, silt up others, and drive up maintenance costs (already clocking up an estimated 500 million Swiss francs annually).[67]

In order to understand the recent, supposed elective affinity of hydroelectricity and digital technology in the Zwischbergen Valley, the history of hydroelectric power use must be examined more closely, then, right up to the question of how energy policy will be shaped after the transition to new sources of energy. Water management in the Alps has always capital-

59

Conversation with Elisabeth Joris and Peter Seiler, May 1, 2020.

60

Bärtschi 1996.

61

Aerni 1958, p. 12.

62

"Ein Schweizer Tal stirbt aus," *Tages-anzeiger für Stadt und Kanton Zürich* (December 3, 1949), Folder "Historique du Simplon," Archiv Zentrale Gondo.

63

Mountain Wilderness, "Kein Aufrüsten auf dem Simplonpass," press release (July 15, 2019), https:// mountainwilderness.ch/fileadmin/ user_upload/Dokumente/Medien/ Medienmitteilungen/2019/190 715_Simplon_MW_MM.pdf. "The army's presence is very important for the revival of the village and for its commercial enterprises," as people in Gondo emphasize to the contrary. See *Bericht zur Verwaltungsrechnung*, 2016, p. 13, https://www.gondo.ch/ueber-die-gemeinde/gemeindefinanzen/ (retrieved July 3, 2020).

64

Aerni 1958, p. 12.

65

Bericht zur Verwaltungsrechnung, 2012, p. 17, https://www.gondo. ch/ueber-die-gemeinde/ gemeindefinanzen/ (retrieved July 3, 2020).

66

Benedict Vuilleumier and Christine Neff, *Verkannte Gletscher. Gletscherschwund in der Wahrnehmung der Schweizer Gletschergemeinden*, Bern, 2008, p. 34. In 2008, Gondo's then community clerk lamented that "the glaciers and their imminent loss" weren't much of a concern to locals (yet): ibid.

Fig. 8

ized on the topographical gradient of the waters, where streams thunder from the heights of the mountains into the depths of the valleys.[68] With the construction of the Klöntalsee, the first modern dam in Switzerland, in 1910, a new phase in the use of hydropower in the Alps began. The construction and maintenance of these major infrastructure projects were capital-intensive, mostly driven by the towns and industrial sites in the valleys, and financed (as in Gondo) by private-sector players or in partnership with the cantons. The canton of Valais was already a leader in the production of hydroelectric power in the 1920s, far ahead of other major producers such as the cantons of Bern, Graubünden, or Ticino.[69] This led to the creation of novel nature-technology hybrids which have drastically and lastingly changed the landscape, people's interactions, and the economy between the mountain and valley communities and between the Alpine and urban cantons. (In the 1950s, Switzerland led Europe in per-capita consumption of cement.)[70]

This also applies to the power plant in Gondo-Zwischbergen, a medium-sized power plant that is part of a larger complex in the Simplon region that collects the inflows in the south of the Simplon. Engineered and built by Énergie Électrique du Simplon (EES), which was founded in 1947, the plant was commissioned in 1952. Since 1969 it has been majority-owned by Énergie Ouest Suisse (EOS),[71] which was acquired by Alpiq Holding in 2009.[72]

The construction and operation of the power plant in Gondo and the related issues of expropriation and maintenance were regulated in a concession agreement between the municipal and civic community of Zwischbergen and Énergie Électrique du Simplon (EES) on March 8, 1947.[73] The EES joint stock company was founded by Geneva's banking circles, which brought the capital, the engineering know-how and also the vision of hydropower utilization to the Zwischbergen Valley. The concession contract was signed by the mayor and the community clerk; one month earlier, the Zwischbergen community assembly had approved the contract. These concession

67

Roger Pfammatter, "Situation und Perspektiven der Schweizer Wasserkraft," Referat Energie-Apéro Schwyz (Schweizerischer Wasserwirtschaftsverband) (April 2018), pp. 12–14; see also e.g. Astrid Björnsen Gurung and Manfred Stähli, *Wasserressourcen der Schweiz: Dargebot und Nutzung – heute und morgen. Thematische Synthese 1 im Rahmen des Nationalen Forschungsprogramms NFP 61 "Nachhaltige Wassernutzung,"* Bern, 2014.

68

Since the mid-nineteenth century, small and medium-sized power stations have been built on the rivers of the Central Plateau to supply the factories. In the 1890s, during what was called the Second Industrial Revolution, the era of large-scale power plants began. These used larger volumes of water, took advantage of the steeper gradients in the mountains, and distributed energy across power lines.

69

Cf. Schweizerischer Wasserwirtschaftsverband, ed., *Führer durch die schweizerische Wasserwirtschaft,* Zurich, 1921.

70

Skenderovic 1994, p. 122.

71

The other shareholders were, with equal shares: ATEL, Alusuisse, Lonza. See "Prospekt. Énergie Électrique du Simplon (EES). Simplon Dorf. 5 ¼ Anleihe 1972," Swiss Federal Archives E8170D-01#1996/50#242*.

72

"Atel and EOS become ALPIQ," press release (December 19, 2018), https://www.alpiq.com/alpiq-group/media-relations/media-releases/media-release-detail/atel-and-eos-become-alpiq/. Alpiq now holds some 80 percent of EES shares and (despite its Alpine name) is involved in power stations (nuclear, fossil, wind, solar) throughout Europe—including in Hungary, Norway, Italy, and the Czech Republic; it also operates in such sectors as "Digital & Commerce" (electricity trading), "Industrial Engineering," and "Building Technology & Design." See https://www.alpiq.com/ (all retrieved July 3, 2020).

73

Konzessionsvertrag von Josef Escher (Notar in Brig) zwischen André Koechlin und Fernand Dominice, beide wohnhaft in Genf, für die in Gründung befindliche Énergie Électrique du Simplon (EES) und Anton Jordan (Gemeindepräsident) und Moritz Lauwiner (Gemeindeschreiber) handelnd für Munizipal- & Bürgergemeinde Zwischbergen, 2. März 1947, Archiv Zentrale Gondo.

Fig. 8　Gondo, Zwischbergenbach, postcard, July 29, 1921. (© ETH-Bibliothek Zürich,
Bildarchiv / Frères Jullien / Fel_000570-RE / Public Domain Mark)

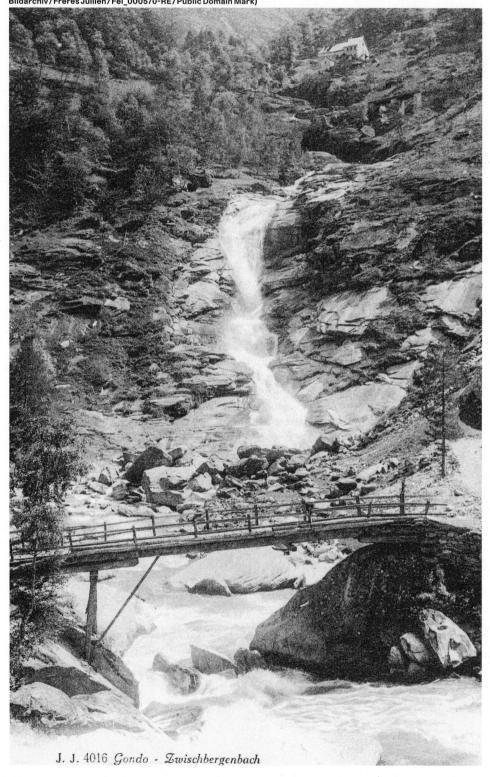

J. J. 4016 *Gondo - Zwischbergenbach*

contracts are an interesting type of historical document because, in addition to shedding light on the rights and obligations, they also reveal the power structure within such large-scale infrastructure projects.

The duration of the concession was set at eighty years, as is customary in Valais, and it has been renewed several times since.[74] EES had the right to dam the water; the uncultivated land that was used was made available to EES free of charge. The owners were compensated for the cultivated land. The community received a one-time compensation of 50,000 Swiss francs. EES paid the community an annual water tax for the right to generate hydropower. It was agreed that the distribution of the water tax between Simplon Dorf and Zwischbergen should be determined "through expertise."[75]

It was further agreed that the residents of Zwischbergen would have the right to preferential employment in the construction and operation of the plant, and this right was actively exercised by the population. In contrast to the construction of the Simplon and Lötschberg Tunnels, for example, for which mainly Italian workers had been hired, the construction of the power plant and the dam created local jobs.[76] These were convenient to a village that the newspapers in the cities of Geneva and Zurich (quite exoticizingly) considered to be situated in one of the most remote valleys: "La plus reculée des vallées suisses."[77] "A Swiss Valley Is Dying Out" was the headline in the Zurich *Tagesanzeiger* in 1949: a place with no electric lights ("unknown"), no cash, no "trace of civilization or mechanized existence" except said telephone connection, which dated from World War II, and some trafficking in "tobacco, coffee, etc."[78] "New life was brought by the construction of the power station," industrial archaeologist Hans-Peter Bärtschi later assessed.[79] In its actual operations, this new life was fairly modest: EES brought nearly twenty permanent jobs to the village at that time. Mainly "maintenance, repair, and inspection work," as the plant regulations phrased it, in the central office, on the "transmission lines"—keeping an eye on inspection

74

In Gondo, reversion (the end of concession) is currently due to occur in 2061. See *Bericht zur Verwaltungsrechnung*, 2010, p. 27, https://www.gondo.ch/ueber-die-gemeinde/gemeindefinanzen/ (retrieved July 3, 2020).

75

Konzessionsvertrag von Josef Escher (Notar in Brig) zwischen André Koechlin und Fernand Dominice, 1947, p. 5.

76

Elisabeth Joris, "Italianità, regionale Tradition und internationale Unternehmen. Soziale Beziehungen und wirtschaftliche Konflikte im Tunnelbaudorf Goppenstein," in *Tiefenbohrungen. Frauen und Männer auf den grossen Tunnelbaustellen*, edited by Elisabeth Joris, Katrin Rieder, and Béatrice Ziegler, Baden, 2006, pp. 86–103.

77

"La plus reculée des vallées suisses," *Tribune de Genève* (May 1953), Folder "Historique du Simplon," Archiv Zentrale Gondo.

78

The place was also haunted by severe, "sheer endless" winters, cut off for weeks and months. Unsurprisingly, or so one journalist pondered in 1949, the young people of Gondo would leave for the towns, lured by "the glittering franc". See "Ein Schweizer Tal stirbt aus," *Tagesanzeiger für Stadt und Kanton Zürich* (December 3, 1949), Folder "Historique du Simplon," Archiv Zentrale Gondo.

79

Bärtschi 1996, p. 41. The "new" life of some Valais mountain villages was already viewed critically by contemporaries: "The whole social and spiritual structure of these valleys is changing in a revolutionary way," observed folklorist Richard Weiss, "by no means only in a bad sense, but always with the painful and inharmonious circumstances of any revolution." See Richard Weiss, "Alpiner Mensch und alpines Leben in der Krise der Gegenwart," *Schweizerisches Archiv für Volkskunde* 4, no. 58 (1962), pp. 232–54, esp. p. 238.

corridors, switches, warning lights, and instruments. Alcohol was not permitted, but there was work on Sundays and public holidays; the reading on the meter was reported to Lausanne over the phone.[80]

Unlike in the construction of power plants, then, very little human power was required during their maintenance and operation. And soon enough, from the mid-1960s onwards, "one-man operation" prevailed in the control room as a matter of principle—"automation" as a sword of Damocles already hung over the Gondo power station a decade after it was opened.[81] At first, this mainly meant "deskilling." EES (or EOS) thus complained early on about difficulties in "recrutement de personnel qualifié" in its "usines électriques," especially in the remote ("mal accessables") areas—and speculated about whether it would be possible to make the operation of power plants more interesting ("de rendre le service d'équipe plus intéressant") or whether it would be better to simply (semi)-automate and hire more unskilled locals—"les éléments indigènes."[82] The shift work guaranteed since 1978 in the (renegotiated) concession contract—or, rather, the guaranteed non-introduction of "remote control"—was eliminated only during the complete overhaul of the plant in 2017[83]—a "delicate" issue about which people in the village did not want to tell us much more.

Historian Elisabeth Joris, who herself comes from Visp, explains that the history of industry in Valais is essentially a history of electricity.[84] As she notes, because of hydroelectric power, industry settled in Valais and the electrical power stations were initiated and co-financed by industry. (Indeed, as late as the mid-1980s, some people even considered Valais to be the "water canton of Alusuisse.")[85] According to Joris, local people and authorities had never been instrumental in this development. But since the beginning, loyalty was bought through representation in the governing bodies. *Red Anneliese*, a local magazine Joris also was involved with, indeed has long criticized the "politics of energy" in Valais, similarly arguing that although the communities were involved on paper, they were nothing more than "straw men" in economic terms.[86] Since the 1970s, the left-wing magazine had been denouncing the prevailing hydroelectric policy: "When setting the maximum water tax rate, a policy has always been pursued over the years that primarily secured cheap electrical energy for the economic bosses and the Swiss population centers," it stated, for

80

Werkordnung der Kaftwerke Gondo und Gabi (1960), and "Dienstmeldungen" (1965), Folder "General. Règlements et notes," Archiv Zentrale Gondo.

81

"Service à un seul agent" (September 24, 1963), Folder "Automation Gondo," Archiv Zentrale Gondo.

82

"Main d'ouvre dans les usines" (October 27, 1964), Folder "Valaisans. Associations et groupements," Archiv Zentrale Gondo.

83

See *Bericht zur Verwaltungsrechnung*, 2017, p. 21, https://www.gondo.ch/ueber-die-gemeinde/gemeindefinanzen/ (retrieved July 3, 2020); and Artikel 6, "Konzessions-Vertrag (Verlängerung der Konzession vom 8. März 1947)" (January 27, 1978), Swiss Federal Archives E8170D-01#2015/239#488*.

84

Conversation with Elisabeth Joris and Peter Seiler, May 1, 2020.

85

"Wasserkanton Alusuisse," *Rote Anneliese*, no. 85 (November 1985), p. 6.

86

"Die Guten in die Ausserschweiz, die Teuren selber bauen," *Rote Anneliese*, no. 80 (April 1985), p. 5.

87

"Müssen Walliser von den Arabern lernen?" *Rote Anneliese*, no. 12 (June 1976), p. 8.

example, in a 1976 article entitled "Must Valaisans Learn from the Arabs?"—an allusion to OPEC.[87] In the early 1980s, relations turned even more conflictual as the foreseeable end of many concession agreements—known as "reversion"—became an urgent matter for the first time; and Alusuisse-Lonza, too, faced a crisis, preparing to sell off (unprofitable) power stations to the canton.[88]

This language—OPEC, éléments indigènes, straw men—reveals that when we speak of Valaisan hydropolitics, we have to consider the dimensions of social and economic policy. In the case of Gondo as well, using capital from Geneva's banking circles to build a power station could be read as a kind of colonization project carried out by city-dwellers and industrialists in a rural area.[89] And the concession system could be described as hydropolitical corruption: On the national or cantonal level, it has posed and still poses questions of fair redistribution, of (in)correct taxation of energy companies, etc.; locally, it has caused resentment. The distribution of the water tax between the communities of Gondo and Simplon Dorf, which is to be carried out on the basis of "expertise," as was agreed upon in the concession contract, led to envy and rancor between the two villages, as Peter Seiler, whose family comes from Simplon Dorf, explained to us.[90] While the one (Simplon Dorf) has to bear higher infrastructure costs (such as for the school), the other (Gondo) is swimming in cash and is at the same time a dying community—a community in which not even the mayor or the vice-mayor still reside.

All this—the growing hunger for energy, increasing environmental awareness, the profit motive of the power companies (located down in the valley), the conflicting interests among the mountain communities—subsequently complicated the political economy of hydropower. In the "moated castle canton" of Valais, not only left-wing groups such as Critical Upper Valais (KO) got involved during the 1970s and 1980s, of course, but increasingly conservation organizations as well, including the Swiss Landscape Protection Foundation, which was established in 1970. It also turned out that nuclear power was by no means as cheap to produce as had once been hoped, so that hydropower again became more appealing for a variety of reasons. As a result, a whole series of hydroelectric power projects were soon underway,[91] including one in Gondo, which this time immediately roused the attention of nature conservationists: In the mid-1980s, the construction of a new power plant or reservoir was prevented, to the chagrin of at least some villagers.[92] The stumbling block was, once again, the beautiful Lagginatal, the valley that had only recently been added to the KLN inventory. "One of the few uncharted areas on the map of benefits and profits," as it was called in the critical 1987 hiking guide *Wandert in der Schweiz solang es sie noch gibt* (Go Hiking in Switzerland

Fig. 9

88

See, for example, "Heimfall – Millionen für das Wallis," *Rote Anneliese*, no. 65 (February 1983), p. 7; and "Dossier Energie," *Rote Anneliese*, no. 86 (January 1986), pp. 6–7. One of the contentious issues here was the question of who would benefit from this reversion: individual communities? Or all inhabitants of the canton?

89

Such terminology was, in any case, readily at hand. See in particular Urs P. Gasche, *Bauern, Klosterfrauen, Alusuisse. Wie eine Industrie ihre Macht ausspielt, Beamte den Volkswillen missachten und die Umwelt kaputt geht: Eine wahre Schweizer Geschichte*, Gümligen, 1981; Tobias Bauer, Greg Crough et al, *Silbersonne am Horizont – Alusuisse, eine koloniale Geschichte*, Zurich, 1989.

90

Conversation with Elisabeth Joris and Peter Seiler, May 1, 2020.

91

See, for example, Jürg Frischknecht, "Wem nützt die UVP?" *Energie & Umwelt* [Themenheft Pumpspeicher Schweiz], no. 4 (1988), pp. 14–17.

Fig. 9 "Valais must finally tax the extra-cantonal energy companies correctly!"
— political cartoon by Martial Leiter. (Rote Anneliese, no. 54/55 (December 2, 1981), p. 16, reproduced in Martial Leiter (Ed.)
Festgenagelt: Politische Zeichnungen 1976–1980, 1980 © Limmat Verlag, Zürich)

Das Wallis muss endlich die ausserkantonalen
Energiegesellschaften korrekt besteuern!

While It Still Exists).[93] The opponents of the project—an alliance of diverse interests, plus one or two local hoteliers—were counting on tourism informed by human geography: starting with the "salvaging" of a historic trade route, christened the Stockalperweg, the community was developed economically through "gentle" tourism.[94] Upon closer inspection, then, the hydroelectric idyll that Alpine Mining so fondly conjured up is anything but intact.

Price Collapse

We returned to Gondo in December 2018 to have another look around and browse through the archives of the power plant. At night, though, we missed the bus back to Brig, or rather, it didn't show up, so we went looking for the community clerk, who was still in his office. We sat there, listening to him expound on the significant decrease of power consumption in the town, when he broke off mid-sentence to toss eight or so oversized chocolate gold coins at us. Electricity consumption, he related, had begun to dip in May, and it collapsed "dramatically" in August, "along with the currency itself."[95] Indeed, by mid-December 2018, the price of Bitcoin, the major cryptocurrency, had dwindled to a mere USD 3,500—down from around 16,500 dollars the year before.[96] "There'll be a shakeout; only a few players will survive," our interlocutor offered, noting he'd been a bit of a "skeptic" all along. The crypto business-friendly strategy the village had adopted—"going on the offensive, hoping that might revitalize the village"—had, at any rate, failed. He then encouraged us to consume the faux gold coins: the remains of a recent, now pointless, PR effort.

Nevertheless, these two narratives, these two scenes—the enterprising "phantom village" of Gondo, controlled from Brig, and Alpine Mining, the entrepreneurial start-up in search of cheap electricity—complemented each other for a while. The attraction was mutual in many ways, as we've seen. In the end, however, the brief media hype was just another episode in a long history of booms and busts, which at best spread the name Gondo around the world via media reports and attracted a few curious people and tourists to the village. We, too, followed this hype and in the beginning quite succumbed to it. On closer inspection, however, it became clear that neither the idea of a literally natural setting, with self-sufficient people living in the backwoods mountains, nor that of the young, daring entrepreneurs "whose tattoos and urban style stood in stark contrast to the practical mountain garb of the locals,"[97] does justice to things. Behind the vision of decentralized, de-politicized and digital "gold," there is and was, in any case, another, much more profound, story: that of resources, hydropower, energy, and the symptoms of climate change: an issue that was, is, and will remain politicized.

92

See, among other things, "Wasser-kraftnutzung im Laggintal, Stellung-nahme der Konzessionsgemein-den" (July 1982), Swiss Federal Archives E8170D-01#2015/239#488*; *Tätigkeit der SL*, 1982, pp. 13–14; "Die Guten in die Aus-serschweiz, die Teuren selber bauen," 1985: 5; Frischknecht 1987, pp. 197–200.

93

Ibid., p. 191.

94

"This project ... is intended to create an example of how a power plant can be placed in nature without leav-ing a disturbing impression for all time," argued the advocates of the power plant project; it would pre-vent the valley from "becoming overgrown," enable "professional alpinism," and create real jobs. See "Wasserkraftnutzung im Lag-gintal, Stellungnahme der Kon-zessionsgemeinden" (July 1982), Swiss Federal Archives E8170D-01#2015/239#488*.

95

Lukas Zenklusen, community clerk (Gemeindeschreiber) since 2009, interview, December 17, 2018.

Seen in this light, the Gondo episode was anything but visionary: the specific constellation of interests in hydropower policy in the Alps hardly provides any incentives for systemic change. It was rather a symptom of path dependencies—technical, economic, and mental. Ruedi Bösiger of WWF Switzerland told us that, in his opinion, a real system change was now imminent and that in the future a large proportion of the energy would have to come from photovoltaics. However, the large electricity producers in Switzerland have been producing energy for a century from hydro-electric power and supplementing it with nuclear power. With photovoltaics, it will now be possible for production to be more decentralized in the future and to meet a large proportion of the need for electricity in a renewable and environmentally friendly way. The age of hydropower having quasi-monopoly status is slowly coming to an end.[98]

The Alps, then, as a hydro-solar "castle"? We shall see. This vision has actually been around for a while;[99] but existing interdependencies of interest continue to perpetuate the idea of the inexhaustible Alpine battery. And perhaps it is just too easy to "refine" cheap base-load electricity at peak times by means of precisely controlled pumped storage power plants[100]—a system of electricity price arbitrage not unlike crypto-mining.[101]

The age of the great Swiss myths is by no means over. The current upheaval brought about by the digitalization of the financial system in particular happily revisits the old myths of Switzerland as an Alpine country with an abundance of natural resources—despite climate change, and even though both the electricity markets and the digital infrastructures are highly globalized and decisions on the use of resources are, just as they were around 1900, not made locally but are shaped by global economic and technical processes. However, it is precisely in such a phase of technological upheaval that the old myths sell particularly well. There must be a little continuity.

Acknowledgments

The authors would like to thank Adrian Arnold, Ruedi Bösiger, Peter Bodenmann, Paul Fux, Rolf Gruber, Elisabeth Joris, Peter Seiler, and Lukas Zenklusen for their willingness to share their knowledge and stories with us. Andrea Helbling, Hannes Rickli, Giorgio Scherrer, and Andres Villa Torres accompanied us on some of our site visits. We would like to thank them for their research and inspiration. Thanks to Niki Rhyner as well.

96

The other major currencies weren't making a good impression either. Ether, for example, was worth about 83 dollars, down from 1,250 dollars. This wasn't just bad news for speculators; it would have been a problem for coin producers as well, insofar as the average cost of "creating" of a single Bitcoin at the time hovered, by one estimate, somewhere in the range of 8,500 dollars (the cost of electricity being the most significant variable when it comes to the "mining process"). See Bendiksen et al 2018, p. 5.

97

"Gondo's New Gold Rush: Crypto-currency Boom Breathes Life into Swiss Village," *The Local* (March 29, 2018), https://www.thelocal.ch/20180329/gondos-new-gold-rush-cryptocurrency-boom-breathes-life-into-swiss-village (retrieved July 3, 2020).

98

Conversation with Ruedi Bösiger, April 30, 2020.

99

Valaisan politician and EES small shareholder Peter Bodenmann, for example, has been advocating a diversified, hydro-solar vision of the Alps, if you like, for decades. See, for example, "Interview mit Peter Bodenmann zum Ausstieg aus Atom, zum Energiesparen, zum Berg-gebiet, zu Sonne und Wind," *Rote Anneliese,* no. 97 (June 9, 1987), pp. 6–7.

100

See Marti 2008, p. 4.

101

"Miners," as *The Economist* notes, "are arbitraging, buying an under-priced commodity (electricity) and converting it to bitcoin for a profit." See "Why Are Venezuelans Mining So Much Bitcoin?" *The Economist* (April 3, 2018), https://www. economist.com/the-economist-explains/2018/04/03/why-are-venezuelans-mining-so-much-bitcoin (retrieved July 3, 2020).

How Clean Are "Clean" Data Centers?

Renate Schubert
Scherwin Bajka
Fatih Öz

As digitization moves forward, the demand for data processing constantly increases. This development expresses itself in a growing hunger for server performance that is necessary for temporary data processing (e.g. streaming), functional caching (e.g. cookies), or for the definitive archiving of data. The context of the content of the data to be processed is highly variable; sometimes the data reflects the behavior of people, sometimes of machines, sometimes a linkage between the two. What the data has in common, however, is that it is compiled unremittingly and in great volume. Those who wish to deal with such large amounts of data must depend on appropriately extensive storage capacity.

Today and in the near future, only data centers are likely to be up to this task. There, the data collected is not only stored (securely) but is also processed via a multitude of networked servers. Centralized data processing (analysis and correlation) allows us, among other things, to gain insight into our behavior (electricity consumption, for example, but also mobility) and into our social networks (Whom do I meet up with? Whom do I trust?). Such insights account for the great potential of data centers, since insights regarding individual behavior and social networks can form a basis from which to develop original approaches, for example, to reduce electricity consumption or reduce the amount of CO_2 used for mobility, and derive practical courses of action to recommend. Data centers, particularly if they are networked internationally, can use these to contribute to sustainable societal development in the age of Big Data. Admittedly, there is a downside: the vast consumption of energy and electricity in particular means that data centers may intensify global climate change, certainly in those cases when they are largely dependent on fossil fuels (for the generation of electricity).

We must assume that the volume of data in Europe will increase by twenty-five percent per year by 2025. Switzerland is expected to profit disproportionately from this growing demand for data center services, as this country has succeeded in establishing itself as a safe haven for data.[1] In order to yield the necessary processing capacity, the centers depend not only on the data, but also on a considerable amount of electric power. As an energy source, it not only serves to enable the data processing, but also guarantees the fundamental cooling and security functions of the data centers. If the large demand for electricity in Swiss data centers is met by electricity generated from fossil fuels, this is problematic from the perspective of climate policy. Now, in Switzerland itself, electricity is generated almost exclusively without fossil fuels. However, the electricity produced in Switzerland is not always sufficient to meet the complete demand for electricity in Switzerland. A large proportion of the electricity

1

Stefan Betschon, "Der grosse Sprung in die Cloud," *Neue Zürcher Zeitung* (August 29, 2019), https://www.nzz.ch/digital/der-grosse-sprung-in-die-cloud-ld.1505065 (retrieved July 3, 2020).

imported to Switzerland as a result—from Germany, for example—is generated from fossil fuels (coal, oil, natural gas) and is thus bound up with considerable CO_2 emissions. Now, using only electricity free of CO_2 emissions is more important to some Swiss data centers than to others. Such centers could then be labeled "clean" from a climate perspective. But how "clean" are the clean data centers in Switzerland really, if the electricity used in Switzerland is at least partly generated from fossil fuels? Can such "clean" data centers be islands in a world dominated by fossil fuels? What role does the price of electricity on the international markets play in this regard? And what affects the price of electricity?

Swiss Data Centers

The area occupied by Swiss data centers (internal and external data centers) in 2013 amounted to about 234,522 m². According to Altenburger et al (2014), about 150,000 m² of this was taken up by external service data centers. Among European countries, Switzerland thus has the sixth-largest "collection of third-party providers."[2] The Swiss are even "better-positioned" in terms of the density of data centers per capita: in this comparison, Switzerland is "beaten" only by Ireland.[3] In absolute quantities, the number of servers in Switzerland in 2016 was 340,000. By comparison, Austria operated only 210,000 servers in the same year.[4] Their electricity consumption indicates that both countries have since increased by about five percent. This trend is not least reflected by the fact that between 200 million and 400 million Swiss francs is being invested annually in the construction and expansion of data centers.

The boom in data centers in Switzerland can be explained by Switzerland's attractiveness as a land of technical innovation. Switzerland is known for its stable political environment, its central geographic location in Europe, and its secure power supply.[5] Switzerland's attractiveness for data centers is systematically recorded in Cushman & Wakefield's Data Centre Risk Index, which ranks various countries according to weighted criteria such as energy prices, Internet speed, energy security, availability of water, political stability, and taxes. The index does not, however, include country-specific measures to detect climate-related effects. Such effects can be relevant insofar as, for example, high ambient temperatures mean higher cooling requirements and consequently a larger environmental impact by a data center of a given size.[6] As Fig.1 illustrates for 2016, Switzerland is, according to this index, the third most attractive country for data centers. Iceland ranks highest, achieving the maximum

2 Adrian Altenburger et al, "Rechenzentren in der Schweiz – Energieeffizienz: Stromverbrauch und Effizienzpotenzial," Report by order of asut and the Swiss Federal Office of Energy, p. 2, August 2014, https://asut.ch/asut/media/id/92/type/document/st_iwsb_amsteinwalthert_rzch_energieeffizienz_201408.pdf (retrieved July 3, 2020).

3 Ibid., p. 14.

4 Ralph Hintermann, "Trotz verbesserter Energieeffizienz steigt der Energiebedarf der deutschen Rechenzentren im Jahr 2016," Borderstep Institute Publication, March 2017, https://www.borderstep.de/wp-content/uploads/2017/03/Borderstep_Rechenzentren_2016.pdf (retrieved July 3, 2020).

5 Nicola Gibbs, "Rechenzentren in der Schweiz – Dynamischer Markt mit bevorstehender Konsolidierung," Deloitte, https://www2.deloitte.com/ch/de/pages/corporate-finance/articles/data-centres-in-switzerland.html (retrieved January 19, 2020).

6 Uptime Institute, "Uptime Institute Global Data Center Survey," Uptime Research Report, https://data-center.com/wp-content/uploads/2018/11/2018-data-center-industry-survey.pdf (retrieved January 20, 2020).

Fig. 1

The ten most attractive countries for data centers according to the 2016 Data Centre Risk Index.

Iceland
100.00%

Norway
96.21%

Switzerland
90.26 %

Finland
90.19%

Sweden
89.92%

Canada
85.07%

Singapore
84.50%

South Korea
83.23%

United Kingdom
79.81%

USA
78.73%

Source: Cushman & Wakefield 2016, p. 8

Renate Schubert
Scherwin Bajka
Fatih Öz

score of 100 points, followed by Norway with a score of 96.21. Furthermore, according to the index, six of the ten highest-ranked countries are in Europe.[7] | Fig. 1 |

One factor that significantly affects a country's rank in the Data Centre Risk Index is the price of electricity there.[8] The price of electricity in Switzerland in 2018 was neither particularly high nor extraordinarily low compared to that in neighboring countries.[9] In 2016, Switzerland was undercut in its price of electricity by its neighbors Austria (10 euro cents per kWh) and France (9 cents per kWh); however, at that time, the price of electricity was lower in Switzerland than in its other two neighbor countries (Germany and Italy). While Swiss industrial customers paid 11.8 cents per kilowatt-hour,[10] electricity was much more expensive for Italian (15.6 cents per kWh) and German (14.9 cents per kWh) industrial customers.[11]

It's also interesting to compare the different ways that the price of electricity in the various countries is calculated. Generally speaking, the price (total charge for consumption) is calculated from the cost of the grid, the cost of the energy, and taxes. Compared to its neighbors, Switzerland tends to have higher grid and energy costs. The generally low taxes make it possible for Switzerland to offer overall prices for electricity that tend to be low. Policy plays an important part in this, as it sets the (generally higher) grid costs and the (generally lower) taxes. The generally low taxes befit Switzerland's image as a country with a generally low level of taxes. The government typically cites solidarity between the different regions of the country as a justification for the high grid cost. From a purely economic perspective, and if the grid cost were low, less lucrative regions could otherwise be completely excluded from the electrical grid. The partially liberalized Swiss energy market is particularly attractive to industrial customers, including data centers. Since 2009, major customers consuming at least 100 MWh have been able to choose the provider of their electricity (even outside of Switzerland). The resultant energy costs thus depend not only on the amount consumed, but also on international prices of electricity.

The price of electricity that is relevant to Swiss industrial customers depends mainly on the cost of power generation in Switzerland and the price of electricity in neighboring countries. In winter, about twenty percent of the demand for electricity in Switzerland is met by electricity imported from surrounding countries.[12] Some sixty percent of the imported electricity comes from Germany, twenty one percent from France, and eighteen percent from Austria.[13] This means that the sources of elec-

7

Cushman & Wakefield, "Data Centres Risk Index 2016," *Cushman & Wakefield Report*, p. 8, https://www.mme.ch/fileadmin/files/documents/161025-data-centre-risk-index-report-2016.pdf (retrieved February 11, 2020).

8

Ibid, p. 20.

9

Swiss Federal Electricity Commission, "Spotmarktbericht vom 02.10.2018," *Federal Electricity Commission Reports on Spot Markets*, https://www.elcom.admin.ch/elcom/de/home/themen/marktueberwachung/spotmarkt-berichte.html (retrieved October 2, 2018).

10

Swiss Federal Electricity Commission, "Basic data for 2016," *Basic data for tariffs of the Swiss Distribution Network Operators*, February 11, 2016, https://www.elcom.admin.ch/elcom/de/home/themen/strompreise/tarif-rohdaten-verteilnetzbetreiber.html (retrieved July 3, 2020).

11

Eurostat, "Electricity price statistics," Eurostat Statistics Explained – Datencode: nrg_pc_205, https://ec.europa.eu/eurostat/statistics-explained/index.php?title=Electricity_price_statistics (retrieved October 2, 2018).

12

Swiss Federal Electricity Commission, "ElCom fordert Anreize für Winterproduktion," *Federal Electricity Commission Press Release*, November 29, 2018, https://www.elcom.admin.ch/elcom/de/home/dokumentation/medienmittei-lungen.msg-id-73132.html (retrieved July 3, 2020).

13

Swiss Federal Office of Energy, "Physikalische Einfuhr und Ausfuhr der Schweiz nach Ländern," *Swiss Federal Office of Energy time series data*, February 26, 2020, https://www.bfe.admin.ch/bfe/de/home/versorgung/statistik-und-geodaten/energie-statistiken/elektrizitaets-statistik.html (retrieved July 3, 2020).

14

International Energy Agency, "Monthly OECD Electricity Statistics," International Energy Agency Reports, March 2020, https://www.iea.org/reports/monthly-oecd-electricity-statistics (retrieved July 3, 2020).

tricity in the neighboring countries are important factors in the ecological balance of the Swiss data centers. Efficient data centers can thus, despite their efficiency, potentially be limited in how "clean" they are if they make appreciable use of emissions-producing electricity. How, then, is Swiss electricity comprised as compared to electricity originating in neighboring countries?

A detailed comparison to neighboring countries is found in | Fig. 2 |. This illustration demonstrates that the electricity produced in each country is very differently comprised. In Austria and Switzerland, hydroelectric power is the main component. A further difference between these two countries is that Switzerland relies strongly on nuclear energy.[14] By contrast, Austrian electricity, aside from hydroelectric power (sixty-one percent), is generated mainly from wind, photovoltaics, and natural gas.[15] Nearly three quarters of the electricity imported from France is produced by nuclear energy, while almost none is produced by coal-fired power plants.[16] Compared to French electricity, a considerable proportion of that imported from Germany is produced from fossil fuels ("conventional thermal").[17] In the context of CO_2 emissions, Germany's high proportion of coal stands out, comprising more than half of the fossil fuels used.

Given the large German proportion in the electricity imported to Switzerland, coal is an important determining factor in the price of electricity in Switzerland and thus in the cost of electricity consumed by Swiss data centers.[18]

15

Manfred Gollner, "Energiedaten Österreich 2016," *STATISTIK AUS-TRIA Report by order of the Federal Ministry of Agriculture, Regions and Tourism*, December 15, 2017, https://www.statistik.at/web_de/statistiken/energie_umwelt_innovation_mobilitaet/energie_und_umwelt/energie/index.html (retrieved July 3, 2020).

16

French transmission system operator, "Bilan électrique 2015," *French Transmission System Operator Annual Report 2015*, https://www.rte-france.com/sites/default/files/2015_bilan_electrique.pdf (retrieved November 22, 2019).

17

Hans-Joachim Ziesing, "Ausge-wählte Publikationen," *Arbeits-gemeinschaft Energiebilanzen e.V. Annual Report 2016*, February 2018, p. 10, https://ag-energiebilanzen.de/42-1-Annual-Reports.html (retrieved July 3, 2020).

18

Swiss Federal Office of Energy 2020.

Austria

Fig. 2

**Composition of electricit
produced in Switzerland
and neighboring coun-
tries, October 2018–2019**

6 Geothermal
5 Solar
4 Wind
3 Hydro
2 Nuclear
1 Conventional Thermal

France

| Fig. 2 |
Composition of electricity produced in Switzerland and neighboring countries, October 2018–2019

6 Geothermal
5 Solar
4 Wind
3 Hydro
2 Nuclear
1 Conventional Thermal

Oct. 18 Nov. 18 Dec. 18 Jan. 19 Feb. 19 Mar. 19 Apr. 19 May. 19 Jun. 19 Jul. 19 Aug. 19 Sep. 19 Oct. 19

000 GWh

500 GWh

000 GWh

000 GWh

Germany

| Fig. 2 |

Composition of electricity produced in Switzerland and neighboring countries, October 2018–2019

6	Geothermal
5	Solar
4	Wind
3	Hydro
2	Nuclear
1	Conventional Thermal

Oct. 18 Nov. 18 Dec. 18 Jan. 19 Feb. 19 Mar. 19 Apr. 19 May. 19 Jun. 19 Jul. 19 Aug. 19 Sep. 19 Oct. 19

60,000 GWh

45,000 GWh

30,000 GWh

15,000 GWh

Italy

Fig. 2
Composition of electricity produced in Switzerland and neighboring countries, October 2018–2019

6 Geothermal
5 Solar
4 Wind
3 Hydro
2 Nuclear
1 Conventional Thermal

Oct. 18 Nov. 18 Dec. 18 Jan. 19 Feb. 19 Mar. 19 Apr. 19 May. 19 Jun. 19 Jul. 19 Aug. 19 Sep. 19 Oct. 19

Switzerland

Fig. 2

Composition of electricity produced in Switzerland and neighboring countries, October 2018–2019

6	Geothermal
5	Solar
4	Wind
3	Hydro
2	Nuclear
1	Conventional Thermal

Oct. 18 Nov. 18 Dec. 18 Jan. 19 Feb. 19 Mar. 19 Apr. 19 May. 19 Jun. 19 Jul. 19 Aug. 19 Sep. 19 Oct. 19

8,000 GWh

6,000 GWh

4,000 GWh

2,000 GWh

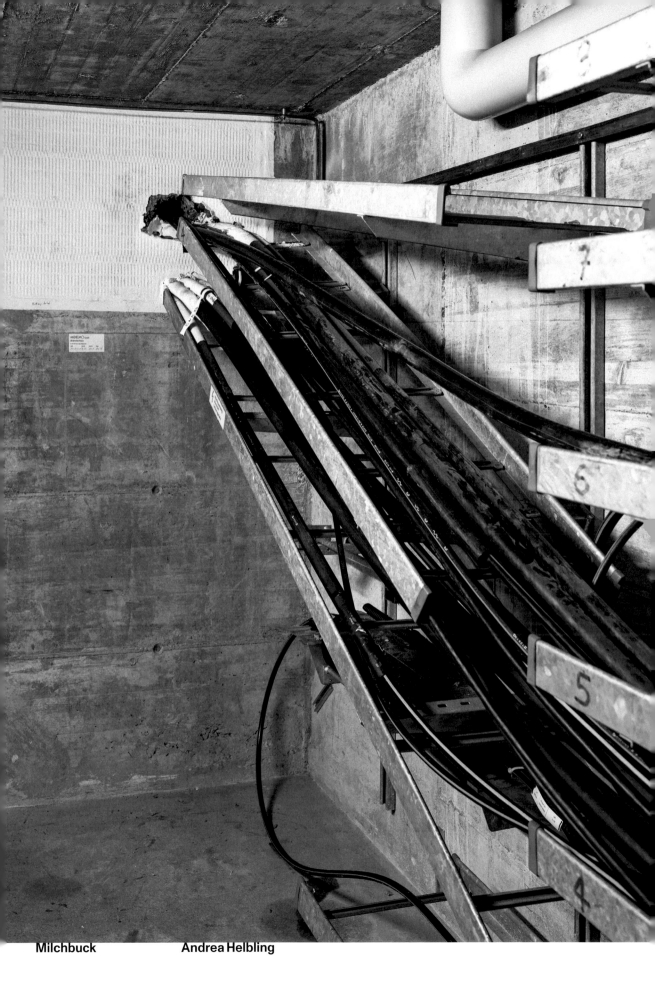

Milchbuck　　　　　　**Andrea Helbling**

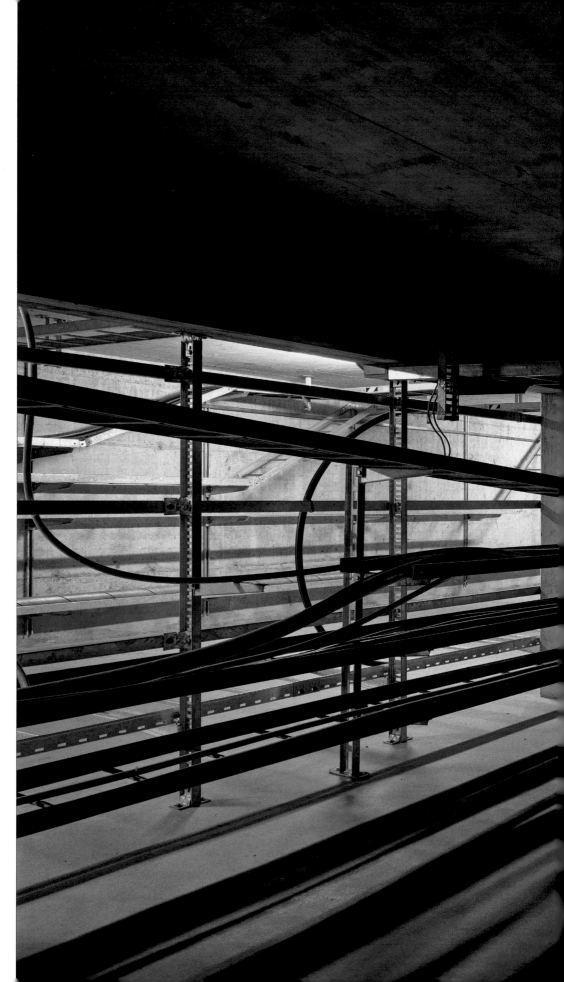

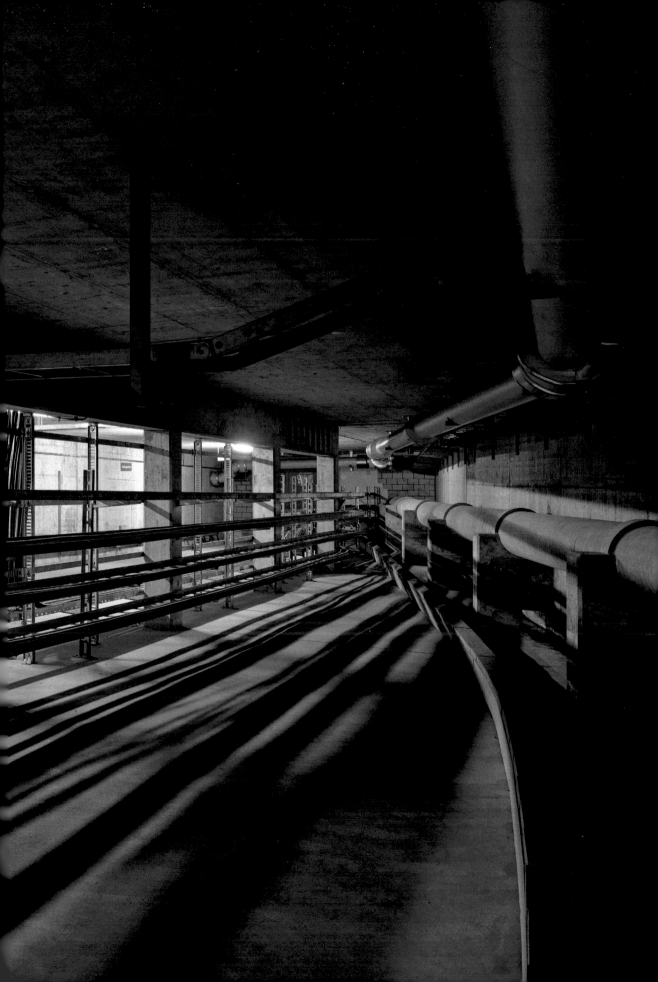

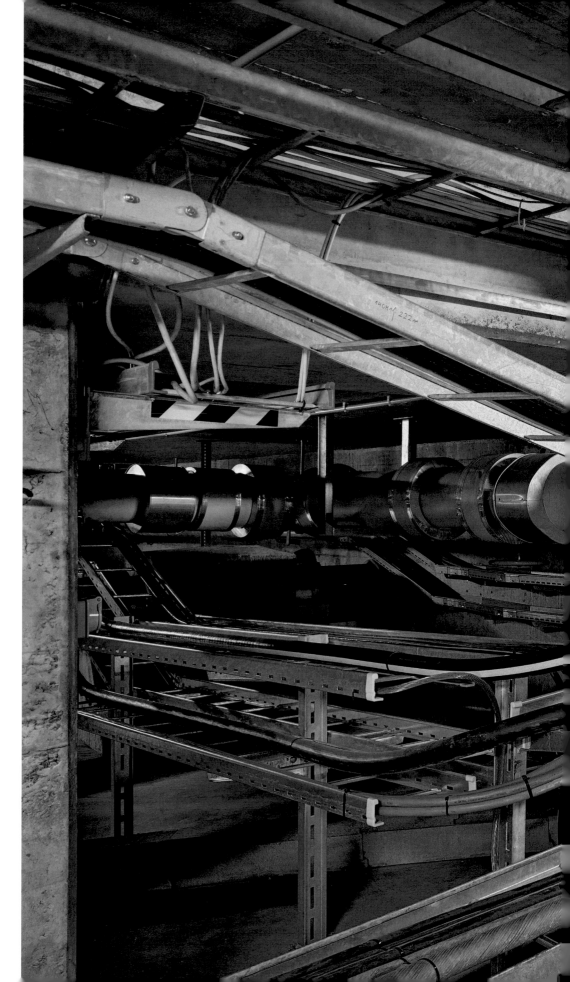

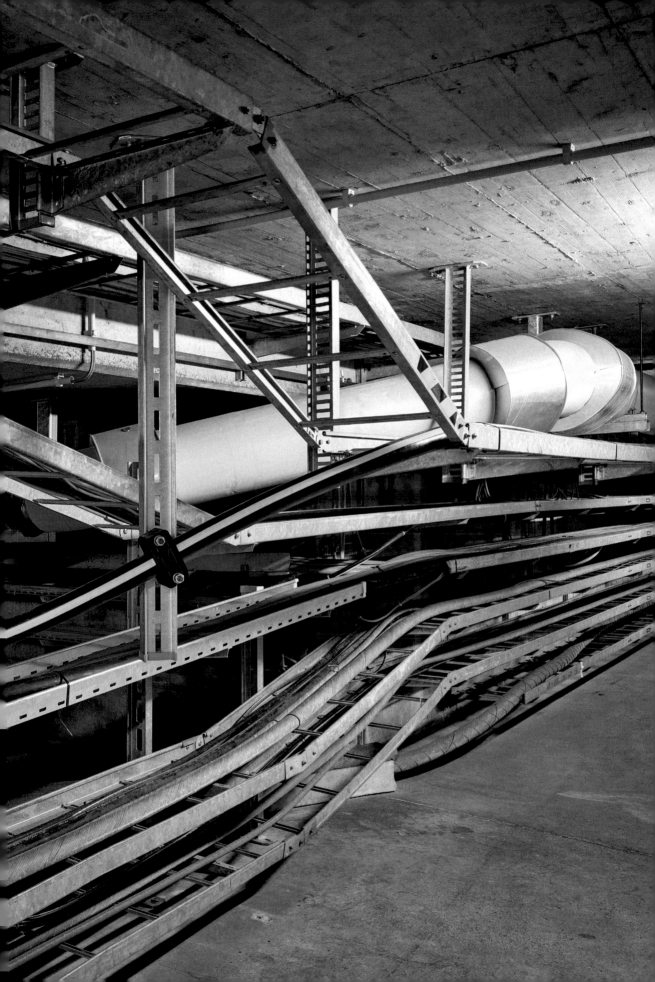

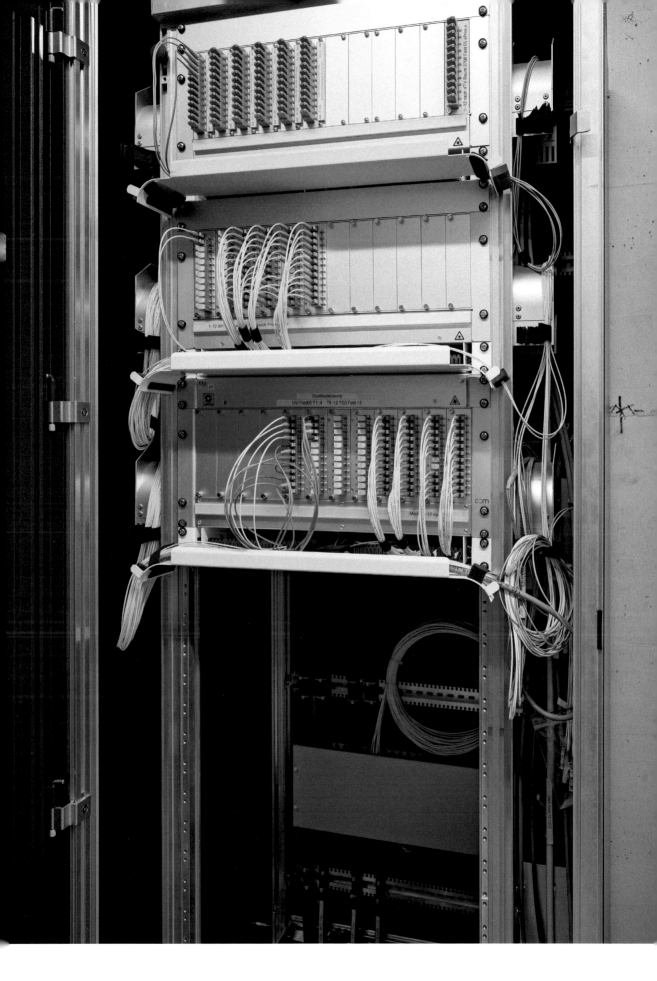

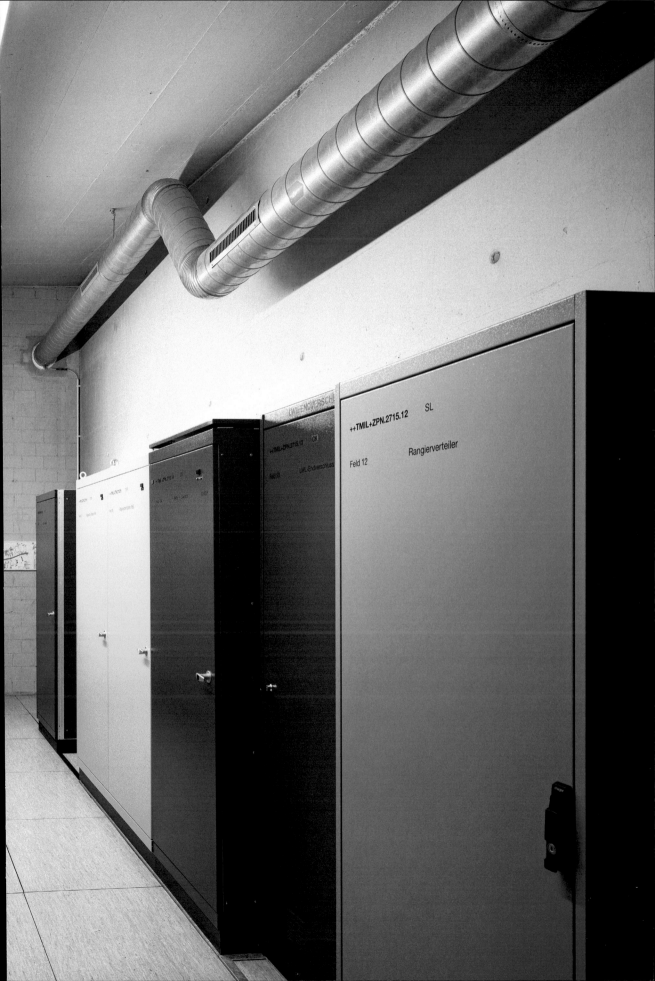

The Role of Coal in the Price of Electricity from Germany

The price of electricity in Germany does not correspond to a price that is set for a certain period of time, but is rather the product of supply and demand on the energy market.[19] The decisive factor in the price of electricity is the qualitative composition of the electricity being offered. Renewable energy (water, wind, and solar) is cheapest, since unlike coal extraction, only a one-time initial cost (installation) is involved. Thus far, however, the rather low number of installed power-generation and transmission facilities means that only a limited amount of sustainable electricity is able to be generated.

The amount of sustainable electricity produced from renewable energy sources is clearly too small to meet the annual demand for electricity in Germany. If the demand for electricity exceeds the amount generated from renewable sources, other types of generation with higher marginal costs come into play. In Germany, beyond power from renewable energy sources, larger amounts of electricity are produced (in order of their additional cost of generation) by nuclear power plants, lignite-fired power plants, anthracite-fired power plants, and gas- and oil-fired power plants.[20] Just under forty percent of the electricity in Germany in 2017 was generated from (lignite and anthracite) coal;[21] in 2019 it was approximately fifty-four percent.[22]

The price of electricity in Germany is largely determined by the price of anthracite coal, since the supply and demand curves intersect in the segment of the supply curve that is dominated by electricity generated from anthracite coal.[23] What factors, though, determine the cost of producing electricity from anthracite coal? Does China, as the world's largest producer of anthracite coal, have any effect on trends in prices?

China and the Anthracite Market

China was for a long time a buyer on the international market for anthracite, because its domestic anthracite production usually was not able to satisfy the high domestic demand. For this reason, China imported anthracite coal from Australia, for example.[24]

In 2016, an unexpected shortage occurred in China's anthracite supply.[25] Extensive flooding in the most important anthracite-producing region in Hebei,[26] along with targeted closures of coal mines intended to offset overproduction,[27] created a decline in supply in China. Unexpected shortfalls in production in Australia and Indonesia led to further scarcity in the global supply of anthracite

19

German Federal Network Agency, "Electricity market explained," *Federal Network Agency for Electricity, Gas, Telecommunications, Post and Railway*, https://www.smard.de/home/wiki-article/446/384 (retrieved November 22, 2018).

20

Ibid.

21

Ibid.

22

International Energy Agency 2020.

23

Ziesing 2018.

24

Tobias Voss, "Chinas Rohstoffhunger," *Foundation Asienhaus Online Brochure* (3), p. 2, September 12, 2016, https://www.eu-china.net/uploads/tx_news/ 2016_Asienhaus_ _Beiblatt-3__SEC.pdf (retrieved July 3, 2020).

25

International Energy Agency, "Medium-Term Coal Market Report 2016," *International Energy Agency Online Article*, December 2015, https://www.iea.org/reports/medium-term-coal- market-report-2016 (retrieved July 3, 2020).

26

Austrian Broadcasting Corporation, "Approx. 100 dead after storm in China," *Austrian Broadcasting Corporation Online Article* (July 23, 2016), https://orf.at/v2/stories/2350859 (retrieved July 3, 2020).

Renate Schubert
Scherwin Bajka
Fatih Öz

coal in 2016. Parallel to this, a hot summer in China made Chinese demand for energy and thus for anthracite rise. Electricity generated from anthracite coal comprises some sixty-six percent of China's total energy mix.[28] Thus, the shorter supply of anthracite coal and China's higher demand for coal in 2016 led to record prices for anthracite coal on the global market.[29] The higher prices for anthracite coal on the world market also forced up the price of energy produced from anthracite in Germany, and with it the operating costs of Swiss data centers. In the meantime, China is tending to encourage domestic coal mining instead of dampening it as the Paris Agreement requires.[30] It can thus be assumed that China's economic situation and China's energy policy will continue to have a considerable effect on the global market price of anthracite coal and thus ultimately on the cost of electricity consumed by Swiss data centers.

Preliminary Conclusion

With regard to electricity prices, at least, even the cleanest data centers in Switzerland are evidently not islands in a fossil-fueled world. The significant imports of electricity from Germany tend to result in parallel variations in the price of electricity in Germany and in Switzerland. If the global supply of anthracite coal falls or the Chinese demand for anthracite rises, this causes electricity not only in Germany, but also in Switzerland, to become more expensive. This then has an effect on the operating costs as well as the viability of Swiss data centers.

Such effects will probably become even more important than they have been until now. Digitization is moving forward, and the demand for electricity for data processing and storage is rising as a consequence. Although Swiss data centers are located in Switzerland, they are viable over the long term only by using electricity from other countries. Neither sufficient availability of this electricity nor in particular its lack of CO_2 can be assumed. The question thus arises of how "clean" Swiss data centers can actually be in the years to come.

Ecology and efficiency of data centers

"Clean" data centers are basically those that guarantee they will operate in an environmentally friendly way. The most important thing for data centers, aside from producing the least possible CO_2 emissions, is to have high energy efficiency. High energy efficiency means that the envisioned storage and processing of the data are done using as little electricity as possible and with minimal loss of current.

27

Spiegel Online, "China about to close a thousand coal power stations," *Spiegel Online Article* (February 22, 2016); Handelsblatt, "Beijing closes 1000 mines due to overproduction," *Handelsblatt Online Article* (February 22, 2016), https://www.handelsblatt.com/politik/international/china-peking-schliesst-wegen-ueberproduktion-1000-bergwerke/12996614.html (retrieved July 3, 2020).

28

Tobias Voss 2016, p. 2.

29

See International Energy Agency 2015; Harald Hecking et al, "Aktuelle Entwicklungen auf den Kohle- und Gasmärkten und ihre Rückwirkungen auf die Merit Order," *Energiewirtschaftliche Tagesfragen*, no. 6 (June 2017), pp. 34–39, https://www.energie.de/fileadmin/dokumente/et/Archiv_Zukunftsfragen/2017/Zukunftsfragen_2017_06.pdf (retrieved July 3, 2020).

30

Reuters, "China Must Cancel New Coal Plants to Achieve Climate Goals: Study," *Reuters Online Article* (January 7, 2020), https://www.reuters.com/article/us-climate-change-china-coal/china-must-cancel-new-coal-plants-to-achieve-climate-goals-study-idUSKBN1Z603Z (retrieved July 3, 2020).

The biggest "consumer of energy" in a Swiss data center is the IT hardware. Serving mainly to store and process the data (CPU, memory, and communication), it accounted for about fifty percent of the electricity used in 2015 | Fig. 3 |. One quarter of the total energy consumed normally goes to the cooling system. The uninterruptible power supply (UPS), transformers, line loss and other losses, lighting inside the data center, and similar things account for the rest.[31]

Since 2005, consideration of the efficiency of data centers has become widespread under the moniker "Green IT." The year 2005 was characterized by, among other things, a marked increase in global oil and electricity prices, though it also included such events as Hurricane Katrina and the Kyoto Protocol taking effect. Efficiency considerations were primarily economically motivated and were intended to counteract the effects of higher electricity prices.[32] In addition, technological developments have brought with them a motivation to increase efficiency. Advancements in microprocessors and server architecture have allowed the extent of data storage and processing to increase while the size of the data centers remains constant.[33]

The energy efficiency of a data center is usually given by its "power usage effectiveness" (PUE) | Table 1 |.[34] This is the ratio of a data center's total energy use (IT and infrastructure) to its energy use for IT, so that the PUE is always larger than or equal to 1. At a PUE of 1 (the optimal case), all of the energy goes into IT and none goes into the infrastructure (cooling, ventilation, lighting, etc.). While using PUE is not uncontroversial,[35] it has established itself in practice and in the media as the tool most frequently used for measuring the energy efficiency of data centers. For the data centers at the Eidgenössische Technische Hochschule (ETH) Zurich, calculations show an average PUE of 1.94, with individual values between 1.4 and 2.29.[36] Mäder (2010) considers the average value for the ETH to be very good when considering the age of the data centers. More recently built data centers in Switzerland, such as the green.ch data center in Zurich-West, achieve a PUE of under 1.2.[37] The PUE values of other "green" data centers in Switzerland lie around 1.5 or slightly below it.[38]

In their study, Altenburger et al (2014) name five different ways that the energy efficiency of data centers can be increased. First, an increase in efficiency can be achieved by cooling data centers using cold air and cold water from the environment (free cooling) instead of using air conditioners to do this artificially. Second, enclosing server racks can allow cold and warm air to be directed more efficiently, thus saving electricity. As a third measure, they recommend reducing IT performance,

31

Swiss Federal Council, "Electricity consumption, energy efficiency and support measures in the field of data centers," *The Federal Council Report – in response to the Postulate* 13.3186, August 19, 2015, https:// www.newsd.admin.ch/newsd/ message/attachments/40632.pdf (retrieved July 3, 2020).

32

Bernhard Aebischer, "Energy efficiency in the data center," *Umwelt Perspektiven*, no. 2 (April 2009), pp. 16–19, https://pueda.tep-energy. ch/wp-content/uploads/2015/ 08/Aebischer_Energieeffizienz-Rechenzentrum_Umwelt Perspektiven_04-09.pdf (retrieved July 3, 2020).

33

Kenneth G. Brill, "The Invisible Crisis in the Data Center: The Economic Meltdown of Moore's Law," *Uptime White Paper*, 2007, http://www.mm4m.net/library/ The_Invisible_Crisis_in_the_Data_ Center.pdf (retrieved January 20, 2020).

34

Altenburger et al 2014, p. 19.

35

Gemma Brady et al, "A Case Study and Critical Assessment in Calculating Power Usage Effectiveness for a Data Centre," *Energy Conversion and Management* 76 (December 2013), pp. 155–61.

36

Christoph Mäder, "Vorschläge zur Optimierung der Serverräume an der ETH Zürich basierend auf einer Kosten- und Energieanalyse," Master's Thesis, 2010, http://www. hpc-ch.org/wp-content/uploads/ 2010/11/Anhang-der-Masterarbeit-von-Christoph-M%C3%A4der.pdf (retrieved July 3, 2020).

37

Green, "Green Pushes Ahead with Construction in Order to Offer Data Center Capacities to International Cloud Providers," *Green. ch. Press Release* (September 14, 2018), https://www.green.ch/ Support/Helpdesk/HelpdeskSub/ TabId/1545/ArtMID/11603/ ArticleID/769/Green-baut-mit-Hochdruck-um-Datacenter-Kapazit228ten-f252r-internationale-Cloud-Anbieter-bereitzustellen. aspx (retrieved July 3, 2020).

38

Green, "How we embrace energy efficiency in the data center," *Green.ch Website Content*, https:// www.colocation-datacenter.com/ locations/greenit.html (retrieved August 27, 2019).

Fig. 3

Typical proportions of electricity use in a Swiss data center.

IT hardware
50%

Cooling
25%

Air circulation and distribution
12%

UPS
10%

Other (lighting, appliances, etc.)
3%

which can be done by partitioning a single physical server into several virtual servers (virtualizing). A fourth suggested approach is the use of sophisticated power management systems. As a fifth way of increasing energy efficiency, they suggest raising the room temperature in data centers.

If measures of this sort were implemented in all Swiss data centers, an average PUE of 1.35 could be achieved. For the centers, this would correspond to an annual power saving of about seventeen percent. In absolute numbers, the power savings would amount to 279.58 GWh per year. As the power consumption of all Swiss data centers amounts to about three percent of the country's annual energy use, these measures could reduce the electricity consumption of all of Switzerland by about half a percent per year.[39] Such savings would amount to 40 to 50 million Swiss francs, given the current number of data centers and the current prices for electricity.[40]

Even if the PUE could be reduced across the board for all Swiss data centers, a problem with their cleanness would still remain. It is possible that an efficient Swiss data center could result in significant CO_2 emissions if or because a large part of the electricity it uses comes from fossil fuels (see the explanation of this above). In order to devote explicit attention to the aspect of carbon dioxide emissions, it has been suggested that "carbon usage effectiveness" be used as an indicator.[41] This is calculated as the quotient of "total carbon dioxide emissions resulting from the total energy used by the data center" and the "power consumption of IT equipment." The ideal value for CUE is zero.

The absolute efficiency value PUE and the sustainability indicator CUE can be combined into the "carbon emission factor" (CEF)│ Table 1 │. The CEF is the result of dividing the CUE by the PUE and is to be interpreted as the "carbon dioxide emissions per kWh of energy" used by data centers. The CEF is calculated using regional and activity-based data on carbon dioxide emissions published by the government.[42] The CEF values should be as low as possible for clean data centers. Interpreting CEF values, however, requires close scrutiny: a low CEF could be caused by rising power use and thus a rising PUE. This would not really be an indication that data centers have become "cleaner."

The Role of Renewable Energy Sources in Swiss Data Centers

Leading technology companies often pay lip service to efficiency goals, but often continue to show little transparency or long-term commitment when it comes to implementing them tangibly.[43] Experts estimate that in 2020, the entire technology sector will be responsible for 3.6 per-

39

Our own calculation based on Swissgrid's "Energieübersicht Schweiz 2018" (Energy Survey Switzerland 2018) as well as data from the Bundesamt für Energie (Swiss Federal Energy Agency).

40

Altenburger et al 2014, p. 22.

41

Belady et al, "Carbon Usage Effectiveness (CUE): A Green Grid Data Center Sustainability Metric," *the green grid White Paper*, no. 32, December 2010, https://airatwork. com/wp-content/uploads/The-Green-Grid-White-Paper-32-CUE-Usage-Guidelines.pdf (retrieved July 3, 2020).

42

Ibid.

43

AI Now, "AI and Climate Change: How They're Connected, and What We Can Do about It," *Medium Online Article* (October 17, 2019), https:// medium.com/@AINowInstitute/ ai-and-climate-change-how-theyre-connected-and-what-we-can-do-about-it-6aa8d0f5b32c (retrieved November 20, 2019).

| Table 1 |
**Key Indicators PUE,
CUE, WUE, and CEF**

Indicator	Description

**power usage
effectiveness (PUE)**

$$PUE = \frac{\text{total electrical power consumed by a data center (DC)}}{\text{electrical power consumed by IT}}$$

- Values: by definition ≥ 1.0.
- The closer the PUE is to 1.0, the smaller the proportion of infrastructure.
- Components in the center's total power consumption.
- Value of 1.0 = 100% efficiency on the level of infrastructure.
- Value of 2.0 = 50% of power goes to IT.

**carbon usage
effectiveness (CUE)**

$$CUE = \frac{\text{carbon dioxide emissions from total el. power consumption of the DC}}{\text{electrical power consumed by IT}}$$

- Ideal value = 0.
- The closer the value is to 0, the lower the data center's CO_2 emissions.
- Alternative method of calculation: CUE = PUE × CEF

**water usage
effectiveness (WUE)**

$$WUE = \frac{\text{annual water consumption}}{\text{electrical power consumed by IT}}$$

- Ideal value = 0
- The closer the value is to 0, the lower the data center's consumption of water.
- Measured in liters per kilowatt-hour.
- Includes: a) evaporation inside the cooling towers as well as
 b) water used to control humidity.

**carbon emission
factor (CEF)**

$$CEF = \frac{CUE}{PUE}$$

- Indicates the carbon dioxide emission per kWh of energy
 for an entire region or an individual power station.

cent of global greenhouse gas emissions—a doubling of its proportion of emissions since 2007. In 2020, the global footprint of the technology industry will be comparable to that of the airline industry. In 2020, data centers are expected to make up about forty-five percent, and network infrastructure about twenty-five percent, of the technology sector's total ecological footprint.[44] As a consequence of this, and because data centers will probably continue to become more common, more and more attention should be given to their environmental impact.

Based on the CUE, clean data centers can only really be "clean" if the electricity they use is from low-carbon sources. As mentioned in this article, there is a limit to the amount of power that can be generated from renewable energy sources. The demand for electricity by data centers in Switzerland can thus generally not be met only with power from renewable sources. Using waste heat or power generated by incinerators, for example, can improve climate-friendliness. Placing data centers adjacent to cooling water and an electricity-generating site is also an attractive option. This proximity guarantees a minimal loss of energy in transmission, and the data center can make use of free cooling in the form of water from a nearby lake, for example. Employing such advantages can pay off economically as well. An Austrian cryptocurrency-mining company named HydroMining, located in close proximity to water and to a hydroelectric plant, has lower energy and cooling costs than its competitors and thus has a competitive advantage.[45] Economic advantages are boosted even further by having a "green" reputation. That's why even data centers run by Big Tech companies such as Apple and Facebook are attempting to capitalize on such advantages. In recent years, through the increased use of renewable energy sources, they have actually been able to achieve a smaller ecological footprint.[46]

Using water to cool data centers is, however, not entirely without its problems. Water is a valuable natural resource that should be used sustainably—even by data centers. In order to quantify this aspect for data centers, one could consider "water usage effectiveness" (WUE) as an indicator, measured in liters per kilowatt-hour | Table 1 |.[47] The denominator of WUE, just as with PUE and CUE, registers the "energy consumption by IT equipment," while its numerator is the annual water consumption by a data center. As with CUE, the theoretical ideal value, viewed in isolation, is zero. However, competition between different usages of water must be taken into account when interpreting these values, so that not only zero, but also various other low values, may still be considered reasonable.

44

Lotfi Belkhir, and Ahmed Elmeligi, "Assessing ICT Global Emissions Footprint: Trends to 2040 & Recommendations," *Journal of Cleaner Production* 177, (March 2018), pp, 448–63.

45

Frank Schmiechen, "Two Austrians start a 65-million-Euro-ICO," *Gründerszene Online Article* (October 18, 2017), https://www.gruenderszene.de/allgemein/hydrominer-ico-start (retrieved July 3, 2020).

46

David Klier, "Die grünen Rechenzentren kommen," *IT-MARKT Online Article* (March 21, 2015), https://www.it-markt.ch/news/2015-03-01/die-gruenen-rechenzentren-kommen (retrieved July 3, 2020).

47

Michael Paterson et al, "Water Usage Effectiveness (WUE™): A Green Grid Data Center Sustainability Metric," *the green grid White Paper*, no. 35 (December 2010), https://airatwork.com/wp-content/uploads/The-Green-Grid-White-Paper-35-WUE-Usage-Guidelines.pdf (retrieved July 3, 2020).

Renate Schubert
Scherwin Bajka
Fatih Öz

If the sustainability of data centers is to be enhanced, the task is then to simultaneously optimize the power usage effectiveness (PUE), carbon usage effectiveness (CUE), and water usage effectiveness (WUE). The solution to this task is complex and will necessarily produce varied results, not least as a result of location. The Ostschweiz (Eastern Switzerland) data center in Gais and the Swisscom data center in Wankdorf are interesting examples in which sustainability (such as from reusing waste heat) plays an important part and the concept of efficiency is firmly established. The PUE of the data center in Wankdorf is a low 1.2; this data center is, compared to the European average, forty percent more efficient in terms of its power consumption.[48] The data center in Eastern Switzerland boasts an even lower PUE of 1.15 and also reuses the heat it produces.[49] Furthermore, this data center generates its own electricity from renewable sources, mostly solar energy. In-house electrical generation from renewable energy sources allows the quantitative limit of renewable energy on the market to be raised significantly or even be bypassed. The energy mix of a "self-sufficient" data center such as this can, therefore, be comparatively "clean" and also independent of foreign terms of delivery. The more that Swiss data centers obtain electricity from their own renewable sources, the greater their future attractivity in terms of "cleanness" (recognizable in their ecological balance or indicators of efficiency such as those listed above) and their independence on an international scale will be. It remains an open question what conditions will make it attractive enough for Swiss data centers to lean more toward having their own sustainable and CO_2-free—in other words, "clean"—power generation. Without stronger political pressure, not much may be achieved here. It is interesting to note, however, that a petition by Google employees recently took things in precisely this direction and put a fair amount of pressure on the company.[50]

48

Swisscom, "Swisscom opens one of Europe's most advanced and efficient data centres in Berne-Wankdorf," *Swisscom Press Release* (September 16, 2014), https://www.swisscom.ch/en/about/news/2014/09/20140916-Rechenzentrum-Wankdorf.html.html (retrieved January 23, 2020).

49

Rechenzentrum Ostschweiz, "ZAHLEN & FAKTEN – Hochverfügbar und umweltschonend," *Rechenzentrum Ostschweiz Website Content*, https://www.rechenzentrum-ostschweiz.ch/zahlenfakten/ (retrieved February 2, 2019).

50

Shirin Ghaffary, "More than 1,000 Google employees signed a letter demanding the company reduce its carbon emissions," *Vox* (November 4, 2019), https://www.vox.com/recode/2019/11/4/20948200/google-employees-letter-demand-climate-change-fossil-fuels-carbon-emissions (retrieved January 23, 2020).

Conclusion

Swiss data centers consume large quantities of foreign electricity, particularly in the winter months. This is less environmentally friendly than using power generated domestically. As a consequence, Swiss data centers are less "clean" than they appear at first glance. In order to be less dependent on electricity that involves CO_2 emissions, data centers must, among other things, increase their (energy) efficiency. Even so, data processing will not be completely emissions-free for the time being. At best, this could happen if data centers were to generate their own electricity entirely from renewable energy sources and derive cooling energy from their immediate surroundings. If water is strongly relied upon as a resource, however, it must be taken into account that its use for data centers could be more controversial than the use of other renewable energy sources. Power generation from solar or wind energy would probably entail less conflict, but would involve other disadvantages, such as variability in production or the obstruction of landscapes and the environment. Waste heat, by contrast, would limit these disadvantages, but would not be available in sufficient quantity.

Thus, it can be shown that there is no easy solution to keeping data centers "clean" from an energy technology perspective. An increasing focus on electricity from renewable resources would appear important. Only in this way will data centers be able to meet the demands of sustainability and thus be fit for the future as the amount of data stored and processed continues to increase.

The figures in this chapter have been stylized, leading to minor deviations from their statistically accurate version. The readers are welcome to contact the authors to request a copy of the data used for creating the graphs.

Zug

Crypto Valley after
Vitalik Buterin

Monika Dommann

Everyone has heard of Silicon Valley. It's not really a valley. Rather, it's a high-tech industry location whose roots extend back to vacuum tube production in the 1930s.[1] After 1970, "Silicon Valley" established itself as the name for the computer industry on the West Coast of the United States. It now stands for the garage economy, Teslas, and Internet giants.

But who's heard of Crypto Valley? It's not a valley either. It's one of the most economically powerful cantons in Switzerland. Measured by GDP per capita, the Canton of Zug is second only to the city of Basel in 2017—and ninety-two percent above the Swiss average.[2] The canton has grown considerably since the turn of the millennium. According to the federal census, 126,837 people lived in the Canton of Zug in 2018.[3] By comparison, in the same year, 33,038 companies had entries in its commercial register.[4]

The Commercial Register

The Commercial Registry Office of the Canton of Zug is located at Aabachstrasse 5, behind the Zug railway station. Since 1883, when the young Swiss federal state adopted the Code of Obligations, all cantons have been obliged to maintain a commercial register.[5] The commercial register was created as a minimal means of transparency in a liberal constitutional state. Since then, it has collected information on commercial enterprises which it has made available to the public: their purpose, share capital, the persons involved, any changes or bankruptcies. And since World War I, as a countermeasure against the so-called foreign economic "infiltration" of Switzerland, the nationality of those on their boards of directors as well.[6]

The notary's offices or law firms that have completed the formalities for their clients still send the documents in hard copy by postal mail to Aabachstrasse 5. An electronic delivery platform does exist in Zug, but it is hardly used because it would require a corresponding digital signature (a SuisseID), which very few people have.[7] In the Canton of Zug, the entries in the commercial register are then printed in the canton's official journal and published on the website of the Cantonal Commercial Registry Office.

On August 22, 2013, the Commercial Registry Office in Zug published a new entry concerning Bitcoin Suisse AG, headquartered at

1
Christophe Lécuyer, *Making Silicon Valley: Innovation and the Growth of High Tech, 1930–1970*, Cambridge, MA, 2006.

2
GDP of the Canton of Zug: https://www.zg.ch/behoerden/gesundheitsdirektion/statistikfachstelle/themen/volkswirtschaft-1 (retrieved February 1, 2020). See also the statistics from the Federal Statistical Office for the Canton of Zug: https://www.bfs.admin.ch/bfs/de/home/statistiken/regionalstatistik/regionale-portraets-kennzahlen/kantone/zug.html (retrieved February 1, 2020).

3
Population of the Canton of Zug: https://www.zg.ch/behoerden/gesundheitsdirektion/statistikfachstelle/themen/01bevoelkerungszahlen/bevoelkerungsstand (retrieved February 1, 2020).

4
Corporate entities in the Canton of Zug: https://www.zg.ch/behoerden/gesundheitsdirektion/statistikfachstelle/themen/volkswirtschaft-1 (retrieved February 1, 2020).

5
Aug. Rothpelz, "Handelsregister," in *Handwörterbuch der schweizerischen Volkswirtschaft, Sozialpolitik und Verwaltung*, vol. 2, edited by N. Reichesberg, Bern, 1903–1911, pp. 545–47.

6
Martin Lüpold, *Der Ausbau der "Festung Schweiz." Aktienrecht und Corporate Governance in der Schweiz, 1881–1961*, PhD diss., University of Zurich, 2008.

7
Telephone conversation between Sascha Deboni and Birgit Urbons, October 4, 2019. Kanton Zug, "Handelsregisteramt: Elektronische Anmeldung," https://www.zg.ch/behoerden/volkswirtschaftsdirektion/handelsregisteramt/elektronische-anmeldung-an-das-handelsregisteramt (retrieved February 1, 2020).

Fig.1

Mühlegasse 18 in Baar.[8] According to the company's articles of incorporation, the purpose of the company is to provide "services related to alternative payment methods," with the provision that the purpose is to "provide opportunities to buy and sell alternative payment methods." Among the registered directors of the Baar start-up was Niklas Nikolajsen, a Danish citizen. The share capital amounted to 100,000 Swiss francs.

A few weeks later, on October 30, 2013, the Commercial Registry Office published the entry of Monetas AG, headquartered at Baarerstrasse 14 in Zug. Johann Lothar Gevers, a Canadian citizen residing in Zug, was registered as chairman of the board.[9] The company's purpose is cryptically described as the "development, marketing, and licensing of software."

Finally, six months later, on July 14, 2014, the commercial register published the entry of the Ethereum Foundation. According to its purpose, the foundation aims in particular "to promote new open decentralized software architectures" and "to enable, promote, and maintain decentralized and open new technology structures." The focus is "to promote the development of the so-called Ethereum Protocol."[10] Among the members of the foundation's board: Russian-Canadian dual national Vitalik Buterin, Canadian national Mihai Alisie, and American national Taylor Gerring.

These three entries in the commercial register mark the beginning of an episode in the recent economic history of the Canton of Zug to which the media have devoted their attention since 2014, labeling it "Crypto Valley."

The history of the Internet, and specifically the history of the emergence of information technology infrastructures for financial transactions, is not based on hardware and software alone. In addition to the computer programs required for this purpose (which are coded by nomadic developers), the white papers (reports by the IT industry addressed to the public), server farms (now mostly located in northern Europe and China) and Bitcoin vaults (which are often stored in decommissioned military bunkers in the Swiss mountains), decentralized blockchain architectures also rely on other infrastructures rooted in certain countries and specific locations: the legal regulations of the financial supervisory authorities and the services of law firms and trust companies. The Canton of Zug is a focal point of these infrastructures. Important providers of storage facilities for electronic data such as Mount10 AG[11] and Xapo[12] are headquartered in the Canton of Zug.

8

See Doku-Zug, "53.2.115 Krypto-waehrungen Kt. Zug 2013–2017": "Bitcoin Suisse AG (Bitcoin Suisse SA) in Baar," in *Amtsblatt des Kantons Zug* (September 13, 2013), p. 99. See also the current entry: Kanton Zug, "Bitcoin Suisse AG," *Handelsregister,* https://zg.ch-register.ch/cr-portal/auszug/auszug.xhtml?uid=CHE472.481.853 (retrieved February 1, 2020).

9

Kanton Zug, "Monetas," *Handels-register,* https://zg.chregister.ch/cr-portal/auszug/auszug.xhtml?uid=CHE-335.879.932 (retrieved February 1, 2020).

10

Kanton Zug, "Stiftung Ethereum," *Handelsregister,* https://zg.chregister.ch/cr-portal/auszug/auszug.xhtml?uid=CHE-292.124.800 (retrieved February 1, 2020).

11

See https://www.mount10.ch/ and Kanton Zug, "Mount10 AG," *Han-delsregister,* https://zg.chregister.ch/cr-portal/auszug/auszug.xhtml?uid=CHE-113.700.136 (retrieved February 1, 2020).

| Fig. 1 | Commercial Registry, Office Zug. Entry: Bitcoin Suisse AG, August 22, 2013. (Doku-Zug, 53.2.115 Kryptowährungen Kt. Zug 2013–2017: "Bitcoin Suisse AG (Bitcoin Suisse SA) in Baar," in *Amtsblatt des Kantons Zug*, September 13, 2013, p. 99)

AMTSBLATT DES KT. ZUG

Nr. *37* dat. *13.9.13*

AMTLICHER TEIL 99

3715

22.08.2013 *53.3 500 Tauschhandel* (11329)

Bitcoin Suisse AG (Bitcoin Suisse SA) (Bitcoin Suisse Inc) (Bitcoin Suisse Ltd), i n B a a r , CH-170.3.038.103-0, Mühlegasse 18, 6340 Baar, Aktiengesellschaft (Neueintragung). Statutendatum: 14.08.2013. Zweck: Dienstleistungen rund um alternative Zahlungsmethoden. Die Leistungen umfassen die Bereitstellung von Möglichkeiten zum Kauf und Verkauf alternativer Zahlungsmittel und damit im Zusammenhang stehende Beratung; vollständige Zweckumschreibung gemäss Statuten. Aktienkapital: CHF 100'000.00. Liberierung Aktienkapital: CHF 50'000.00. Aktien: 1'000 Namenaktien zu CHF 100.00. Publikationsorgan: SHAB. Die Mitteilungen an die Aktionäre erfolgen durch Publikation im SHAB oder, sofern die Adressen sämtlicher Aktionäre bekannt sind, durch eingeschriebenen Brief, Telefax oder E-Mail. Mit Erklärung vom 14.08.2013 wurde auf die eingeschränkte Revision verzichtet. Eingetragene Personen: Wetlesen, Rune Wessel, dänischer Staatsangehöriger, in Baar, Präsident des Verwaltungsrates, mit Kollektivunterschrift zu zweien; Phan, Charles, dänischer Staatsangehöriger, in Unterägeri, Mitglied des Verwaltungsrates, mit Kollektivunterschrift zu zweien; Nikolajsen, Niels Niklas Bang, dänischer Staatsangehöriger, in Baar, Mitglied des Verwaltungsrates, mit Kollektivunterschrift zu zweien; Schweifer, Johannes Michael, österreichischer Staatsangehöriger, in Zürich, Mitglied des Verwaltungsrates, mit Kollektivunterschrift zu zweien.

The Documentation Center

Since the 1980s, Daniel Brunner, son of the industrialist family that had managed the Landis & Gyr meter factory until 1987, has been collecting documents on Zug's recent social and economic history.[13] These have grown into a unique archive of the Central Swiss Canton on St.-Oswalds-Gasse on the edge of the old town in Zug. The documentalists at the Doku-Zug Documentation Center started a new portfolio in 2013. Its title: "Cryptocurrencies of the Canton of Zug." Over the years, the folders have grown into a neat stack of paper. On the basis of newspaper articles and the collected entries from the commercial register, one can trace how, after the establishment of Bitcoin Suisse AG, Monetas AG, and the Ethereum Foundation, a veritable hype arose around the arrival of companies in the field of cryptocurrencies and blockchain. The media reports do not simply bear witness to this hype, but were themselves a driving force behind it, helping to spread stories about the ascent of Zug from a paradise for tax attorneys and a hub of commodities trading to a digital hub of the new economy of the twenty-first century. Reading the stack of press releases at the Documentation Center, I could not help but feel that the media there often operated in a mode of self-fulfilling prophecy. Prophesies of a coming big blockchain and Bitcoin revolution are followed by reports of small blockchain and Bitcoin revolutions.[14] And the warnings of scams, fraud, and crime are inevitably followed by reports of plunging stock prices, money laundering, and a "high-risk area" called "Crypto Valley."[15]

Signs of Cryptoeconomics in Zug

Searching for real traces of these cryptoeconomic revolutions that had been circulated by the media, I set out to search the Canton of Zug for the addresses I had come across in the commercial register entries. I found some relevant company names on the mailboxes of fiduciary and law firms (for example, on Zugerstrasse in Baar and on Baarerstrasse in Zug). I also ran aground several times. Had companies been dissolved or moved on? Nevertheless, there were signs and symbols here and there that pointed to cryptocurrencies. On Bahnmatt in Baar, for example, I saw a sticker with the Bitcoin symbol on an apartment door in an unadorned apartment building, next to which a child's grass-green skibob was leaned. On my walks, I also discovered traces of the old textile industry that had settled on the Lorze in Baar in the nineteenth century.[16] In the meantime, this area had been converted into the industrial park on the Lorze (at Haldenstrasse 1) and the Spinni complex (at Haldenstrasse 5). On the mailboxes, I came across company names such as

12

See Kanton Zug, "Xapo GmbH," *Handelsregister*, https://zg. chregister.ch/cr-portal/auszug/ auszug.xhtml?uid=CHE-166.362. 115 (retrieved February 1, 2020).

13

See Doku-Zug, https://www. doku-zug.ch/ueber-doku-zug.html (retrieved February 1, 2020).

14

See, for example, Doku-Zug, "53.2.115 Kryptowaehrungen Kt. Zug 2013–2017": Alexandra Bröhm and Christoph Behrens, "Am Vorabend der Bitcoin-Revolution," *Sonntags- zeitung*, no. 25 (June 18, 2017).

15

See, for example, Doku-Zug, "53.2.115 Kryptowaehrungen Kt. Zug 2013–2017": Werner Vontobel, "Crypto-Valley wird zum Jammer- tal," *Blick*, no. 265, (November 14, 2017), p. 10.

tendex GmbH (development of computer software in the field of automated trading and arbitrage with securities, foreign exchange, commodities, and cryptocurrencies)[17] and PrepayWay AG (development and maintenance, design, distribution, and licensing of software products, particularly in the real estate sector).[18] There was also more than just mailboxes to discover on these commercial register walks in Zug. In the post and telegraph building on the Postplatz in Zug, which had been built in "Renaissance style" around 1900,[19] the Officelab had moved in and rented out co-working spaces.[20] Just opposite the co-working space in the restaurant/bar plaza, I discovered a sticker ("WE ACCEPT: bitcoin, ethereum") that also referred to Bitcoin Suisse AG (which I had already encountered in the commercial register).

A little further from the center of Zug, in the Lower Old Town, the streets were richly decorated with the flags of Zug and Switzerland on that Friday before the *Eidgenössisches Schwing- und Älplerfest* (big Swiss Wrestling and Alpine Festival) in late August 2019. On a mailbox, I found a sign bearing the name of one of Crypto Valley's illustrious personalities, Johann Gevers. In 2014, the *Neue Zürcher Zeitung* (*NZZ*) had reported on the libertarian "visionary" (born in apartheid South Africa) who had published a libertarian manifesto in the 1990s[21] and had dreamed of founding a "free city" in Honduras with Patri Friedman (the grandson of Milton Friedman).[22] Under the sign, someone had used a black marker to write "Monetas" (the name of a company that no longer exists) on a paper sticker and below it, separated by a line, scribble "Crypto Valley GmbH" (a company that Johann Gevers had registered[23] in 2014).

The commercial register entries had led me to real addresses. But increasingly, I wondered what I was actually looking for. More than thirty years ago, I had moved away from the Canton of Zug, where I was born and raised. As a high-school student, I had soldered together components for meters at the Landis & Gyr meter factory. Later, as a waitressing student, I

16

See Gisela Hürlimann, *Open End – Baar und seine Spinnerei. Von der industrialisierten zur postindustriellen Gesellschaft*, in Staatsarchiv des Kantons Zug, ed., *Zug erkunden. Bildessays und historische Beiträge zu 16 Zuger Schauplätzen. Jubiläumsband Zug 650 Jahre eidgenössisch*, Zug, 2002, pp. 208–31.

17

Kanton Zug, "tendex GmbH," *Handelsregister*, https://zg.ch-register.ch/cr-portal/auszug/auszug.xhtml?uid=CHE-219.473.382 (retrieved February 1, 2020).

18

Kanton Zug, "PrepayWay AG," *Handelsregister*, https://zg.chregister.ch/cr-portal/auszug/auszug.xhtml?uid=CHE-370.342.884 (retrieved February 1, 2020).

19

Christine Kamm-Kyburz (with Christian Raschle), *Zug. Architektur und Städtebau 1850–1920, Inventar der neueren Schweizer Architektur 1850–1920*, INSA, vol. 10, Zurich, 2004, p. 81.

20

Office Lab, "Office Lab Freiruum," https://www.officelab.ch/standorte/zug-freiruum/ (retrieved February 1, 2020). These spaces have since moved to the Freiruum on Zählerstrasse in the former factory building of Landis & Gyr.

21

As of February 2020, there is still a URL registered in 2006 (http://freedomuniversal.com/) that refers to Johann Gevers as the founder of Freedom Universal.

22

Doku-Zug, "53.2.115 Krypto-waehrungen Kt. Zug 2013–2017": Matthias Sander, "Visionäre aus 'Crypto Valley'. Wie Internetunternehmer aus Zug die Welt verbessern wollen," *NZZ*, no. 210 (Sepember 11, 2014).

23

Kanton Zug, "Crypto Valley GmbH," *Handelsregister*, https://zg.chregister.ch/cr-portal/auszug/auszug.xhtml?uid=CHE-499.848.828 (retrieved February 1, 2020).

happened to witness a luncheon at a small private function in the Casino Restaurant (this was in late 1986 or early 1987) to celebrate the sale of the Landis & Gyr meter factory to entrepreneur and financier Stephan Schmidheiny. The old manager of Landis & Gyr, Andreas Brunner, was already badly afflicted by his illness, of which he died a few weeks later. He had hoped, they said, that the sale to Schmidheiny would secure an industrial future for the well-established meter factory. Things were to turn out differently. Schmidheiny sold the company to Elektrowatt, which in turn sold it to Siemens.[24] In the meantime, the old factory site behind the railway station has become the city's urban development area.

In Search of Crypto Valley

Something seems to have happened in Zug. But what? Could the launch of Crypto Valley perhaps be the key to learning something about the intersection of local economies and decentralized technical infrastructures? Could the small canton of Zug be used as an example to study the relationship between national law, local politics, and the globally oriented New Economy? This, particularly in view of the fact that a dense network of fiduciary and law firms with expertise in holding and domiciliary companies and tax services for an international clientele has been established in the canton since at least the 1960s?[25] Is the launch of Crypto Valley simply the follow-up to the El Dorado of fiduciary and law firms, which many scandals (white-collar crime, espionage, and dubious transactions) in the 1980s and 1990s repeatedly brought into the national and international spotlight?[26] In a canton which, after the demise of major industrial enterprises (Ägeri textile mill, Spinnerei an der Lorze in Baar, Landis & Gyr in Zug) around 1990, had become an international financial, commercial, and service center?

The emergence of Crypto Valley as an event of recent history is completely unsuited to research using the methods of the historian. The records of the city, the canton, the courts, and possibly the law firms will not be available for several decades. Whether the portals, websites, and chats of the cryptocurrency and blockchain community and the volatile start-up companies will ever be accessible to historians is more than doubtful. Nevertheless, I decided in the summer of 2018 to make a first attempt at a history of Zug at a socio-technological and socioeconomic turning point. After reading the commercial register entries and media reports, I talked to some of the protagonists between December 2019 and February 2020.[27] I listened to their stories and was particularly interested in the period between 2013 and 2016. The selected interviewees were contacted according to a snowball

24

Renato Morosoli, "Landis & Gyr," in *Historisches Lexikon der Schweiz* (HLS), July 12, 2019, https://hls-dhs-dss.ch/de/articles/041874/2019-07-12/ (retrieved February 1, 2020).

25

On the history of tax legislation in the Canton of Zug, see Michael van Orsouw, *Das vermeintliche Paradies. Eine historische Analyse der Anziehungskraft der Zuger Steuergesetze*, Zurich, 1995.

26

See also the sensational reports by journalists Ruedi Leuthold, Niklaus Meienberg, and Erich Koch: Ruedi Leuthold, "Zug & Co. Int. Holding A. Drehscheibe des eidg. Männlichen Braunvieh-Samengutes und des int. Kapitals," *Die Region*, no. 38 (September 29, 1982), pp. 14–21; Niklaus Meienberg, "Zug– fast wie Dallas," *Bilanz*, no. 6 (June 1984), pp. 92–111; Erwin Koch, "Das Millionending. Die Kleinstadt Zug ist Zentrum grosser Geschäfte," in *Schweiz*, edited by Will Keller,

Merian. Das Monatsheft der Städte und Landschaften, Hamburg, 1991), p. 44–48.

Table 1

Selected crypto-related entries from the commercial register, Zug.

A
0KIMS
21Shares AG (ehem. Amun)
AButure
Abypay AG in Liquidation
Acatena
Accloud Switzerland
Adara in Liquidation
AirToken
akabenos
Aladin Consulting
Alessio Palmieri
Ampere Energy Investments
AMT Capital AG
Andromeda Suisse
Anon
APPICS
Aragon One
Artemesiumtrust Masters
ARXUM Business
ASQ Network
Astratum
ASURE STIFTUNG
Autark Ventures
AXEOM

B
B&B GAIN Partners
Banx.one
bardicredit
Base58 Capital
BaselBit Zug
BC-Investment
BETREASURY Asset Management
BIAMON
Binance (Switzerland)
Binfinity
Biocryptology neu: CERTUM Technology AG
BitBoost Technologies GmbH in Liquidation
Bitcoin Genesis
Bitcoin Suisse
BitcoinOil
Bitfineon GmbH in Liquidation
Bitfinitum LLC
Bitmain Switzerland
BITNATION GmbH in Liquidation
Bitproperty GmbH in Liquidation
Bitscale Capital
Blicico
BLOCK NET
Block Stocks Swiss
Blockchain (Switzerland)
Blockchain Applications
Blockchain Company
Blockchain Exploration
Blockchain Hill Ventures
Blockchain Propulsion
Blockchain Source
Blockchain Source Betschart
Blockchainpark
BlockDev
BlockLogiX
BlockState
Bloomio
Bloxolid
bloxxter
Bluenote World AG in Liquidation
BONATHAN INNOVATIVE TECHNOLOGIES

C
Calamnius Consulting
Chain M
Chaince Blockchain International
ChainTech
Chainwork
ChainX
CHINA INVESTMENT SUISSE
Codex Execution
Coinmat
Coinounce GmbH in Liquidation
Coinvista
Collider
Commtact
Comply Now
Concordium
Corion Stiftung
Craider Technologies
Cryptadvise
Cryptix
Crypto Broker
Crypto Economics
Crypto Finance
Crypto Fund
Crypto Invest
Crypto Land Fund
Crypto Real Estate
Crypto Storage
Crypto Technology
Crypto Valley
Crypto Valley Association (CVA)
CRYPTO VALLEY PARTNERS
CryptoAssetPro GmbH in Liquidation
crypto-bond
Cryptocurrency & Blockchain Assets AG in Liquidation
CryptoHawk AG in Liquidation
cryptolounge
Cryptonomics Capital
Cryptosphere Systems
cryptostage
CryptoStars
C-Trading Growth
CX Solutions

D
dlFinTech
Dacoco
DactaTrace.swiss
Darico
Dark Matter
Dash Suisse
Decentriq
Demiurge Technologies
DEZOS
DIE QRL STIFTUNG
DIFF Schweiz
Digipharm GmbH in Liquidation
Digital Assets Legal Advisors
Digital Finance Compliance Verein (DFCA)
Digital Wave Finance
DLT Advisory Xperts
Dr. Mattia L. Rattaggi, Advisory and Consultancy
Drakkensberg
Dynamic Blockchain Group
Dynasty Global Investments
DYOS

E
eCharge.io
eCharge.work
EISENRING Digital Assets
element36
eMBe Consulting
eMusic.com Switzerland
Energy Web Stiftung
Enigma Digital Assets
envion AG in Liquidation
Equibit Group
Ethereum Switzerland GmbH in Liquidation
EveriToken
ExChainger GmbH in Liquidation
Exfluency

F
FanGold
FasT Software
FETCH BLOCKCHAIN LTD, London, Zweigniederlassung
Finnowex
Flame Technologies
FLUSH Global Rewards
Foin Foundation
Food Forward Group
ft.digital fintech
Future Wealth & Technologies
Futurix Lab

G
GC Exchange Switzerland
GC Holding
Genesis IT
GHU
GIWAG
GloBee International
Goldcoin
GVEX

H
Hashtrend
HDAC Technology
heller.ch Consulting Pierre-M. Heller
Hey, Be Well!
HODLR
HumanAI AG in Liquidation
HVLA
Hypoterra

I
ICOVO
ilg solutions
INDIGI TOKEN
INFRA - Investments
Inspirant (Schweiz)
integratedCAPITAL
International Cryptocurrency Exchange
Interprom Mining
INVESTMENT SOLUTIONS
ioVentures
IOVO Ledger
iprotus
IPVISIONTECH
iVirtual Technologies AG in Liquidation
iZiFinance

J
Jibrel
JobCoin

K
Kepler Technologies
Kore Technologies
Korona Blockchain Ecosystem
Kress Crypto Consulting
KryptoPal
Kuende Swiss

system. They represent only some of what was happening at that time. All the interviewees are still working and living in Zug. They are all men. They are mostly middle-aged and established in Zug society. And they are convinced of the future viability of the cryptocurrency and blockchain companies in the Canton of Zug. I often noticed that they were not telling their stories for the first time. These are the same stories that have probably been told to business partners, investors, or journalists. I therefore tried to open up other perspectives. The stories sometimes contradicted each other. The paths of the protagonists had all crossed at some point between 2014 and 2016. But one could see that this period gave rise not only to friendships but also to rifts. A future long-term study would have to include those who were in Zug for only a short time, and in particular the sceptics, critics, and those who faltered. I have not, for example, spoken with the driving forces of the younger generation (who have already appeared in many media reports), such as Mihai Alisie (who had been the first to talk to Herbert Sterchi, the ambassador of the Canton of Zug, in December 2013) and Vitalik Buterin (who lived in the Canton of Zug in 2014). Based on the accounts of contemporary witnesses, Vitalik (as everyone calls him) was an important catalyst in linking the blockchain scene with the Canton of Zug. However, I just missed him. On November 30, 2018, he was on his way to Basel to receive the honorary doctorate awarded him by the School of Economics[28]—because he had paved the way for science and industry to work together to further develop blockchain technology for the benefit of mankind, as Aleksander Berentsen, a professor of economics, stated in his tribute to him.

From Credit Suisse to Bitcoin Suisse

Grafenauweg 12: an office building behind the railway station. Directly opposite is the Commercial Registry Office of the Canton of Zug. Here in Zug, distances are short. Downstairs in the lobby, by the window, a polyester sculpture of a bull bears the logo of Bitcoin Suisse AG. The bull is reminiscent of the cow statues that the City Association of Zurich set up on the streets of the city in 1998. But the bull, I later learned, is an important reference in Bitcoin culture: in the financial world, it's a symbol of bullish markets, i.e. markets with rising prices.[29] This symbolism is not new, but is based on the culture of the stock markets, where the bull stands for rising prices and the bear for falling prices. In the offices upstairs, I again discover a bull in a gaudy work of art in the lobby: a bull adorned with Bitcoin necklaces, striking a defiant pose in front of a rock face. In the artwork on the opposite wall, I see a Viking (with a Bitcoin tattoo on his arm) defying the head of a dragon. A circular rug on the floor bears the symbol of atomic radiation, and in the middle of it is once again

| Fig. 2 |

27

Doku-Zug, "53.2.115 Kryptowaehrungen Kt. Zug 2013–2017": "Crypto Valley Association gegründet," *Stadtmagazin*, no. 17 (May 2017).

28

University of Basel, Center for Innovative Finance, "Vitalik Buterin erhält die Ehrenpromotion der Wirtschaftswissenschaftlichen Fakultät der Universität Basel anlässlich des Dies Academicus am 30. November 2018," press release, https://wwz.unibas.ch/fileadmin/ user_upload/wwz/Pressemitteilung_ Vitalik_EN.pdf (retrieved February 1, 2020).

29

E-mail from Marc Baumann, Bitcoin Suisse AG, to Monika Dommann, February 14, 2020.

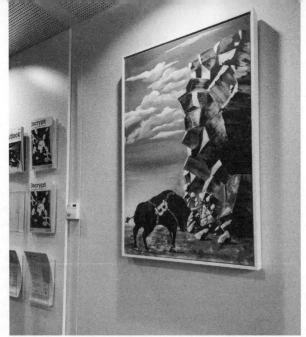

the Bitcoin logo. Is this a sign that the wallet (a virtual purse containing client software that provides access to cryptocurrency transactions) would survive even a nuclear apocalypse intact?[30]

Anyone who enters Crypto Valley enters a world whose language and symbols must first be deciphered by outsiders. Much (but not everything) in this world revolves around the movement of the markets. In the functional rooms, divided into plain meeting rooms and open-plan offices, I see lots of large screens on which graphs of the exchange rates could be followed live.

Niklas Nikolajsen, founder and president of the board of Bitcoin Suisse AG, welcomes me warmly.[31] He wears his long hair bound up. His clothes (black trousers, black waistcoat with a gold chain of Bitcoins and a long black jacket) remind me (perhaps because of the many buttons and the finely crafted buttonholes and collars) more of the men on the cover of the Beatles' *Yellow Submarine* album than of a licensed banker in the making.

Niklas Nikolajsen (born in 1975, according to Wikipedia) is a gifted storyteller. I had heard many of his stories on YouTube and in interviews.[32] I had seen him among a group climbing a snow-covered Swiss mountain (with ropes, climbing harnesses, carabiners, and crampons) to hoist the Bitcoin flag. I tried to elicit new stories from him. Even when it came to the most minor incidents in his life, Nikolajsen always returned to the basics. His father, originally a farmer in Denmark, had worked in relief aid in Africa since the 1960s, first for the Danish church and then ultimately for the United Nations. During stays with his parents in African countries (including Ethiopia, Liberia, Sierra Leone, Namibia, Mauritania, Tanzania, and Kenya), he saw in some of these how dysfunctional systems of government can be. Nikolajsen attributes his libertarian attitude to experiences in his youth in Africa. Corrupt dictators could use their citizens' money to enrich themselves or wage wars: "What if we

30

On this, see also the article in *Blick*, a tabloid newspaper: Patrick Züst, "Der geheime Schatz der Krypto-Milliardäre. Codes lagen in Militär-bunkern," *Blick* (December 14, 2018), https://www.blick.ch/news/wirtschaft/codes-lagern-in-alten-militaerbunkern-der-geheime-schatz-der-krypto-milliardaere-id1506-5637.html (retrieved February 1, 2020).

31

The conversation with Niklas Nikolajsen was held on February 1, 2020. Unless otherwise stated, the following information refers to this interview.

32

See "Bitcoin Suisse—Daring to Do Since 2013," https://www.bitcoinsuisse.com/news/bitcoin-suisse-daring-to-do-since-2013/ (retrieved February 1, 2020).

33

Unless otherwise stated, the following remarks refer to Finn Brunton, *Digital Cash: The Unknown History of the Anarchists, Utopians, and Technologists Who Built Cryptocurrency*, Princeton, 2019. See also Nigel Dodd, "The Social Life of Bitcoin," *Theory, Culture & Society* 35 (2018), pp. 35–56.

had a world where money was not political? More like a neutral tool of the people?" Why, then, did he join a bank (Credit Suisse) of all things after completing his BA in computer science? Nikolajsen responds that this was not a decision he'd made on his own. He'd worked for three different consultancies as a computer programmer and was contracted out by his employer for projects. That's how he ended up at Credit Suisse from 2011 to 2013.

Utopias of Spontaneous Order

Finn Brunton has highlighted the utopian character of the projects involved in the development of cryptocurrencies since the 1980s.[33] One could start the tale in California with the cypherpunk scene, a community that was driven by the big questions "on authority, sovereignty, and the nature of value."[34] With the open source communities that communicated via mailing lists. With the hacking conferences, where programmers and electrical engineers met with legal hackers from the Electronic Frontier Foundation. With operators of illegal businesses and activities who were interested in anonymous channels of transaction. With utopians who thought about cryptocurrencies because they were interested in privacy, freedom, or because they wanted to develop cryptocurrencies as a lever for a general transformation of the world, and who were inspired by the economists of the Austrian School, Ludwig von Mises and Friedrich von Hayek.[35] That Friedrich von Hayek, who was guided by physiological and cybernetic ideas when he spoke of "spontaneous orders" and "self-organizing systems" in 1968.[36] And in so doing, he wanted to limit the state ("public power") to "protecting the individual from the pressure of society," which in his view "only the institution of private property, and all the liberal institutions of the rule of law associated with it, can bring about."[37]

The crypto-anarchic visions of a loose network of criminals, do-gooders, hackers, libertarians, and utopians were able to take off at the height of the global financial crisis in the autumn of 2008. At the time of the most serious banking crisis since the Great Depression, decentralization could now be seen as salvation from a banking system perceived as corrupt. On Halloween night 2008, Satoshi Nakamoto (a pseudonym for a woman, a man, or even a group) sent a message to a mailing list—"I've been working on a new electronic cash system that's fully peer-to-peer, with no trusted third party."[38]—with a link to a white paper announcing nothing less than the abolition of financial institutions as intermediaries in the financial system.[39] The paper is nine pages long, including references. It is written in a way that can be understood by laypersons and contains the requisite mathematical formulas for the initiated. A few weeks later (on January 3, 2009), Satoshi Nakamoto

34

Brunton 2019, p. 68.

35

Friedrich August von Hayek, *Der Wettbewerb als Entdeckungsverfahren*, Kiel, 1968. See also the English translation by Marcellus S. Snow: F. A. Hayek, "Competition as a Discovery Procedure," *Quarterly Journal of Austrian Economics* 5, no. 3 (Fall 2002), pp. 9–23, https://cdn.mises.org/qjae5_3_3.pdf.

36

Hayek 2002, p. 15.

37

Ibid., p. 19.

created the very first block: the genesis block. This day is considered *ex post* to have seen the birth of a technology that is now called blockchain.

Niklas Nikolajsen became aware of Bitcoin in 2010: "A friend urged me to read the Nakamoto white paper on Bitcoin." The semantics of religious conversion resonate in Nikolajsen's stories. For example, when he says that he didn't read even half of the paper, but knew immediately that the system could work. Or when he talks about the sermons he gave during his time at Credit Suisse: "I was preaching Bitcoin during every lunch break." Familiar talking points from the ideas of Friedrich von Hayek, Ludwig von Mises, or Hans-Hermann Hoppe pop up here and there in his stories: "I would align with Adam Smith, Ludwig von Mises.... I really love the spontaneous order."

With money from friends and acquaintances, some of whom he had met at Credit Suisse, he set about founding Bitcoin Suisse outside of Credit Suisse in 2012. In 2013, the company was added to the commercial register. Switzerland as a confederation of cantons, with direct democracy and neutrality, is also crucial to Nikolajsen's founding story of Bitcoin Suisse AG. The decision to choose Switzerland as the site of the company was made after a comparison with Singapore, Canada, Dubai, the United Kingdom, and Luxembourg. He would not want to live in a country like Singapore, for example, where gay people are imprisoned.

Ethereum Arrives in Zug

A temporary sojourn in Zug by a group centered around mathematical genius, college dropout, and Thiel Fellowship recipient Vitalik Buterin became the crux of what is now known as the emergence of Crypto Valley.[40] In his about.me entry, Buterin reveals that he was born in Russia in 1994 and moved to Canada in 2000.[41] From 2007 to 2010, he played World of Warcraft: "But one day Blizzard removed the damage component from my beloved warlock's Siphon Life spell. I cried myself to sleep, and on that day I realized what horrors centralized services can bring. I soon decided to quit."[42] Vitalik Buterin also tells the story of a conversion that led him away from centralized services. After founding *Bitcoin Magazine* with Mihai Alisie in May 2012,[43] Buterin published a white paper in November 2013 that proposed a distributed open-source platform on which smart contracts could

38

The Mail Archive: Satoshi Nakamoto, "Bitcoin P2P e-cash paper," Sat, 01 Nov 2008 16:16:33 -0700, https://www.mail-archive.com/cryptography%40metzdowd.com/msg09959.html (retrieved February 1, 2020).

39

Satoshi Nakamoto, *Bitcoin: A Peer-to-Peer Electronic Cash System*, https://bitcoin.org/bitcoin.pdf (retrieved February 1, 2020).

40

On Vitalik Buterin, see Hannes Grassegger, "Der digitale Lenin," *Das Magazin*, no. 46 (November 14, 2015), https://desktop.12app.ch/articles/12155630; Robert Pybus, "The Uncanny Mind That Built Ethereum," *Wired* (June 13, 2016), https://www.wired.com/2016/06/the-uncanny-mind-that-built-ethereum/; Nick Paumgarten, "The Prophets of Cryptocurrency Survey the Boom and Bust," *The New Yorker* (October 15, 2018),

https://www.newyorker.com/magazine/2018/10/22/the-prophets-of-cryptocurrency-survey-the-boom-and-bust.

41

https://about.me/vitalik_buterin (retrieved February 11, 2020).

42

Ibid.

43

https://bitcoinmagazine.com (retrieved February 28, 2020).

44

Paumgarten 2018.

be created, managed, and implemented. This does not mean contracts based on law, but on code. Vitalik Buterin later told journalist Nick Paumgarten in *The New Yorker* magazine that he'd come across the name Ethereum while searching Wikipedia for elements in science-fiction stories. He liked Ethereum: "[it] sounded nice and it had the word 'ether,' referring to the hypothetical invisible medium that permeates the universe and allows light to travel."[44] Underlying Ethereum, one could argue, was the notion of repairing and revolutionizing the Internet: an Internet, the website of the Ethereum Foundation proclaimed, "where users can own their data, and your apps don't spy and steal from you."[45] An Internet "where everyone has access to an open financial system." And an Internet "built on open-access infrastructure, controlled by no company or person."

Herbert Sterchi is at least old enough to be the grandfather of the young people who came to Zug in 2014 to finish developing Ethereum, to give it legal status, and to release it.[46] The sixty-year-old economist had attended the University of St. Gallen a long time ago. He had started out as a controller at Sulzer, an industrial company, and later built an international network by taking on jobs all over the world. Through his involvement with Oracle, he had also ventured into IT and was therefore recruited by the Canton of Zug to serve as a commercial ambassador to encourage companies to locate here in 2013.

Guido Bulgheroni, head of the Canton of Zug's Economic Liaison Office, had put him in touch with Johann Gevers. Gevers, who had founded his company Monetas the previous October, recommended that he call Ethereum. In December 2013, Mihai Alisie from Ethereum and Herbert Sterchi, the commercial ambassador of the Canton of Zug, met for the first time in Zurich. After Ethereum's developers had rented rooms, first from Regus and then from Airbnb, Sterchi took them into his home for two weeks in February 2014 because they had no place to stay. Eleven of them lived in a small apartment: Mihai Alisie, Roxana Sureanu, Taylor Gerring, Mathias Grønnebæk (with his girlfriend), Charles Hoskinson, Lorenzo Patuzzo, and two or three others. Finally, Sterchi found a house for the group in Baar on March 1. The house at Grienbachstrasse 55 was converted into the Ethereum shared apartment from March 2014 to December 2015. The rent (around 80,000 Swiss francs) had to be paid in advance to the landlord, who was the father of a Zug government official.

Vitalik Buterin, who only joined the group after it had moved to Grienbachstrasse 55,[47] received a class L residence permit for one year for his stay in the Canton of Zug[48]—even though he was not a citizen of an EFTA or EU country, did not have a university degree, and could not yet demon-

45

See the self-description on Ethereum's website, https://ethereum.org (retrieved February 28, 2020).

46

The following information derives, unless otherwise stated, from the conversation with Herbert Sterchi, February 21, 2020.

47

Vitalik Buterin presented Etherium at the Bitcoin Conference in Miami in January 2014: "Vitalik Buterin reveals Ethereum at Bitcoin Miami 2014," https://www.youtube.com/watch?v=l9dpjN3Mwps (retrieved February 28, 2020).

48

Conversation with Bernhard Neidhart, February 18, 2020.

strate any economic success (all criteria for a residence permit). Cantons may, however, apply to the Federal Office for Migration as intermediaries for a permit based on an applicant's potential.

Johann Gevers and Ethereum seem to have established contact with Luka Müller's law firm, MME, through Herbert Sterchi, who knew Dr. Samuel Bussmann (a partner at MME) from PwC.[49]

I meet Luka Müller in his Zurich office in the former industrial district.[50] The Zug office of the MME law firm is located in the former headquarters of Landis & Gyr in Zug, two floors above the city administration, which moved into the same building in autumn 2019. Here in Zug, people know each other and cross paths. Luka Müller's family history is deeply rooted in Zug—at least almost. He comes from an old Zug family who would have held the office of standard-bearer. His great-grandfather sailed to the South Sea island of Tonga via Hawaii, Fiji, and Samoa in the nineteenth century—and never came back. Although his grandfather returned to Switzerland to study medicine, he turned his back on this conservative city in central Switzerland and also went back to Tonga. Luka Müller's Tongan-born father finally returned to Zug and was firmly anchored among Zug's elite as president of the High Court and candidate for the government council.

Like his father, Luka Müller studied law. He maintains the family ties with the Kingdom of Tonga, and is also an honorary consul of the Kingdom of Tonga. In order to format documents and "make clean, beautiful seminar papers for the study of law," Luka Müller imported Tulip computers in the mid-1980s. Prior to the turn of the millennium in 1999, he and two friends founded MME. It was at this time that he first traveled to Silicon Valley. As a lawyer, he worked his way into the field of new technologies in connection with a Web interface for stock issues. In 2003 he founded his second company, KYC Spider, which offers a compliance tool for financial service providers. "Specializing in digital applications and compliance, I was probably predestined for this field."

In 2012, MME received an inquiry from an American law firm asking whether Bitcoin could be offered in Switzerland. Müller began to look into this with the help of the publication *Bitcoin: A Primer for Policymakers*.[51] This paper made an enthusiastic appeal for Bitcoin technology and future innovations in the field, recommending that governments not ban Bitcoin, but instead provide regulatory support for the experiments. In 2013, MME encountered Johann Gevers, who was looking for a lawyer to manage his decentralized notarization system. Gevers also mentioned for the first time the project that MME would ultimately submit to the Zug commercial register as the Ethereum Foundation in July 2014. After Gevers told him about the pro-

49 Conversation with Herbert Sterchi, February 21, 2020.

50 Conversation with Luka Müller, January 31, 2020.

51 Jerry Brito and Andrea Castillo, *Bitcoin: A Primer for Policymakers*, Arlington, 2013.

52 Conversation with Niklas Nikolajsen, February 11, 2020.

ject ("he was talking at the time about the next generation of blockchain applications that were becoming possible, the so-called smart contracts applications"), he was completely puzzled, Müller said.

One day in February 2014, a group from Ethereum showed up at the offices of Bitcoin Suisse in Baar, Niklas Nikolajsen tells me.[52] Mihai Alisie was the group's spokesperson: "They walked into the office and said: We want to design Bitcoin 2.0, and we have Bitcoins, and we need money for a deposit on a house. And we said we could help with that." At that time, it was not yet easy to sell cryptocurrencies in volume. Bitcoin Suisse would have given the group about 20,000 francs, after all. That was a lot of money back then. Everyone would have fanned out the banknotes and taken selfies.

In February 2014, Luka Müller received Charles Hoskinson of Ethereum in his office in Zug for a preliminary briefing on how the development and launch of Ethereum could be legally framed. Subsequent briefings were attended by Gavin Wood, Joseph Lubin, Mihai Alisie, Vitalik Buterin, and others. Müller tells me that he didn't even know what Vitalik Buterin's role in this team was at first. MME, he says, was the first law firm in Switzerland to deal with this subject.

He'd noticed right away that his customers were from a different generation. "That was often difficult." His clients were interested only in the thing itself and not in the money, and they didn't like it when he sent them a bill each time.

Initially, the legal form of the GmbH was the central issue. Buterin, however, had been looking for a way to develop an open-source protocol that was public and not owned by anyone. A legal framework involving owners was thus out of the question for him. "We said there was only one way not to have an owner. It's a foundation." The law firm resorted to the traditional Swiss legal form of the foundation, which is defined by the condition that it is based solely on the will of the founder at the time it was established. The idea of an organization set in stone was in line with Vitalik's idea of decentralization, Luka Müller explains to me. After the foundation was established and the project was launched, its legal form was discussed with the Swiss Financial Market Supervisory Authority (FINMA). It was determined that no financial market regulations apply to this framework. This was, therefore, the right structure for this specific application, says Luka Müller in hindsight.

Starting in the spring of 2014, the Swiss press ran article after article about Vitalik Buterin and the "visionaries and programmers" at Ethereum's shared apartment at Grienbachstrasse 55 in Baar. The articles read like expeditions to another planet and like an attempt to tie the terms

"Ether" and "Ethereum," which evoke transience, to a specific place. The articles read like this: "It is 10 o'clock in the morning, quiet, and the only mailbox at this gray apartment building is labeled Etherum Switzerland GmbH." ... "The detached apartment building is divided into two zones. The bedrooms are downstairs; upstairs there's a large work room with an open kitchen. Laptops lie around, bacon sizzles on a hot plate, and formulas and organization charts are scrawled all over the windows. The building is a shared flat, a place of work, and an inn all in one. Only eight people are here this morning."[53]

Herbert Sterchi describes the time of Ethereum's shared apartment as a period of extreme emotional intensity and ecstasy.[54] Incredible emotions played out on the Grienbachstrasse, he says. The residents worked around the clock. One of them lay in bed and talked to a radio station in LA while another was coding, a third was cooking, and a fourth was showering. There were three camps in the shared flat: a "soft group" that worked conceptually, which included Mihai Alisie (who held everything together), his girlfriend Roxana Sureanu (the kind heart of the group), Taylor Gerring, and Lorenzo Patuzzo. Opposite them were the "hard coders": Gavin Wood, Aeron Buchanan, and Vitalik Buterin. And in between, Joseph Lubin and Anthony Di Iorio. Charles Hoskinson was expelled from the group in the summer of 2014.

On July 22, 2014, Vitalik Buterin commented online about delays in Ether sales: "We certainly miscalculated the sheer difficulty of navigating the relevant legal processes in the United States and Switzerland, as well as the surprisingly intricate technical issues surrounding setting up a secure sale website and cold wallet system. However, the long wait is finally over, and we are excited to announce the launch of the sale."[55]

Herbert Sterchi also tells me about the heated arguments that broke out in the shared apartment in September 2014, when Ether's distribution key was discussed prior to Ethereum going live: "I had to go and arbitrate a few times."[56] In September 2014, they even called him at midnight once: "I said, Work together. Work together on the last mile. Don't give up."[57]

A lot of stories about Ethereum's history revolve around a clash of generations, the price of Bitcoin and Ether, and the role of money as a driver of discord. Niklas Nikolajsen tells me about the pizza parties at the Ethereum developers' house, to which everyone had to bring their own beer. Andrej Majcen, co-founder of Bitcoin Suisse, brought twenty-four bottles of beer to one of these parties: "They wrote him: If and when we launch Ether, you'll get 2,000 Ether. ... I can tell you, Andrej Majcen looked everywhere for that note when Ether started to have a market price. And he found it. And he

53

See, for example, Doku-Zug, "53.2. 115 Kryptowaehrungen Kt. Zug 2013–2017": Marc Badertscher, "Bitcoin 2.0 Swiss Made," *Handels-zeitung*, no. 16 (April 17, 2014), p. 12.

54

Conversation with Herbert Sterchi, February 21, 2020.

55

Vitalik Buterin, "Launching the Ether Sale," July 22, 2014, https:// blog.ethereum.org/2014/07/22/ launching-the-ether-sale/ (retrieved February 28, 2020).

56

Conversation with Herbert Sterchi, February 21, 2020.

got rid of the Ether at five dollars. He bought an expensive watch." That sum would have been worth millions when it hit its highest price, and at the time of my conversation with Niklas Nikolajsen, 250,000 dollars.

Luka Müller recounts lively discussions between the "co-founders" at Ethereum. The whole team consisted of very bright people. "They sometimes acted rather aloof around me, because they of course knew a lot more than I did, and they had to constantly educate me as their lawyer." Vitalik Buterin was still very young at that time, and—especially after the emerging success of Ethereum—did not know whom he could trust. Luka Müller looks back self-critically on the hype that began in 2016, when Crypto Valley was overrun with inquiries. At that time, the focus was on young development teams and technological developments in many interesting areas. But the trends in the price of individual tokens had drawn attention to and created interest in the price of the tokens. The technology and the ardor for the possibilities it offered faded completely into the background at times: "And of course there were cases of fraud, bankruptcies, and disputes that attracted media attention. But even these things have calmed down, and it is a pleasure to see that the projects have continued to develop and the spirit is not dead. On the contrary." He learned that ultimately there is always a so-called human interface: "You can program a protocol perfectly, set up a structure perfectly, but the human factor remains a factor that should never be ignored."[58]

Today, the Ethereum Foundation is managed by PST, the law firm of Patrick Storchenegger, who serves on the board of trustees.[59] Vitalik Buterin moved to Singapore in December 2014 to pursue a relationship, although he could have extended his special Swiss residence permit (as part of a start-up with potential) for another year at that point. In retrospect, the Directorate of Economic Affairs of the Canton of Zug is convinced that its decision to allow Ethereum to locate in Zug under these circumstances was the right one. Bernhard Neidhart from the Canton of Zug's Department of Economics and Labor explains to me that locating the company here was an important piece of the puzzle for the development of the blockchain ecosystem in Zug and thus ultimately in Switzerland. The proximity to the protagonists, one of the strengths of this small canton, was decisive. The same applies to XAPO, a company that offers wallets for digital currencies, which was able to be lured from Palo Alto in Silicon Valley to Zug in 2015.[60]

The lease on the apartment at Grienbachstrasse 55 in Baar was terminated at the end of December 2015.[61] Herbert Sterchi tells me that Vitalik Buterin's personal assistant, Ming Chan, played an important part in the organizational restructuring in late 2015.[62] Several former roommates

57

Conversation with Herbert Sterchi, February 21, 2020.

58

Conversation with Luka Müller, January 31, 2020.

59

See Kanton Zug, "Stiftung Ethereum," *Handelsregister*, https://zg. chregister.ch/cr-portal/auszug/ auszug.xhtml-?uid=CHE-292.124. 800 (retrieved February 28, 2020).

60

Conversation with Bernhard Neidhart, February 18, 2020. Kanton Zug, *Handelsregister*, https://zg. chregister.ch/cr-portal/auszug/ auszug.xhtml;jsessionid=bdefccb41 7386c07c65de61b280c?uid= CHE166.362.115 (retrieved February 28, 2020).

61

Conversation with Herbert Sterchi, February 21, 2020.

62

Conversation with Herbert Sterchi, February 21, 2020.

moved their new projects to other parts of the world, choosing not to set up their companies in Zug. These include Lorenzo Patuzzo, who established his base in Barcelona. Other former residents of the shared apartment in Baar and their projects are still connected to Zug as a location: for example, Joseph Lubin's ConsenSys AG, which offers Ethereum blockchain solutions,[63] and the AKAƷHA Foundation of Mihai Alisie, who now owns a plot of land in Zug as well, as Herbert Sterchi reveals.[64] And Gavin Wood, who, together with Aeron Buchanan, registered the Web 3.0 Technologies Foundation in Zug as well.[65]

From Start-up Spirit to "Ecosystem"

Café Schoffel in Zurich's Niederdorf district was the first bar in Switzerland to accept Bitcoin.[66] This café became the site of the early meetups, as informal gatherings are called in the community, where technical things like block sizes and signature models were discussed, beer was drunk, and a world without dictators and kings was dreamed of. When big business entered the scene in 2017, the core developers no longer came to these meetups, Niklas Nikolajsen tells me.

How did the term Crypto Valley and an association of the same name that strives to popularize Crypto Valley emerge from these early informal meetings?

Mihai Alisie from Ethereum's shared apartment, according to several accounts, has the distinction of having brought the term "Crypto Valley" into play for the first time. Niklas Nikolajsen relates the founding myth as follows: "We said: Maybe we can get people together and get a thriving ecosystem. Like in Silicon Valley. I don't know who said Silicon Valley. Maybe Luka Müller. And then Mihai said: Yes, a Crypto Valley!"[67] Johann Gevers had a company called Crypto Valley GmbH registered in his name and entered in the commercial register in 2014.[68]

I meet former mayor Dolfi Müller and Zug town clerk Martin Würmli in the Zug town hall shortly before Christmas 2019.[69] Only a few months earlier, in July 2019, the city administration of Zug had moved into the office building formerly occupied by Landis & Gyr at Gubelstrasse 22, which is now a historic landmark. Although the Zug city council had already been aware of the existence of the blockchain scene, it invited a student from the University

63

Kanton Zug, *Handelsregister*, https://zg.chregister.ch/cr-portal/ auszug/auszug.xhtml?uid= CHE-462.543.441 (retrieved February 28, 2020).

64

Kanton Zug, *Handelsregister*, https://zg.chregister.ch/cr-portal/ auszug/auszug.xhtml?uid= CHE-189.356.574 (retrieved February 28, 2020).

65

Kanton Zug, *Handelsregister*, https://zg.chregister.ch/cr-portal/auszug/auszug.xhtml? uid=CHE-322.596.347 (retrieved February 28, 2020).

66

Conversation with Niklas Nikolajsen, February 11, 2020.

67

Conversation with Niklas Nikolajsen, February 11, 2020.

68

Kanton Zug, *Handelsregister*, https://zg.chregister.ch/cr-portal/ auszug/auszug.xhtml?uid=CHE-499.848.828 (retrieved February 28, 2020). The online register of the World Intellectual Property Organization now contains an entry on CRYPTO VALLEY (1495481) by a Dirck Gevers from Bergkirchen: https:// www3.wipo.int/madrid/monitor/ en/ (retrieved February 28, 2020).

69

Conversation with ex-mayor Dolfi Müller and town clerk Martin Würmli, December 20, 2019.

70

Doku-Zug, "53.2.115 Kryptowaeh-rungen Kt. Zug 2013–2017": Erich Aschwanden, "Zug wird weltweit zum Bitcoin Pionier," *NZZ*, no. 107 (May 10, 2016).

of St. Gallen, who had written a bachelor's thesis, to explain the technical mechanisms behind cryptocurrencies for the first time at a city council meeting in April 2016. Martin Würmli then visited Niklas Nikolajsen of Bitcoin Suisse AG at his former office in a plain three-room apartment in Baar and told him about the idea of accepting Bitcoin. In May, the city council then decided to accept residents' registration fees of up to 200 francs in Bitcoins as part of a pilot project.

The echo in the media was tremendous. The *NZZ* quoted the mayor of Zug, who announced that the city wanted to gain experience with such technologies in view of the "Zug 2035 Strategy."[70] There was also criticism from the political arena regarding the introduction of Bitcoin by the city administration: the conservative SVP faction inquired in the Greater Community Council about the legal basis on which the city council was basing this decision and feared that speculative experiments would be carried out at taxpayer expense, or that the city could be left sitting on the Bitcoins.[71]

The city of Zug appropriated the decentralized utopias of the neo-bankers for its vision of a smart city. This was not a marketing gag, but rather an attempt to gain experience, as the town clerk and the former town president emphasized. "I was told that in a marketing course at a Swiss university, the value of the action taken by the city council had been estimated at around 20 million Swiss francs," former mayor Dolfi Müller recounts. Media from all over the world (including *The New York Times*, *Forbes*, and *CNN*) reported on the pioneering project by the city of Zug, the former mayor announced in a press release on July 1, 2016.[72]

The publicity brought not only many serious players to the city, but also a few strange characters with ideas, Würmli, the town clerk, reports.[73] From utopians to criminals, adds former mayor Müller. Vitalik Buterin was one of the magnets of the scene at the beginning. Former mayor Müller only saw him once from a distance, at a blockchain conference in the casino. He breezed in like a god. Müller never had the courage to speak to him.

One term that my interlocutors keep mentioning in connection with Crypto Valley is "ecosystem." This term had a long history in the life sciences before it was married to cybernetic technology utopias and popularized in the 1960s.[74] It is about the idea that individual parts that interact function like a machine. The term has since become firmly established in the semantics of Silicon Valley. Margaret O'Mara used it about thirty times in her history of Silicon Valley.[75] No place (not even Boston with MIT and Harvard) could have matched the competitive edge of the Silicon Valley ecosystem.[76] It's not at all surprising that the term "ecosystem," along with other magical narratives imported from Silicon Valley, eventually found its way to Zug's Crypto Valley.

71

Doku-Zug, "53.2.115 Kryptowaeh-rungen Kt. Zug 2013–2017": "Bleibt die Stadt auf den eingenommenen Bitcoins sitzen?" *Neue Zuger Zeitung*, no. 111 (May 14, 2016).

72

Doku-Zug, "53.2.115 Kryptowaeh-rungen Kt. Zug 2013–2017": "Bitcoin Project in der Stadtverwaltung Zug gestartet," press release from the City of Zug, July 1, 2016.

73

Martin Würmli then addressed the question of the potential of block-chain technologies in a paper at the FHS St. Gallen: Martin Würmli, *Auswirkungen der Blockchaintechnologien auf öffentliche Verwaltungen, dargestellt am Beispiel der digitalen Identität für die Stadt Zug*, FHS St. Gallen, EMBA program, January 2018.

74

See Benjamin Bühler, "The 'Ecosystem' Concept in the Political Ecology Discourse," in *Forum für interdisziplinäre Begriffsgeschichte* (FIB), edited by Ernst Müller and Zentrum für Literatur- und Kunstforschung Berlin, vol. 3, no. 2 (2014), pp. 19–32. See also Richard Buckminster Fuller, *Operating Manual for Spaceship Earth*, Carbondale, IL, 1969.

On January 14, 2017, the Crypto Valley Association was founded at the Lucerne University of Applied Sciences and Arts (Hochschule Luzern, HSLU)[77] in the new Suurstoffi complex behind Rotkreuz station, a farming village and railway junction until just twenty years ago.[78] René Hüsler is the head of the HSLU's Computer Science Department. He grew up in Steinhausen alongside Luka Müller, a partner at the MME law firm, whom he has known all his life. After completing an apprenticeship as a machine mechanic at Verzinkerei, a sheet metal factory in Zug with a long tradition, he went on to study computer science at the Swiss Federal Institute of Technology, where he also completed his doctorate under Anton Gunzinger. I meet Hüsler on the dignified campus of the HSLU. From the conference room, there's a view of the railway tracks and the sugar-coated foothills of the Alps in winter.

René Hüsler tells me that the Crypto Valley Association was founded, effectively, thanks to him. The idea had been around for a long time, but no one had acted upon it. Hüsler shows me the minutes of the founding meeting. According to the charter, the purpose of the association is to create "an optimal ecosystem for cryptographic and related technologies and businesses, including blockchain and other distributed ledger technologies, in Switzerland and internationally."[79] The list of founding members includes not only the HSLU professor of computer science and the company's founders, but also those circles that Niklas Nikolajsen might call big business.[80] A representative of the Canton of Zug was also present. In the beginning, a good twenty people attended the meetups in various locations in the city of Zug, Hüsler explains. Soon that number grew to more than 200 people.[81] Because foreign delegations wanted to visit Crypto Valley, tours were organized. At the time of the hype, René Hüsler often worked two days a week for the association in addition to setting up the Department of Computer Science at HSLU. He was the secretary and treasurer. Oliver T. Bussmann took over the chairmanship of the association.

In December 2019, Oliver T. Bussmann welcomes me at a large oval table in his office near the train station in Zug.[82] Using the slogan "Creating New Ecosystems," the Westphalian-born business economist is advertising for customers on the website of his consulting firm. Bussmann Advisory sells consulting and advisory services to manage technological

75

Margaret Pugh O'Mara, *The Code: Silicon Valley and the Remaking of America*, New York, 2019.

76

Ibid., p. 121.

77

Conversation with René Hüsler, January 30, 2020.

78

See Richard Hediger, *Risch. Geschichte der Gemeinde*, Rotkreuz, 1982.

79

Protokoll der Gründungsversammlung der Crypto Valley Association (CVA), 14. Januar 2017 (in Archiv René Hüsler).

80

For a list of founders, see the e-mail from René Hüsler to Monika Dommann, February 11, 2020: Oliver T. Bussmann (Bussmann Advisory), Sam Chadwick (Thomson Reuters), Søren Fog (iprotus GmbH), Johann Gevers (Monetas AG), René Hüsler (Hochschule Luzern – Informatik), Niklas Nikolajsen (Bitcoin Suisse AG), Vasily Suvorov (Luxoft Global Operations GmbH).

81

Conversation with René Hüsler, January 30, 2020.

82

Conversation with Oliver T. Bussmann, December 17, 2019.

change.[83] Bussmann's father had worked in the coal industry as a mining engineer. After completing his education, Bussmann joined IBM in 1990 (he doesn't pronounce the company's initials in English, but strictly in German!) and stayed there for eight years: "If you were an IBM employee, you actually had a lifetime commitment. Until the 1990s. Then that commitment was over."[84] Once the supposedly lifelong relationship with IBM was dissolved, the former IBM employee continually sought new challenges: with Allianz, SAP, Deutsche Bank, and UBS. In 2000, Bussmann was working in Silicon Valley for the first time, for the Allianz Group in San Francisco, where he became acquainted with a different management structure—"highly diversified," with fifty to sixty percent of the executives being women—and with his wife.

Bussmann and his family moved to the Canton of Zug in 2013. In April 2015, he told the *NZZ* in an interview that UBS has a strategy of actively engaging in "digital disruption."[85] The banks were indeed coming under pressure from decentralized systems based on blockchain: "But not infrequently they worked with the start-ups and used their solutions—or they developed their own approaches."[86] Until 2016, he was still at UBS, where he was involved in digitally transforming the bank and implementing blockchain projects there. After leaving UBS, he founded his consulting firm Bussmann Advisory AG in 2017.[87] Bussmann's company Blockchain Valley Ventures AG, founded in 2018, invests directly in start-ups.[88]

Bussmann tells me that he met Vitalik Buterin at a blockchain event at the Swiss embassy in London around 2015: "You could see a clash of systems. I as a representative of a central business model (UBS), the decentralized Buterin…. If you've come of age in a large company, you have to ask yourself: When can you implement it? How do structures change? What can you do with it?" Bussmann now regards the crypto community with alienation: it's too emotional and too radical for him, he says. But maybe this radical spirit is necessary for people to stay true to their cause if they want to change the world, he points out.

The promise of "Crypto Valley" had lured utopians, criminals, developers, and consultants to Zug, as well as investors and trend scouts from banks. In August 2017, the Swiss minister of economic affairs, Federal Councillor Johann Schneider-Ammann, also visited Zug. (Oliver T. Bussmann

83
https://www.bussmann-advisory.com/

84
Conversation with Oliver T. Bussmann on December 17, 2019.

85
Christoph Leisinger, "Die 'Blockchain Technologie' hat Zukunft," *NZZ* (April 17, 2015), https://www.nzz.ch/finanzen/standpunkt/die-qualitaet-digitaler-angebote-und-der-anlageberatung-zaehlt-1.18520906 (retrieved February 28, 2020).

86
Ibid.

87
Kanton Zug, *Handelsregister*, https://zg.chregister.ch/cr-portal/auszug/auszug.xhtml?uid=CHE-198.579.363 (retrieved February 28, 2020).

88
Kanton Zug, *Handelsregister*, https://zg.chregister.ch/cr-portal/auszug/auszug.xhtml?uid=CHE-229.521.048 (retrieved February 28, 2020).

knows him from his time at UBS.) He applauded Zug for having the courage to try new things.[89] The local legal know-how of the pioneers in Zug was also in demand in Bern for a strategy of national regulation. In the summer of 2018, the Federal Department of Finance organized a roundtable on blockchain, involving the Crypto Valley Association, as the Federal Council's report of December 2018 states.[90]

From Mint Master to Bitcoin Banker

When I set out for Zug once again to talk to people in February 2020, a good one and a half years had passed since I'd started my historical research in Crypto Valley. When I walked past the town hall on Kolinplatz, where the city administration had been located since the late 1970s, I noticed that since then—after the city administration had moved into the former office building of Landis & Gyr—a cryptobank called SEBA had moved into the town hall.[91] The "showcase of the new banking"[92] had moved into a traditional building in the old town on November 1, 2019. The company had made a good offer, town clerk Martin Würmli tells me.

Some neo-bankers are putting down roots in Zug. This is evidenced not only by the SEBA cryptobank's move to Kolinplatz, but also by the sale of the baroque St. Karl mansion near Oberwil to Bitcoin banker Niklas Nikolajsen in November 2018.[93]

Fig. 3

The St. Karlshof, or St. Karl estate, looks back on a long and varied history that can actually be read as a microcosm of the history of Zug. The building bears witness to the commitment of Zug's elite to international mercenariness, to early modern monetary policy pursued by local authorities surrounded by European monarchy, to the central role of Catholicism in the Canton of Zug, and to the growing importance of expatriates in Zug society in recent times.

Tradition has it that the chapel was built in 1616 in honor of Charles Borromeo.[94] The chapel and the estate came into the possession of wealthy mint master Kaspar Weissenbach (builder of the Lower Mint in Zug) in 1624. Although he had eagerly sought to be a patron, he was denied Zug citizenship because the ruling families in Zug feared the influence of the rich man. Johann Kaspar Luthiger, who owned the estate in the eigtheenth century, acquired a dominant status in the canton thanks to his position as a pension distributor. He is testimony to the commitment of Zug's elite to regiments in the service of European monarchies.[95]

In 1841, Father Alberik Zwyssig composed the Swiss Psalm ("Trittst im Morgenrot daher") in the chapel. On November 22, the Swiss

89

Doku-Zug, "53.2.115 Kryptowaeh-rungen Kt. Zug 2013–2017": "Schneider Amman lobt das 'Crypto Valley Zug,'" Neue Zuger Zeitung, no. 189 (August 18, 2017), p. 23.

90

Schweizerische Eidgenossen-schaft, Rechtliche Grundlagen für Distributed Ledger-Technologie und Blockchain in der Schweiz. Eine Auslegeordnung mit Fokus auf dem Finanzsektor. Bericht des Bundes-rates, December 14, 2018, 17, https://www.newsd.admin.ch/newsd/message/attachments/55150.pdf (retrieved February 28, 2020).

91

https://www.seba.swiss/ (retrieved February 28, 2020).

92

Lukas Hässig, "Trading-Schlacht-rösser beherrschen Krypto-Start--up," Inside Paradeplatz (October 25, 2019, https://insideparadeplatz.ch/2019/10/25/trading-schlachtroesser-beherrschen-kryto-startup/ (retrieved February 28, 2020).

Fig. 3

Postcard Salesianum St. Karl Chapel in Oberwil/Zug, between 1900 and 1930. (© Stadtarchiv Zug, P.67.101.)

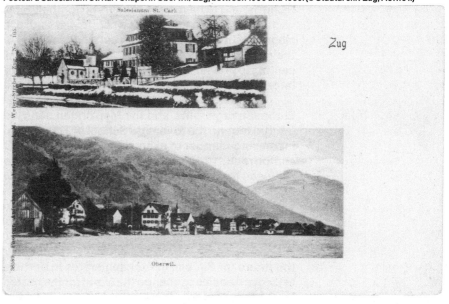

Psalm is said to have been rehearsed for the first time in the northwest room on the first floor. In 1898, St. Karl estate was sold to the teacher nuns of the Menzingen Institute, who gave the estate the name "Salesianum" (in memory of their mother superior, Sr. Salesia Strickler) and used it during the twentieth century to provide training in home economics for the daughters of the city and later to educate young women with learning disabilities.

The mint master, the distributor of pensions from European regiments, and the Menzingen nuns were followed in 2003 by an interim tenant, the Riverside School of Zug, which served the children of the increasing number of expatriates moving to the Canton of Zug. In 2015, the canton rented the property in order to house refugees. In March 2016, the first refugees from Afghanistan, Somalia, Eritrea, Sri Lanka, and Iraq moved in:[96] twenty men and five women, the men in shared rooms, the women in twin and single rooms. Unlike Vitalik Buterin, the digital nomad, they'd come to Switzerland not on an L visa (for people with economic potential), but on an N permit (for asylum-seekers).

Niklas Nikolajsen not only speaks enthusiastically of the future (of Bitcoin, of exchange rates in particular, and of the potential of cryptocurrencies to change the world for the better), but also shows a passion for the historical details of his future home. The new landlord of the former Salesianum likes the original name of the estate he bought, St. Karlshof, better than Salesianum. He even fantasizes about an extension of the name: "I would like to consider applying, at some point, for the name 'von Karlshof.'"[97] Nikolajsen also likes the idea that he is following in the footsteps of the old mint master, Kaspar Weissenbach. He already has a view from his apartment on Zeughausgasse of the beautifully painted Haus zur Münz diagonally opposite, where Weissenbach had been mint master. Nikolajsen plans to move to St. Karlshof with his family after a renovation based on the state of the house around 1900. The chapel is to become a museum, and Nikolajsen is also thinking about organizing philosophical events, following the example of the Prosperity Society of libertarian philosopher and economist Hans-Hermann Hoppe in Turkey.[98] An application for Swiss citizenship is also being considered for 2021: "Then you won't have to write 'Niklas Nikolajsen, the Dane' anymore," he says with a smile.

Bitcoin Suisse hired the former head of private banking at Credit Suisse, Arthur Vayloyan, as its CEO in 2017 and applied to FINMA for a banking license in 2019. This admirer of Switzerland ("I love the way the nation works in Switzerland") has arrived in the banking system and the Canton of Zug.

I had one more question for the aspiring Swiss citizen and aspiring Swiss banker before I left his offices at Grafenauweg 12 in

93

See Nikolajsen Capital AG, "Salesianum Zug. Öffentliche Ankündigung," November 9, 2018, https://www.nikolajsencapital.ch/Salesianum_Oeffentliche_Ankundigung_DE.pdf (retrieved February 28, 2020). Charly Keiser, "Salesiamun wird verkauft, saniert und renoviert," *Luzern Zeitung* (November 10, 2018), p. 29.

94

The following information is based on Linus Birchler, "Hof St. Karl bei Oberwil," in *Die Kunstdenkmäler des Kantons Zug. In zwei Halbbänden*, Basel, 1934, pp. 338–42; Viktor Luthiger, *Kapelle St. Karl und Hof "Salesianum," früher St. Karl*, Zug, 1958–1959.

95

Pensions were payments by foreign warlords to local officials. Until the eighteenth century, these represented an important source of funding in Catholic cantons. On Johann Kaspar Luthiger, see Renato Morosoli, "Johann Kaspar Luthiger," in *Historisches Lexikon der Schweiz* (HLS), July 29, 2009, https://hls-dhs-dss.ch/de/articles/026782/2009-07-29/ (retrieved February 28, 2020).

96

Andreas Faessler, "Zug: Das Nötigste für ein wenig Privatsphäre," *Luzern Zeitung* (April 13, 2016), p. 17, https://www.luzernerzeitung.ch/zentralschweiz/zug/zug-das-noetigste-fuer-ein-wenig-privatsphaere-ld.106022?reduced=true (retrieved February 28, 2020).

Fig. 4

"Be curious": Interior of the Frei-
ruum co-working space, situated
in the former Landis & Gyr factory,
Zählerweg, Zug, February 2000.
(© Monika Dommann)

Fig. 4

Zug in February 2020. I wanted to know whether the former Army bunkers in the Swiss Alps were really a particularly suitable location for the Swiss Crypto Vault, for storing the crypto assets kept in a secret place in the Swiss mountains.[99] Nikolajsen replied that this solution had of course been tested and certified according to the ISAE 3402 Type 1 standard. And of course they have a redundant setup. But there is a problem with the mountains, he explained, and that is the humidity. A shaft with twenty meters of concrete would be far more suitable, he said.

Opposite Bitcoin Suisse, on Zählerweg, where I had soldered meter components together at the Landis & Gyr factory in 1980 as a teenager, a company called Freiruum has now rented space in the building for temporary use. It operates the premises as a co-working space, recreational facility, and food court. I drank a latte macchiato, looked at the many encouraging signs on the walls ("Be curious," "Be aware of contagious inspiration," etc.), and suddenly noticed the old glass cubicles of the factory supervisors who had inspected my soldered components. And on the floor, yellow lines still testified to the once busy traffic inside the factory halls.

In my thoughts, I recalled the anarchist ideal of a decentralized organization of the financial system from the 1990s and the affirmative call for a revolution after the 2008 financial crisis—as well as the vision of solving the issue of trust in banks and payment transactions by delegating authority to algorithms. My case study on Crypto Valley Zug has shown, however, that the developers of decentralized technology infrastructures have nevertheless been concentrating in very real spaces, such as the temporary shared apartment at Grienbachstrasse 55 in Baar, near Zug. It has also shown that living and working closely together in a specific community is a key characteristic of the way this community works. Mistrust and diverging interests in the launch of this open source platform during the hot months in the Canton of Zug also could have jeopardized the undertaking at

97

Conversation with Niklas
Nikolajsen, February 11, 2020.

98

In 2010, Hans-Hermann Hoppe was
described by René Scheu (editor-
in-chief and publisher of the liberal
Schweizer Monatshefte, as of 2016
editor-in-chief of the *NZZ* feuille-
ton) as "one of the leading libertar-
ian intellectuals of the present day":
Hans-Hermann Hoppe and René
Scheu, "Hans-Hermann Hoppe im
Gespräch," *Schweizer Monatshefte.
Zeitschrift für Politik, Wirtschaft,
Kultur* 982, no. 90 (2010), pp. 46–50.

99

Matthew Allen, "Military-Grade
Swiss Bunker Opens Vaults to Crypto
Investors," *Swiss Info* (June 27, 2018),
https://www.swissinfo.ch/eng/
safe-storage_military-grade-swiss-
bunker-opens-vaults-to-crypto-
investors/44220960 (retrieved
February 28, 2020).

certain points in time. The issue of trust does not seem to have been completely resolved by algorithms.

Divergences and conflicts can also be identified in what's known as the Crypto Valley ecosystem: for example, between the core developers and those who do the conceptual work, and between the community of the decentralized organization that represents open systems and the advocates of closed systems within the framework of centralized business models such as those operated by traditional banks.

In the Bitcoin protagonists' portrayals of themselves, I came across many stories whose motifs are deeply rooted in Swiss history. The mountains of Switzerland continue to play a central part in the many narratives about Swiss cybersecurity in the age of the NSA, following on from Swiss narratives from World War II and the Cold War. Another central narrative is the one about the special affinity of Switzerland, as a decentralized organization characterized by openness, to decentralized blockchain technology.[100]

In my story I've used Vitalik Buterin, the prodigy who dropped out of college in Canada and ended up in Baar, near Zug, endowed with a 100,000-dollar fellowship from libertarian investor Peter Thiel, as the MacGuffin of my Crypto Valley story. Through him, it was possible to find out about temporary communities, business relationships, and more or less successful attempts to capitalize on his ideas (and those of his comrades-in-arms).

The fact that companies such as Bitcoin Suisse AG and projects such as the Ethereum Foundation chose Zug to give their project a legal footing also demonstrates the great importance of the question of the regulatory framework for decentralized technology infrastructures. The libertarian visions and techno-utopian templates from California had inspired a tech scene in various places around the world, which inspired the Canton of Zug, the city administration of Zug, the IT department at the regional university, intergenerational cross-border commuters, and representatives of big business as well as a number of business-friendly federal councillors. The Canton of Zug helped to arrange visas and apartments. The city quickly demonstrated its openness to Bitcoin and accepted it as payment for certain fees. It also hoped that this would provide an impetus for a "smart city" strategy. The financial sector also worked hard to "open up the world of crypto-money as an area of speculation."[101]

First and foremost, however, law firms were on the spot to draft regulations that had been drawn up locally and could be applied nationally, embedding them in an attractive tax system and subjecting them to a cautious regulator, the FINMA. The exceptional spatial proximity in this

100

Alexander E. Brunner, *Crypto Nation. Die Schweiz im Blockchain-Fieber*, Bern, 2019.

101

Tom Sperlich, "Im tiefen Tal der Kryptowährungen: Ein Besuch in Zug," heise.de, July 2, 2017, https://www.heise.de/newsticker/meldung/Im-tiefen-Tal-der-Kryptowaehrungen-Ein-Besuch-in-Zug-3760567.html (retrieved February 28, 2020).

small canton, which could well be described as corruption, struck me again as I walked from the Freiruum past the city administration (with the MME law firm on its top floor) and, on my way to the train station, saw the offices of Bitcoin Suisse AG in the dark of night, softly illuminated by the traders' screens.

Acknowledgments

The author would especially like to thank Sascha Deboni, who supported her in her research and, walking through the city with camera in hand, approached the mailbox landscapes with a view of Mount Pilatus and Rigi. Special thanks are also due to Dieter Müller, who opened many doors, and Oliver T. Bussmann, Martin Würmli, Dolfi Müller, René Hüsler, Luka Müller, Bernhard Neidhart, Niklas Nikolajsen, and Beat Sterchi, who were willing to share their stories with me. Marc Baumann, Ralf Kubli, Karin Schraner, Max Stadler, Mischa Suter, and Simon Teuscher, as well as Frederik Furrer and Thomas Glauser from the City Archives and Bea Dugarte from Doku-Zug also deserve gratitude for their support and tips. The author alone is responsible for any errors or misunderstandings that may have crept into the story of this fleeting era.

A World Made of Paper: Computing Centers in the 1970s

Emil Zopfi

Photos by Roland Schneider

The sounds, the noises, the unique melody of the data center still rings in my ears, even after fifty years. To the whirring of fans, disk packs sing in high C while read heads crackle out a beat above the rotating platters and jerk spools of magnetic tape back and forth. Then, abruptly, the punch-card reader comes to life with a loud rattle, swallows stacks of cards and spits them back out. After a short interval, the console typewriter hammers out a line of text on paper, and right after that, in the background, the buzzing whir of the line printer sets in. The orchestra swings, machine music of the data mill, the stage bathed in a cool, blue light. A person rushes to and fro—a shadow, almost: the operator.

It was a world made of paper. At its entrance, the punch card as a program-bearer and storage medium: "input"; at the exit, striped paper with the results: "output." This was called the IPO model: input, processing, output. Preschools were delighted to receive thick bundles of the green-and-white-striped, endlessly folded sheets of paper, densely printed with letters and numbers, the back of it white, thus perfectly suited to drawing and coloring. Sensible recycling. The thin cardboard punch cards, on the other hand, were used, at best, as bookmarks; I'm able to locate a very last one in a children's book I own. The card is green, and above the small, rectangular holes is printed: //SDATA SAFIR22, JC=DATA. A cryptic message from a distant era.

The punch card was, historically, part of the beginning of a culture that called itself electronic data processing (EDP). The term "information technology" (IT) caught on only more recently; since 1981, there has been an IT department at the Eidgenössische Technische Hochschule (ETH). IBM, on the other hand, was a synonym for EDP, a global brand with the punch card as its trademark. In the early 1970s, the corporation dominated seventy percent of the global market in computers in public and private administration, in banks, airlines, and industry.

This market dominance was founded on tradition. The first use of punch cards was by Herman Hollerith for the 1890 census in the United States—if one disregards the much older punch card systems of Jacquard looms and music boxes. Hollerith sold his Tabulating Machine Company in 1911. In 1914, Thomas J. Watson became head of the company and turned it into the International Business Machines Corporation (IBM) in 1924. Office technology using punch cards became the basis for the more than hundred-year business success of "Big Blue," as IBM was also called because of the "cool" blue color it used to identify itself.

I was an errand boy in a machine and appliance factory in 1958 when I first held an IBM punch card in my hand and used it, instead of a paper delivery order as before, to fetch nuts and bolts from the storeroom.

Figs. 1–11

The photographs—"IBMPressionen"—form part of a series commissioned by IBM Switzerland in 1972/73, documenting "life and still life" at IBM's various branch offices in Zurich.[1] Roland Schneider (b. 1939 in Solothurn), a prolific exponent of Swiss industrial photography, attended Folkwang University of the Arts (1960–1963) and was briefly employed as an in-house photographer at Von Roll AG; from 1963, he worked as a freelance photographer, eventually covering more than two hundred firms, frequently in collaboration with Franz Gloor. As he recalled at the time: "On my own initiative, I begin taking pictures at various industrial plants. My main interest now is the relations that exist between people and 'their' machines. ... I photograph things that I believe have to be changed."[2] Schneider's publications include *Ereignisse in Stahl* (1963); *Switzerland's Economy and Main Industries* (1969), *"... ich arbeite, weil ...", Bildband über die Mitarbeiter der Nagelfabrik Hilti* (1975), *Bildband über die Maschinenfabrik Burckhardt* (1976), and *Die Demokratie der Schweiz* (1981).

Fig. 1

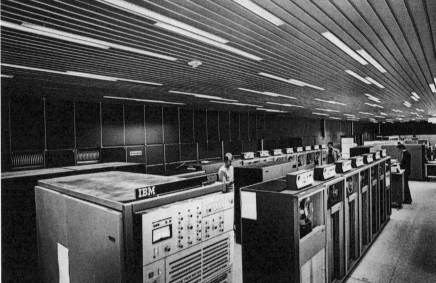

Fig. 2

1
"IBMPRESSIONEN. Durch das
Objektiv seiner Kamera sah der
Schweizer Fotograf Roland Schneider
das Leben und Stilleben der IBM,"
mosaic IBM Schweiz 7/11 (1972), p. 12.

2
*Roland Schneider: Meine Bilder.
Fototagebuch 1962–1982*, Olten,
1983, p. 36, p. 75.

Thus, in my daily routine, I experienced the technological transformation of industrial administration—and its effects on the work environment. Looking through panes of glass as I walked past, I saw a room full of women punching cards on rattling machines with one hand. The punch card created a new profession for women: the keypunch operator. There were hardly any men in this monotonous work environment.

Twelve years later, I was sitting in an upholstered chair in an open-plan office on the second floor of an office building in Zurich-Altstetten, leaned over a thick folder and engrossed in self-study in what was called a training course in programming: "Basic Data Processing (BDP)," the basics of electronic data processing according to IBM. I'd become a member of a global community of 250,000 employees. As an IBM employee, I wore a white shirt, tie, and coat, and bored myself with bits and bytes, hexadecimal code, punch-card code, and floating-point arithmetic, the basics of the System/360 family of mainframes, the core of IBM's business since 1964. All around were the dampened voices of my coworkers on the phone, mostly in English, two tables down the head of the work group, at the far end of the room the department head. Once an hour, I'd interrupt my studies, walk across the green fitted carpet, down the center aisle, past diligently working people and hydrocultures to the coffee machine. Eight hours are a long time, and I needed the exercise. Moreover, eight hours were seldom the norm. As long as the boss held out at his desk, the employees were expected to stay, was an unwritten rule, and the boss was glued to his chair. Everything has its price; the pay was far above average for the industry.

I was given a new professional title; my business card read, "Associate Systems Engineer." This title carried worldwide import within a community that had its own hierarchical system of steps and functions. Earlier job titles became obsolete. Good work was rewarded with pay raises and promotions to "Systems Engineer" or "Advisory Systems Engineer."

In my previous life, I'd referred to myself as an engineer who'd graduated from a technical college and specialized in computer-aided process control, a technology in which computers don't just make printouts on striped paper, but use electrical signals to control technical processes. "Direct digital control" or DDC is what it was called—the origin of what's known as digitalization today. In 1968, at the ETH's Department of Physical Chemistry, I'd installed a PDP-8i, one of the first minicomputers from Digital Equipment, and programmed it using punch tape. Then, at Siemens in Karlsruhe, I wrote a program to collect data in an oil refinery which required two thousand punch cards. The Siemens 300 system computers were programmed in an

Fig. 3

Fig. 4

assembly language that was amusingly called PROSA (Programming with Symbolic Addresses, which meant machine code, symbolically represented).

"Computer," as an aside, was a proscribed word back then in the land of Goethe, since it reminded people that not only the term, but also the technology, was imported from the United States. West Germany poured a lot of money into developing an autonomous German data-processing industry, supporting Siemens, Zuse, and Nixdorf, but IBM remained number one. In Germany, computers had to properly be referred to as "calculators," although they were already able to do more than calculate—but that's where opinions diverge. (At the core of a computer, everything is digital, every piece of information is reduced to a succession of 0s and 1s, every operation is mathematical—even if we speak of "artificial intelligence.")

In the fall of 1970, I left Siemens to become a young IBM employee with some experience, thanks to which I was hired without the usual entrance test. My group dealt with process control systems, a fringe discipline at IBM. Big Blue was rooted in the world of punch cards and offices. There were only four of us on the team, on cordial but very polite terms with each other. At the Swiss national load-dispatch center for electrical energy in Laufenburg, at chemical factories and textile mills and laboratories, we maintained a number of IBM 1800 process-control computers—large beasts, a series of two-meter-high and half-meter-wide equipment cabinets, preferably in IBM blue, occasionally in red as well if the customer desired it. Magnetic-core memory, hard disk drive platters, printers, and the indispensable console typewriter to run the system—the noisy precursor of monitor, keyboard, and mouse.

I still had a lot of ground to cover before I'd be allowed to get "hands-on" with such an expensive system. From the ground up, as they say. That meant leaving the open-plan office and the dry programming handbooks behind for several weeks and attending IBM's introductory course in a classy hotel that was largely free of guests in the off-season. Going back in time to the origin, to the punch card.

The first thing we learned was how to operate punch card tabulating machines, an ancient technology dating back to Hollerith. Industrial archaeology, as it were. Using wires on a plugboard, we programmed (in the abstract) the tabulators that were able to read and sort punch cards and print tables. This museum-worthy technology is still said to be used for elections in some states in the US and to be responsible for glitches, delays, and errors in counting. Logically from a historical standpoint, the course taught us the RPG, or Routine Program Generator, programming language,

Fig. 5

Fig. 6

which emulates the function of a tabulating machine on a computer. The highlight, finally, was an introduction to the IBM System/360, the family of mainframes introduced in 1964, also rather dated.

"Why am I in this course?" I occasionally asked myself. "I don't need what I'm learning; it has almost nothing to do with my area of process control systems." Looking back now, I'd say that it was less about specific technical knowledge than about the individual being assimilated into the company culture. The course was a practical reenactment of IBM's history from Hollerith to the present that molded us into IBM employees who could be deployed anywhere inside the company. The corporation invested a lot in its employees, and this paid off: many of them stayed with the company until retirement.

An instructor gave a lecture on the history of IBM, singing the praises of Thomas J. Watson, who'd used his talent at salesmanship and his Puritan work ethic to enlarge the company, drive the stock price to dizzying heights, and make his family wealthy. The fact that he'd admired Hitler and supplied the Nazi administration with tabulating machines wasn't discussed. Up until just before I joined, employees were required to sing together, among other things a song of praise to Watson, a devoutly religious man, "that 'man of men,' our friend and guiding hand."

A part of the course that I found very educational was a company game called TOPIC. In groups, we simulated companies that competed in the same market, made decisions, drew up advertising and research budgets, bank loans, production volumes, and the like. The input was processed during the night, the fictitious commercial success delivered in printouts and discussed the following morning. It was an impressive rehearsal of the ideology of capitalist market economics. The occasional recent high-school or college graduate who had internalized some of the ideas of the late 1960s niggled a bit that these market models left out ordinary people, that all of the societal and political ramifications were being ignored.

The final part of my in-house training was a three-week course in the PL/1 programming language at the Löwen Hotel in Einsiedeln, which also had little to do with my area of specialty but offered a further opportunity to escape the open-plan office. It was winter, excellent weather for skiing, and in the afternoon, the gracious instructor allowed us to do some skiing on the slope behind the hotel. IBM had developed PL/1 for its mainframes as a synthesis of the older, machine-independent programming languages COBOL (Common Business-Oriented Language) for business and commercial applications and FORTRAN (Formula Translation) for

technical and scientific use. PL/1 was a rather complex, but also cumbersome, language that was never widely accepted outside of IBM. I never had a practical use for PL/1, but the course made me successful at programming in it, something I look back upon with pride.

No computers were available for the course; instruction was purely theoretical. The flip chart was the preferred didactic tool, popular at the company since Thomas J. Watson introduced it a half century earlier. Today it's impossible to imagine a three-week programming course without seeing, let alone using, a computer. Most of my coworkers, only a few of them women, were younger than I. Many of them had joined IBM right after high school for training with the prospect of a lifetime career with the company and a solid pension—why go the arduous university route? I was probably the only one with a fair amount of programming experience. When the instructor announced toward the end of the week that everyone could write a program that would be sent to the computing center and run, I spent half the night working in my hotel room. I programmed Game of Life, a game developed in 1970 by mathematician John Horton Conway. (In mathematical terms, it's a two-dimensional cellular automaton. Wikipedia offers a good explanation of Life, including links to executable simulations.)

I wrote the code on PL/1 forms and the instructor sent them to the computing center. The next day, a long list came back: the program worked on the first try. No errors in the code, none in its execution.

Years later, I met the instructor again. We became friends, and when we occasionally saw each other, we talked about the "output" of my program, which looked pretty cryptic: printed pages full of asterisks that formed strangely proliferating figures.

Programming was, at the time, a cumbersome and time-consuming affair, almost entirely mental exertion, as computing time was a scarce and costly resource. A good programmer had to work through the program in his or her head until it was as error-free as possible. Program code was written on forms; keypunch operators transferred the code to punch cards, and the pack of cards was then sent to the computing center. The operator ran one job after another on the computer in what was referred to as "batch mode." It was called this because he grouped the packs of cards together as a batch to be fed into the card reader. In order for the computer to know what to do, job control cards used a special code to set the procedure—for example, starting a compiler, a program to translate PL/1. The red job control cards also included instructions for mounting reels of magnetic tape or hard disk drive platters and determined how the results were to be output.

Fig. 7

Fig. 8

Fig. 9

Some hours or a day later, the printed program lists were sent back to the programmer. Any programming errors were noted on the lists. If the program worked, the results were printed out as well. Otherwise the cycle began anew: fixing bugs, running another iteration, waiting a day for the next printout. Testing a program, something that now takes a couple of seconds, took hours or days back then. The large, expensive computers in the computing centers hummed all day and night as one job followed another. The time pressure, shift work, and night shifts made the operators' work difficult and stressful, and handling the heavy packs of punch cards and stacks of hard disks made it arduous physical labor. This setup was called a "closed shop." An "open shop" was where a programmer was allowed a certain amount of time to operate the computer himself in the computing center—sometimes in the middle of the night. I recall an hour of computing time between 3 and 4 a.m. on a Sunday.

Computing centers were, as the name suggests, the expression of a centralized concept of computing technology. I noticed this, as well its political implications, when I was part of an international project team. We were developing software for a control center in Tehran that was to control the entire electrical grid in Iran. At the heart of the system were two IBM 1800 process-control computers, which were rather outdated even then. Shah Reza Pahlavi ruled Iran, and to me this facility, designed to be centralized, reflected the country's dictatorial political system, which used secret police and the army to suppress any opposition. The project team included engineers and programmers from Switzerland, the United States, England, Sweden, Brazil, and Iran. Political discussions at the workplace were off-limits.

You have to imagine: the two IBM 1800 computers had 128 kilobytes of RAM. The Mac on which I'm writing this has more than 100,000 times that amount; its processor is a thousand times faster. I wrote a program—in FORTRAN—to monitor the performance of all the electrical generators in the country, in nuclear, gas-driven, and hydroelectric power plants. Only a few kilobytes of memory were available for this. I never found out whether it all ever functioned after it was set up in Tehran.

IBM's adherence for so long to large, centralized computers, called mainframes, nearly led to the company's downfall when small autonomous systems—minicomputers, microprocessors, and personal computers—started to become widespread in the mid-1970s. In the early 1980s, "Big Blue" was able to avert its demise at the last minute via technology it had bought up. A small software outfit called Microsoft headed by Bill Gates supplied DOS (the Disk Operating System) for the first IBM personal computer.

A big problem, not only for the Iran project, was memory. Magnetic-core memory—large, expensive, and relatively slow—was the main form of random-access memory. Disk storage units and magnetic tape as external memory offered minuscule storage capacity compared to today's hard disk drives and flash memories. Only a few kilobytes of RAM were available for complex tasks. For the programmer, this meant: "Use your whole bag of tricks to save space!" Programmers back then were still lone warriors; everyone had his own style of coding. The modern tools of software engineering were still in their infancy. As a result, programs were complicated, poorly documented, often convoluted "spaghetti code," and bugs were common. The largest software package at the time, the OS/360 operating system for IBM's System/360, contained a constant thousand bugs, I once read. Every "patch" that was delivered to fix a bug added one new bug on average. In short, the software was no longer under control, the scale and complexity of the projects kept increasing, the costs went through the roof and soon exceeded those of the hardware. People spoke of a "software crisis."

Because IBM provided computers and software as a package, its competitors sued in the late 1960s for violation of US antitrust laws. A situation in which it was nearly impossible for independent suppliers of hard- or software to compete with the quasi-monopoly held back technological progress in the industry. Courts ordered IBM to "unbundle" its hard- and software, that is, to offer them separately.

A typical shortcoming from the age of ruthless space-saving had a certain notoriety: the millennium bug. In programs, it was common to use a two-digit, rather than a four-digit, year format—99 instead of 1999. That saved a couple of bits at least. An industry whose PR departments constantly raved about a magnificent future could not, in its everyday operations, even look ahead as far as the year 2000. Shortly before the date turnover, word spread that the turn of the millennium could have devastating consequences for hundreds of thousands of programs worldwide. For example, the entire electrical grid of Iran or other countries could be crippled because the central computers were paralyzed or calculating the wrong output levels. A global catastrophe loomed, but in the end the world emerged unscathed, as billions were spent in the nick of time to overhaul the old programs. Retired software experts such as my old PL/1 instructor lined their pockets nicely by "debugging," that is, removing legacy issues in the programming.

My final project for IBM was developing a computerized testing facility for two-way radios used by the Swiss Army: heavy devices with a very short range. They had already caused me a lot of frustration when I

was a radio operator stationed in the mountains. IBM had introduced a new process-control computer, the System/7, designed to be a "front end" for mainframes of the System/360 and System/370 families. This made programming more, not less, complicated. We developed the programs at the computing center using the conventional method and input them via punch cards. We had to convert the output from punch cards to punched tape in order to transfer the program code to the System/7. A teletype served as input device, console typewriter, and printer. This roundabout way of working was a technological step backwards, mandated by the concept of centralized, hierarchical systems. Years earlier, I had already worked with powerful, autonomous minicomputers at the ETH. I wondered why our customers didn't prefer the exquisite machines offered by the competition. However, the three letters "IBM" opened a lot of doors; the market power of "Big Blue" worked wonders.

Nevertheless, the project was interesting and gave me the opportunity to work on an IBM/360 myself, at a computing center in Altstetten. My heart leapt a bit one night when I stood alone before the impressive front side of the mainframe for the first time. Myriad lights blinked on a light-gray surface about a square meter in size, while a number of buttons and switches were assigned to functions that only the initiated understood. We hadn't gotten to their secrets in the introductory courses. The manual was about the size of three telephone books. At top right, there was a large, mushroom-shaped button labeled "Emergency Switch." If the system were to get completely out of control, the hard disks spun too hard, or smoke were to emerge from the blue cabinets, this was the emergency brake that had to be pulled—but only in the most extreme cases, because only service technicians knew how to get the machine running again. I was lucky: I never had to reach for that last mushroom.

A colleague and I occasionally did our work for this project in a computing center owned by the Swiss Department of Defense inside an industrial warehouse near Bern. What surprised me was that at the entrance, we had only to press the button on the intercom and say, "We're from IBM," for it to be open sesame at this top-secret military location. No checkpoint, no badge, nothing: the magic of the three letters opened this door, too. I'm almost tempted to speak of the "good old days of electronic data processing." Computing centers had almost no security. In downtown Zurich, you could look through windows and watch IBM operators working. The systems weren't yet fortified like they are today, where sensitive data is kept in old military installations and protected by steel-reinforced doors, secure corridors with facial-recognition systems, and software firewalls against viruses, trojans, hackers, cyberwarriors, and Internet terrorists.

Fig. 10

Fig. 11

IBM was not a prison—unless perhaps it was one with gilded walls—yet to me, the company increasingly appeared to be its own environment, isolated from the rest of the world. Today, the term "echo chamber" might be used to describe it. When I entered the open-plan office in the morning, wearing my coat and tie, I was a different person than the one who wore jeans and a leather jacket to Vietnam War protests in the evenings—that brutal conflict in which US troops used IBM technology as well. Professionally, I felt increasingly confined to a technological monoculture, with certain prospects inside of, but waning prospects outside of, the world of "Big Blue."

When I once again walked down the central aisle of the open-plan office on the first work day of 1973, my destination was not the coffee machine, but the department head. I handed him my letter of resignation. Our long conversation demonstrated that he was a person who completely understood me. "What are your plans?" he asked in conclusion. "To write," I said, "but not programs." He shook my hand and wished me luck.

That's how life is: two years later, I was sitting on a hard chair in a Siemens laboratory in Zurich-Albisrieden, building and programming computerized testing systems for components used in analog and digital telephony. We used microprocessors and small, powerful PDP-11 computers from Digital Equipment. I wore a T-shirt and jeans, had an informal relationship with the colleagues in my work group, and the coffee machine was close by. I became a father, a union member and workforce representative, and worked on my first novel. Subject: one night in a computing center. When I was hired, I expressed a wish, unusual for that day and age, to work part-time. The head of the personnel department agreed without asking why I needed two days off every week. Maybe my reference from IBM had opened this door as well.

Ostermundigen

Ruins of Post-Industry:
The Rise and Fall
of ERZ/W

Max Stadler

I Remains

The state enterprise is, so to speak,
an institution made for eternity.
Arnold Reber, head of PTT's Punch Card
Division, 1960

My first attempt at visiting ERZ/W—Switzerland's erstwhile largest "computing center," operated by the Swiss National Post-, Telefon- und Telegrafenbetriebe (PTT)—failed. I had, it transpired, gotten in touch with the wrong real-estate or, for that matter, facility management company: a company in charge not of the defunct Elektronisches Rechenzentrum (ERZ), which I consequently was unable to inspect; but one in charge of the eighteen-or-so-story R&D building next door, the former PTT Research and Development Center—an imposing (by Swiss standards), vaguely modernist looking high-rise towering over the eastern outskirts of the nation's capital city, Bern.

This much I already knew: the high-rise had indeed been built by a man with impeccable credentials—Hans Brechbühler, a disciple of Le Corbusier's. And much like ERZ/W, the adjacent Labor-Hochhaus (R&D skyscraper), completed in 1972, had gone through several hands since. Or so I was told by the person who did show up that day, a local contractor working for said facility management company: Swisscom, PTT's quasi-private successor company as of January 1, 1998, had first sold, then leased back, the buildings so as to produce the considerable amounts of cash it presumably needed to bid in the first wave of mobile license auctions back in the early 2000s. Several billion Swiss francs were necessary, if the prior auctions in the UK and Germany were any indication. As it turned out, though, they weren't any indication. One of the prospective bidders—Sunrise—pulled out at the very last minute, making the price tag drop far below expectations.[1] The maneuver, then, ultimately proved unnecessary. Meanwhile, Swisscom continued to rent rather than own the place. By 2014 the company had completely evacuated the area, leaving the site in various states of abandonment.

As a result, on this uncomfortably cold December morning, I found myself not in the building that for some thirty years had housed the data-processing machinery of Switzerland's erstwhile largest provider of "services"—from 1967, when ERZ/W had opened its doors, until 1997/98, when PTT was broken up and its telecom branch incorporated—but some fifty meters to the east. And about eighty-one meters above ground. Standing on top of the concrete-clad Labor-Hochhaus, I took in the view—the city, a graveyard, scattered construction cranes, the rolling hills stretching out toward the Alps ... and the mostly desolate complex of buildings at our feet that had once

Fig. 1

[1]
On these auctions, see Josef Egger, *Die Genesis eines alternativen Telekomanbieters im Gleichschritt zur schweizerischen Telekomliberalisierung*, Preprints zur Kulturgeschichte der Technik 28, Zurich, 2008, p. 24. Incidentally, Sunrise was (and is) another deregulated offshoot of Switzerland's formerly public enterprises, the railways in this case.

Fig. 1
PTT R&D skyscraper
(under construction), 1970.
(© PTT Archiv, Köniz,
D Tele 195 - 0003: 01)

184

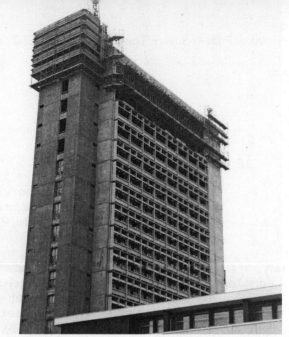

Fig. 2

made up PTT's Technisches Zentrum (Technology Center). This comprised various garages, logistics facilities, laboratories, and depots; the nearby train tracks (PTT's precursor organizations had moved into the area by the late nineteenth century); a spacious parking lot, nestling against ERZ/W, now covered in weeds; and the two-story staff canteen, also built in the 1960s, by which time the population of Bern-Ostermundigen, to give these outskirts a name, would peak at about 15,000—up from a few thousand in 1950.

Swiss suburbia. Or, as a 1983 tourist brochure from the PTT Archives, graced with the paintings of Paul Klee—*Quarry at Ostermundigen*—somewhat nostalgically recorded: rather "explosive" growth. "[S]tatistically speaking," by the time ERZ/W arrived on the scene, it had become a minor city unto its own.[2] Indeed, "[i]n this, Ostermundigen [was] no exception," the PTT Directorate General was told (with some alarm) back in 1962. It was a place where new apartments had multiplied "much like mushrooms." Which was why long lines formed at the post office (a new one was being planned) and why newcomers who wanted a telephone had to be put on a waiting list. (The local telephone exchange dated from 1926, maxing out at about 2,800 connections, and it, too, was about to be replaced.)[3]

The buildings that went up in and around Ostermundigen, to be sure, pale in comparison with, say, the ones in Ivrea, where Adriano Olivetti had been dreaming of a *Città dell'uomo* (1960) and where Le Corbusier himself was commissioned to a design a vast, futuristic Centro di calcolo elettronico, complete with showers, cloakrooms, and an encephalon-shaped floor plan.[4] But the Technisches Zentrum and the residential buildings nearby and the neatly landscaped PTT headquarters (1965–1970)—located in a different part of Bern, and providing office space for some 1,000 people—clearly were an expression of that same moment. Further afield, beyond the circumference of the Zentrum, I thus discerned, or tried to, what must have been "Rueti I," "II," and "III"—yet another relic, that is, from the mid-1960s: patches of land pur-

2
"Ostermundigen," 1983, OK 0117: 01, PTT Archiv. As the brochure explained, the commuter-friendly suburb had been blossoming notably in the three or so decades "since the last war." Only in the mid-1970s, following the recession, did things stagnate somewhat. Franz Hohler's *The Fringe of Ostermundigen,* a 1973 short story featuring "a man nobody [knew]," made a similar point (in more bemusing terms): it is, or was, a quite generic, ordinary place.

3
"PTT Gebäude, Ostermundigen. Betriebswirtschaftlicher Bericht," January 23, 1962, OK 0117: 01, PTT Archiv.

4
Le Corbusier's Centro, to be based in Rho, near Milano, was never completed. See Silvia Bodei, *Le Corbusier e Olivetti. La usine verte per il Centro di calcolo elettronico,* Macerata, 2014.

Ostermundigen Andrea Helbling

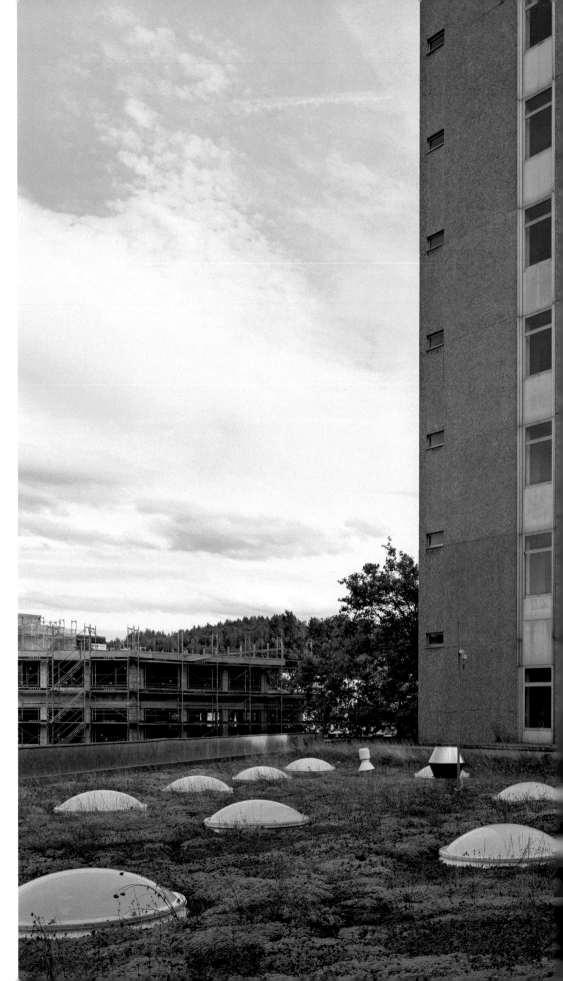

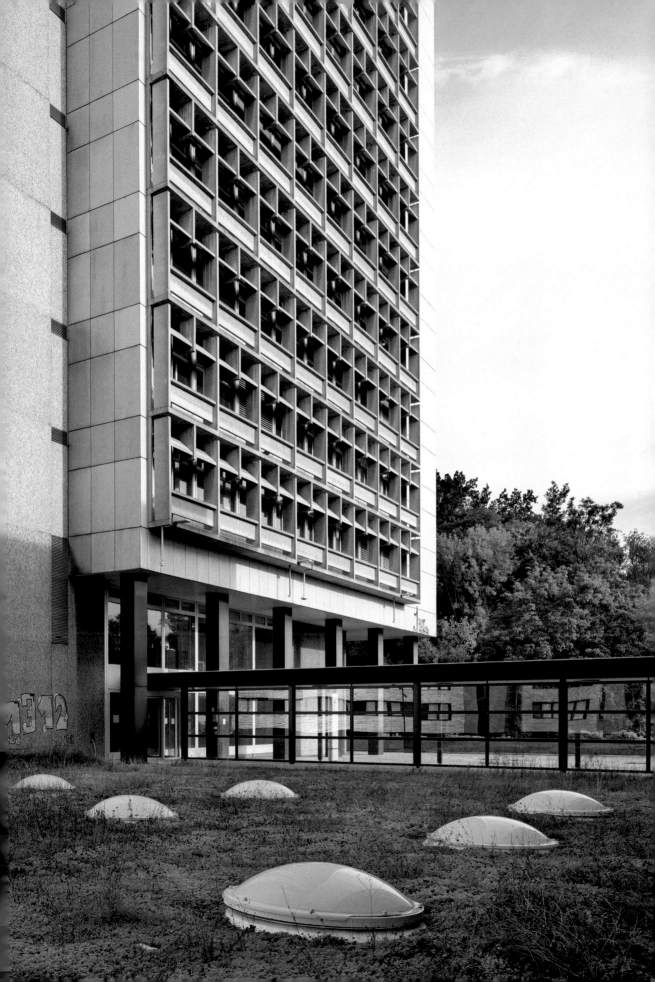

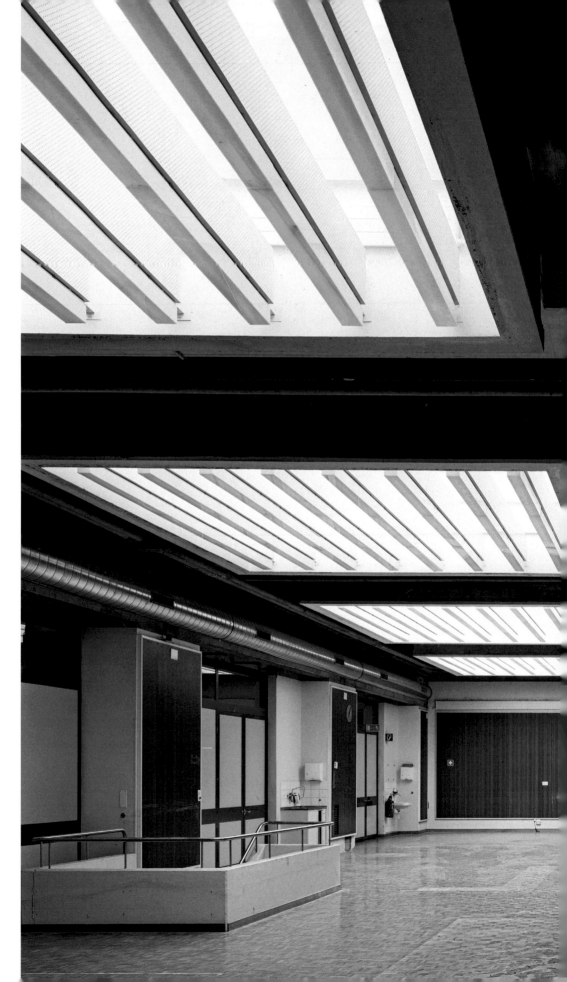

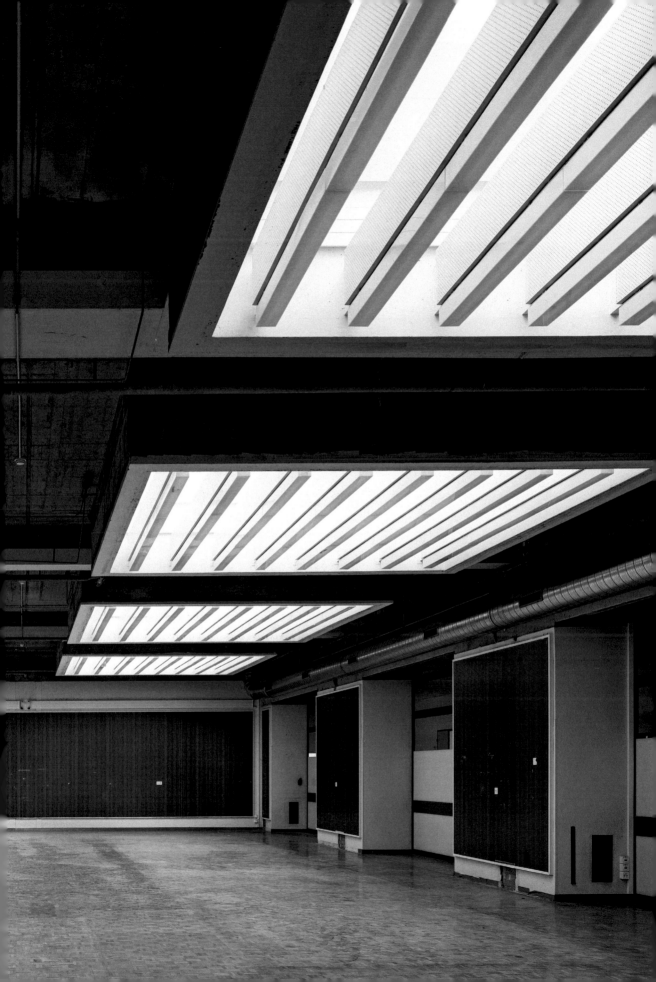

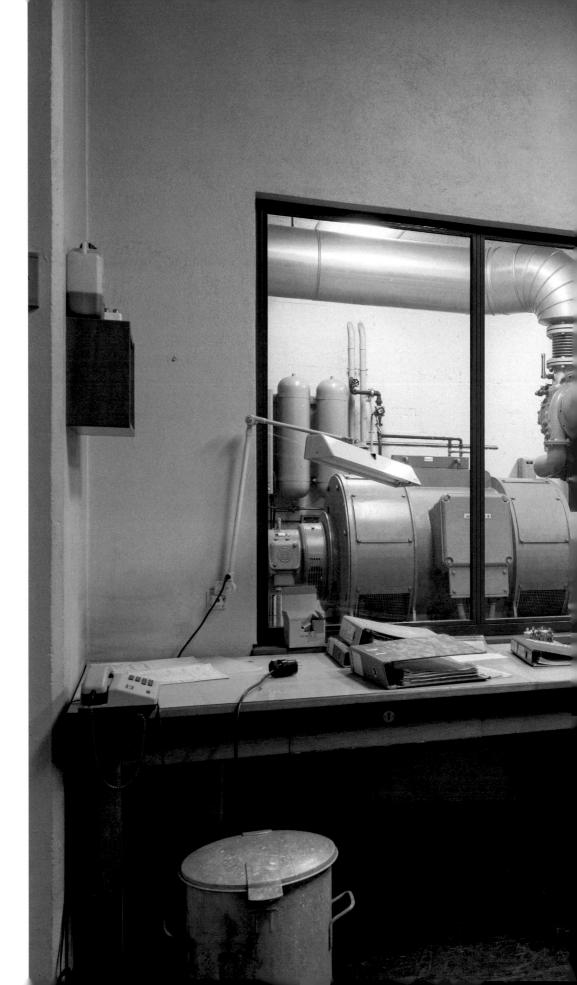

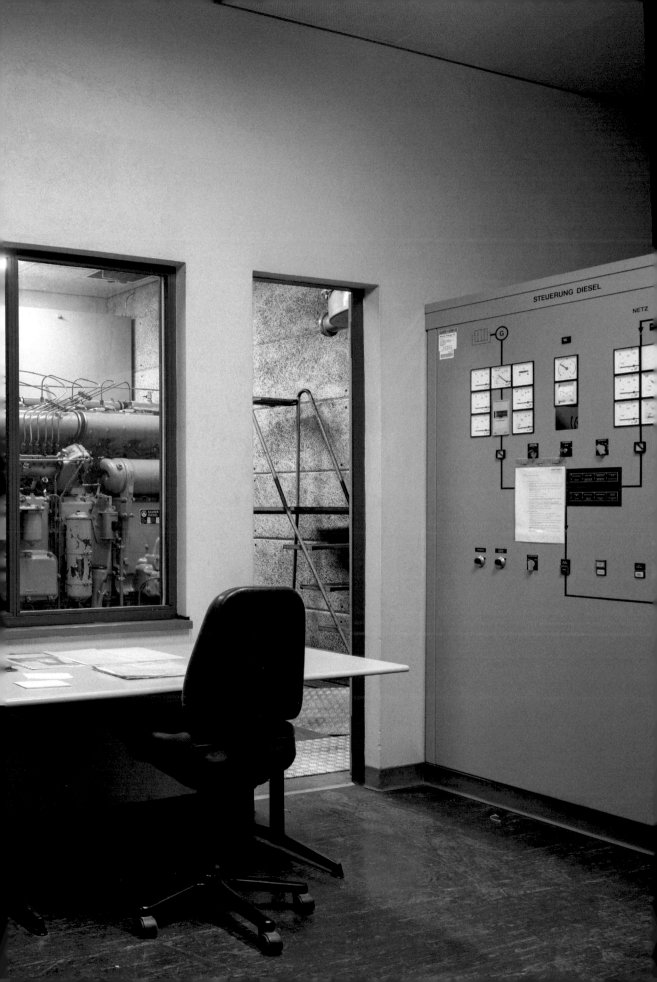

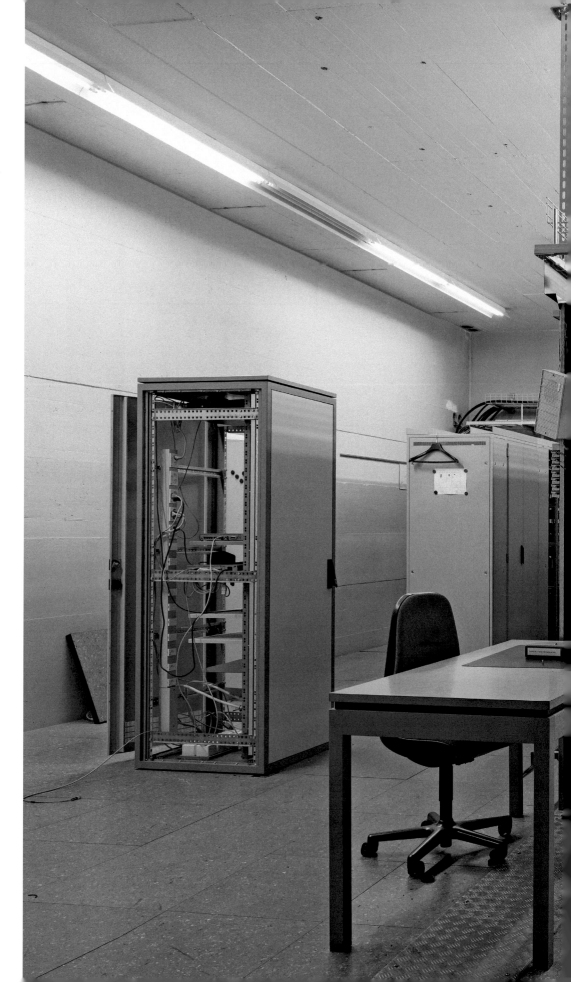

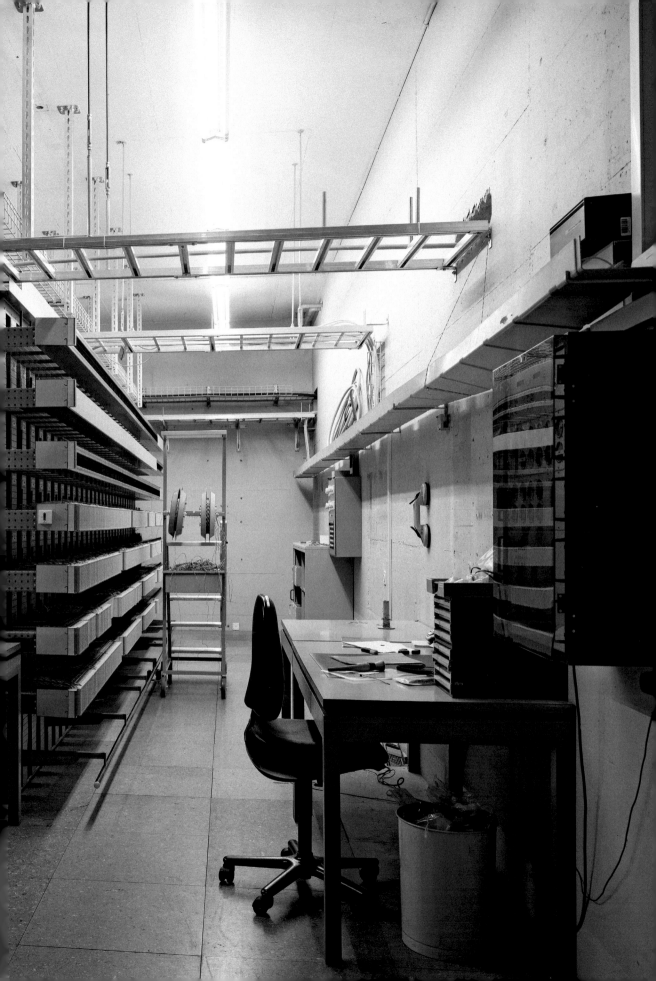

Fig. 2
PTT ERZ/W, top view with
parking area. (© PTT Archiv, Köniz,
D Tele 195 - 0003: 03)

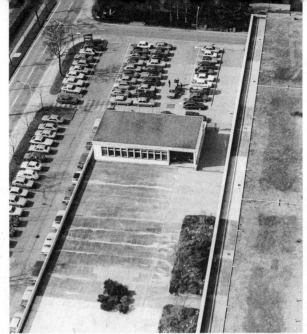

Fig. 3

chased by the state and filled up by local developers with modern apartment buildings, lodgings, and small family homes for PTT personnel. Some came with balconies, some with subsidized refrigerators; others, including the spartan rooming house destined for the "girls" from ERZ/W's "data entry" division, came with shared amenities, notably a TV room, as I'd previously discovered when browsing through PTT's archival collections. Not too much, in fact, has been preserved relating to this once-magnificent computing center: the odd picture, the occasional yearbook, heaps of technical drawings, dating from the construction phase in the mid-1960s.

The world of ERZ/W, or indeed that of PTT, has by and large disappeared, in other words. It's an impression difficult to avoid, at any rate, when paying a visit to the Technisches Zentrum these days: the scenery can be a bit glum, almost as if to vindicate the old swan songs for PTT. Unsurprisingly, these had steadily swelled since sometime in the 1980s, when PTT's expansive monopoly began to be seen as a liability—its near-exclusive right, that is, dating from the early 1920s, "to establish and to run any kind of transmission or receiving machinery serving the transmission of electric and radio-electric signs, pictures, or sounds."[5]

It was, as I'd soon come to appreciate, a similar spirit that animated histories of PTT, many of them written in the 1990s or early 2000s, many of them echoing what had long ossified as so many truisms: the state cannot innovate, markets do; the public, "classic" PTTs were "legacy powers"; one definitely couldn't pull off such things as the Internet by way of any "central committee, planned economy, or infrastructural policy"; it required "a mixture of rebellion and uncontrolled growth," and so on.[6] In these histories, ERZ/W, to be sure, barely gets a mention—PTT, after all, was a huge organization, employing 64,841 people at its peak, doing many things *besides* internal administration (i.e., what ERZ/W was for, by and large). Meanwhile, the few histories that do tell of ERZ/W typically tend to approach it, naturally enough,

5

Translation as per Peter Zweifel, ed., *Services in Switzerland: Structure, Performance, and Implications of European Economic Integration*, Berlin, 1993), p. 104.

6

See, for example, Richard Cop, *Telekommunikation in der Schweiz – Geschichte und Perspektiven einer Technik im Wandel*, Zurich, 1993; Philipp Ischer, *Umbau der Telekommunikation. Wechselwirkungen zwischen Innovationsprozessen und institutionellem Wandel am Beispiel der schweizerischen PTT (1970–1998)*, Zurich, 2007; cited is "Klick in die Zukunft," *Der Spiegel*, no. 11 (1996), p. 81.

Fig. 3 Post office for Bern-Ostermundigen, architectural model, 1950s. (© PTT Archiv, Köniz, OK 0117: 07)

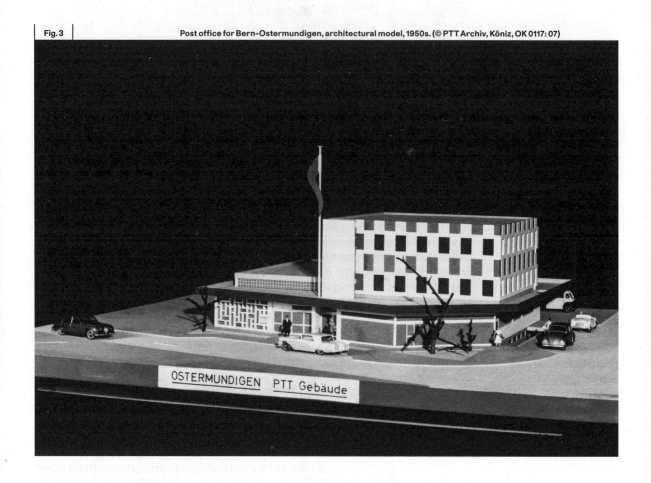

as something that did something *to* PTT: much like Rechenzentren (data centers) elsewhere—many similar ones shot up at the time—would gradually transform the ways of retail, banking, insurance, industry, and, indeed, of government.[7] And, sure enough, a case could be made that the managerial techniques adopted, refined, or initiated at ERZ/W and allied operations at the time—at computer services firms, at consulting agencies, at university institutes peddling in "scientific management," "automation," or "operations research"—soon radiated outwards, transforming the ways PTT and other (Swiss, in this case) corporations or state agencies were run.[8]

And yet, as I stood there amid the ruins of Ostermundigen, framing it this way didn't seem right: it seemed like a partial, even computer-centric, view. It's a view broadly in line, to be sure, with the ways we tend to construe the contemporary data center (a building-with-lots-of-computers-inside, owned by tech companies); and one in line, too, with the peculiar division of labor that historians have tended to adopt when approaching the making of the digital age (computing here, infrastructure or telephony there). But it's also a view largely oblivious of the fact that PTT was once itself a formidable force of change. Historically speaking, this framing—building-with-computers-inside—can be a little deceptive, in other words;[9] it tends to obliterate, for one thing, said "legacy powers," be they the German Bundespost or the British GPO or the Swiss PTT. What follows, consequently, is an attempt to portray ERZ/W, Ostermundigen, as a product *of* PTT—as something contiguous with, rather than exogenous to, this vast, sprawling operation with its projects and buildings and people. Certainly in the case at hand, this chapter argues, making too much of the fact that the highly modern computing center, ERZ/W included, was a transformative thing (and it undoubtedly was) would mean accentuating a familiar, entrenched, and somewhat one-dimensional narrative at the expense of those very forces that had arguably made Switzerland "digital" in the first place.

That PTT would have been such a force is a trivial observation, to be sure. However, it's also a narrative receding from collective memory: one whose nuances, in this age of Alphabet/Google, Alibaba, and kindred unfathomable entities, seem ripe for revisiting.[10] More broadly, of course, these two histories—computing and telecommunications—can't be separated so neatly.[11] By the late 1970s, when ERZ/W was firmly established as PTT's in-house data-processing outfit, there was indeed much excited talk of convergence between precisely these two fields—an entanglement then typically referred to as "telematics." It's a term that has since fallen out of fashion, having been replaced by "cyberspace" and "the Net," then "cloud" and

7

Much like Amazon Web Services or Microsoft Azure, if you will, are poised to transform public and/or private corporations today. On this earlier moment, see, for example, Joanne Yates, *Structuring the Information Age: Life Insurance and Technology in the Twentieth Century*, Baltimore, 2005; Jeffrey R. Yost, *Making IT Work: A History of the Computer Services Industry*, Cambridge, MA, 2017.

8

On such dynamics, see the ongoing project "Aushandlungszone HERMES" by Nick Schwery, https://www.tg.ethz.ch/projekte/details/aushandlungszone-hermes; for a particular case study, see Daniela Zetti, *Personal und Computer. Die Automation des Postcheckdienstes mit Computern, ein Projekt der Schweizer PTT*, Preprints zur Kulturgeschichte der Technik 22, Zurich, 2008.

9

Even while "networks" inevitably play into this frame, of course, arguably, much of the historiography in question tends to be Internet-centric. See, for example, Tung-Hui Hu, *A Prehistory of the Cloud*, Cambridge, MA, 2015; Julien Mailland and Kevin Driscoll, *Minitel: Welcome to the Internet*, Cambridge, MA, 2017.

10

As I write this, for instance, movements are underway in both the US and the UK—pioneers in matters of telecom deregulation—that push for the breakup of "Big Tech," the "renationalization" of broadband infrastructures, and so on. In a more academic vein, the private enterprise = innovation equation, too, has lost much of its erstwhile, quasi-dogmatic self-evidence. See, for example, Mariana Mazzucato, *The Entrepreneurial State: Debunking Public vs. Private Sector Myths*, London, 2018.

"tech"—things less obviously telephonic, and things that, at any rate, happened in California, or maybe in Japan or in China. No question: it's doubtful that anyone who wanted to explore this history would have to travel to Ostermundigen of all places. ERZ/W, as we shall see, wasn't even in the business of "tele-informatics," as it was called in an internal memo from 1985 on "Developments in Electronic Data Processing."[12] Certainly by the 1990s, by which time deregulation was gathering speed, ERZ/W had become a minor asset; even the distinction of being the largest Swiss computing center was now a thing of the past, ceded to operations such as Credit Suisse.[13]

And yet ERZ/W or, rather, its surroundings, as the following suggests, isn't such a bad place from where to revisit this history. For these surroundings ultimately point to a different kind of narrative, as I hope will emerge in due course: a narrative infatuated less with the disruptive powers that be—"tech," "the digital," "the cloud"—as with the things that have been undone in the process.

As for the "center," to which I would return on another day, only a few sparse details disturbed the drab scenery, exacerbated on that day by the thick, gray clouds hanging over Ostermundigen: the "focus" cubicles, for instance, which must have been added to the spacious, period-style open-plan offices sometime in the 1990s; and, visibly a product of that same era, the mint-green cafeteria in the adjacent high-rise, featuring a lounge area of sorts and dot-com-era wall decorations—courtesy, as my guide wryly noted, of the renowned architecture firm Herzog & de Meuron. Puzzled by the (mostly) young men who wandered about in the R&D skyscraper, I also gathered that the building was currently being populated with start-ups and artists' studios—for fear of squatters. (It is, as the real-estate person I had erroneously contacted told me, of course rather difficult to actually rent out a place this huge.)

II Concentration

> As for the history of IBM [Switzerland], the introduction in 1955 of the PTT utility bill punch card proved a landmark event.
> "Sie begannen zu dritt," mosaic IBM Schweiz, 1979

The erstwhile Labor-Hochhaus, once proudly celebrated as Bern's very own skyscraper, commands, in other words, a somewhat depressing view today: a place muffled in a strange sort of melancholia—ruins, if you will, of what one Swiss newspaper disparagingly referred to as "mégalomanie" when, in 1958, it first got wind of PTT's plans to expand into the area: "des somptueux palais postaux."[14] At the time, such sentiments would have been few and far between,

11
See, for example, Andrew L. Russell, *Open Standards and the Digital Age: History, Ideology, and Networks*, Cambridge, 2014.

12
ERZ PTT, "Entwicklungen in der Informationsverarbeitung und ihre Auswirkungen auf die Standardisierung der EDV in Unternehmen," October 1985, Tele 195-0011: 04, PTT Archiv.

13
Interview with Hans Rehmann by Sascha Deboni and Max Stadler, April 9, 2019.

14
"Un gratte-ciel de 45 étages," *Tribune de Genève* (January 10, 1958), OK 0117: 07, PTT Archiv.

Fig. 4
Boxes with IBM punch cards, PTT
Punch Card Division, Zurich,
1959. (© Museum für Kommuni-
kation, Bern)

Fig. 4

of course. While state bureaucratic largesse, along with the "shades of social-ism" that it presumably signaled, had its distractors, more likely that contem-porary observers would have insisted on the naturalness of state monopolies in matters of communications, and thus on a certain technocratic grandeur.[15] "[S]tate bureaucratic integration," as one 1960 treatise on "automation" put it, "[was] only the logical expression of the postal services' exclusive duty to fulfill a society's communicative needs and requirements."[16]

 By the same token, such requirements had to be ful-filled "optimally," which is why PTT's very raison d'être—the so-called common good, or what the Swiss call *service public*—had become deeply entangled with questions of rationalization: the pursuit of efficiency by each and every means available, be that mechanized letter-sorting, automatic telephone exchanges, or a system of postal codes (which would be introduced in 1964, trailing behind only the US and West Germany).[17] To wit: the vanguard role that PTT would play in Switzerland as an early adopter of advanced, namely elec-tronic, computing machinery—including (reportedly) Switzerland's very first off-the-shelf digital computer, an IBM 650, which ERZ/W's precursor organi-zation, the *Lochkartensektion* (Punch Card Division), took delivery of in 1957. In no time, PTT's electronic machine park had grown to include an IBM 7070, five IBM 1401 systems, and (from 1968) an IBM S/360 M50 mainframe.

 And, sure enough, these acquisitions were accompa-nied by the usual Automation Age hyperbole: they meant emancipation from monotony and mind-numbing drudgery, the machines themselves being a product of an eminently scientific age, "l'ère des organisateurs," about to deliver a death knell to the present, outdated "monde du papier."[18] To a monopoly enterprise lacking competition and not bound by the profit motive, such enter-prising measures were all the more important, as the head of PTT's Financial Division, Dr. Fritz Sauser, explained. Data processing, whether electronic or "con-ventional," was labor-saving, the rhetoric went, thus cost-saving, thus rational.[19]

15

Cited is Max Silberschmidt, *Ameri-kas industrielle Entwicklung. Von der Zeit der Pioniere zur Ära von Big Business*, Bern, 1958, p. 12.

16

Johann Rohde, "Post-Versand," in *Aspekte der Automation*, edited by Harry W. Zimmermann, Basel, 1960, p. 182. This mentality is still palpable when flipping through, say, the pages of *Revues des PTT*, the in-house magazine and premier outlet for parading the nation's new postal buildings (invariably func-tional and modernist-looking), PTT's (generous) social welfare facilities, or its stupendous invest-ments: "hundreds of millions of francs," as one 1960 article on long-distance communications excitedly reported, had already been put into cables alone.

17

See, for example, "Mechanisierung und Automatisierung. Die schwei-zerische PTT im Angesicht kühner Neuerungen," *PTT-Union* 63, no. 24 (June 17, 1960), pp. 1–2; General-direktion PTT, *Die Postleitzahl. Gründe und Hintergründe*, Presse-dienst, 1964.

18

In the words of Charles Frédéric Ducommun, PTT's director general from 1961 to 1970. See Charles Frédéric Ducommun, "Ostermundi-gen: le centre de calcul électron-ique de l'entreprise des PTT et sa significance humaine," *Gazette de Lausanne* (June 29, 1967), OK 0117: 07, PTT Archiv; and see "Gedanken für Pressekonferenz vom 27.4.60 bei F 5," 1960, 2, Tele 195-0011: 04, PTT Archiv.

It was, at any rate, the only viable response to the looming dearth of skilled labor.[20] And, as Sauser's subordinate, Arnold Reber, the (then) "chief" of PTT's punch-card operations, noted in 1960, on the occasion of moving his outfit into their new, temporary premises in Zurich-Wiedikon: "repetitive bulk jobs" —telephone bills, payment notices, payrolls, and so on— quite simply had been escalating continuously at PTT. One therefore had to "cherish the means that technology offered," Reber noted, adding ominously that the "state enterprise [was], so to speak, an institution made for eternity."[21] Not quite. Naturally enough, though, PTT functionaries were inclined to think this way, taking pride in the many superlatives that came attached to this monopoly enterprise. PTT was, after all, Switzerland's largest employer (with 35,898 employees in 1959), its largest real-estate owner/developer, a major investor in telecommunications infrastructure (per capita, the most magnanimous, globally), a mover of more cargo per capita than anywhere else, and the operator of the densest telephone network *worldwide*.[22] Not surprisingly, the sheer scale of PTT's operations entailed considerable administrative efforts: "incessant floods of paper," in the words of Sauser above.[23] And unsurprisingly, too, as the *Neue Zürcher Zeitung* noted back in 1956, PTT operated a rather large "punch-card organization" (Switzerland's largest, in fact).[24]

Indeed, without PTT's multiple and manifold public "services"—transport, logistics, finance, telecommunications—the country's "spectacular economic performance" quite simply was unthinkable, as was expressed in a 1961 memorandum to the Swiss government in an attempt to justify the considerable outlays that PTT required that year for projected expansions, the Technisches Zentrum included.[25]

Some 61,386,500 Swiss francs had already been put aside for the latter;[26] another 2,391,000 were requested on the occasion, because, owing to peculiarities of Ostermundigen's subsoil, construction works at ERZ/W—initially costed at 19.5 million—had run into difficulties. (It was then

19	**20**	**21**	**22**
The profit motive, it was admitted, might have reined in inefficiencies; in its absence, the "principle of rational management [betriebs-ökönomisches Prinzip] assume[d] the highest priority," as he put it. See Fritz Sauser, "Die Entwicklung der Lochkartensektion PTT," April 21, 1960, Tele 195-0011: 04, PTT Archiv.	"Gedanken für Pressekonferenz," 1960; the perceived pressures of a labor market that had severely "dried up" then provided a fairly consistent refrain to the efforts of ERZ/W. See, for example, Alphons Stadler, "Der Zehnjahresplan des Elektronischen Rechenzentrums PTT," *PTT Revue*, no. 1 (1971), p. 3.	"Gedanken für Pressekonfer-enz," 1960.	See "Die Rationalisierung des Postbetriebs," December 27, 1960, 54.45.19, SOZARCH; Sauser 1960. Philippe Braillard, *Switzerland as a Financial Center: Structures and Policies*, Dordrecht, 1988, p. 191.
23	**24**	**25**	**26**
Sauser 1960.	It was widely visible, too. In fact, the NZZ report went on, "almost every family ha[d] made acquaintance with the punch card," because PTT had just recently taken to sending out punch-card bills for radio fees and telephone services. See "Loch-kartenverfahren und elektronische Data-Processing-Maschinen in der Schweiz," *Neue Zürcher Zeitung* (September 6, 1956), p. 27.	"Verhandlungen der Eidgenössis-chen Räte Nr. 8202/1961," June 7, 1961, p. 1, OK 0117: 01, PTT Archiv.	"Ein PTT-'Wolkenkratzer' in Oster-mundigen," *Neue Berner Nach-richten* (February 11, 1958), OK 0117: 07, PTT Archiv.

Fig. 4

Fig. 5

PTT Technisches Zentrum (Technology Center), architectural model. (© PTT Archiv, Köniz, OK 0117: 08)

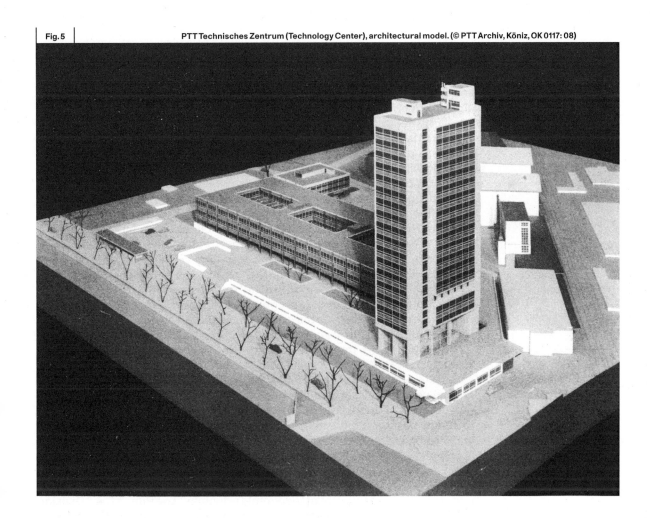

decided to add a third basement level, rather than put ERZ/W on "stilts," as had been planned initially.)[27] Ostermundigen's *palais postaux* had otherwise been meticulously planned, the ERZ design having been commissioned from the architectural company Frey + Egger, W. Peterhans, who had already made a bit of a name for themselves. They had, for example, just recently designed the new city hall in nearby Olten—a modest, tower-like office building somewhat reminiscent (it is said) of Le Corbusier's Unité d'Habitation in Marseille—and, somewhat less practical, a church in Biel, made almost entirely of concrete and adorned with abstract sculptures.[28] For PTT, they would create an "avowedly functional building," as a local newspaper put it on the occasion of the (much delayed) opening ceremony in 1967; it featured mobile partitions, cable ducts, raised floors and ceilings, state-of-the-art air conditioning, and an intercom system. "The principle of flexibility ha[d] been followed throughout."[29]

 The site had in fact been chosen as early as 1951—a decision backed up in 1955 with an expert opinion issuing from the fledgling Handels-Hochschule in St. Gallen. The "spatial resources [were] depleted," PTT officials were concerned, due to the "extraordinary growth in commerce and communication." Worse, essential PTT facilities were scattered around Bern as a result, which incurred additional costs and a waste of precious time. The R&D department, for instance, had seen a fifty percent increase in personnel in recent years. Its engineers were now toiling away in various places around town. The "Radio Service" was similarly suffering from dispersal. The same fate—lack of space—troubled the upstart Punch Card Division: in 1949, in what was considered a makeshift solution, the entire operation had been outsourced to Zurich, first to the so-called Fraumünsterpost, then, as noted, to Zurich-Wiedikon.[30] And it kept growing—from twelve people in 1949 to 184 in 1962. The experts from St. Gallen, part of an incipient wave of management scientists, operations researchers, and, indeed, "*organisateurs*" in the style of IBM Extension Suisse—a company whose local footprint grew from thirty or so employees in 1943 to 500 in 1960 to 2,350 in 1977[31]—thus recommended "concentration" as a matter of "economic principle." The Punch Card Division in particular was deemed to require "permanent, intimate contact" with all the PTT departments that might profit from its services.[32]

 ERZ/W, much like the Punch Card Division that had birthed it, would duly fashion itself as the *Dienststelle aller Dienststellen*—the "service center of all service centers": one that wouldn't be content with routine administrative duties (such as processing radio fees), but would instead be able to offer various statistics on PTT performance, conjure up projects so as to boost "productivity," and even extend its services to "third parties."[33] In

27

"Verhandlungen der Eidgenössischen Räte Nr. 8202/1961," p. 6. Because there was an ongoing "boom in construction," however, which absorbed developers' capacities, completion of ERZ/W would be delayed even further (until 1967).

28

"Betonwand in der reformierten Kirche in Biel-Bözingen," *Das Werk: Architektur und Kunst* 56, no. 3 (1969), pp. 191–93.

29

"Elektronisches Rechenzentrum (ERZ) und Wertzeichen- und Drucksachenabteilung," *Der Bund* (October 3, 1967), OK 0117: 01, PTT Archiv. Needless to say, in the absence of much other guidance (architectonically speaking), this principle was deemed supremely important: technological change in matters of computing was rapid, after all, and it would likely even be more rapid in the future.

30

"PTT-Bauten für technische Dienste Bern-Ostermundigen," November 6, 1957, p. 1, p. 7, p. 9, OK 0117: 01, PTT Archiv; "Das TT-Magazin- und Werkstättengebäude in Ostermundigen," *Der Bund* (December 3, 1951), OK 0117: 01, PTT Archiv.

Fig. 6
PTT ERZ/W, basement, 1967.
(© Museum für Kommunikation, Bern)

Fig. 6

1969, reflecting the ERZ's growing ambit, the computing center was extracted from "F5" (the accounting department) and attached directly to the PTT Directorate General.[34] And already, new acquisitions were being scheduled. Existing capacities would soon be exhausted. By 1968, the aging "EDP System 7070" alone was in nonstop "production" [sic] twenty-two hours a day (up from twelve hours in 1965), operated in three shifts.[35]

Meanwhile, the drive toward concentration evidently hadn't stopped short of matters of data. The new PTT headquarters, which would eventually have a slightly more bucolic air about it, was then about half-way through construction: from 1970 onward, it would provide much-needed office space and plenty of shrubbery.[36] In addition, the Bundesrat (Federal Council) had previously secured some 40,000 square meters of land in Oster-mundigen, enough to fill with 270 apartments, a rooming house for unmarried personnel, and "social housing"—some 625 apartments in total.[37] The R&D skyscraper alone, which doubled as a transmission tower, would offer labora-tory space for 240 men of science, bringing them together, it was said, in order to "direct" PTT's technological endeavors. By the time the building was nearing completion in the early 1970s, it, too, was peering into a future of zeros and ones: the transmission of "speech, music, data, images" by digital means.[38]

31

P. Haegi, "35 Jahre bei der IBM Schweiz," *mosaic IBM Schweiz* 11, no. 1 (1972), p. 20; "Organisa-tionsstruktur und Management System der IBM Schweiz," *mosaic IBM Schweiz* 16, no. 2 (1977), p. 4.

32

Alphons Stadler, "Umzug des elekt-ronischen Rechenzentrums PTT," *PTT Revue*, no. 6 (1967), p. 161; the preference for such "central" solu-tions would have been entirely ty-pical, of course; in part, simply as a matter of cost. See, for example, Heinz-Leo Müller-Lutz, "Zentrale oder dezentrale Lösungen," in *Das programmierte Büro*, Wies-baden, 1960, pp. 160–61.

33

Arnold Reber, "Der Aufgabenbe-reich der Lochkartensektion PTT," April 20, 1960, Tele 195-0011: 04, PTT Archiv; Stadler 1971. The em-phasis—on improved surveys, reports, statistics on the "Betriebs-geschehen" (operations), and thus on enhanced productivity—was, needless to say, entirely in line with manufacturers' newspeak. See, for example, *Rundgang durch die IBM*, Zurich, 1960.

34

Stadler 1971, p. 3.

35

Alphons Stadler, "Ein neuer Gross-computer im Elektronischen Re-chenzentrum PTT," *PTT Revue*, no. 12 (1968), p. 325. One might say that ERZ/W itself had grown into a vast, sprawling kind of machine, process-ing (by 1967) per annum some 20 million telephone bills, 1.2 million radio bills, 150,000 newspaper sub-scriptions, 41 million so-called *Einzahlungskarten* (deposit cards), 4.5 million overdue notices, 18,000 clothing receipts (for PTT personnel), 510,000 pay slips, and a host of other things.

36

W. Neukom, "Grünflächenplanung zum Verwaltungsgebäude der Generaldirektion PTT in Bern," *Anthos: Zeitschrift für Landschafts-architektur* 20, no. 1 (1981), pp. 6–11.

37

"Grosszügiger Wohnungsbau in Ostermundigen," *Der Bund* (November 11, 1966), OK 0117: 01, PTT Archiv.

38

"Forschung bei den PTT-Betrieben. Schrittmacher in Fernmelde-technik," *Neue Zürcher Zeitung* (February 2, 1973), p. 17.

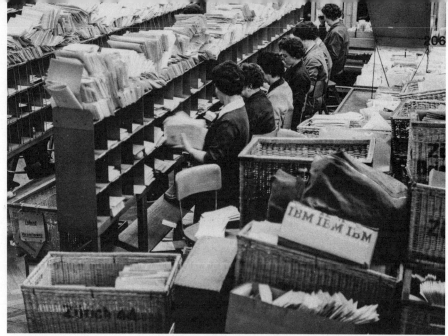

The Technisches Zentrum, in other words, only befit-
ted an operation like PTT—this "engine of progress," as one late-1950s eulogy
had it.[39] It was a public enterprise operating an immense and varied sort of tech-
nical infrastructure, including such widely visible landmarks as the Sihlpost in
Zurich, a veritable "logistics factory" where in those days cargo was moved on
an "industrial scale" (The Sihlpost is now home, incidentally, to Google offices.)
The figures were nothing short of astounding: by 1961, the Swiss PTT in total
moved some 1.5 billion letters annually, plus 800 million newspapers, plus
98 million parcels.[40] It tended to radio, the parvenu television network, nearly
5.5 million telegrams, 7 million telex messages, and 1.55 billion telephone con-
versations.[41] It was also, at the time, a major provider of financial services
—194 million deposits a year—making it the "poor man's bank."[42] And all this had
begun to flow, in some way or another, through what would become ERZ/W.

Fig. 7

III Foreign Bodies

*Wirtschaftskrise, Widerstände, Weltkrieg—time
and again these three "Ws" had set our efforts back.*
Notes on "50 Years of ERZ," Robert Zurflüh, 1976

PTT, in short, meant a lot of traffic: "hypertrophy of administration," as PTT
accountants had worried.[43] Indeed, few things in the story so far will surprise
readers versed in the history of computing; it was, arguably, this newly
"affluent," techno-optimistic world of growth—or, for that matter, this bureau-
cratic age of escalation in forms, bills, paychecks, records, and transactions—
that had spawned so much progress in matters of data processing.[44] Includ-

39

Werner Reist, *Die Sihlpost in Zürich,*
Bern, 1957, p. 6.

40

Kreispostdirektion Zürich,
"Die Sihlpost Zürich," November 8,
1962, 5, Appendix, 54.45.19,
SOZARCH.

41

"Aus dem Geschäftsbericht der
PTT für das Jahr 1959," *PTT Revue,*
no. 7 (1960), pp. 179–83.

42

In the words of Fulvio Caccia. See
Arbeitskreis Kapital und Wirtschaft,
*PTT im Umbruch. Liberalisierung
und Privatisierung im Brennpunkt,*
Zurich, 1996, p. 14.

43

Sauser 1960.

44

Quite despite, that is, digital com-
puters' somewhat sinister reputa-
tion as technologies born of war and
destruction. See, for example, Jon
Agar, *The Government Machine:
A Revolutionary History of the Com-
puter,* Cambridge, MA, 2003; Yates
2005; Corinna Schlombs, *Produc-
tivity Machines: German Appropria-
tions of American Technology from
Mass Production to Computer
Automation,* Cambridge, MA, 2019.

45

Hans Rehmann, "Asbestbelag
an Decke einkapseln," July 30, 1982,
ERZ/W.

46

Case in point: Swisscom's 2014
showpiece data center, ERZ/W's
distant offshoot, which is also,
as it is billed on their website, the
"most modern data center in
Switzerland." It is located in yet an-
other suburb of Bern—a nonde-
script area otherwise dominated
by shopping malls, McDonald's
restaurants, and the like. Home to
some 5,000 servers and Tier IV-
rated, it almost lives up to the Shut-
terstock-type, LED-drenched

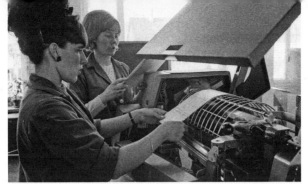

Fig. 8

Fig. 9

ing the object in Ostermundigen, the one I had ostensibly come here for, the Elektronisches Rechenzentrum ERZ/W: an oblong, fairly inconspicuous "functional building" with tinted panes of glass tinted in green, yellow, and purple sprinkled along its façade—now deserted, deteriorating, and (as it transpired) asbestos-ridden.

When, on a subsequent visit, I made it inside (this time guided by a man working for a subcontractor for Swiss Post), strolling through its eerily empty hallways, the signs of past glory were ever so few: an orphaned floppy disk, some cabling, a bunch of discarded circuit boards, a stash of files relating to site remediation works in the 1980s and 1990s—good for health reasons, but troubling insofar as decontamination would interfere with system uptime.[45] Half of the tract, in fact, is still basically in its original, late-1960s condition, with linoleum floors now dull and pallid; much of the rest had been renovated and equipped with the aforementioned "focus cubicles." The only signs of life we found in ERZ/W's basement: the heating system, I was told, is still operational, serving some of the adjoining buildings (including, presumably, the handful of start-ups residing in the skyscraper). It once (in 1967) employed upwards of 250 people, 160 of them female, doing things then variously referred to as "repetitive," "mind-numbing," or "monotonous": sixty keypunch "girls," fifty-five secretaries, thirty-five "operatrices."

And this, in a way, was what had initially brought me here: not PTT, nor subcontractors, nor telephones, but people. Or, rather, what had brought me here was a place or a configuration that was evidently quite different from what pundits call the dispeopled, "unbelievably abstract," even nonhuman kind of space that is the contemporary "data center."[46] As anyone studying the data-center industry will tell you, such construals are of course misleading at best. While the benefits and spillovers the industry brings to local economies are debatable,[47] it (still) generates any number of typically low-skilled jobs: minor armies of clickworkers, content moderators, and so on.[48] They're merely hidden from view, as it were.

Even so, the old ERZ/W still was, shall we say, a more people-centered affair—because of, rather than despite, its "highly delicate machine park."[49] Trivially, somebody still had to mind all those machines:[50] tabulators, collators, keypunches, verifiers, reproducers... Here, for example, is how one automation expert imagined an employee—a "young, well-trained female worker," that is—dealt with a device called a sorter: insert card deck, operate selection switch, depress start key... twelve or so "simple" operations, interspersed with lots of waiting. "Attention [was] basically required only in cases of malfunction (card jam)."[51] Needless to say, the job was almost certainly

47

iconography dominating much of the media coverage relating to data centers. Cited is "Ich würde gern Gebäude für Maschinen bauen (Interview with Rem Koolhaas)," *brandeins*, no. 5 (2019), https://www.brandeins.de/magazine/brand-eins-wirtschaftsmagazin/2019/provinz/rem-koolhaas-ich-wuerde-gern-gebaeude-fuer-maschinen-bauen (retrieved May 22, 2020).

48

On these benefits, see, for example, Copenhagen Economics, *European Data Centres: How Google's Digital Infrastructure Investment Is Supporting Sustainable Growth in Europe*, 2018.

See, for example, Sarah T. Roberts, *Behind the Screen: Content Moderation in the Shadows of Social Media,* New Haven, 2019.

49

"Gedanken für Pressekonferenz," 1960, p. 2.

Fig. 8 PTT ERZ/W, Bern-Ostermundigen, 1967. (© PTT Archiv, Köniz, Tele 195 - 0003: 03)

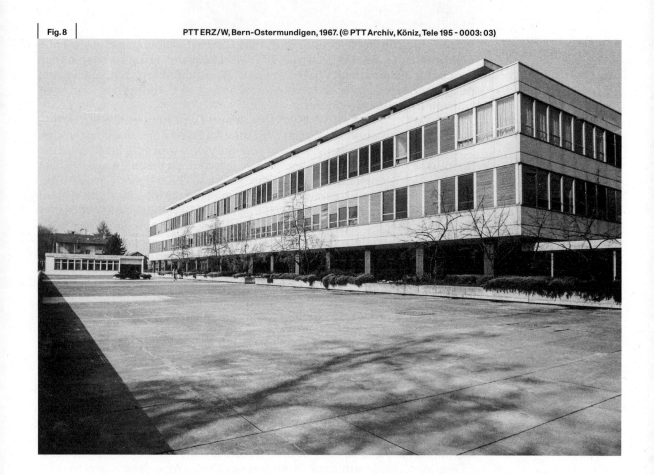

Fig. 10

more complex and demanding than that. To most, "data processing" neverthe-less meant unheroic work—"repetitive bulk jobs."[52] Or, as a more sympathetic account related (thanks to Bernese sociologist Urs Jaeggi):[53] These young women displayed "job-thinking." That is, they had a "realistic attitude. She [the keypunch operator] knows she cannot move up the ranks, and she puts up with it." They "accept[ed] monotony" as well as the considerable psychological pressure that was put on them only because they knew the job wouldn't last for long: namely, "until marriage."[54] Indeed, of those 160 women who arrived at ERZ/W in 1967, 150 were "single."[55] Hence, of course, the rooming house and TV room; hence, too, the "welfare building"; and hence (among other things) the cafeteria, which came decorated with murals.[56]

It's tempting, then, to construe ERZ/W as some kind of primitive precursor to the modern data center, displaced and replaced by successive generations of computing technology, then by networks of com-puters, Internet companies, and, eventually, new kinds of monopoly enter-prises hailing from California and China. In fact, the name suggests as much: *Rechenzentrum*. (The term is still widely used today.) This was certainly the mindset I had had when I arrived, although I had been intrigued not so much by ancient IBM machines as by the post-industrial setting. Or if you prefer, by manifestations of what the Bernese polymath Prof. Hans Zbinden, in his *Humanismus der Wirtschaft* (1963)—a book based on talks he had given at PTT "executive training courses"—framed as "progress as humanization." There was, he said, with a nod to "human relations" and kindred managerial innovations, a special "responsibility" on the part of the enterprise today: "responsibilities which [could] only be ignored or disobeyed by the short-sighted, by, indeed, the obsolete profit motive."[57]

That, of course, was a rather rosy view. (Zbinden, to be sure, also worried, as did much of the contemporary commentariat, about the potentially devastating social and psychological effects of "automation").[58] But clearly enough, even a place such as ERZ/W hat something distinctly *human* about it. And the fact is, despite shifting sensibilities on the part of historians of computing, we don't know all that much about places such as ERZ/W Ostermundigen. These, evidently, weren't mere beachheads of a new breed of technocrats-in-suits (they certainly were that); they also were spaces of fairly

50

At least during ERZ/W's early years, there was a good deal of "conven-tional" data processing going on, and the lowlier type of "data entry" duties wouldn't be going away anytime soon. For details, see, for example, "Transportgut. Zusam-menstellung Maschinen und Zubehör," May 6, 1967, Tele 195-0011: 04, PTT Archiv.

51

Johann Haas, "Büro und Verwal-tung," in *Aspekte der Automation*, edited by Harry W. Zimmermann, Basel, 1960, p. 234.

52

As for "repetitive" jobs, these, of course, were legion at PTT, not only at ERZ/W. "Automation" pro-ceeded on many fronts: "Everything that might increase performance [*Leistung*], we'll look into," as one PTT functionary put it in 1960. See "Die Rationalisierung des Post-betriebs," 1960.

53

Urs Jaeggi and Herbert Wiedemann, *Der Angestellte im automatisi-erten Büro,* Stuttgart, 1963, p. 136. (Neither Jaeggi nor Wiedemann, an in-house sociologist with IBM Germany, ever set foot in ERZ/W, as far as we know.)

54

Ibid., p. 137, pp. 191–94.

55

Stadler 1967, p. 163.

56

"Wettbewerb zur Erlangung von Entwürfen für ein Wandbild im Speisesaal," October 1, 1962, OK 0117: 01, PTT Archiv.

57

Hans Zbinden, *Humanismus in der Wirtschaft,* Bern, 1963, preface.

Fig. 11
PTT housing estate (Rüti-Ostermundigen), common room with television set, 1967.
(© Museum für Kommunikation, Bern)

Fig. 11

Fig. 12

monotonous work, or if you prefer, "jobs."[59] If the former worried about their "highly delicate machine park[s]," which shouldn't be exposed to humidity or dust or heat up too terribly, which is why any "computing center" (even then) would have imposed special architectural requirements, a vaguely analogous sort of concern thus pertained to people: the "sensitive employee," in the words of one PTT functionary.[60] In many ways, indeed, the machinic space that was ERZ/W only exacerbated the artificiality of the modern, "industrialized" office: HVAC systems, the modern science of lighting, insulation materials (a flourishing industry), ergonomic furniture, soundproofing, intricate communications systems, and potted plants (which had a reputation of attenuating noise).[61]

More to the point, there are good reasons to construe ERZ/W, Ostermundigen, not only as essentially continuous with clerical spaces of work—not much different, to the majority of people involved, from minding letter-sorting machinery or toiling at the telephone exchange—but to take seriously its continuities with PTT as well. That is, even while (male) ERZ/W actors themselves were prone to fashion themselves as some kind of "foreign body" within PTT, and while their projects met with hostility und resistance,[62] a computing center would have been a "foreign body" only to a certain degree in the technological enterprise that was PTT. It also was, for one thing,

58

See, for example, Hans Zbinden, "Mensch und Technik im Zeitalter der Automation," *Wirtschaftspolitische Mitteilungen* 12, no. 12 (December 1956).

59

Only recently have historians of computing taken a more systematic interest in computing-as-labor, though the concern, per se, is hardly new. See, for example, Ute Hoffmann, *Computerfrauen. Welchen Anteil haben Frauen an der Computergeschichte und -arbeit?* Munich, 1987. More recently, see esp. Jane Abbate, *Recoding Gender: Women's Changing Participation in Computing,* Cambridge, MA, 2012; Mar Hicks, *Programmed Inequality:*

How Britain Discarded Women Technologists and Lost Its Edge in Computing, Cambridge, MA, 2017.

60

F. Rauch, "Der empfindliche Mitarbeiter," *PTT Revue,* no. 7 (1963), pp. 182–83. Sociological musings from the 1950s and 1960s are replete with such accounts, noting, for instance, that the modern office made people dress better or develop certain expectations as to the proper "indoor climate." As one PTT personnel manager lamented in 1964: while average office temperatures "at the end of the war" had been around 18–20 degrees

61

Celsius, what was considered "normal" had now risen to 22–25 degrees Celsius (which he felt was excessive). See M. Wüthrich and W. Ernst, "Raumklimatisierung," *PTT Revue,* no. 12 (1964), pp. 288–89; more broadly, see Rachel Plotnick, "The Unclean Human-Machine Interface," in *Computer Architectures: Constructing the Common Ground,* edited by Theodora Vardouli and Olga Touloumi, London, 2019, pp. 114–32.

The euphemism in contemporary (German-speaking) industrial sociology would have been *Betriebsklima*—"office climate," an appropriately malleable concept.

62

See Robert Zurflüh, "Tätigkeitsbericht 1976 (50 Jahre Datenverarbeitung ERZ PTT)," 1976, foreword, Tele 195-0011: 01, PTT Archiv; Informatikdienste PTT, *70 Jahre ERZ. Festschrift der Informatikdienste PTT,* Bern, 1996, p. 5; Interview with Hans Rehmann 2019.

Fig. 12 PTT ERZ/W, Bern-Ostermundigen, 1967. (© Museum für Kommunikation, Bern)

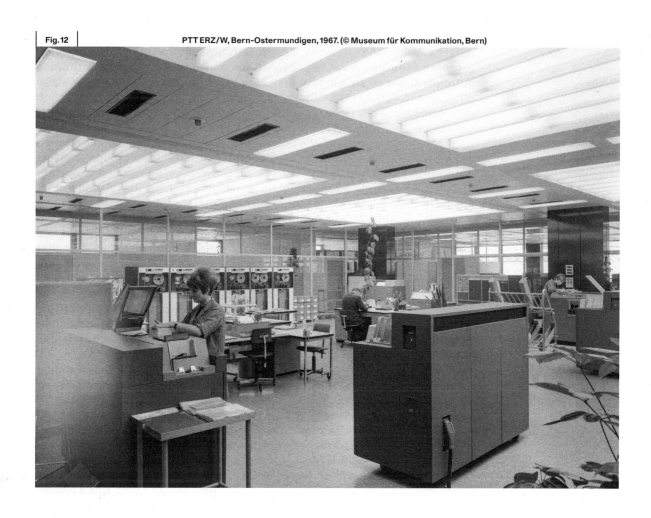

part of a *Technisches Zentrum*, the result of so many efforts to rationalize PTT's present and future operations, as we have seen. It was also of a piece with office structures, whose architects—Frey + Egger, W. Peterhans, in this case—may otherwise have built postal branch offices or city halls or churches. And it had developed roots in a postwar, suburban setting that, at least in parts, was an outgrowth of PTT's paternalist ways.

To be sure, any large corporation that could afford it back then was visited upon by a whole series of "entirely new groups": not just data-entry personnel, but operators, programmers, analysts, and system planners. As Jaeggi above, alongside his collaborator, the IBM in-house sociologist Herbert Wiedemann, contended, these latter, more skilled occupations already had established a new kind of "power nexus" within companies and organizations, dismantling established hierarchies, reshaping workflows, and optimizing things. And yet, even they cautioned that the developments that were underway couldn't be properly understood if they were approached "one-sidedly, from the perspective of large computer installations."[63] The modern business of business machines was, after all, a matter involving all manner of machines: typewriters, Dictaphones, Flexowriters, teleprinters, desktop calculators, copier machines, reproducers, filing systems... and telephones.[64] But I'm getting ahead of myself.

IV Fluctuations

DP jobs continue to be attractive ...
even in light of the new economic climate.
ERZ PTT, 1976 Annual Report, p. 5

In 1967, when ERZ/W commenced "production" after four and a half years of construction—two years alone having been consumed by electrical and utility installations, getting the HVAC system up and running, and interior fitting—this future was, by and large, still invisible. Even the economic turmoil of the mid-1970s, which would also reshape PTT's data-processing outfit, was a distant prospect. (PTT would incur its first deficit in 1971, which brought on pressure.) But the harbingers of leaner times were already on the horizon. At IBM Switzerland, the computing hegemon that, locally, counted PTT among its earliest, indeed major, customers—a "landmark event" as far as IBM's (Swiss-based) punch-card production was concerned[65]—there already was talk of "Business Effectiveness Program[s]," job rotation, and increased "mobility." When the crisis hit, the newspeak of "uncertainty," "adaptable organizations," and "decentralized enterprise[s]" would only intensify, as would demands for cuts in such areas as "telephony"—a significant instrument for any multina-

63

Jaeggi and Wiedemann 1963, p. 2, p. 142.

64

Sure enough, much the same—"impact"—could be said, and was said, about telecommunications. Since anyone could place a call to anyone, technologies of telecommunication had the effect of short-circuiting established hierarchies, as one sociologist of the "industrialized office" put it, causing existing organizations to resemble "circuit diagrams" more than they resembled an army. See Hans Paul Bahrdt, *Industriebürokratie. Versuch einer Soziologie des industrialisierten Bürobetriebes und seiner Angestellten*, Stuttgart, 1958, p. 55.

65

"Sie begannen zu dritt. Werdegang der IBM Schweiz," *mosaic IBM Schweiz* 18, no. 5 (1979), p. 6.

66

See Hans-Rudolf Lüthy, "Die Seite der Geschäftsleitung," *mosaic IBM Schweiz* 14, no. 1 (1975), p. 2, no. 2 (1975), p. 2 and no. 5 (1975), p. 2.

tional operation. "A reduction in telephony expenditures by just 10 percent, for instance, mean[t] 200,000 Swiss francs in savings annually."[66]

At ERZ/W, certainly part of a slower-moving ship,[67] one effect of this, besides a hiring freeze (1974) and cost-saving measures (average system utilization, for example, dropped by several hours in 1973/74), was reduced short-term fluctuations in personnel. Or as it was put in 1976, somewhat telegraphically, on the occasion of ERZ/W's "50-year" anniversary (counting from 1926, when the first four Hollerith machines had been acquired): "Increased loyalty as a consequence of recession." This consequence was especially pronounced when it came to female employees, who were beginning to stay on noticeably longer: twenty-eight months (on average) in 1973, thirty months in 1974, thirty-six months in 1975, forty-five months in 1976. This was a trend that agreeably meshed with the (similarly new) objective of recruiting fewer part-time aides and more "skilled personnel."[68]

Hitherto, by implication, the turnover rate at ERZ/W had been considerable, the major reasons to quit being marriage, job dissatisfaction, and "advised" discharge, in that order. (Tellingly, corresponding figures for male employees weren't even compiled.) Considering the nature of the implicated "repetitive bulk jobs," such fluctuations aren't exactly surprising, of course. It may also have had to do with the growing willingness on part of the younger generation to question "our institutions, value system, and authorities," as one PTT union boss lamented in 1971.[69] Until the recession, they would easily have been sustained, at any rate, insofar as females, who by the late 1960s had swelled to a flexible, part-time labor force, had served as a convenient "buffer."[70] And needless to say, they were entirely in line with prevailing articles of faith at the time, including at PTT: women were more "resistant to monotony," neater, and less unruly. When it came to the "purely manual tasks such as operating typewriters, calculating machines, etc., the female worker likely [was] ... superior."[71]

Such preconceptions were ingrained in PTT's corporate culture, but they were hardly exceptional. By the late 1960s, as one (American) computer worker observed, the "computer field ... look[ed] like a feudal hierarchy, with, at the base of the pyramid, a large number of women in keypunching and lower level programming jobs."[72] Even at a company such as IBM, one that (in Switzerland as well) had moved earlier than others toward making gestures to "equal opportunity," contemporary studies found that females were concentrated in unskilled jobs. The only exception to such patterns could be found, as one sociologist pointed out, at comparable institutions in the Eastern Bloc—say, the GDR's computing industry.[73] Things weren't much

67

More so than PTT, of course, a company such as IBM would at the time have been seen as some kind of corporate crystal ball. See, for example, Jürgen Alberts et al, *Mit IBM in die Zukunft. Berichte und Analysen über die "Fortschritte" des Kapitalismus,* Berlin, 1974.

68

Zurflüh 1976, pp. 4–6.

69

"Jahreskongress der PTT-Union," *Neue Zürcher Zeitung* (September 14, 1971), p. 15; more broadly, see Brigitta Bernet, "Mitbestimmung oder Selbstverwirklichung? Kritik und Krise des 'organisierten Unternehmens' um 1970," in *Zwang zur Freiheit. Krise und Neoliberalismus in der Schweiz,* edited by Regula Ludi, Matthias Ruoss, and Leena Schmitter, Zurich, 2018, pp. 61–83.

70

Käthe Biske, *Frauenarbeit in Beruf und Haushalt: Entwicklung in der Schweiz und in der Stadt Zürich nach den Volks- und Betriebszählungen,* Zurich, 1969, pp. 56–63.

Fig. 13

Fig. 14

different in Ostermundigen. Unlike the men of ERZ/W, to put it crudely, the women never were meant to be civil servants, advancing through the ranks.[74]

"Conventional" data processing was, at any rate, much like growth or cheap oil or full employment, on its way out. The arrival of magnetic tape—ERZ/W had amassed an inventory of 14,828 tapes by 1975 (up from 4,000 in 1968)—was in full swing by the early to mid-1970s. This brought new opportunities for some, who could now retrain, for instance, as "operatrices," handling the tapes, card readers, printers, and so on. In tendency, however, it made females gradually disappear from the halls of ERZ/W. Or rather, it soon made them reappear elsewhere at PTT, notably at the new-fangled, so-called "VDU workplaces," many of which would soon diffuse throughout PTT's branch operations—owing, in part, to projects initiated at ERZ/W, including, for instance, TERCO (Telephony Rationalization with Computers).[75] For its part, the impending demise of punch-card machinery had been prophesied for a while. In fact, and somewhat counterintuitively, card consumption in Ostermundigen would peak in 1974 (at 91.6 million cards per year).[76] The same almost sudden decline then happened everywhere, notably at IBM's punch-card printing plant in Zurich, whose employees fondly remembered PTT as their first "wholesale customer." It alone, in the course of its forty-five years of existence, produced some 20 billion cards. Peak production came in 1972 (5.4 million cards per day), after which things declined rapidly. The plant was shut down in 1977.[77]

When, in the spring of 2019, I had coffee with Hans Rehmann, a longtime DP veteran and ERZ/W's director from 1981 to 1997, he broadly confirmed this picture, recalling that the old Punch Card Division (which he had joined in October 1961) even took in "disabled" people occasionally. The work there was noisy, so the workers used earmuffs; electronic computers brought some improvements, or new job profiles, including the aforementioned "operatrices;" the employees were mostly young and female, staying with PTT for a few years, then marrying and moving on. Trajectories such as that of Lilian Hager, Rehmann's secretary, were thus more of an exception. She had originally trained as a shoemaker, then applied to PTT's Punch Card Division (still a better deal, apparently), eventually landing a proper office job. Rehmann's own career, in fact, wasn't exactly what you'd call streamlined, though it illustrates

71

Such issues were hardly endemic only to computing, of course. As a PTT union complained in 1961 apropos the introduction of letter-sorting machines: Because of these machines, men (who were less resistant to monotony) were now threatened to be replaced by female workers, or worse, "degraded to mere women's underlings." See "Betrifft: Mechanische Briefsortierung," March 27, 1961, 54.45.19, SOZARCH.

72

Cited is Joan Dublin, "Woman's Page," *Interrupt*, no. 10 (April 1970), p. 3; more generally, see Hicks 2017.

73

Gerd Peter, *Das IBM-System. Zur Lage der abhängig Arbeitenden in den achtziger Jahren: Disziplinierung durch Programmierung*, Frankfurt am Main, 1975, p. 81; and see, for example, "Chancengleichheit? Liberté, egalité … feminité," *mosaic IBM Schweiz* 15, no. 1 (1976), p. 15.

74

They were, in other words, considered a bad investment: destined for marriage, they weren't going to stay. A woman like Wanda Sas, a mathematician, who, as part of her work at IBM, ran "simulations" for PTT with an eye on the "rationalization of telephony via computer" (TERCO), were pretty much the exception. See "Mathematiker bei der IBM," *mosaic IBM Schweiz* 14, no. 4 (1975), p. 9.

75

In terms of workforce, ERZ/W was growing, generally speaking. In line with broader trends in IT, however, the proportion of female workers was in decline: 72% in 1962, 49% in 1981, 22.5% in 1996.

76

Zurflüh 1976, p. 9.

77

"Tempi passati. Eine kleine Geschichte der Lochkartendruckerei," *mosaic IBM Schweiz* 17, no. 1 (1978), p. 22.

| Fig. 13 | VDU workstations, PTT telephone center, 1983. (© Gertrud Vogler / Sozialarchiv Zürich / F 5107-Na-02-138-004 /
Bestand Gertrud Vogler)

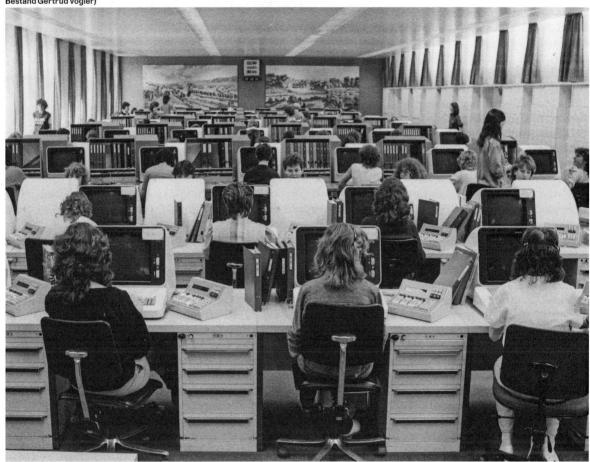

Fig. 14
TERCO Computing Center,
interior. (© PTT Archiv, Köniz,
D Tele-195 - 0009: 01)

something of the unequal opportunities at play: he himself had started out as a lowly PTT driver, but subsequently received diploma training for postal workers (something women couldn't do until 1971).[78] He then transferred to the Punch Card Division "by chance." While taking DP courses with IBM, he now oversaw an *équipe* of five or six women who processed radio bills.[79]

It is, at any rate and unsurprisingly, much easier to find out about men of ERZ/W, the Rehmanns, Rebers, Zurflühs—men with backgrounds in management science or PTT career officers who were busy thinking up projects and acronyms: ATECO, TERCO, APOCO, MATICO, FIRICO. The women, in contrast, typically don't show up in the record except as figures: as fluctuations, discharges, keystroke frequencies: 502,380,201 keystrokes in 1975, 501,348,039 keystrokes in 1976 (which in fact meant a performance increase of 7.8 percent because of a simultaneous decrease in "traffic").[80] A rare exception, if you will, were moments of exceptions, of which there were few, because even in those days a premium was placed on system "availability"— uptime.[81] By the late 1970s, such concerns had begun to translate into a language, still familiar, of "operational security": uninterruptable power supplies, "inconspicuous, non-exposed location[s]," "sabotage protections," and so on.[82] But just ten years prior, such concerns were nascent at best. Notably, the move in the spring of 1967 from the old Zurich "IBM Center" (as it was sometimes called) to the brand-new, Bern-based ERZ/W caused a set of fairly different problems. It was a meticulously planned, eight-day maneuver: downtime was to be avoided at all costs; the delicate, expensive machines weren't to be damaged during transport; and operations had to resume smoothly—which meant headaches inasmuch as relocating to the Technisches Zentrum meant transplanting an entire organization or, for that matter, a few hundred people, many of whom had put down roots in Zurich or even "fallen in love" there.[83]

Not everyone made the move. (Those who didn't were asked to quit by March 1967.)[84] "[I]n order to staunch the growing flood of

78

Albrecht Eggenberger, "Die Frau bei den PTT-Betrieben," *Gewerkschaftliche Rundschau* 67, no. 3/4 (1975), p. 123.

79

Interview with Hans Rehmann 2019. To give another example, Carlo Müller, one of the men overseeing PTT's system IBM 1401/ 1410, had started out delivering mail for the "Express Service." Having picked up what was an exotic and valuable skill set, he helped to build up Zurich's municipal computing center before moving to Ticino, peddling Memorex products. See Carlo Müller, *Carlo's Story. Erinnerungen und ein Dankeschön*, Frauenfeld, 2008, pp. 75–76.

80

Zurflüh 1976, p. 13. For a (recent) exception, see "Interview with Susanne Kobi," October 8, 2018, 012-SAM-OHP_059, Oral History Project, PTT Archiv. (Susanne Kobi started out at ERZ/W as an "operatrice".)

81

In 1975, for instance, system availability hovered somewhere around 97.1–99.4%, with computers operating up to 15.25 hours a day—a far cry from current figures or requirements, but still a considerable achievement in the eyes of ERZ/W higher-ups. See Zurflüh 1976, p. 11.

questions" and presumably to tempt his employees, the personnel director, a Mr. Hadler, even put out a special newsletter, the *OM Nachrichten*, which appeared in several issues starting in February 1966.[85] As ERZ/W neared completion, the newsletter instructed the employees of the DP Department on the essentials: on how Bern schools differed from those in Zurich (of interest to married employees); on the cafeteria (which would feature "tasteful furniture and cutlery"); on parking opportunities and where to buy bus tickets; on the option to buy a fridge; on how to organize a "monthly trip back to the parents" (of interest to those not yet married); on which apartment types would be available (with or without a balcony; with two, three, four, or even five rooms); and on the rooming house, which came with rooms that were 12.3 square meters in size, running water, shared toilets, and said TV room. Laundry and kitchen utensils would be supplied by PTT. Rooms had to be cleaned weekly, and so on.

It's rather more difficult to form a clear picture of life *inside* ERZ/W once it was up and running. Surviving photographs, notably those held at the Museum of Communication in Bern, tend either to parade the impressive, vast technical infrastructures sustaining life at ERZ/W (HVAC, power supplies, etc.) or to display the familiar 1960s-era poses similarly destined for the pages of the *PTT Revue*—people and machines, interspersed with potted plants, in clean and bright rooms: numerous women doing data entry, an "operatrice" mounting tapes, the men looking intently at their consoles, studying printouts and manuals, pointing their fingers at switches, or sitting at their desks, being analytic. As for general flair, PTT Director General Charles F. Ducommun's view was probably at least symptomatic: in this era of "cols blancs" (white-collar workers), he wrote in 1967 in a gesture towards ERZ/W's "significance humaine," "l'entreprise est semblable à l'armée."[86]

V Dissolution

Around the world ... a stone has been set rolling.
Hans Rehmann, "Das ERZ gestern – heute – morgen," *PTT Zeitschrift*, 1985

By way of conclusion, let us zoom out ever so slightly. Much of the preceding narrative worked, to the extent it did, by virtue of being set in a fairly generic place—suburban Ostermundigen—and by virtue of dealing with a fairly generic thing: the Rechenzentrum. In terms of a history of the data center, however, specifics do matter. The specifics in this case touch upon not only questions of computing, as noted, but naturally upon matters of telecommunications as well. In other words, the very monopoly that had been placed under the control of PTT, and which itself had begun to mutate—reshaped

82

"Raumprogramm für TERCO-Zentren," 1979, p. 3–4, Tele 195-0007: 01, PTT Archiv.

83

Stadler 1967; Interview with Hans Rehmann 2019.

84

Allegedly, the move also met with some resistance from the City of Zurich, which didn't like losing its taxpayers to Ostermundigen.

85

OM Nachrichten, no. 1 (February 10, 1966), p. 1, 195-0011: 05, PTT Archiv.

as a *digital* technology (in Ostermundigen's very own R&D skyscraper, along with many other places).

Telecommunications—or, if you prefer, what by the late 1970s was being floated as "telematics," the incipient "convergence" of data processing and telecommunications—was a big deal.[87] Indeed, while "telephony" may have an air of mid-century about it, the sheer numbers are staggering: in 1986, PTT investments in "telecom installations" amounted to 1.5 billion Swiss francs, peaking at 3 billion francs in 1992; per capita, no other country invested as much. If there were 2 billion calls a year in 1960, that figure had risen to 10 billion a year in 1990. And all this would become increasingly important, financially speaking. By the early 1980s, some two thirds of PTT's profits would derive from telephony.[88] By 1991, international and long-distance voice telephony had become the most profitable PTT branch by far, grossing 882 million Swiss francs, with all other services (local-area telephony, data transmission, logistics, etc.) incurring more or less heavy losses. "These profits," as one survey put it, "have financed almost completely all other PTT sectors including postal services."[89] Indeed, because the future of telecommunications looked so bright and profitable, while that of the so-called "yellow services" (postal delivery and the like) did not, the Swiss PTT, like other "classic" PTTs elsewhere, came under intense scrutiny.[90] Symptomatically, in 1992, a former "top executive" from Alusuisse was brought in. He was duly succeeded by an ex-IBM man to steer PTT through its final phase: *Change Telecom*, as the initiative was called.

ERZ/W wouldn't be quite the same either, even though being a "data entry typist" at ERZ/W—which in 1984 meant activating (on average) 18.4 million keystrokes per year—was still "purely a woman's thing … simply because they [were] better at it than men!"[91] (Some things were slow to change.) But change there was. ERZ/W's well-calibrated atmosphere, for one thing, had slowly begun to backfire, or at least the go-to insulation mat-

86

Ducommun 1967. Many contemporaries, as is well known, concurred: there would be, in this incipient post-industrial age, a technological sea change, bringing more "intellectual work" to some—the "technical intelligentsia" (as Zbinden above put it)—as well as, for many more, a "loss of function" [Funktionsverlust]. Clerical workers were about to be "reduced," as one sociologist characteristically ventured in 1963, "to more or less mechanical,

preparatory functions such as the visual control of data." See Siegfried Braun, "Angestellte im technischen Fortschritt," *atomzeitalter. Information und Meinung*, no. 11 (1963), p. 195.

87

On "telematics," see Simon Nora and Alain Minc, *L'informatisation de la Société*, Paris, 1978; Dan Schiller, *Telematics and Government*, Norwood, 1982.

88

Rudolf Trachsel, "Freiheit und Staat, Wo stehen die PTT?," in *Entwicklungsperspektiven des Kommunikationswesens*, edited by Universität Bern, Bern, 1983, p. 13.

89

Zweifel 1993, p. 111.

90

See, for example, Eli Noam, *Telecommunications in Europe*, New York, 1992, who ventured that "it seem[ed] inevitable that Switzerland will have to reconcile telecommunications with its traditional economic function as an international cross-roads. The increasingly electronic form of financial transactions and their resultant distance-insensitivity puts Swiss banks into direct competition with such centers as London, New York, Singapore, Tokyo, and Hong Kong." (p. 186).

91

"Elektronisches Rechenzentrum PTT. Dokumentation" (ERZ PTT, 1984), sec. "Die Datatypistin," Tele 195-0011: 01, PTT Archiv.

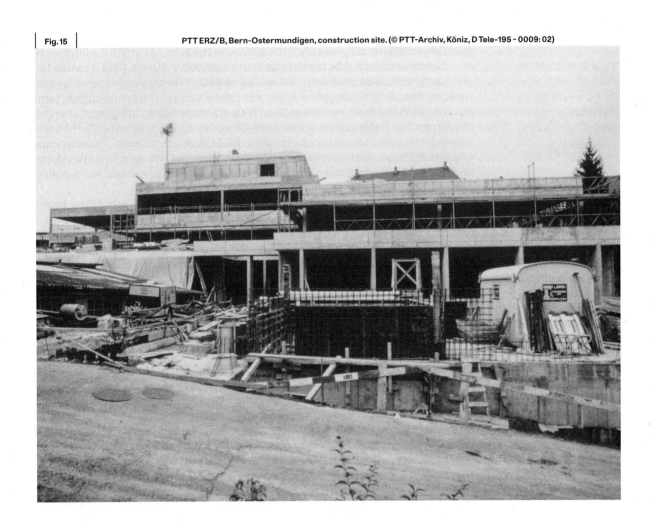

Fig. 15 PTT ERZ/B, Bern-Ostermundigen, construction site. (© PTT-Archiv, Köniz, D Tele-195 - 0009: 02)

erials of yesteryear did, notably "crocidolite." In the summer of 1982, a high level of airborne asbestos was measured in the computer rooms. (Not a cause for "alarmism," as was cautioned.)[92] Worse, since ERZ/W kept growing, employees were, by the early 1980s, once again scattered around Ostermundigen, temporarily working from no fewer than *four* different sites: "fragmentation of resources," as Rehmann, the incoming director, warned repeatedly.[93] There was also talk now, in the memos penned at ERZ/W, of "job rotation," "continuous education," "personal initiative," and of the challenges wrought by networking and "IDP"—"individual data processing." In 1985, Rehmann proposed a policy of "controlled decentralization."[94]

Indeed, the exterior climate was what had been transformed most of all. The reasons for this are complex, if broadly familiar—and they could hardly be discerned, needless to say, by walking into a 1960s computing center. Nor could even they be gleaned—if there was a "foreign body" in Ostermundigen, it was this—from its more recent sibling computing center: ERZ/B, the construction of which would commence in the fall of 1986. Amid the vaguely high-modernist scenery—the Hochhaus, the local bus stop, and the (admittedly more rustic) Restaurant Waldeck, where I had met Rehmann—its grayish, squat exterior has a less inviting air. In fact, there isn't much to see: while it has six levels, most of them are underground, as if heeding PTT's policy, which had been taking shape during the 1970s, to build critical computing facilities only in "inconspicuous, non-exposed location[s]" and, if feasible, at a safe distance from power plants, factories, and rivers.[95]

ERZ/B, for its part, had been drawn up to contain some of the decentralizing forces that had begun to descend onto Ostermundigen. "[F]ragmentation of resources," indeed, was only one thing. More troubling, not just to the men of ERZ/W, but to administrators of computing centers everywhere, was the chaotic, wildfire-like spread of "microcomputers": a trickle at first that later mutated into a veritable "PC metastasis," bypassing received channels and authorities.[96] This was a new, peculiar "dynamic," as Rehmann noted in 1985, apropos the *Past, Present, and Future* of ERZ/W: "everybody [was] doing data processing now."[97] Already, for instance, local PTT branch offices had taken to simply purchasing their own computers, as if ERZ/W's services didn't exist.[98] Such unconstrained shopping sprees exacerbated the kinds of problems that had been mounting anyway: the proliferation of systems, standards, and protocols, many of them compatible only in theory—by 1985, ERZ/W had to deal not just with IBM machines, but with some twenty different manufacturers of computing equipment.[99] Not least, as a measure of its own success, and certainly reflecting the diffuse Thing that was "telematics,"

92

Hochbauabteilung PTT to SUVA Sektion Chemie, "Asbestbelag an Decke Computerraum," September 20, 1982, ERZ/W.

93

Hans Rehmann, "Das ERZ gestern – heute – morgen," *PTT Zeitschrift*, no. 1 (1985), p. I.

94

ERZ PTT, "Entwicklungen in der Informationsverarbeitung," p. 11.

95

"Raumprogramm für TERCO-Zentren."

ERZ/W had been spawning other "computing centers" besides itself, centers geared toward making Switzerland's infrastructure digital: APOCO centers, ATECO centers, TERCO centers. No longer was there one center, a *Dienststelle aller Dienststellen*. It certainly was a different center: an "Information Services Center," as it was duly rebranded, offering software training, managing IT procurement, and the like.[100]

More ominously, computers had lost their mystique in other ways, too.[101] When planning for ERZ/B got underway in 1984, rather than generating new apartments or cafeterias or gushing articles about "cols blancs," it symptomatically produced a local movement—a citizens' initiative called Livable Ostermundigen—which, alongside a Bernese conservation society, the Heimatschutz, mobilized against ERZ/B. The center would deface the place, it was argued, and represent an "irresponsible intervention" into the suburban idyll.[102] Appeals were made; signatures were collected. PTT, in true technocratic form, was having none of it and went ahead regardless, even expropriating some elderly people along the way. (Whether ERZ/B went underground for security reasons, or to appease neighbors, or both, isn't entirely clear.) More to the point: more broadly, of course, the Swiss PTT, much like PTTs elsewhere, had fallen into disrepute.[103] Pressure, indeed, mounted from all sides, very much despite the fact that the Swiss PTT kept investing so heavily and spawned so many so new products and futuristic services: Natel B, Citycall, Telepac, Voicemail, Teletex, Natel C, Videotex, Arcom 400 (an "electronic mail service"), optical fiber…

"Thanks to these electronics means, large corporations may now decentralize and thus revitalize," wrote the newspapers.[104] But no longer were such feats seen as unequivocal signs of progress, let alone of *service public*. Quite the opposite. If anything, ordinary consumers and (certain) journalists now lamented the lack of choice, the exorbitant prices, and the fact that PTT, by its nature, schemed to monopolize these novel electron-

96

See, for example, Karl-Gottfried Reinsch, "Strukturveränderungen des Rechenzentrums und seiner Benutzer," *Das Rechenzentrum* 5, no. 3 (1982), pp. 171–75; Klaus Rosenthal, "Wenn sich der PC mit dem Großrechner unterhält," *dfz wirtschaftsmagazin* 13 (1984), p. 12.

97

Rehmann 1985, p. II.

98

Interview with Hans Rehmann 2019.

99

ERZ PTT, "Entwicklungen in der Informationsverarbeitung," p. 4.

100

By 1996, ERZ/W hardware purchases amounted to roughly 4 million CHF per year, of which 70–80% went to PCs. See Martin Brogli, *Steigerung der Performance von Informatikprozessen*, Braunschweig, 1996.

101

"Unmistakably," they had become associated with the broader public with such things as "decimation of jobs" and the "compromise of privacy," as Rehmann's predecessor had begun to worry sometime in the late 1970s. See Robert Zurflüh, "Einladung zur ERZ-Konferenz," September 26, 1978, Tele 195-0011: 04, PTT Archiv.

102

"Umstrittenes PTT-Bauvorhaben," *Der Bund* (October 23, 1984), Tele 195-0003: 03, PTT Archiv.

103

There was, as one German Bundespost employee despaired in 1986, a "demonization of telecommunications technology" here, a pushback against "national telecommunications sovereignty" there, including by US firms, which then grew increasingly impatient with Europe's "excessively restrictive and discriminatory" telecom markets. See Kurt von Haaren, "Sichert die Post – Rettet das Fernmeldewesen," *Gewerkschaftliche Monatshefte* 37,

ic services, too ... as if there hadn't already been a flourishing black market in illegal phones "from the East."[105] Economists of a neoliberal persuasion predictably came out against the "billions in subsidies" which, in their view, promoted the lack of "innovative disposition" on the part of recipients, including PTT's halo of suppliers.[106] Swiss investment bankers, in turn, by the early 1980s had garnered a reputation of putting their money on only "certain types of high-technology companies ...—Fujitsu, Matsushita, and Hitachi."[107] And for a new kind of left, more inclined to pirate radio stations than state monopolies, PTT, far from being an agent of the common good, stood for decisions made behind locked doors—an extended arm of the state in pursuit of an "aggressive information and technology policy en route to a wired society."[108] As evidence, a 1985 meeting of computer critics in Zurich listed Videotex (which would be of use to no one except banks wishing to reduce their staff); the "wiring of Selnau" (location of the Zurich stock exchange); the multiplying business line rentals (700 in 1970, 19,000 in 1982, 38,000 in 1985); and the new ERZ/B in Bern, which, it was pointed out, would cost taxpayers 37.4 million Swiss francs alone.[109] (In truth, 48 million had been put aside.)[110]

"The state," the conclusion went, "no longer [was] to invest in the public good, but in infrastructures that [would] enable an all-encompassing wave of rationalization." Already, there was a decimation of bank branch offices; peripheral regions at any rate would be left behind, inasmuch as wiring them up wasn't profitable; and soon enough, the mailman would be a thing of the past, because it would be much cheaper to send letters "via optical fiber."[111] Even though these (increasingly isolated) computer critics may have misconstrued the role of ERZ/B, Ostermundigen, in all this, such fears weren't exactly unfounded.[112] Robert Trachsel, the then director of PTT, admitted as much in 1982, when noting in a speech defiantly titled "Liberty and the State" that calls for the "re-privatization" of PTT had been growing louder, even though, as he said, PTT had technically never been

104

no. 11 (1986), p. 680, p. 684; and US International Trade Commission, *Operation of the Trade Agreements Program, 37th Report 1985,* USITC Publication 1871 (1986), pp. 122–23.

105

Willi Schenk, "Die Kultur einer Informationsgesellschaft. Gefahren und Hoffnungen (Tagesanzeiger)," in *Westeuropa auf dem Weg in die Informationsgesellschaft,* edited by Christian Lutz, Zurich, 1984, p. 107.

106

The 1982 PTT mission statement was widely seen as evidence of just that. See Schweizerische PTT Betriebe, *Kommunikationsleitbild,* Bern, 1982; on illegal phones, see Trachsel 1983, p. 18; and Günter Knieps, "Möglichkeiten des Wettbewerbs im schweizerischen Telekommunikationssektor," *Schweizerische Zeitschrift für Volkswirtschaft und Statistik,* no. 4 (1985), p. 411.

Christian Lutz, "Informationsgesellschaft – ein Schlagwort mit vielen Realitätsgehalten," in *Westeuropa auf dem Weg in die Informationsgesellschaft,* edited by Christian Lutz, Zurich, 1984, p. 11. (For their part, these suppliers prepared for a merger to hopefully weather the gathering storm of foreign competition: ASCOM, which was formed in 1987.)

107

Bruce Nussbaum, *The World after Oil: The Shifting Axis of Power and Wealth,* New York, 1983, p. 12.

108

"Texte zur Computerveranstaltung im Provitreff vom 28.6.1985," 1985, p. 24, Bestand: Medien und Computer, Papiertiger Archiv, Berlin.

109

Ibid., pp. 19–23.

110

"ERZ-Gebäude B. Auswertebericht," February 13, 1984, Tele 195-0003: 03, PTT Archiv.

private. (He also pointed out, apropos the "privatization of profits," that, curiously, nobody even talked about wanting to "re-privatize" the postal services.)[113] Trachsel, the engineer, then firmly came down on the side of monopoly, unsurprisingly. The detracting voices kept getting louder, however. "Innovations cannot be judged by the state, let alone generated by the state!" as economist Walter Wittmann, whom Trachsel had singled out as one particularly insistent detractor, characteristically put it.[114]

And, by and large, it's this story that has stuck, of course: the story of innovation and markets and private enterprise. Rather than, say, Trachsel's narrative, which came out in defense of publicly governed infrastructure, a less timely selling point. Or the narrative of those PTT critics who didn't care much about "innovation," but who accused this behemoth of, if not playing into the hands of the powerful, at least being an undemocratic institution, operating in a "para-political space."[115] Let alone the narrative of ordinary PTT employees who soon could be seen walking the streets of Switzerland carrying banners that said "Enough of Hayek," "Job-Killer no. 1," and the like.[116] Undoubtedly, the story that stuck, the story of innovation, contains more than a grain of truth; even when compared to the (much better paid) IBM men in their suits, the men and women of PTT can come across as a bit stiff. And yet it's a convenient construction, too: isolating, even distorting, a few variables, occluding others.

Were one to try to explain the post-industrial ruins of Ostermundigen, other forces besides innovation or the lack thereof were surely at play, as we have seen. Some of these factors may have been peculiarly Swiss (a tiny country/market, the "militia system," and so on); others, not so much (equipment manufacturers' increasingly multinational entanglements, for instance). And a few of them, arguably, were quite simply about special, rather than common, interests. Still, back in 1975, for example, the very same year that Rehmann at ERZ/W would initiate the so-called "mixed-hardware

111

"Texte zur Computerveranstaltung," 1985, p. 7, pp. 19–20, p. 23.

112

In fact, they could point to the fate of the British General Post Office (now British Telecom) and rather similar tendencies in West Germany, where the Bundespost—Europe's largest service provider, no less—had come under pressure as well (while pursuing a similarly "aggressive" strategy of wiring the nation).

113

Trachsel 1983.

114

Walter Wittmann, "Innovationen: Der strategische Faktor," in *Innovative Schweiz. Zwischen Risiko und Sicherheit*, edited by Walter Wittmann, Zurich, 1987, p. 9. When, in 1983, PTT's grandiose, expensive network digitalization project, the IFS (Integrated Fernmeldesystem) was canceled, it certainly could be construed this way, for instance: as the failure of the cozy, army-like ways of PTT and their pampered halo of manufacturers. In truth,

the situation was probably more complicated. Not only was the IFS a fairly risky (aka "innovative") undertaking, one which few private companies would have embarked on in the late 1960s; by 1983, the cancellation came at a time when PTT's project partners—local subsidies of multinational corporations, notably Siemens and ITT—essentially had marketable systems already, which then indeed were rolled out in Switzerland, too. On the IFS, see

David Gugerli, *"Nicht überblickbare Möglichkeiten". Kommunikationstechnischer Wandel als kollektiver Lernprozess, 1960–1985*, Preprints zur Kulturgeschichte der Technik 15, Zurich, 2001.

115

See, for example, Jürg Frischknecht, "Von der Medienpolitik das Amen!" *vt. Magazin für Bildschirmtext*, no. 5/6 (1985), p. 28.

116

On the banners, see Collection F_5107 (Vogler, Gertrud), SOZARCH. To be fair, the oral histories assembled, for example, at https://www.oralhistory-ptt-archiv.ch/ present a rather more complicated picture, but such initiatives do not (yet) add up to much of an alternative plotline.

group"—a pressure group consisting of various local *Rechenzentrum* players (Ciba-Geigy, Teledata, BBC, Schweizerischer Bankverein, etc.)—another kind of user group had formed in Bern: a group called asut. This group, l'Association Suisse des Télécommunications, consisted of "PTT's largest clients." And where Rehmann's "mixed-hardware group" worried about IBM's quasi-monopolistic stranglehold on their data centers, asut worried about "problems of tariff."[117] These were (too) high—in part, of course, because of PTT's afore-mentioned habit of cross-subsidizing loss-making "services," such as local-area telephony and public transport in remote regions, through profitable ones.[118] Needless to say, such redistributive methods were increasingly out of sync with the times, or with dreams, for that matter, of a new kind of "Switzer-land ... [as a] hub of information flow."[119] Or in the words of Fulvio Caccia, the man who would have a hand in the making of the Centro Svizzero di Calcolo Scientifico in Ticino, too (see Giorgio Scherrer's contribution to this volume): "the message [of a liberated telecommunications market] would be: come to Switzerland, build your company headquarters and communications centers here, and also everything that goes along with them."[120]

Such considerations, admittedly, may seem some-what peripheral to the history of ERZ/W, Ostermundigen, and everything that went along with it, be that TV rooms or cafeterias or HVAC systems. And yet it stands to reason that the ruins of Ostermundigen, skyscraper, subcontrac-tors, and all, can't be really grasped otherwise. What brought PTT, this "legacy power," down, and with it such places as the Technisches Zentrum, Ostermun-digen, we must assume, wasn't simply inevitable. It was the result of a com-plex amalgam of interests, reshaping telecommunications into "value-added services" and chipping away at what once might have been, however imper-fectly, an institution devoted to the common good: *service public*. Even so, and evidently enough, there's no reason to be overly sentimental: the keypunch operators, shared toilets, the TV room ... *l'entreprise est semblable à l'armée*. Nostalgia seems misplaced. But neither does the story of "innovation" ring particularly true today.

ERZ/W was, in any case, more of a bystander in this or any such history, but clues and traces remain. Take the very name: ERZ/W, which I hadn't paid much attention to until I found, on a somewhat antiquated website, a pixelated photograph showing a group of angry protesters, circa 2001, holding up placards in front of the *Rechenzentrum*'s entrance. The "W," it turns out, stood for *Wertzeichen- und Drucksachenabteilung*—the "Stamps and Stationary Department," which occupied part of the building. In fact, the building's most expansive "machine room"—I had, somewhat naively, mistaken

117

"Protokoll der konstituierenden Sitzung der Arbeitsgruppe 'Mixed Hardware,'" September 29, 1975 (copy kindly provided by Hans Rehmann); "Schweizerische Verein-igung der Fernmelde-Benützer," *Schweizer Bauzeitung* 93, no. 14 (1975), p. 206.

118

Arguably, it was (not least) such in-terest groups that chipped away at policies of the common good. In-deed, it might be argued that, as far as Switzerland was concerned, *service public* was merely rede-fined into something more "user"-oriented (rather than society-oriented), bringing cheaper phones to all. However, the term "user" clearly is a bit deceptive, for not all users are made alike. On the latter point, see Jacob Ward, "Financing the Information Age: London Tele-City, the Legacy of IT-82, and the Selling of British Telecom," *Twentieth Century British History* 30, no. 3 (2019), pp. 424–46; and on the former: Gisela Hürlimann and Philipp Ischer, "Kontinuität im Wandel. Das Gemeinwohl als zentrale normative Instanz bei den SBB und den PTT," *Schweizer-ische Gesellschaft für Wirtschafts-und Sozialgeschichte* 22 (2007), pp. 229–247.

119

As were issuing by now from St. Gallen, for instance. See Stefan Zbornik, "Elektronische Märkte in der Schweiz: Die Zeit läuft ab!" in *Management Zeitschrift* 62, no. 1 (1993), pp. 89–94.

it for a space having housed punch-card equipment— had originally hosted three rotary presses, churning out (in 1967) some 10 million multicolored stamps *per day*.[121] It was, incidentally, for this reason—the "considerable monetary value" that was literally being produced there—that the newly minted ERZ/W had to be specially secured, not because of the expensive computers or valuable data. As for the protesters in the photograph: they (unsuccessfully) tried to prevent the closure of Section "W." In 2001, the production of stamps was first outsourced, as scheduled, to a private company in La Chaux-de-Fonds; it eventually was moved out of the country entirely.

Acknowledgments Many special thanks to Sascha Deboni for his invaluable assistance in preparing this chapter.

120

Arbeitskreis Kapital und Wirtschaft, *PTT im Umbruch*, p. 8.

121

On Section "W," see *50 Jahre Wertzeichendruckerei PTT, 1930–1980*, Bern, 1980.

Bern

Computing Aliens:
From Central Control
to Migration Scenarios,
1960s–1980s

Moritz Mähr
Kijan Espahangizi

In 1974, Switzerland's first Central Aliens Register became fully operational. With it, the Swiss Federal Administration had at its disposal not only an information system that included personal data on its alien population, but also a highly available electronic tool for data-driven immigration policy. In the process, the data of more than one million foreigners was transferred fully automatically from punch cards and magnetic tapes to the mainframe of the Electronic Computing Center of the Federal Administration in Bern. Several dozen elaborately programmed counting and sorting routines processed these personal records, keeping the cutting-edge IBM System/360 Model 65 busy; acquired in 1971, it needed several days to perform the calculations. The result, however, was impressive: some 100 different types of statistical table, over 37,000 pages of charts and lists, as well as residence- and work-permit quotas that the cantons were allowed to issue on a monthly basis.[1]

Designed against the backdrop of the postwar economic boom and a surging demand for foreign labor, the Central Aliens Register embodied the aspiration of a powerful centralized nation-state. With almost sixty employees and annual operating costs surpassing 2 million Swiss francs, it was the most complex and expensive statistical tool of which the Federal Administration had availed itself to date. Indeed, this enormous organizational and financial effort couldn't be justified in terms of "rationalization"—that is, accelerated admission procedures—alone. The Central Aliens Register was a more ambitious project entirely: a beachhead of automation in the Federal Administration; and as such, it was to stand paradigmatically for how questions of "government" might be modeled as a sociotechnical control system utilizing the methods of operations research and cybernetics.[2]

The Central Aliens Register, a large-scale technocratic project housed in a sizable computing center, contrasts sharply with the population scenarios that would be drawn up by the Federal Statistical Office only a decade later, in the 1980s. The new global challenges that became apparent in the wake of the mid-1970s recession revealed the limitations of the national cybernetic system metaphor. The Federal Statistical Office responded to this new political reality and the concomitant uncertainties with innovative approaches. Instead of overarching, hierarchical project structures, small teams would now be deployed. The IBM mainframe computer gave way to a small Mitek workstation. Data originating from different sources was to be systemically collated and translated into scientifically verifiable hypotheses. As we shall see, the demographic department of the Federal Statistical Office then developed a new, future-oriented understanding of migration that shaped the reorganization of Swiss state authorities (and the technical tools at their disposal) into the 2000s.[3]

[1]

Swiss Federal Archives E3325-02#2013/10#18*, E6502-01#1993/126#68*.

[2]

On cybernetics, see, for example, Andrew Pickering, "Cyborg History and the World War II Regime," *Perspectives on Science 3*, no. 1 (1995), pp. 1–48.; more broadly, see Andreas Wimmer, and Nina Glick Schiller, "Methodological Nationalism and Beyond: Nation-State Building, Migration and the Social Sciences," *Global Networks 2*, no. 4 (October 2002), pp. 301–34; Guido Koller, "The Central Register of Foreigners: A Short History of Early Digitisation in the Swiss Federal Administration," *Media in Action*, no. 1 (June 6, 2017), pp. 81–92, https://www001.zimt.uni-siegen.de/ojs/index.php/mia/article/view/6; David Gugerli, *Wie die Welt in den Computer kam. Zur Entstehung digitaler Wirklichkeit*. Frankfurt am Main, 2018.

[3]

Hans-Rudolf Wicker, "Migration, Migrationspolitik und Migrationsforschung," in *Migration und die Schweiz. Ergebnisse des Nationalen Forschungsprogramms "Migration und interkulturelle Beziehungen,"* edited by Hans-Rudolf Wicker, Rosita Fibbi, and Werner Haug, Sozialer Zusammenhalt und kultureller Pluralismus, Zurich, 2003, pp. 12–64.; Marcel Berlinghoff, *Das Ende der "Gastarbeit": Europäische Anwerbestopps 1970–1974*. Paderborn, 2013; André Holenstein, Patrick Kury, and Kristina Schulz,

In this chapter, we shall use the example of Switzerland's migration policy to explore how computers have reconfigured the administrative activities of the nation-state—and how, in turn, this has shaped the uses and materialities of computing within the administration. Part I will focus on major administrative automation projects of the 1960s and 1970s and the ways through which they propelled a massive centralization of data, services, and competencies. Part II then looks at the shift towards decentralized, situational uses of electronic data-processing tools in the 1980s and 1990s. We shall conclude with an outlook on more recent developments concerning the "digitization" of administration and its consequences for Switzerland's migration policy.

Centralized Control in the Era of the "Guest Worker"

In the three decades after World War II, the Swiss economy experienced impressive growth, as is well known. Due to the lack of a sufficient native labor supply, millions of foreign workers, mostly from Italy, then were drawn into the country, toiling in Swiss factories, on construction sites, in agriculture, gastronomy, and so on. The Swiss Aliens Law, which had come into force in the aftermath of the economic crisis in the 1930s, guaranteed the temporary stay of foreign workers. Its seasonal and annual permits were the legal basis of what was called a principle of rotation: as in other affluent European countries, foreigners were welcome to sell their manpower, but not to settle down.[4]

By the 1960s, the gains of labor migration had helped to promote the emergence of a prosperous, middle-class consumer society in Switzerland. Nevertheless, the rising number of foreign workers and a rising rate of inflation were beginning to revive xenophobic tendencies, with right-wing and trade union circles in particular reinforcing each other. The Swiss government initially ignored these concerns, continuing its pursuit of a liberal admission policy in the interest of industry. Such passivity on the part of authorities contributed to the fact that those who rallied against *"Überfremdung"* ("overforeignization") consistently gained ground in the second half of the 1960s. Only to avert all too rigorous limits on immigration did the Swiss government then start to adjust its policy: admission quotas were introduced on the level of individual companies and branches of industry, accompanied by a policy of assimilation for those foreigners who were already living in the country. The first such national immigration quota was issued on March 16, 1970, only months before the first referendum on "overforeignization" would be held. Known as the Schwarzenbach Initiative, it aimed at limiting the proportion of resident foreigners to ten percent (per canton, except Geneva with

4

Schweizer Migrationsgeschichte: Von den Anfängen bis zur Gegenwart, Baden, 2018; Kijan Espahangizi, "The 'Sociologic' of Postmigration: A Study in the Early History of Social Research on Migration and Integration in Switzerland, 1960–73," in Switzerland and Migration. Historical and Current Perspectives on a Changing Landscape, edited by Barbara Lüthi and Damir Skenderovic, Cham, 2019, pp. 33–59.

5

In addition, this flexible foreign work force could be used as an economic buffer in times of decreasing labor demand. Jakob Tanner, *Geschichte der Schweiz im 20. Jahrhundert*, Munich, 2015, pp. 338–43.

Damir Skenderovic, and Gianni D'Amato, eds. *Mit dem Fremden politisieren. Rechtspopulistische Parteien und Migrationspolitik in der Schweiz seit den 1960er Jahren*, Zurich, 2008.

6

Michael Mülli, "Kontingentierung von Migration. Zur Soziologie einer Regierungstechnik," in *Staatlichkeit in der Schweiz: Regieren und verwalten vor der neoliberalen Wende*, edited by Lucien Criblez, Christina Rothen, and Thomas Ruoss, Zurich 2016, pp. 171–91.

its many international organizations). With public debates overheating and anti-immigration sentiments spreading, thousands of foreigners were literally packing their bags. The Schwarzenbach Initiative failed by a narrow margin, but it was to have a lasting impact on the political landscape.[5] From 1970, the federal authorities, for one, embarked on a policy of balancing economic and nationalist-protectionist interests. Their plan, in other words, was to limit the influx of foreigners to a minimum without jeopardizing economic growth. In order to do so, however, the Federal Administration first needed a powerful statistical tool and reliable data. Indeed, the success of the policy would hinge on the ability to register and precisely monitor the movement of foreign workers into, and out of, different sectors and professions. On January 28, 1970, the government decided to create the Central Aliens Register.[6]

It didn't come out of nowhere, of course. Notably, Max Holzer, head of the Federal Office for Industry, Trade and Labor, had recognized the importance of a new national immigration policy long before this. In 1961, he had appointed a Study Commission on the Issue of Foreign Labor. In order to curb growth and inflation, the commission's 1964 report had proposed limiting immigration. At the time, this came as no surprise in view of the restrictive measures vis-à-vis companies and cantons that the Swiss government (Federal Council) had already adopted on March 1, 1963 and February 21, 1964. The commission's proposals, in particular those regarding nationwide restrictions on immigration, went somewhat further, however, aiming as they did at the reorganization of competencies belonging to the Swiss Confederation and the cantons, respectively. In addition, the commission called for the new policies to be put on a sound quantitative basis.

In the 1960s, to be sure, the Federal Administration already had various statistical devices at its disposal that kept track of foreigners: the business census, the factory statistics, the population census, the population movement statistics, the statistical survey of the Federal Office of Industry, Trade and Labor, and the statistics of the Federal Aliens Police. However, these various measures were incomplete in many respects. No statistic covered the foreign labor force and the foreign resident population completely. Foreign workers residing in neighboring countries, for instance, were missing from certain statistics, as were workers who had acquired the right to settle and were therefore exempt from the corresponding reporting obligations. Depending on the collating authority, data was collected from either municipal residents' registration offices, cantonal immigration police authorities, companies, or directly from households. The survey intervals varied between semiannual and decennial. Such lack of comparability led to a number of partly

contradictory figures that were circulating within the Federal Administration and also among the public regardless.[7]

In 1965, following the Study Commission's report, the Swiss government arranged for an internal task force to examine how more reliable figures on foreigners could be technically implemented. This task force was headed by the Central Office for Organizational Issues, represented by the Coordination Office for Automation, a branch that had been established in 1960. The Swiss government had entrusted this outfit not only with the supervision of its Bernese computing center, but with *all* automation projects underway at the Federal Administration. Indeed, the Coordination Office, wielding the military planning methods of operations research, then quickly emerged as the driving force behind rationalization efforts in the Federal Administration. Important players here included Otto Hongler, who was a teacher at the Institute of Business Administration at ETH Zurich as well as the president of the Swiss Society for Rational Administration and first head of the above-mentioned Central Office for Organizational Issues; and Hans Kurt Oppliger, an economist and former employee of the Bull computer company who was now the head of the Coordination Office for Automation. The idea that mathematical constructs and formulae should be relevant to capturing and implementing such criteria as effectiveness and efficiency was new to an administration still characterized by corporatism and militia structures.[8] Their reports on "Improvements in the Federal Council's Governmental Activities and Administrative Management" and on "The Status of Automatic Data Processing in the Federal Administration" were important milestones in this regard.[9]

Unsurprisingly, the task force came out in favor of data-processing machinery when it came to immigration. Following this, Max Holzer had a commission of experts draw up concrete measures for a new data-driven admission policy. Two years later, in 1967, the final report stated that effective management of immigration would only be possible if complete, accurate, and regular statistics on aliens were available. In turn, a promising solution for evaluating such large amounts of data accurately and quickly (thus enabling said data-driven policy) was, of course, the use of computer-generated statistics. The expert group on automation therefore took over all central design decisions from the task force led by the Central Office for Organizational Issues.[10]

Consolidating Power around a Single Data Source

The new statistics on foreigners were a prime example of automation in the administration of government, promising as it did the optimal control of the labor supply. Central data storage would guarantee a

7

Matthias Hirt, *Die Schweizerische Bundesverwaltung im Umgang mit der Arbeitsmigration: Sozial-, kultur- und staatspolitische Aspekte von 1960 bis 1972*, Saarbrücken, 2009; Hans Ulrich Jost, *Von Zahlen, Politik und Macht. Geschichte der schweizerischen Statistik*, Zurich, 2016.

8

Pius Bischofberger, *Durchsetzung und Fortbildung betriebswirtschaftlicher Erkenntnisse in der öffentlichen Verwaltung. Ein Beitrag zur Verwaltungslehre*, vol. 2, Winterthur, 1964.

9

See Swiss Federal Archives E65-02#1984/182#193*, E6502#1987/100 #45*. On the history of the emergence of the computing center in the context of the 1960 census, see Nick Schwery, "Die Maschine regieren. Computer und eidgenössische Bundesverwaltung, 1958–1965," in *Preprints zur Kulturgeschichte der Technik*, no. 29 (2018).

10

Swiss Federal Archives E6270B-01#1981/186#206*.

Fig. 1

high level of reliability and availability. New and partially automated processes linking up the federal government and the cantons were to guarantee the smooth and uniform collection and permutation of data. The optimistic vision was that in the future a work permit would only be issued to migrant workers who could be properly integrated into the Swiss economy and civil society. In line with this plan, the process of granting work and settlement permits would be implemented uniformly throughout Switzerland; the labor supply in turn would be distributed evenly and fairly across all regions of Switzerland according to economic needs. For this reason, separate statistics had to be compiled for each canton: How many foreigners stayed or settled in the canton in a certain year? How many of them were children, how many were adults? By how many individuals had the population changed compared to the previous year? What were their home countries? How many foreigners with a residence permit were in employment? How many foreigners with a permanent residence permit were employed? In which sectors were they employed? Which professions, if any, did they exercise?

This clearly was a daunting project. In order to win over the cantons, these were promised financial compensation for each "registration or permutation report." They were also assured that they would receive statistical evaluations (on a monthly basis) and copies of the register (on a quarterly basis) so as to be able to compare their own data sets with that of the federal state. Nevertheless, both at the Federal Office for Trade, Industry and Labor and the cantonal offices, initial euphoria over the automation of statistics on foreigners quickly ebbed in view of the complex technicalities. In order to meet deadlines, automated data transmission was dispensed with at many municipalities. The economically and numerically significant group of foreign border migrants was not integrated into the system and continued to be collected manually. In the beginning, this led certain cantonal authorities, now slowly adapting their allocation practices to federal guidelines, to simply misuse the reporting forms. As a result, the projected annual operating costs, initially set at 1.5 million Swiss francs, had to be adjusted several times, creeping up to more than 2.3 million Swiss francs.

The computer forced its logic onto the authorities in other, unforeseen ways. Due to the high cost of computer and tape storage, for example, personal records were kept as small as possible. Even the maximum possible length of foreigners' names was limited. In order to write the most efficient search routines possible, a unique key had to be available for each record. This key consisted of the surname, given name, date of birth, and a few other fields. Cyrillic letters overtaxed the system, as did people who had no last

Moritz Mähr
Kijan Espahangizi

Moritz Mähr / Kijan Espahangizi — 232

Fig. 1 "Permutation report," Central Aliens Register. (Swiss Federal Archives E3321-01#1985/36#103*)

name or who did not know their date of birth. Changes to the field definitions and the corresponding COBOL routines were time-consuming and often affected the entire system. To limit the impact of these modifications, the computing center introduced its own, very rigid and detailed project management methodology, called HERMES, in 1976. This organizational measure made it even more cumbersome for external stakeholders to make spontaneous requests for changes. No more adjustments were made without project submission and preliminary analysis. As a result, the Central Aliens Register isolated itself substantially from the cantons, basically operating as an autonomous unit within the Federal Administration.[11]

The Central Aliens Register, meanwhile, did not have the kind of impact that planners had expected. With the introduction of national immigration restrictions, the Swiss government had adopted a centralistic national immigration scheme, the material manifestation of which came in the form of a centralized database. Its adoption resulted in profound changes: the admission procedures were now standardized throughout Switzerland; the federal government and its immigration authorities were given larger budgets and more powers of control, intervention, and decision-making. Yet the Central Aliens Register was unable to meet the actual goal of adapting the migratory flows to the needs of the economy with its would-be fully automated quota system.

In the early 1970s, the number of foreign workers in Switzerland continued to rise significantly despite the restrictions imposed by the Federal Council. And when the Central Aliens Register finally went online in 1974, the global recession led to a sharp drop in the demand for labor, and well over 200,000 foreign workers and their families had to return to their home countries. They acted as an economic buffer, in accordance with the traditional principle of rotation, Switzerland being spared a rise in unemployment as a result. The lack of unemployment insurance along with weak worker protection and high worker mobility, rather than cybernetic control of the Central Aliens Register, had effectively "managed" the flow of migration.[12]

Moving from Real-Time Data to Scenario Analysis

After the recession, the postwar "problem of the foreign workers" thus lost part of its political urgency. Along with hundreds of thousands of foreigners, unemployment had been "successfully" exported and the structural transformation of the Swiss economy into a service economy was underway. The end of the boom era brought changes to the social challenges that would attract the attention and imagination of the public, as well as to the scientific experts and actors within the Federal Administration. One of these

11

Analogous obstacles posed to the administration by technical logic are also evident in Great Britain. See Jon Agar, *The Government Machine: A Revolutionary History of the Computer*, Cambridge, MA, 2003.

12

See also Jérôme Brugger, "At the Dawn of Swiss E-Government: Planning and Use of a Unique Identifier in the Public Administration in the 1970s," *Administration & Society 50*, no. 9 (October 1, 2018), pp. 1319–34. Migration policy in the 1970s was significantly influenced by European integration; see *Thomas Gees, Die Schweiz im Europäisierungsprozess. Wirtschafts- und gesellschafts-politische Konzepte am Beispiel der Arbeitsmigrations-, Agrar- und Wissenschaftspolitik, 1947–1974*, Zurich, 2006.

rising concerns—with regard to "the limits to growth"—was demography.[13] In fact, whereas fertility rates in developing countries were leading to exponential population growth and fanning fears of overpopulation, fertility had been in decline in industrialized Western countries such as Switzerland since the mid-1960s. In the following decade, the bump in the curve hardened into a more disturbing trend. The Swiss Society of Economics and Statistics duly expressed its unease with this demographic trend in a publication with the sensationalist title *Will the Swiss Die Out?*[14] In the late 1970s, the combined effects of declining native fertility, an exponentially growing population in developing countries, and the accompanying dynamics of global migration in a now decolonized world amalgamated into a perception of a veritable demographic challenge to the Swiss state. This required new approaches. In 1977, the Swiss parliament asked the government to "lay the foundations for population policy" by creating a new department of population statistics and demographic studies at the Federal Statistical Office: this novel department would report back to parliament and develop "proposals for the solution of the economic, social, cultural, and economic problems that follow the demographic situation."[15]

The computerized Central Aliens Register, built in the spirit of the Cold War "guest worker era," was unable to offer answers to these new demographic challenges—challenges that nevertheless were increasingly related to immigration issues. Registering, counting, and allocating foreign individuals, calculating in- and outflux rates, was simply an insufficient basis for developing sustainable population policies. What was needed now was a more innovative and exploratory approach, one that would allow the *modeling* of national demographic developments in a broader global framework. Both the rather rigid and nation-centric container model of the foreign-worker era and its underlying cybernetic data infrastructure had to be integrated into, and adapted to, the global environment of changing economic, demographic, and migratory patterns.

A rather different paradigm of statistical data processing would have to deal with these socioeconomic dynamics—even as, in the aftermath of the boom era and the rather unexpected global economic crisis, such complex dynamics appeared far less predictable than before, even to experts. Traditional predictive modeling techniques had provided forecasts based on mathematical extrapolation and well-defined probabilities; new and more sophisticated tools would have to try to explore and describe the systemic complexity of a fundamentally uncertain future. By the 1980s, the development of "population scenario analysis" at the Federal Statistical Office seemed to provide a way to do this, offering a more globally oriented, flexible,

13

Donella H. Meadows et al., *The Limits to Growth: A Report for the Club of Rome's Project on the Predicament of Mankind*, London, 1972.

14

Schweizerische Gesellschaft für Statistik und Volkswirtschaft (Kommission Bevölkerungspolitik), *Sterben die Schweizer aus? Die Bevölkerung der Schweiz: Probleme, Perspektiven, Politik*. Bern, 1985.

15

77.448 Postulat Morel. Bevölkerungspolitik, in *Amtliches Bulletin der Bundesversammlung*, 1978 Band I, Januarsession, Sitzung 06, Nationalrat: pp. 158–59.

Fig.2 System flowchart, 1978, Central Aliens Register. (Swiss Federal Archives E3325-02#2015/17#122*)

and exploratory approach to dealing with the demographic future of the Swiss nation-state. This new perspective, as we shall see, materialized not only in the general conceptual outlook and methodology of scenario analysis, but also in more exploratory and decentralized forms of electronic data processing.

Flexible Machines, Multiple Data Sources

In 1979, the Swiss government took a first step toward such a more integrated view of national demographics and immigration when the newly established demographics department of the Federal Statistical Office was asked to develop an integrated statistical tool, as well as produce annual updates of total population movements in Switzerland, that is, of citizens *and* foreigners. The resulting ESPOP database (Statistique de l'état annuel de la population) drew from various data sources. The Central Aliens Register provided valuable data on the foreign population, arriving at the Federal Statistical Office on magnetic tapes. In view of migratory movements of the native population (international and between the Swiss communities, cantons, and regions), a new database had to be built from scratch. The geographer Hans Steffen, who had been hired as head of the ESPOP project, was responsible for gathering the necessary data and implementing it in cooperation with the cantonal agencies and roughly 3,000 local communities.[16] In a next step, the accumulated data was aggregated in comprehensive tables in the Electronic Computing Center of the Swiss Federal Administration, which at that time was located under the roof of the Federal Statistical Office.

This in-house infrastructure, however, wasn't suited for running the customized computer programs that were necessary in order to edit, integrate, and smoothen the data. Most importantly, it did not provide an APL environment—a programming language that had been developed by mathematicians in the 1960s that was geared toward statistical purposes. Failing such capacities, the ESPOP project instead used the time-sharing system of an APL-based computing center in Toronto, operated by I. P. Sharp. Having started as a small consulting firm in 1964, I. P. Sharp had by the early 1980s turned into a multinational APL time-sharing company with offices all over the world, including in Zurich. Its *I. P. Sharp Newsletter* served as an information platform for the growing international user community, showing off APL applications, explaining code snippets, and announcing training courses.[17] A series of "on line" (*sic!*) workshops held in Zurich in 1981, for instance, offered an introduction to APL programming as well as more advanced immersion.[18] The APL users at the demographic department of the

16

Thérèse Huissoud, Martin Schuler, and Hans Steffen, *Les migrations en Suisse entre 1981 et 1993: Une analyse des statistiques de l'état annuel de la population et des migrations (ESPOP)*. Bern, 1996, p. 8.

17

See, for example, I. P. Sharp Associates, *I. P. Sharp Newsletter* 10, no. 1, Toronto, 1972.

18

The advertising for the courses was attached to the newsletters as a flyer. Ibid.

19

Interview with Hans Steffen by Kijan Espahangizi in Bern, May 9, 2019.

Federal Statistical Office appreciated this kind of community service on the part of I. P. Sharp—it allowed them to emancipate themselves from the professional computer engineers who still did the programming at the big centralized computing and data centers.[19] For two Swiss francs per hour, data from the Federal Statistical Office was sent to Canada for processing via Mitek terminals, telephone cables, and a front-end computer used to schedule the incoming tasks.

In contrast to the personal data records stored in the Central Aliens Register, which had to be kept in Switzerland, the transatlantic transfer of aggregated (and therefore anonymous) demographic tables didn't raise any concerns with regard to national data security. The trans-border stream of data flowing back and forth between Bern and Toronto, as well as the participation in a growing international user community, were symptomatic of the accelerating global reach of electronic information technologies at the time—and of a new kind of mindset. The results of these transnational data calculations—a few kilobytes per year—were then stored again and backed up onto the magnetic discs of the Electronic Computing Center of the Federal Administration in Bern. The whole setup, indeed, was only barely reminiscent of the omnipresent centralism that had determined the visions of migration policy just a few years earlier.

Shortly after the decennial national census of 1980, ESPOP was up and running, ready to deliver annual data on natural population movements (deaths and births) as well as all migratory movements of what would now be framed as the "permanent resident population" (a new notion that no longer focused on the legal distinction of citizenship).[20] The implementation of ESPOP took place at a time when the Swiss government was more broadly reorganizing its knowledge production policies in response to the challenges of a shifting, uncertain global economy. In the aftermath of the crisis in the mid-1970s, determining the status of the resident population was still important, of course, but it wasn't the sole purpose of data processing. Various decentralized data sources had to be processed flexibly, producing knowledge about future developments that could guide long-term policy decisions and inform the work of various departments within the Federal Administration, including on such questions as social security.

Population Scenarios: Computing Uncertainty

In 1980, *The Global 2000 Report to the President*, a comprehensive report by the US government on global environmental, socio-economic, and demographic developments, was published and rapidly trans-

20

Huissoud 1996.

lated into numerous languages.[21] The report, commissioned by US president Jimmy Carter three years earlier, attracted wide interest. In 1982, the Swiss parliament asked the government to consider the report's implications, especially in relation to its consequences for Switzerland.[22] In 1983, against the backdrop of a broad political want for improved analytical and orientational knowledge in a dynamic, global context, the Swiss government passed a law requiring the Federal Administration to produce "perspectival studies" (Perspektivstudien) on a regular basis.[23] The "perspectival staff" later put in charge of these studies was to include employees of the Federal Chancellery, representatives from the two main state-owned companies SBB (railway and public transport) and PTT (post, telephone, and telegraph), the demography department of the Federal Statistical Office, and the St. Gallen Center for Futurology (St. Galler Zentrum für Zukunftsforschung, SGZZ). The private think tank led by renowned (and notorious) economist Francesco Kneschaurek would be running the macroeconomic part of the studies.

Kneschaurek had been creating reports for the Swiss government since the late 1960s.[24] These studies were still being conducted under the impression of the postwar boom period, using traditional prognostic techniques such as extrapolation and projection. When faced with criticism that questioned the value of this kind of futurology in the aftermath of the global economic crisis, however, the SGZZ notably began adjusting its futurological methods. In its demographic study of 1978, the SGZZ already made use of simulations using four variations of basic demographic parameters.[25] But it wasn't until the early 1980s that a new notion entered their vocabulary and methodological tool kit: "scenario."[26]

The futurological method of "scenario analysis" had, in fact, been developed by Hermann Kahn at the RAND corporation against the backdrop of Cold War military logic of the 1950s and '60s.[27] In the ensuing decades, it increasingly found use in both private and public insti-

21
Gerald O. Barney, and Council on Environmental Quality, *The Global 2000 Report to the President: Entering the Twenty-First Century*. 3 vols. Washington, DC, 1980.

22
82.461 Postulat Bäumlin, Bericht "Global 2000," June 24, 1982, *Amtliches Bulletin der Bundesversammlung* V/Winter (1982), pp. 1789–99.

23
"HERMES Projektantrag Szenario, February 9, 1984," in Swiss Federal Archives E1010C#2009/102#89*.

24
Francesco Kneschaurek, and Terenzio Angelini, *Entwicklungsperspektiven der schweizerischen Volkswirtschaft bis zum Jahre 2000*, St. Gallen, 1974, pp. 1–11.

25
Francesco Kneschaurek, *Entwicklungsperspektiven der schweizerischen Volkswirtschaft. Teil 1. Demographische Perspektiven*, 2 vols., Entwicklungsperspektiven der Schweizerischen Volkswirtschaft, St. Gallen, 1978.

26
See Francesco Kneschaurek, *Das richtige Zukunftsbild*, St. Gallen, 1982, p. 18; see also pp. 26–29.

27
Patrick Kupper, "Szenarien. Genese und Wirkung eines Verfahrens der Zukunftsbestimmung," in *Die Krise der Zukunft I. Apokalyptische Diskurse in interdisziplinärer Diskussion*, edited by Georg Pfleiderer and Harald Matern, Baden-Baden, 2020, pp. 126–81.

28
Elke Seefried, *Zukünfte: Aufstieg und Krise der Zukunftsforschung 1945–1980*, Berlin, 2015.

tutions, including in Switzerland; its popularity surged especially after the rather unexpected global recession of the mid-1970s had challenged classical predictive approaches. In order to design hypothesis-based scenarios, a heterogeneous bundle of factors had to be considered, including but not limited to knowledge and data on past developments: political targets and other constraints, assumptions about the range of possibly relevant sociological, cultural, and economic developments and future events, and so on.[28] In 1983, against the backdrop of the general diffusion of this methodology— scenario analysis had also been employed in the *Global 2000* report—the Swiss government commissioned perspectival studies that would include "population scenarios" to be realized by the demographic department of the Federal Statistical Office.[29]

Exploratory in nature, population scenario analysis required an adequate technological environment: one providing access to the necessary data and flexible enough to carry out the according simulations. The division of labor that had worked for the Central Aliens Register—statisticians on the one side, computer engineers / scientists doing the programming on the other—clearly did not match the implied need for a "dialogue," that is, the back and forth communication and adaptive processes between scenario design, statistical operationalization, and information technology. The statisticians at the Federal Statistical Office in charge of calculating the scenarios, Hans Steffen and Erminio Baranzini, who had been trained as an economist, had to be able to work on the level of programming themselves.[30]

A more user-oriented electronic infrastructure for statistical calculation purposes at the Federal Administration continued to be lacking; yet by now, it was possible to draw and build upon the earlier experience of the ESPOP project in the area of APL programming and the time-sharing services of I. P. Sharp.[31] At the time, the only facility within the Swiss state bureaucracy that provided this kind of working environment was the computing and data center of the PTT, also in Bern (ERZ PTT).[32] Indeed, PTT had previously founded the Swiss APL User Group that provided advanced training and assisted in building a community of users from different professional backgrounds (state agencies, banks, insurance companies) who shared codes and practical knowledge. Offering both flexible time-sharing technology and a user-oriented APL programming environment, it was well-suited to running the statistical simulation of the perspectival study there.[33] The fact that the PTT was already represented on the perspectival staff further facilitated the cooperation. In addition, all the necessary datasets for the demographic scenario, most importantly the ESPOP database, had already been transferred to its computer center.

29

The demography department at the Federal Statistical Office produced a first "scenario"-based population study in 1980, for a UN project. In this study, conducted at a time when immigration numbers in Switzerland were still decreasing, migration was not considered to be a relevant demographic factor. The computer-generated tables in the printouts of the study noted only briefly: "migrations not assumed." Jean-Emile Neury, and Hans Steffen, "Scénarios d'évolution de la population résidente 1980–2040, préparés à l'aide du programme de l'ONU," 1980, Swiss Federal Archives E3321# 1998/304#26*.

30

Owing to Hans Steffen, his colleague Erminio Baranzini—an economist with some earlier expertise in scenario analysis—was in charge of the elaboration of the scenarios. Interview with Hans Steffen in Bern, May 9, 2019.

31

Interview with Hans Steffen in Bern, May 9, 2019.

The first perspectival demographic study of the Federal Statistical Office was published in 1985. It focused on the development of fertility rates in Switzerland between 1985 and 2025. The second study, which was carried out in fall 1986 and published in 1987, changed the focus and emphasized the effect of global migration on Swiss population growth. In 1986/87, the perspectival staff agreed to work with three hypotheses on future migration proposed by the Federal Statistical Office team, and to elaborate on the following scenarios. The first of these, a scenario of "stabilization" (2A-86), proceeded from the mindset of cybernetic equilibration and the associated policies that had been established before the global economic crisis of the mid-1970s in the context of the heated debates on foreign workers. It set a target of a stable percentage of foreigners in the resident population. The second scenario, "closed Switzerland" (2B-86), started from the rather unrealistic assumption of net zero immigration. The third scenario, "increased immigration" (2C-86), meanwhile, explored the effects of a new, externally induced global "migration pressure."[34] The Swiss government, keen to avoid conflict, followed established policy in choosing its preferred scenario: "stabilization." In spite of this ostensible continuity, however, the practice of producing population scenarios soon became routine within the Federal Administration.

Toward an Integrated Information System

With the implementation of the Central Aliens Register in the 1970s, the foreign population entered, if you will, the computing centers of the Swiss Federal Administration. In the spirit of cybernetics and operations research, migration policy was modeled as a system and foreigners as data points; their influx had to be regulated on the input side in order to produce the right labor supply on the output side. Although this vision soon faded away, increasingly powerful computers, rationalization, and practices of statistical/numerical control became an integral part of a newly emergent administrative culture.[35] The recession of the 1970s affected not only the nascent post-industrial society's belief in growth, but also the planning security of the nation-state. Economic and political uncertainties were tackled using new technologies, scientific approaches, and studies involving more distant horizons. Seen this way, the movement from heavily centralized to distributed forms of "computing" aliens did more than just follow the technical development from large mainframes to smaller workstations; it was itself a product of newly integrated migration and population policies that were increasingly globalized and temporalized in orientation. Data on and analyses of migration flows and population developments had begun

32

Daniela Zetti, "Die Erschliessung der Rechenanlage. Computer im Postcheckdienst, 1964–1974," in *Gesteuerte Gesellschaft – Orienter la société*, edited by Gisela Hürlimann, Daniela Zetti, and Frédéric Joye-Cagnard, traverse 2009/3, 2009, pp. 88–101.

33

On the historical shift to user orientation, see Gugerli 2018.

34

Werner Haug, "Ausblick auf die Zukunft der schweizerischen Bevölkerung: Bevölkerungsperspektiven 1986–2025." *Schweizerische Zeitschrift für Volkswirtschaft und Statistik* 124, no. 2 (1988), p. 201.

35

On the monitoring culture, see David Gugerli, and Hannes Mangold, "Betriebssysteme und Computerfahndung. Zur Genese einer digitalen Überwachungskultur," *Geschichte und Gesellschaft. Zeitschrift für Historische Sozialwissenschaft* 42, no. 1 (2016), pp. 144–76; Lucas Federer, "Aktiv fichiert," in *Archive des Aktivismus: Schweizer Trotzkist-*innen im Kalten Krieg*, edited by Lucas Federer, Gleb J. Albert, and Monika Dommann, C1–C18. Æther 2. Zurich, 2018, https://aether.ethz.ch/ausgabe/archive-des-aktivismus/

to cross the borders of national discourse and become an important currency of international politics.

Beginning with the population scenarios of the Federal Statistical Office in the 1980s, the immigrant population began to play a constitutive role in Swiss demography, albeit at first only in the form of a computer-based model, linking the future of the resident population with global demographic developments. In the following decades, this new approach would shape not only the analyses and statistics, but also the policies and institutions of the Federal Administration. Since the late 1980s, a notion of integrated migration policy had emerged—departing from global scenarios—overshadowing, absorbing, and reconfiguring the established postwar apparatus of foreign worker admission policy.[36] This development was reflected not only in the total revision of the Aliens Act from the 1930s around the turn of the millennium and the institutional reorganization of the migration authorities, but also in the implementation of a new migration information system by 2008. The Central Migration Information System CEMIS integrated not only the erstwhile Central Aliens Register, but also several, hitherto distributed migration databases, into a comprehensive but flexible system with over 11 million individual entries which is also embedded in an international network of migration data systems. The multiple historical pathways since the 1960s that led to the Swiss CEMIS highlight the fact that electronic data infrastructures are more than mere tools of migration governance. Increasingly, they are shaping the ways in which state authorities, as well as other societal actors, perceive and understand social phenomena of migration; they are shaping policies, social interactions, and even visions of the future.

Acknowledgments We would like to thank Fabian Grütter and the editors for their critical remarks.

36

Kijan Espahangizi, and Moritz Mähr, "The Making of a Swiss Migration Regime. Electronic Data Infrastructures and Statistics in the Federal Administration, 1960s–1990s," Journal of Migration History (2020, in print).

Dällikon
Zurich

Delete Information:
Sanitize, Shred, and Burn

Sascha Deboni

Photos by
Marc Latzel

On the edge of a large parking lot, directly behind the noise abatement wall of Autobahn A1 just outside Bern, is "Switzerland's most modern data center."[1] Rudolf Anker, the leading executive for all of Swisscom's data center services, welcomes us here in Wankdorf, where he will guide us through the plain concrete building that he has just circled with a camera drone—likely for promotional purposes.

After being admitted through security gates "like at the airport," as Anker proudly comments, and a tour of the server rooms, we're now in a wide passageway in the basement. One half of this level houses 2.5 million liters of fresh and purified rainwater for cooling the data center. On this gray winter day, no water is needed for the heat exchangers on the roof—it's cold inside the data center as well. Anker leads us into a spacious cell opposite the tank. Illuminated by a cool fluorescent ceiling lamp, this room seems like the cellar of an urban apartment building, with basement storage rooms separated by strong, fine-mesh steel grids. Anker points to a horizontal slot in the grid and explains the security concept for destroying discarded storage media: hard disk drives are pushed through the slot and land in a bin on rollers. In the same storage room, there's also a large black box: a shredder. No storage medium leaves the building unscathed, Anker assures us. At regular intervals, an employee locks himself in the cage, dons hearing protection, and shreds the hard disk drives. Only granules are allowed to leave the data center via the transport corridor.[2]

Shred Digital Data?

The technology of interlocking rollers developed by German engineer Adolf Ehinger in 1935 for shredding paper files, which he was able to mass-produce as the paper shredder,[3] destroys Swisscom's storage media in the black box in the company's basement. This seemingly antiquated technology in modern use and the risk posed by the discarded, at first glance ordinary-looking, metal hard drives, will be the focus of this essay. What do other guardians of sensitive data do with their defunct storage media? To find out, we contacted various companies that, in some cases, gave us a terse response by e-mail and in others, an extensive interview. These companies, various banks, government institutions, and a hospital are case studies that give insight into the diverse practice of data destruction.

This assemblage of case studies provides a typology of strategies for destruction. Some of the actors make use of standardized norms that allow destruction to be completely outsourced to specialized firms with contractual safeguards, while others prefer to carry out or oversee the physical destruction by fire or the shredder themselves. On a small scale, even rudimentary tools are used by individuals: the storage media are destroyed

1

Swisscom refers to its data center as such in its promotional brochure. See *Swisscom Rechenzentrum Wankdorf. Für eine Erfolgreiche Zukunft*, Bern, 2014, p. 2.

2

Interview with Rudolf Anker by Sascha Deboni, Hannes Rickli, and Max Stadler, January 18, 2018.

3

John Woestendiek, "The Complete History of Shredding," *The Baltimore Sun* (February 10, 2002).

Fig. 1

Fig. 1

using a drill and a grinder. Not only in terms of their technical means, but also in the openness of their communication about the processes of destruction, can distinctions be seen between the institutions.

Sanitizing (Bank) Secrets

This was particularly evident in our contact with the large banks. None of the large Swiss banks, nor the Swiss National Bank, wanted to comment on their procedure for destroying their storage media. Raiffeisen responded courteously:

Please understand that for security considerations we are not providing any information about the handling of decommissioned hardware.[4] Without discussing their procedures, UBS clarified: *In Switzerland, UBS does not allow any computers to be given to private individuals or to institutions, mainly for privacy reasons, in order to minimize the possibility of data being recovered even after a factory reset / full wipe.*[5]

A locally based bank[6] that maintains its own server infrastructure provided some information and even extended an invitation for an interview, but wished to remain anonymous. The company's internal protocol stipulates that the department responsible collect the storage media centrally in a secure area on the bank's premises and organize transportation of the hardware to a recycling firm on its own. The recycling firm, which has a shredder for hard disk drives, has been a long-standing partner of the bank since even before the age of computers, which is why the bank also wanted to work with it in destroying hard disk drives. Those responsible are present during the destruction procedure, in order to personally ensure the destruction of all storage media.

Only Alternative Bank Schweiz (ABS) was willing to provide information about its system. In accordance with its policy of "transparency,"[7] the bank communicated that its entire server infrastructure was completely outsourced to Swisscom's certified data centers. This therefore includes the data center in Wankdorf with the shredder in the basement that guarantees that decommissioned storage media do not leave the secured premises. According to ABS, the following procedure is in place for the disposal of storage media containing less sensitive information:

Individual laptops are wiped (DoD standard) using security software in order to be reused. A new operating system is then installed on the reformatted hard disk and in some cases made available for personal use by employees.[8]

4

Letter from Chiavi Dominik, April 15, 2019. The response to the question, asked for the purpose of scientific research, of how the bank regulates the handling of decommissioned hardware. Credit Suisse had a similar reaction: "I've clarified this in-house: for security reasons, we are unable to offer any assistance in this case," letter from Gérianne Cruz, April 11, 2019.

5

Letter from Simone Meier, July 23, 2019.

6

Interview with an anonymous employee by Sascha Deboni, June 26, 2019.

7

See Alternative Bank, "Unsere Grundsätze. Handlungsmaximen," https://www.abs.ch/de/ueber-die-abs/das-abs-geschaeftsmodell/unsere-grundsaetze/ (retrieved October 18, 2019).

This bank is thus the only institution among our case studies that does not provide for the physical destruction of hard disk drives for a specific area of use.

Governmental Shredding

Even public institutions in Switzerland handle the destruction of their storage media in different ways. Federal guidelines follow the Federal Act on Data Protection.[9] These include certified bodies as possible guarantors of data protection, but are vague when it comes to more exact procedures.[10]

The Federal Archives' decommissioned storage media, for example, which contain the federal agencies' digital archive dossiers, created during replacement cycles or whenever there's a glitch within the archives' server infrastructure, are transferred to the Bundesamt für Bauten und Logistik (Federal Construction and Logistics Agency, BBL), which carries out their destruction according to contracts and a certified procedure. Other federal agencies cooperate with the BBL on the safe disposal of their hard disk drives.[11]

Setting Fire to Military Data

The Departement für Verteidigung, Bevölkerungsschutz und Sport (Department of Defense, Civil Protection, and Sport, VBS) oversees highly sensitive information, mainly for the Army. Internal policies for the secure destruction of this data are in place, although no cooperation takes place with the BBL, which is responsible for other departments. According to the VBS data security officer, the VBS policy specifies: *Storage media containing sensitive data are strictly to be brought to an incinerator and their destruction overseen in person.*[12] VBS staff, already entrusted with the confidential data, arrange for and attend the destruction by fire. In a normal waste incineration plant, the storage media are channeled directly into the regular waste-disposal furnace and consigned to the fire. The metallic components, partially burned but mostly melted, are left behind as part of the residue in the incinerator. Specialized machines then extract these valuable materials from the residue.[13] For the VBS, incineration and the melting down of storage media represent the only secure solution.

8

Letter from Markus Egger, April 3, 2019.

9

Federal Assembly of the Swiss Confederation, Federal Act on Data Protection (FADP), Art. 7 Par. 1 (status as of March 1, 2019): "Personal data must be protected against unauthorized processing through adequate technical and organizational measures."

10

FADP 2019, Art. 11 Certification Procedure: "1 In order to improve data protection and data security, the manufacturers of data processing systems or programs as well as private persons or federal bodies that process personal data may submit their systems, procedures and organization for evaluation by recognized independent certification organizations.

2 The Federal Council shall issue regulations on the recognition of certification procedures and the introduction of a data protection quality label. In doing so, it shall take account of international law and the internationally recognized technical standards."

11

Interview with Stefan Kwasnitza and Krystyna Ohnesorge by Sascha Deboni, September 10, 2019. Conversation with the deputy director and department head of the Federal Archives.

12

Letter from Richard Zollinger, October 17, 2018.

13

Letter from Roland Wichtermann, August 21, 2019.

Only a few incineration facilities offer the incineration of storage media. To the Hagenholz Municipal Waste Incineration Power Plant in Zurich, for example, it's apparent that hard disk drives must always be disposed of as electronic waste: they won't allow any electronic storage media in their incinerators. While there is a hatch that leads directly to the furnace, it's used only to destroy drugs in the presence of someone from the public prosecutor's office. The incineration of hard disk drives is out of the question, even for the police.[14] If customers desire secure destruction, the Hagenholz Incineration Plant refers them to specialized providers of shredding services.

Hospitals: In-House Destruction and Service Providers

The Universitätsspital Zürich (University Hospital Zurich, USZ) works with such a service provider. The USZ uses securely sealed metal containers to centrally collect storage media from the server system that accumulate during the maintenance cycle or that have become defective.[15] Upon request, the destruction and recycling company Reisswolf collects the containers with electronic opening protocols and transports them to the company site in GPS-monitored vehicles. At the end of the process, the destruction of the contents is confirmed in writing.

However, not all of the hospital's storage media waste ends up at Reisswolf: hard disk drives used by the hospital during the operation of various medical equipment, such as X-ray machines, are destroyed by the USZ after they fail or are replaced—sometimes even directly on site, where the disk is punctured several times.[16] For this type of waste, manual destruction is the most practical and effective way of removing traces of information. The hard disks of the internal server system, on the other hand, are destroyed by the hospital in cooperation with Reisswolf.

Reisswolf operates as a franchise company: the more than thirty partner companies, scattered over almost as many countries, are mostly recycling and waste disposal companies.[17] For example, the company Lopatex AG, which acts on Reisswolf's behalf in the greater Zurich area, also comes from the waste disposal sector. Only a few employees work for Reisswolf itself in all of Switzerland. All of them have to undergo a safety check on a regular basis: the franchise company checks the employees' criminal records as well as their extracts from the debt collection register.

At their site in the industrial area of Dällikon, two shredders for storage media are located in a large room next to a hall for paper shredding. The machines and all persons around the devices are permanently monitored by video. One shredder destroys magnetic tapes and other softer

14

Interview with Christoph Leitzinger by Sascha Deboni, July 19, 2019. A further facility in the canton of Zurich confirmed this: Interview with Kurt Bürki by Sascha Deboni, February 11, 2020.

15

An electronic lock, accessible only with an RFID card, secures the container. Storage media that have gone through the container's hatch are securely enclosed prior to opening with the electronic key. In addition, the lock records all openings of the container as well as its position; furthermore, an alarm can be programmed to sound, should the container be opened.

16

Interview with Erik Dinkel by Sascha Deboni, June 17, 2019.

17

Reisswolf is a franchised business that markets certified services under the same name in different countries and in various locations. See Reisswolf International AG, "Our Locations," https://www.reisswolf.com/en/reisswolf/locations/(retrieved October 18, 2019).

Fig. 2

Fig. 3

Figs. 2, 3

storage media such as old floppy disks and discs, CDs, DVDs. Next to it is a conveyor belt that feeds the robust hard disk drives, usually in metal housings, to the chute of the large shredder with its interlocking rollers. The shredder noisily eats its way into the material of the storage media: the machine in Dällikon manages several hundred storage media per hour. The granulated remains of the shredded hard disks are then sent to be recycled.[18] The destruction by physical shredding of the storage media by a shredder guarantees the irreparable destruction of the hard disk. This promise is contractually clad in an industry standard. As an additional security option, customers can request a record of all the serial numbers of the destroyed hard disks.

Norms Yield Solutions

The origins of such promises—reliability thanks to standardization—can be located in the context of the onset of industrialization, especially in the field of weapons production in the eighteenth century.[19] In 1917, such efforts led to the establishment of the Normenausschuss der Deutschen Industrie (Standardization Committee of German Industry), later to become the Deutsches Institut für Normung (German Institute for Standardization, DIN) or in 1918, the Normalienbureau of the Verein Schweizer Maschinenindustrieller (Standardization Bureau of the Association of Swiss Machine Manufacturers). Such organizations, in constant discussion with various partners, increasingly standardized areas outside of mechanical engineering.[20]

As a discussion about data protection emerged in the 1980s, DIN developed standards that specified the technical characteristics and organizational procedures for handling sensitive documents. DIN 32757 for the secure destruction of sensitive documents was published in 1984—one year before Reisswolf was founded.[21] While this older version formulated only technical details prior to 2012, the new DIN 66399 also describes the process for certified outsourcing of the destruction: it regulates all processes, from the way storage media are kept at the collection point—in the electronically sealed metal containers, for example—to their transport and destruction.[22]

As was evident almost without exception in the practices of the companies investigated, DIN 66399 stipulates in detail down to the size of the shredded particles. For this purpose, the standard creates various categories of classification and describes the technical requirements for the shredding processes for the different types of storage media, including paper documents, depending on their security classification.

Fig. 4

18

Interview with Bruno Röschli by Sascha Deboni, July 23, 2019.

19

See Bernd Hartlieb, Albert Hövel, and Norbert Müller, *Normung und Standardisierung. Grundlagen*, Berlin 2016, p. 29.

20

Ibid., p. 31.

21

The first DIN standard in this area: Deutsches Institut für Normung, *DIN 32757-1:1983-11, Büro- und Datentechnik – Vernichten von Informationsträgern – Maschinen und Einrichtungen – Anforderungen und Prüfung*, Berlin, 1983.

Shredding Machines

Despite some patents already having been filed in the United States in the nineteenth century, the aforementioned invention by Adolf Ehinger from Balingen, Germany, dominates the story of the shredder's origin.[23] According to this story, in 1935, Ehinger adapted the mechanical system of a pasta machine to a device with which he was able to shred his own screeds against the Nazi regime in such a way that they no longer posed any risk. He refined his invention, and after World War II he established a professionalized production facility. However, Ehinger's shredder did not yet achieve widespread public awareness.[24]

Only with new technical means of reproducing paper documents did paper consumption increase significantly, as did concern about the destruction of the information it contains. In addition, the Watergate scandal and the leak of Pentagon Papers in the early 1970s shook up the US government. The inconspicuous office machine thus came into the public eye. In this climate, spurred on by scandals and driven by a growing flood of paper and clandestine reproductions by Xerox copiers, shredder manufacturers advertised the shredder as a solution to the stubborn persistence of information.[25] The shredder can be seen as a complementary product to modern copiers.[26] In the 1980s, the emergence of the concept of data protection cemented the essential role of the shredder.[27]

Ultimately, the problem acquired a political component. Ehinger had already given the machine a mythical quality, as it served him in his struggle for the Resistance.[28] In the 1970s, as mentioned above, Watergate played a central role in the public reception of the shredder. In recent times as well, the shredder has ended up in the media whenever it is engulfed in the turmoil of a scandal.[29] Wherever data that is sensitive but potentially relevant to the public has been erased, the shredder emerges and appears as the point of final destruction, even if only as a secondary actor.

Paper and Hard Drive

But why do we still need this machine in the age of digital files? The simple goal, in terms of information technology, of destroying all traces of sensitive information on a storage medium is contrasted by

22

See Deutsches Institut für Normung, *DIN SPEC 66399-3:2013-02, Büro- und Datentechnik – Vernichten von Datenträgern – Teil 3: Prozess der Datenträgervernichtung*, Berlin, 2013.

23

A technical history of the paper-shredding machine has yet to be written. A solid ethnographic study that also covers the mythical depiction of the paper-shredder as an agent of the Resistance is provided by Sophia Booz, *Der Reisswolf. Aktenvernichtung als destruktiver, ordnender und produktiver Umgang mit Daten* (1965–2015), Tübingen, 2018, p. 21.

24

See Woestendiek 2002.

25

See Booz 2018, pp. 22 f. Using advertising material as a starting point, Booz impressively describes how the terms used to describe the increase in the amount of information stored are based on metaphors of nature.

26

Ibid., p. 25.

27

Ibid., p. 26.

28

Ibid., p. 21.

29

See Ivo Mijnssen, "Ein verdächtiger Gang zum Reisswolf und eine unbezahlte Rechnung von 76 Euro 45 versetzen Österreich in Aufregung," *Neue Zürcher Zeitung* (July 24, 2019).

Fig. 4

complex cultural techniques that govern the handling of the hardware. But how can it be explained from a technical point of view that the storage media of digital information end up in the shredder just like paper?

As a printed book, paper document, or dossier, the storage medium is one with the data. The medium gives the information physical form. The information is embedded in it as the printed word. In digital media, however, the information is not directly tangible. It can only be accessed via a whole range of technical equipment and software that decrypt the digital code on the medium.

This code is a binary representation of information, that is, its unique encryption in a sequence of 0s and 1s—a sequence of bits. One bit corresponds to a binary quantity of information, the value of 0 or 1. This binary sequence of information finds its expression in the material world just as the printed word does on paper. All information, including digital information, is ultimately present on the storage medium as a physical state: most often as a sequence of magnetized regions on the nano scale on a hard disk drive, which have either a positive or negative charge.

In companies and administrative bodies, information is stored on a scale that transcends individual media, on linked server racks and thus on several HDDs, increasingly SSDs, or even magnetic tapes. Individual files and entire databases are fragmented—decentralized—on these media.[30] The systems continually discard obsolete storage media during cycles of renewal or when they become defective. Even if the databases' virtual storage units are ultimately what matter for regular access, potentially sensitive records still remain in the fundamental realm of hard infrastructure, on the individual hard disk.

Lay people can't do anything with a single disk, as opposed to an analogous secret paper dossier that can be read even if the context is missing. However, the binary sequence on the disk provides computer

30

Sales statistics show that at present (2019), even more HDDs are being delivered. Even if the trend is toward the increasing use of solid-state disks (SSD), it can be assumed that, due to their longer lifespan and the even more cost-effective and larger capacity they currently offer, much larger volumes of data are being stored on magnetic storage media worldwide. See Arne Holst, "HDDs and SSDs: Global Shipments 2015–2021" (Statista, 2017),

31

https://www.statista.com/statistics/285474/hdds-and-ssds-in-pcs-global-shipments-2012-2017/.

On PCs, simple deletion usually just means moving file access to the recycle bin. See Joel Reardon, *Secure Data Deletion: Information Security and Cryptography*, Cham, 2016, p. 131.

32

The following description assumes an intact, secure system. In principle, a deletion that appears as such on the user interface could, on a system that has been tampered with, also be based on a copy on another storage medium, although the associated files disappear on the interface.

33

See Simson Garfinkel and Abhi Shelat, "Remembrance of Data Passed: A Study of Disk Sanitization Practices," *IEEE Security Privacy* 1, no. 1 (2003), pp. 17–27, esp. p. 26: These two computer scientists undertook an experiment in addition to their research on secure disk wiping. They bought 158 hard drives from various second-hand shops and tried to restore the data on them. They succeeded in doing so on an astonishing 90% of the hard drives they were able to access.

Only 10% had been correctly overwritten. See Garfinkel and Shelat 2003, p. 24.

34

As a form of sanitization in the US guidelines for secure deletion of data on storage media: Richard Kissel et al., "Guidelines for Media Sanitization," *National Institute of Standards and Technology Special Publication* 800-88 (September 2006), p. 12.

35

Joel Reardon, David Basin, and Srdjan Capkun, "On Secure Data Deletion," *IEEE Security Privacy* 12, no. 3 (2014), pp. 37–44, esp. p. 40.

Fig. 5

science and data forensics experts with access to potentially sensitive data. With a single hard disk, they hold dossiers that lack context, yet are nonetheless potentially unsafe. Knowing this is fundamental to understanding the processes involved in erasure.

Real Deletion—How?

Why not simply delete all the files on the discarded hard drives digitally? As a rule, virtual deletion of digital data on storage media does not mean final destruction of the information. The binary sequence on the storage medium is not irreversibly neutralized. Data that can be erased by simple commands is cleared superficially from the system, but the computer only removes access to the corresponding sectors of the storage medium;[31] the physical traces of the 0s and 1s, the information, remains intact. This is not only the case when data is deleted and moved to the recycle bin,[32] but also when partitions or even entire disks are formatted.[33]

To neutralize the physical imprint of the binary sequence on the storage medium, it is advisable to overwrite the sequence.[34] To do this, it is necessary to know the storage structure of the medium in order to refill all the positions of binary code.[35] Depending on the storage medium, it can be necessary to completely overwrite these positions several times in order to effectively delete physical traces of the original information.[36] In addition to overwriting, it is also possible to erase magnetic tracks permanently by means of a so-called degausser. A degausser is a machine that generates a magnetic field that far exceeds the field strength with which the hard disk drive normally writes data records. As a result, all magnetic positions are magnetized in such a way that all information, including information necessary for the operation of the drive, disappears irretrievably. The physical storage medium is not destroyed, but is rendered completely inoperable by the process. The hard disk can then be disassembled into its individual parts and disposed of.[37] This method is seldom used in practice, not least because it is only applicable to magnetic media and requires special equipment. Deleting data digitally and eliminating its traces on digital storage media is therefore a complex and time-consuming undertaking from a technical point of view. Companies and their partners such as Reisswolf and other providers of destruction services rely on demolition and apply DIN 66399 to address this problem. The digital overwriting of storage media is mentioned in standards from the United States, though only for wiping storage media that are not too sensitive,[38] whereas this method is not part of the frequently referenced DIN standard:[39]

36

Ibid., pp. 38 f. Reardon explains that, for example, in magnetic storage media, a binary position (i.e. the digit encoding 0 or 1) is constituted by numerous analog charges. Thus, although a majority of the magnetic charges are altered when overwritten, it is still possible for some information about the previous charge to be revealed. With modern hard disk drives, however, this is less of a problem due to the density of the data.

37

Michael Cross, *Scene of the Cybercrime*, Burlington, 2008, p. 343.

38

In relation to the United States, the DoD 5220.22-M standard is often referenced by ABS, among others. However, this is a comprehensive manual issued by the National Industrial Security Program (NISP) to specify how companies should handle classified material. The National Institute of Standards and Technology (NIST), on the other hand, describes the technical procedure for overwriting storage media in order to comply with security and confidentiality classifications. Even here, however, overwriting is not considered a secure method.

39

See Kissel 2006, p. 12.

Fig. 5

"Destruction of storage media"
Process in which the physical form or condition of storage media is altered,
| Fig. 6 | *usually by shredding, dissolving, melting, heating or incineration*[40]

Companies Follow Norms as Well as Their Own Logic

As the case studies at the beginning have shown, reference to the industry standard plays only a partial role. The state actors have developed their own processes for destruction, as has the military, which incinerates the data carriers—and is thus well within the specifications of DIN 66933, which also provides for melting down as a form of destruction worthy of the highest security level—but does not explicitly refer to the standard. Even the University Hospital only provides for certified destruction of some of the hard drives; a smaller, manageable number are drilled into. This has nothing to do with outdated methods, but instead with pragmatically suiting the logic of the company.

ABS overwrites its hard disks and continues to use the devices after verifying that the process has been completed. In an interview, the head of the Digital Forensics Department of the Zurich Cantonal Police pointed out that a simple overwrite would make it practically impossible to recover the data. A magnetic storage medium only has to be overwritten once with random values, and then it is no longer possible to draw conclusions about what was originally stored, he said. This is particularly the case with newer storage media, as their data is stored in a particularly dense manner. Multiple overwriting is overstated and stems from the technical requirements of the 1990s, he said.

The fact that physical destruction is usually preferred in practice, including for police work with sensitive storage media, has to do with its feasibility. Overwriting hard disks and thoroughly verifying the completed process would take too much time and hardly bring any added value, he explained.[41]

| Fig. 7 |

The Cultural Dimension of Sanitization

Storage media are discarded by companies during cycles of maintenance and renewal or when they become defective, and thus, as operational scrap, represent nothing more than waste. In her ethnographic study on the shredder, cultural scholar Sophia Booz describes the possibility of causing damage with this waste as data potential. What is important, she says, is "that it is not a question of whether the possibilities and dangers represented by data are or can actually be realized, but that they exist as a general possibility."[42]

40

Normenausschuss Informations-
technik und Anwendungen (NIA)
in DIN: *DIN 66399-1:2012-10, Büro-
und Datentechnik – Vernichten
von Datenträgern – Teil 1: Grund-
lagen und Begriffe*, Berlin, 2012,
p. 4. The ISO standard adopts the
DIN specifications 1:1.

41

Interview with Steffen Görlich by
Sascha Deboni, October 8, 2019.

42

See Booz 2018, p. 139.

Fig. 6

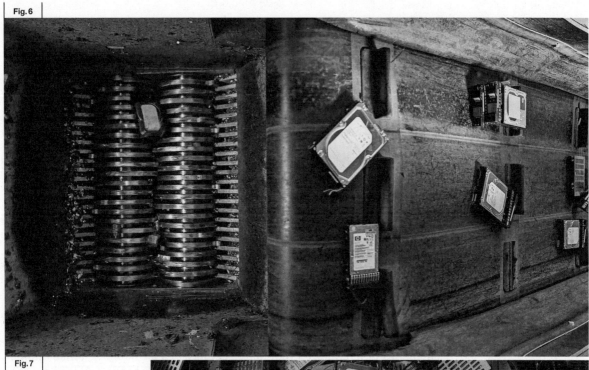

Fig. 7

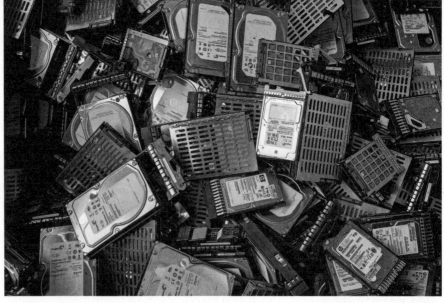

This potential needs to be regulated. The mechanisms that regulate the handling of data and storage media that store potentially sensitive data function as ordering acts. The actors can be norms and certificates that give a contractual dimension to the social and cultural potential of the act of destruction in the interest of a common understanding of security.[43]

The fact that this regulation of the problem also contains a productive component is suggested by the term that describes the methods of managing the danger posed by the data: "sanitization" refers to this ordering act. In the case of hard disk sanitization, it means the complete erasure of the storage media and thus the removal of all traces of information. The process of erasure is also known as wiping. Both terms originated in the realm of cleaning and hygiene. While "wiping" is essentially a synonym for "cleaning," "sanitizing" refers more to disinfecting.

If these operations are not carried out or are carried out poorly, the companies' scrap remains potentially dangerous. The internal protocols or even the referenced norms therefore clearly regulate technical requirements and processes and thus resemble a ritual that has the function of creating order through regulated action.[44] To quote ethnologist Mary Douglas: "As we know it, dirt is essentially disorder.... Eliminating it is not a negative movement, but a positive effort to organise the environment."[45] In this case, the ritual prevents the possibility of misuse or eliminates the risk of harm by letting potentially secret data fall into the wrong hands.[46]

The ritual of order is based on technologies of disorder. As we have seen, the mechanical destruction of storage media suffices by itself in practice. Destruction by a shredder reduces whole, robust hard disks to metal granules. In doing so, the shredder functions as a machine that not only uses brute force for physical destruction, but that also creates security through a sensual experience. Shredders, on the one hand, make noise—noise that stands for destruction and thus conveys security as a sensory impression. The fact that destruction produces noise is also suggested by the sounds that Apple's operating system makes: when files are deleted and the virtual recycle bin emptied, a sound is made that ostensibly gives the impression of destruction.[47] On the other hand, the product of the shredder is visually and haptically tangible.[48] The granules of a previously complex, fragile hard drive suggest its irreversible destruction in an impressive and tangible way.

| Fig. 8 |

43

Ibid., p. 137. Booz writes in Chapter 4 about "the destruction of files as an act of creating order" and goes into detail about how the destruction of files (mainly paper files in her case) is already preceded by an ordering through classification. The destruction is ultimately the finalization of this act of ordering.

44

See Mary Douglas, *Purity and Danger: An Analysis of Concepts of Pollution and Taboo* (Abingdon-on-Thames, 1966; here, Milton Park, 2002), p. 86.

45

Ibid., p. 2.

46

Ibid., pp. 119 f. Douglas explains that disorder contains the potential for both danger and power in relation to the ordered state. The danger seems clear in our example, but the power is the basis for order in the purification process.

Fig. 8

Purification Rituals in Accordance With Company Logic

Even if the digital information on each medium exists only as a bitstream and is thus not readily intelligible, access to and the possibility of reconstructing the encoded data must be excluded. In this respect, the digital storage media that are discarded represent disorder. As the terms used to describe the processes of irreversible deletion suggest, the processes of removing this disorder are social and cultural purification rituals in the tradition of Mary Douglas: the data potential of the carriers is eliminated and order is restored.

Standards bureaus provide meticulous descriptions of these processes to ensure safe destruction. The way the cases presented deal with them in practice demonstrates that these standards are only sometimes applied. They are particularly applicable in cases where the destruction is outsourced and the standard provides a contractually regulated promise.

Shredders then break up the storage media into particles of precisely defined sizes. For other situations, industrial destruction is practically impossible, in which case the fragile storage media are drilled through, the traces of the bitstream destroyed in rustic handcraft and thus directly obliterated. The VBS consigns the storage media to fire, while the big banks, on the other hand, shroud their processes in secrecy and provide no information.

Thus, the destruction also reflects varying logical approaches to security. In the cases discussed, however, it emerged that for highly sensitive storage media, the cleaning process ultimately entails physical destruction. Information is, in this sense, only apparently virtual. According to Douglas, the purification ritual functions through being able to experience it sensually. Machines, processes, and the methods of destruction aim to tangibly tear up digital media. The immediacy of the experience, to end with Booz, satisfies the need for security.

Acknowledgments

The infrastructures of maintaining and destroying sensitive data are kept under lock and key. To find out about them, we were dependent on the generous support of a number of professionals willing to share their insights, for facilitating site visits, and for their patient cooperation during interviews. We'd like to thank Martin Blumenstein, head of the Documentation and Archival Systems at SRF. An interview with him triggered our interest in long-term storage and provided some core input. A tour through the Swisscom Data Center in Wankdorf, guided by Ruedi Anker, first introduced us to their destruction machine in the cellar. Bruno Röschli, head of Reisswolf in Zurich, provided further information on the procedures of shredding, as did Erik Dinkel, chief information security officer at the University Hospital Zurich. We'd also like to extend our thanks to two experts from the Swiss Federal Archives—Krystyna Ohnesorge, head of the Information Preservation Division, and Stefan Kwasnitza, deputy director—as well as Steffen Göhrlich, head of the Digital Forensics Department of the Zurich Cantonal Police.

47

See Sophia Booz, "Die Sinnlichkeit der Zerstörung. Zur Vernichtung von Daten und Datenträgern," in *Kulturen der Sinne. Zugänge zur Sensualität der sozialen Welt*, ed. Claus-Marco Dieterich, Thomas Hengartner, Bernhard Tschofen, and Karl Braun, Würzburg, 2017, pp. 392–98, esp. pp.395 f.

48

See Booz 2018, p. 75.

Long-term Storage

Andrés Villa-Torres

While digital information can travel at the speed of light, it is not produced, stored, maintained, or accessed as fast. It requires time and resources in order to be preserved and to be made accessible. Much like sanitization and destruction—the reverse operation—digital storage and data preservation are in continual need of care, which translates into a continuous flow of resources.

The archives at the Swiss National Radio and Television Broadcasting Company (SRF) provide insight into the complexity of data storage practices. There, the shift toward digital file-based systems not only has required a radical overhaul of storage infrastructures and logistics; it has also entailed considerable efforts regarding the digitization of video and audio materials. These previously have been recorded and produced through analog means and stored in their original medium such as 16 mm film, Betamax cassettes, magnetic audio tape and so on, all of which has until recently been kept physically at the SRF archive for preservation as well as for research and production purposes. (Some material still is because of its outstanding analog quality—16 mm film, for example.) In 2009, SRF began a digitization process (estimated to be completed in 2022). Currently, the SRF thus produces thousands of hours of broadcast video and audio information which is also automatically reproduced (copied), stored, and made available online daily through an almost fully automated multilayer storage system.

At its core, the archival machine at the SRF consists of a server room plus a hard disk system, a robotic magnetic tape system and a magnetic tape system backup, which is located in a separate, secured room. Both facilities are maintained remotely: they're inhabited exclusively by machines. Humans rarely need to enter these spaces; they would only do so in case of damage or for transferring material into the permanent archive. The archive, then, comes with its own timescales. Indeed, in cases of rarely used or otherwise peculiar data, a request in the online search engine becomes physically manifest through the response time, or rather the delivery time of the desired storage medium. This delivery time essentially equals the period of time that the robotic device requires to travel within an eight-cubic-meter space, search for a cassette, and pick it up, plus the time the robot arm requires to return it to one of the eight drives that are able to read the tape at a speed of 250 megabytes per second.

Fig. 9

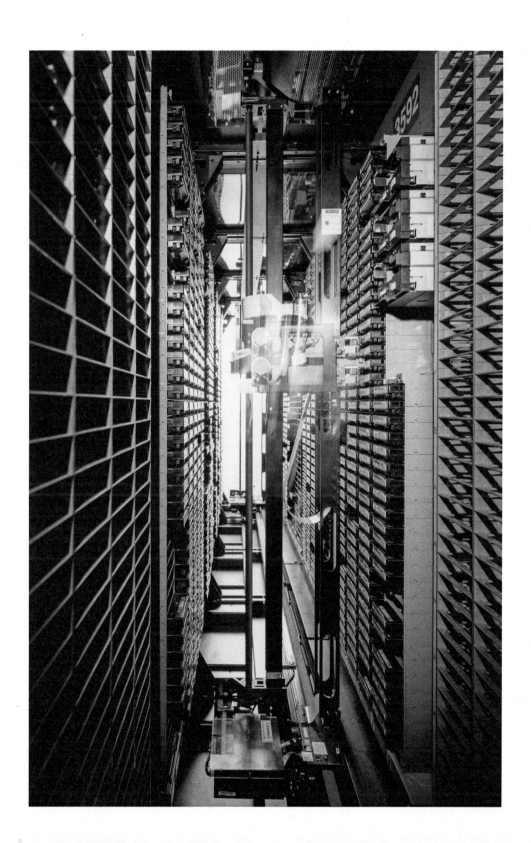

**Altdorf
Shanghai
Shenzhen
Liebefeld**

**Swiss-Chinese
Entanglements
in Digital
Infrastructures**

Lena Kaufmann

**Photos by
Marc Latzel**

There seemed to be only one main road. Stepping off the train in Altdorf, we found ourselves in a small town in the middle of Switzerland, at the southeasternmost tip of Lake Lucerne, surrounded by mountains. We took a bus, and after some bends in the road, the screen finally showed "Dätwyler AG"—the cable producer we planned to visit. Next to the bus stop were a couple of flat, gray workshop and office buildings. Just beside them, cows were grazing, and behind the buildings the steep, forested foot of a mountain emerged. Once inside the factory, we heard the constant humming and buzzing of the machines. They seemed to be operating autonomously, although under cautious human observation. Only occasionally, a worker would halt them to start a new strand of cables, carefully adapting the machine to the right speed and distance, ensuring that the different parts that would form a specific fiber optic cable would fit well. To protect the fibers, the fiber optic cable part of the factory was warmer than the other parts, and the light shirts of the workers stood in contrast to their heavy black work shoes.

For the workers, many of whom come from other countries, such as Turkey or Croatia, the shift work in the factory is an integral part of their everyday lives in Switzerland. At the same time, people outside of Altdorf seem to be barely aware of the existence of this rather unexciting factory. Nevertheless, much of the Internet traffic in Switzerland actually passes through and depends on the cables produced there. For example, several thick strands of Dätwyler cables run through the Milchbuck tunnel in Zurich, forming the backbone of the city's telecommunications network. The cables are a crucial component for enabling digitalization in the first place. What is more, they are also an important component of Switzerland's intricate global digital connections.

Making raw fibers is technically most demanding and is currently not done in Switzerland.[1] However, the production of fiber optic cables is not an easy enterprise either. As several Dätwyler employees explained, the complex and lengthy process of manufacturing fiber optic cables includes coloring the raw fibers, producing a thin colored cable containing twelve or twenty-four fibers, and stranding a number of these thin cables into even thicker cables that may contain up to 500 fibers. In the process, it is important to handle the delicate fibers carefully as well as to let them rest after each step in production. Twisting the fibers too much breaks them, and touching them with bare hands deeply affects their transmission capacity. Moreover, the different colors are of particular importance. During the production process, they make it possible to trace back the origin of each individual fiber. Later, when the cables are laid and connected, the colors allow techni-

1

Fiber optics or optical fibers commonly consist of a glass core that guides the light and a surrounding glass cladding that prevents the light from leaking. There are different processes for making the fibers. These include producing a preform from fused silica glass in an initial step. This preform contains both core and cladding. In a second step, the preform is heated and fibers are drawn away from it. The biggest challenge is making the preform. Further challenges are achieving the extreme transpar- ency required for communication as well as making thin, uniform fibers. See Jeff Hecht, *Understanding Fiber Optics*, 5th ed. Auburndale, MA, 2017, pp. 125–37. To serve as media for telecommunications, the raw fibers have to be transformed into proper cables.

cians to differentiate between the up to 500 fibers and ensure that the data passing through these cables will find their correct destination. Accordingly, producing a fiber optic cable takes between four and six weeks.[2]

Not only that, many of these cables are customized products, meaning that they cannot be produced ahead of orders and kept in stock. The cables have to meet the requirements of specific customers. These include practical and technical issues: for example, whether a cable runs parallel to a high-voltage installation up in the air, undersea, or alongside tremoring train tracks; whether it is round, passing through ducts, or flat, serving elevators; whether it has to be fireproof or is buried directly in the ground; and whether it connects continents, data centers, or individual households. Different customers have different quality and color-code expectations. In addition, political and competition requirements may apply.[3] For example, Switzerland's fiber-to-the-home network, in which partly state-owned Swisscom is the main player, is based on the so-called four-fiber model. Other countries have different models.[4] Finally, the fiber optic industry is particularly dynamic. Not only do the raw fibers keep changing—by becoming thinner, for example—but the development of the other components that make up a fiber optic network is also a continuous process.[5]

These other network components are also called active or opto-electronic components. They are powered components that can manipulate signals, for example by controlling the intensity of light or by amplifying the signal strength in order to enhance data transfer. Moreover, they can convert signals, when linking fiber optics to other communications infrastructures such as wireless networks or copper wires.[6] In the 1980s and '90s, the global centers of fiber optic and component research were the United States and Japan in particular, and to some extent Western Europe (especially the United Kingdom, France, and West Germany).[7] However, in the past two decades, Chinese companies such as ZTE and Huawei Technologies have become serious competitors, challenging the world order of the fiber optics industry.[8] The latter company has gained a strong foothold in Switzerland, where it cooperates with numerous companies, including with Dätwyler Cabling in the area of data centers.[9]

2

Dätwyler factory workers, personal interviews and observations, April 29, 2019 and October 14, 2019. All the translations of written and oral (Swiss) German sources in this chapter are by the author.

3

Ibid.

4

See Gabriela Weiss, "Glasfaserausbau kostet 20 Prozent zu viel," *Neue Zürcher Zeitung* (September 1, 2011), https://www.nzz.ch/glasfaserausbau_kostet_20_prozent_zu_viel-1.9032095 (retrieved December 12, 2019).

5

Dätwyler factory workers, personal interviews and observations, April 29, 2019 and October 14, 2019.

6

See Hecht 2017, p. 33.

7

IGI Consulting, *China Telecom Volume 2: Fiber Optics Markets and Opportunities*, Boston, MA, 2001, p. 101.

8

See, for example, Perez Bien, "Under Siege, Chinese Telecoms Gear Champions Huawei and ZTE Pitch 5G Plans at MWC Barcelona," *South China Morning Post* (February 26, 2019), https://www.scmp.com/tech/gear/article/2187700/under-siege-chinese-telecoms-gear-champions-huawei-and-zte-pitch-5g-plans (retrieved December 12, 2019).

Meanwhile, Dätwyler has also become an established cable producer in China, where it has equipped numerous flagship sites and institutions with cables, such as Shanghai's Oriental Pearl Tower, major airports, a Communist Party school and a Huawei data center.[10] Like an emblem of its intimate connection to China, a model of the Chinese Dätwyler factory now furnishes the entrance of the company's showroom in Altdorf.

Taken together, Dätwyler's and Huawei's Swiss-Chinese trajectories exemplarily challenge established ideas about the presumed global centers of modernity, of a one-way technology transfer from West to East, and of confining a given technology to the boundaries of a single nation. A closer look also highlights some of the everyday people behind the seemingly technical digital infrastructures and their global entanglement.

While economic relations between Switzerland and China can be traced back to the seventeenth century, these relations have entered a new dimension in the past three decades. Since the 1990s, the two countries have become deeply entangled in the field of digital infrastructures. This was the time when the Internet went commercial and grew exponentially, when globalization became a buzzword, and many North American, Japanese, and Western European companies greatly expanded their production activities abroad in fierce competition. They were grappling with overproduction, labor shortages, rising wages, and falling market prices at home as well as rising production costs in once-popular overseas locations such as Taiwan, Hong Kong, Singapore, and South Korea. In the 1980s and '90s, the People's Republic of China (PRC) became the new place to go. Under the leadership of Deng Xiaoping, the country had just undergone a decade of reform and opening up. It was moving rapidly from a planned, collective economy toward a market economy, eager to attract foreign capital, technology and know-how in order to catch up economically and regain a place in the global market.[11]

Since the founding of the PRC in 1949, importing foreign technology and adapting it to make a new Chinese version has been an important way of creating an ostensibly modern and industrialized China.[12] Information and communications technology (ICT) in particular was a key part of this strategy. ICT was central to the process of opening up, receiving special attention, and earning policy support in China.[13] Foreign producers, in turn, felt especially attracted by the PRC's new favorable investment policies on the one hand, and the immense number of cheap rural migrant laborers on the other hand.[14]

The 1990s were also the time when a global fiber optics industry emerged, paving the road for fiber optics to become the back-

9

Johannes Müller, Dätwyler Cabling, personal interview, April 29, 2019.

10

Ibid. Dätwyler Cabling Solutions, "Reference Projects & Case Studies: China," https://www.cabling.datwyler.com/en/reference-projects.html (retrieved January 24, 2020).

11

See Martin Hart-Landsberg, Capitalist Globalization: Consequences, Resistance, and Alternatives, New York, 2013, pp. 15–16; Maurice Meisner, Mao's China and After: A History of the People's Republic, 3rd ed., New York, 1999, pp. 449–520.

12

See, for example, Sigrid Schmalzer, Red Revolution, Green Revolution: Scientific Farming in Socialist China, Chicago, 2016; TU Berlin, Center for Cultural Studies on Science and Technology in China, "DFG-Projekt 'Making Technology Appropriate: Technology Transfer from Germany to China. The Case of Steam and Ordnance Technologies, 1860–1980,'" 2019, http://www.china.tu-berlin.de/menue/forschung/projekte/making_technology_appropriate/ (retrieved December 12, 2019); In the 1950s, the import of Soviet

bone of digitalization. Research on fiber optics goes back several decades. The development of the laser in 1960 had made it worthwhile to give fiber optics a second look as transmission media. In the 1970s and '80s, the thin, transparent glass fibers finally achieved the necessary purity, transmission capacity, and affordability to be used for wide-scale communication. In contrast to the older copper telecommunications networks, the advantage of fiber optics is that they can transmit large amounts of information at high speed and over long distances. Instead of electrical signals, they use optical signals, in the form of light.[15] In the 1990s, the growth of the Internet and the unquenchable thirst for ever more bandwidth gave this technology new importance.[16] Accordingly, a whole industry grew around this medium, ranging from the production of preforms, raw fibers, cables, plugs, and racks, to laser and LED transmitters, connectors, amplifiers, receivers, and testing machines.[17]

The most successful raw fiber producers were American and Japanese companies. Engaged in a head-to-head race with Japanese companies, the US enterprises were highly concerned about losing their dominant position in the industry. As a US industry report from 1985 notes: "The Japanese, in particular, are aggressively seeking business around the world"[18]—reminding us of similar remarks currently being made in the US about Chinese ICT companies. The major international raw fiber producers were AT&T and Corning in the US, as well as a range of Japanese companies, including Sumimoto Electric, Fujikura, and Furukawa Electric. The latter two were also among the biggest cable manufacturers, along with Siecor, a former joint venture between the German firm Siemens and Corning.[19] Around the same time, commercial fiber optic production also began in other parts of the world, including in Switzerland. Among these producers was, for example, STR, a subsidy of ITT—names that are now forgotten. Dätwyler, in contrast, flourished.

Dätwyler: From Altdorf to Taicang

Even though Swiss economists and policy-makers might regret that Switzerland does not have its own Silicon Valley, medium-sized companies such as Dätwyler nevertheless play an important, though overlooked, role in the making of a global digital Switzerland. Similar to the big

13

technologies was crucial for triggering the development of the Chinese electronic industry. Yun Wen, "The Rise of Chinese Transnational ICT Corporations: The Case of Huawei," Vancouver, 2017), pp. 48–50.

14

Yu Hong, "Distinctive Characteristics of China's Path of ICT Development: A Critical Analysis of Chinese Developmental Strategies in Light of the Eastern Asian Model," 2008, pp. 457–59.

See Hart-Landsberg 2013, pp. 15–16; Hong 2008, pp. 457–59.

15

See Jeff Hecht, *City of Light: The Story of Fiber Optics*, New York, 1999; Hecht 2017. According to Hecht, the idea behind fiber optics has its origins in the nineteenth century, when similar technologies were used to guide light for illumination and for seeing inside the human body.

16

Hecht 2017, p. 6, p. 11.

17

See also Timothy C. Finton and US Department of Commerce, "A Competitive Assessment of the US Fiber Optics Industry," *Fiber and Integrated Optics* 5, no. 4 (1986), p. 332, pp. 338–41.

18

Ibid., p. 352.

19

Ibid., p. 332, pp. 338–41, pp. 355–57; See also Hecht 1999; Office of Industries, US International Trade Commission, *Industry & Trade Summary: Optical Fiber, Cable and Bundles*, Washington, DC, 1995, pp. 5–6.

US and Japanese cable manufacturers, the Swiss company Dätwyler Cabling Solutions is able to look back on more than a century since its founding. The company has its roots in Draht- und Gummiwerke AG in Altdorf, in the Canton of Uri. In 1915, Adolf Dätwyler (1883–1958), the son of a farmer from Aargau, became its director. He saved the company from bankruptcy, bought it, and later renamed it Dätwyler AG. In 1926, the company, which had specialized in wire and gum, began producing its first telephone cables. It successively added other types of products to its production portfolio, from automotive and pharmaceutical products to food packaging and various types of cables. After several trials and field tests in the early 1980s,[20] the Dätwyler company began producing fiber optic cables commercially. This was in 1986, when the global fiber industry emerged—along with a few other Swiss companies such as cable manufacturer Huber+Suhner AG and raw fiber producer Cabloptic S.A.[21] The Dätwyler company produced fiber optic cables for both private and public communications networks in Switzerland, including for the Postal Telegraph and Telephone, PTT. It did not succeed at raw fiber production, however. A raw fiber factory in Neuchâtel, which Dätwyler once purchased, was eventually sold. Instead, the company turned to importing fibers from the American company Corning.[22]

 The production of fiber optic cables was already under the management of Adolf Dätwyler's sons, Peter (1926–1993) and Max Dätwyler (b. 1929). The two brothers, an engineer and a chemist respectively, assumed control of the company in 1958 and transformed it into a holding. They took the first steps abroad, making Dätwyler a global company. Both of them had received part of their professional training in the United States. Having first broadened their own horizons overseas, they set out to expand the company's activities across the globe in the late 1960s.[23] This was, as a company report states, "[i]n view of the very tight labor market in Switzerland and the uncertainty regarding what Switzerland would face with the establishment of the European Economic Community." [24] The brothers therefore first turned to Europe and

20

See PTT Archive in Köniz, file P-15-2.

21

Dätwyler Cabling Solutions, "100 Jahre Dätwyler," 2019, https://www.cabling.datwyler.com/de/unternehmen/wir-ueber-uns/100-jahre-daetwyler/100-jahre-daetwyler.html (retrieved December 12, 2019); Huber+Suhner AG, "Geschäftsbericht 1979," Pfäffikon/Herisau, 1980, University of Zurich, Zentrale für Wirtschaftsdokumentation. Cabloptic S.A. in Cortaillod near Neuchâtel was a joint venture of the three cable plants

Brugg, Cortaillod, and Cossonay. By the late 1970s, it was already engaging in raw fiber production, supported by a license agreement with Corning. Rudolf Trachsel, *Ein halbes Jahrhundert Telekommunikation in der Schweiz*, Aarau, 1993, p. 322; Hans Ulrich Dätwyler, e-mail conversation, March 1, 2020. Kabelwerke Brugg was founded towards the end of the nineteenth century by Gottlieb Suhner as a branch of his company Suhner & Co. AG. The

latter later became part of Huber+Suhner. Brugg became officially independent in 1991. Andreas Steigmeier, "Kabelwerke Brugg," in *Historisches Lexikon der Schweiz*, 2011, https://hls-dhs-dss.ch/articles/043147/2011-08-24/; Thomas Fuchs, "Huber+Suhner," in *Historisches Lexikon der Schweiz*, 2019, https://hls-dhs-dss.ch/articles/041909/2019-07-12/.

22

Johannes Müller, personal interview, April 29, 2019.

23

Hans Stadler, "Adolf Dätwyler," in *Historisches Lexikon der Schweiz*, 2005, http://www.hls-dhs-dss.ch/textes/d/D30538.php; Dätwyler, "100 Jahre!: Dätwyler Holding AG," 2019, https://www.datwyler.com/de/unternehmen/100-jahre/ (retrieved December 12, 2019); Dätwyler Cabling Solutions, "100 Jahre Dätwyler;" Christoph Zurfluh, "Max Dätwyler wird 90," *Luzerner Zeitung* (January 26, 2019), https://www.luzernerzeitung.ch/zentralschweiz/uri/das-leben-ist-ein-grosses-abenteuer-ld.1088274 (retrieved December 12, 2019).

24

Dätwyler Holding AG, "Geschäftsbericht 1989/90," Altdorf, 1990, p. 8, Swiss Economic Archive, Basel.

bought a gum factory in the Netherlands. In 1970, they founded a steel factory in Bottrop, West Germany. In the mid-1970s, parts of the Dutch factory were moved to Belgium, and later expanded to Italy and the United States. Numerous other moves of the various company segments followed. One of the first activities in Asia was gum production in Thailand. Meanwhile, the first sales activities of technical equipment as well as pharmaceuticals targeted Hong Kong and Taiwan as well as Indonesia.[25] As of today, the Dätwyler Holding AG has more than 9,000 employees worldwide, 2,300 of whom are in China.[26]

Not until the early 1990s did the cable business move abroad as well. In 2012, it became a private sister company called Dätwyler Cabling Solutions AG, which now has about 1,000 employees. The first Asian representative offices were opened in Singapore and Jakarta. In the late 1990s, the actual production of cables started in the PRC.[27] As Johannes Müller, CEO of Dätwyler's cable business since 2013, states, market entry in China was based on the company's premise that "[production in] China is for China," because reimporting cables to Europe would not be competitive. The strategy of producing in and for the PRC has resulted in a revenue from China that constitutes almost one third of the entire company revenue worldwide. Johannes Müller himself has traveled to China about eighty times, where he even shook hands with Chinese president Xi Jinping.[28]

The person who established the Chinese premises amidst the excitement in the 1990s at globalization and fiber optics was Hans Ulrich Dätwyler, a distant relative of the Dätwyler company. According to him, the China story of Dätwyler Cabling unfolded along two paths. First, then CEO Robert Lombardini attended a seminar organized by the Swiss Office of Commercial Expansion (today Switzerland Global Enterprise), which convinced him to expand to the PRC. Mr. Lombardini thus established a project group that was to evaluate the feasibility of a Sino-Swiss joint venture. Hans Ulrich Dätwyler led the group. Assisted by the audit and advisory firm KPMG and the Swiss-Chinese Chamber of Commerce, the group received a thick folder containing a preselection of potential partners among the cable factories in China. From these, they selected and visited five factories near Shanghai in 1996 and '97.[29]

At that point, there were approximately 120 Chinese optical cable manufacturers in the PRC.[30] These entered the fiber optic industry around the same time as companies elsewhere. However, compared to their global competitors, they often lacked longstanding experience in glasswork or cable manufacturing, and the industry initially faced some difficulties. Research and trial production of fiber manufacturing in China began in the 1970s, i.e. in

25

Dätwyler Holding AG 1990, pp. 8–9, p. 37; Dätwyler Holding AG, "Geschäftsbericht 1994," Altdorf, 1995, pp. 12–13, Swiss Economic Archive, Basel; Dätwyler Holding AG, "Geschäftsbericht 1996," Altdorf, 1997, pp. 12–13, Swiss Economic Archive, Basel.

26

Stadler 2005; Dätwyler 2019.

27

Dätwyler Holding AG 1990, pp. 8–9, p. 37; Dätwyler Holding AG 1995, pp. 12–13; Dätwyler Holding AG 1997, pp. 12–13.

28

Johannes Müller, personal interview, April 29, 2019. Dätwyler Cabling Solutions, "Meeting with Chinese President: Datwyler Invited to Join in the Discussions," January 24, 2017, https://www.cabling.datwyler.com/company/news/detail-view/article/meeting-with-chinese-president.html (retrieved December 12, 2019).

Fig. 1

Color-coded optical fiber strands.

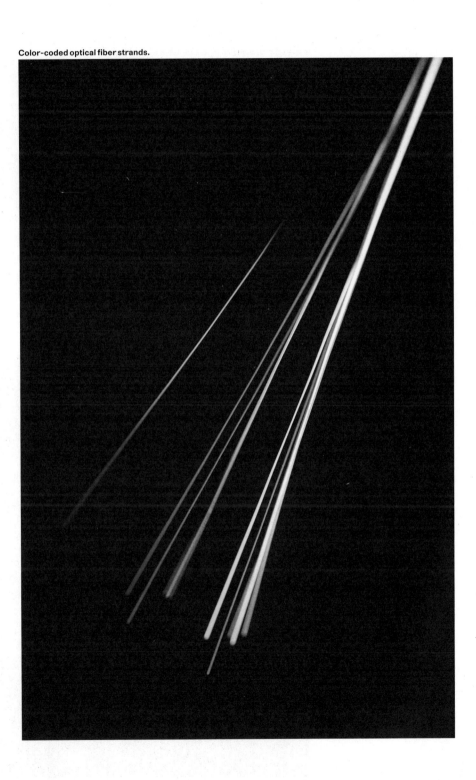

Fig. 2

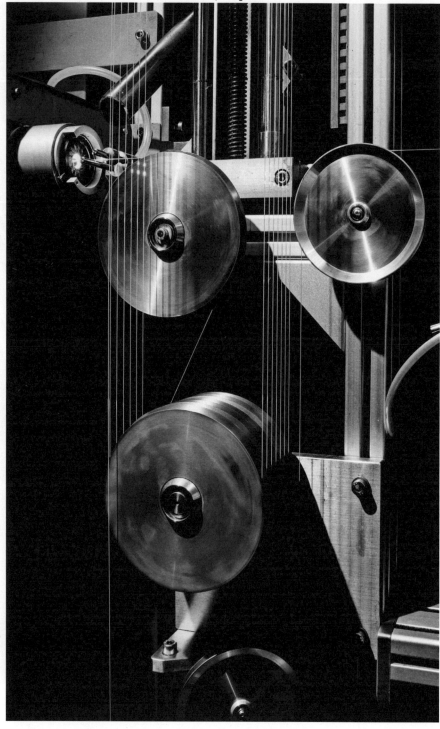

Fiber strands come color-coded in twelve basic colors, here green.

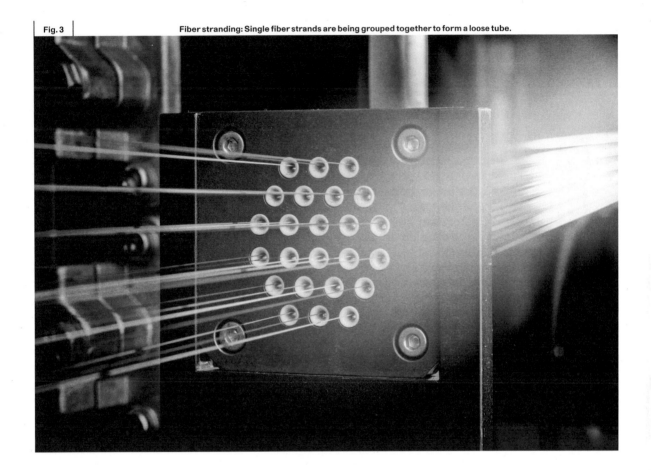

Fig. 3 Fiber stranding: Single fiber strands are being grouped together to form a loose tube.

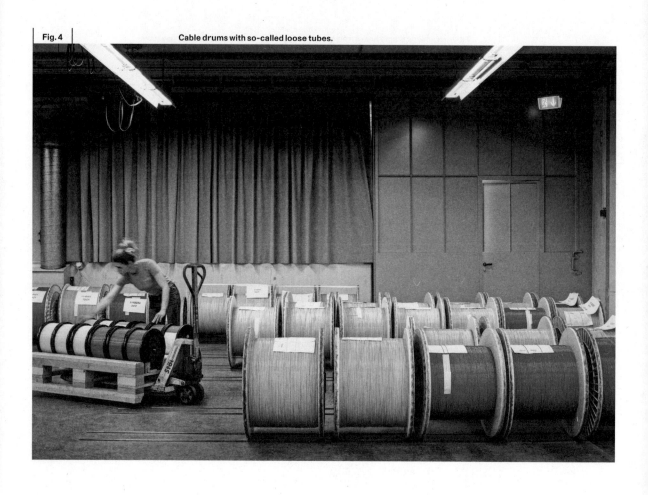

Fig. 4 Cable drums with so-called loose tubes.

the final years of the socialist era under Mao Zedong. From then until 1988, to jump-start the industry, ten still mostly state-owned Chinese companies imported optical fiber manufacturing equipment from Finland, the UK, France, Germany, and the United States. These Chinese companies mostly failed, however. Among the survivors were joint ventures with Fujikura of Japan, Lucent Technologies (spun off from AT&T), and the Dutch firm Philips. The other companies succumbed to a lack of funding and lacking complementary industries. Moreover, they resigned from making fiber optics because of the high cost of acquiring technology and know-how, especially with regard to the most challenging part of fiber production, i.e. preform manufacturing. Subsequently, some of them turned to producing fiber optic cables instead of raw fibers. Like Dätwyler, they, too, imported most of their preforms or fibers from Corning.[31] The Chinese cable companies, however, expanded their production know-how in steps, first with regard to fiber and then to preform production. Subsequently, by the mid-2000s, the Chinese fiber optics and cable industry had become one of the largest in the world[32], and now, the PRC can be considered a third center of preform production, on a par with the United States and Japan.[33]

In the 1980s and '90s, the situation was still different, however, and foreign technical know-how was in high demand. One of the Chinese cable companies that emerged out of this context and that made its way onto the Dätwyler shortlist was Zhongtian Cable Co., Ltd. (now part of the Jiangsu Zhongtian Technology Group, ZTT). The choice was rather intuitive, says Hans Ulrich Dätwyler.[34] Nevertheless, on January 28, 1998, the two companies officially created a joint venture[35] and it was through Zhongtian that Dätwyler managed to enter the Chinese cable market. As Hans Ulrich Dätwyler remembers, what seemed to be close to Shanghai on the map, however, was actually worlds apart. Zhongtian was located in Rudong, a town in the countryside of China's Jiangsu Province, north of Shanghai. When he traveled there for the first time in 1996 to meet his partner, Zhongtian's President Xu, the trip

29

Hans Ulrich Dätwyler, personal interview, September 17, 2019. Karl Lüönd and Christoph Zurfluh, *Die Kraft der unscheinbaren Dinge: 100 Jahre Dätwyler*, Zürich, 2015, pp. 189–90.

30

IGI Consulting, *China Telecom Volume 2: Fiber Optics Markets and Opportunities*, Boston, MA, 2001, p. 101.

31

IGI Consulting 2001, pp. 101–07; Xiaolan Fu, *China's Path to Innovation*, Cambridge, 2015, pp. 242–43. Contemporary China's biggest preform, fiber and cable company, YFOC (Yangtze Optical Fiber and Cable Co., Ltd.), which now ranks second globally after Corning, has its origins in this joint venture with Philips, formerly called Wuhan Changfei. IGI Consulting 2001, p. 132; Network Telecom Research Institute, "The Top 10 Competi-

tiveness Enterprises in the Optical Communications Industry of China & Global Market in 2019," 2019, http://list.nti.news/ (retrieved December 12, 2019).

32

IGI Consulting 2001, pp. 101–7; Fu 2015, pp. 242–43.

33

Research and Markets, "Global & Chinese Optical Fiber Preform Industry Report, 2019–2025," August 2019, https://www.researchandmarkets.com/reports/4832645 (retrieved December 12, 2019). Nevertheless, the quality of Chinese fibers and cables was thus far unconvincing to my Swiss interview partners. Various interviews with Swiss fiber optics industry experts between March and November 2019.

34

Hans Ulrich Dätwyler, personal interview, September 17, 2019.

35

Feng Gao 高峰, "陇上行——中天德特威勒有限公司周年庆典纪实 Long shang xing——Zhongtian Deteweile youxian gongsi zhounian yingdian jishi (Walking on the Ridge: Zhongtian Dätwyler Co., Ltd. Anniversary Celebration Documentary)," 上海微型计算机 *Shanghai Computer Weekly* 185, no. 09 (1999), p. 10.

seemed adventurous to him. He had to travel 200 kilometers north from Shanghai to Rudong. Accompanied by lots of chickens, he had to cross Asia's longest river, the Yangtze, by boat. According to Hans Ulrich Dätwyler, when he arrived, many of the locals greeted him with astonishment. It seemed to him that it was the first time they had met a Westerner: "People looked at us as if we were extraterrestrials." [36]

The delegation was accompanied by two key individuals, Mrs. Sui, a professor from Peking University, and China expert and lawyer Esther Nägeli of the Chamber of Commerce's legal chapter. Both were crucial confidants who gave legal and intercultural advice to the negotiators. According to Hans Ulrich Dätwyler, this was important, as the negotiations were not easy. Initially, written contracts did not seem to mean much to their Chinese counterpart, who kept changing the terms every other day. On both sides, there was a lot of mistrust that had to be reduced. One way to build up trust was to eat and drink with the Chinese company employees and the local Party secretary. Pointing to a photo that shows him making a toast, he recalls, "I never had to drink so much [alcohol] in my life!"—a common way of forging business relations in the PRC. His wife, who joined him in 1998, adds that sometimes they had to eat things like a "red mush" that seemed horrific to them because they were unable to identify what it was and were not accustomed to it. "People wanted to touch us," she remembers. "Almost nobody spoke English, street signs were written only in Chinese, and when we went to the restaurant, we just had to point at something, because the menu was only in Chinese.... We were totally unprepared." [37]

Of course, the Dätwylers were not the first Swiss businesspeople in the telecommunications sector to have such seemingly exotic experiences in East Asia. In 1984, for example, the Standard Telephon und Radio AG newsletter *STR Impuls* printed a similar report by Jens Alder, who established a business in South Korea, calling himself "a product manager on the front." A year later, an export manager wrote a report jokingly entitled "Frog Stomachs, Bear Paws, and Flamingo Steaks." The report described his team's trip to China, where they participated in a telecommunications sales fair in Guangzhou organized by Swisscom. At that time, STR was already producing telecommunications equipment for the Swiss PTT in a joint venture factory in Shanghai. [38] While such experiences from "the front" were quite typical then, what did change was the systematic nature of such entanglements.

In the late 1990s, the second path that led the Dätwylers to the People's Republic was an invitation from the Schindler company, a Swiss producer of elevators. The two companies had previously

36

Hans Ulrich Dätwyler, personal interview, September 17, 2019. Lüönd and Zurfluh, 2015, pp. 189–90.

37

Hans Ulrich and Ursula Dätwyler, personal interview, September 17, 2019.

38

The company was part of the US company ITT (later part of the French Alcatel). STR, *STR Impuls, Hauszeitung der Standard Telephon und Radio AG Zürich* 19, no. 7 (1984); STR, *STR Impuls, Hauszeitung der Standard Telephon und Radio AG Zürich*, April (1985).

39

Johannes Müller, "20 Jahre in China: Erfahrungsbericht von Dätwyler Cabling Solutions AG," *Swiss Export Journal: Fachmagazin der Schweizer Aussenwirtschaft* 2, (2019), pp. 12–13; Schindler, "About Schindler: Company Facts," 2019, https://www.schindler.com/content/com/internet/en/about-schindler/_jcr_content/contentPar/downloadlist/downloadList/19_1461919093155.download.asset.19_1461919093155/schindler-company-facts.pdf (retrieved December 12, 2019); Hans Ulrich Dätwyler, personal interview, September 17, 2019.

collaborated in Switzerland. Schindler had established the first-ever Western industrial joint venture in China in 1980.[39] Dätwyler made use of Schindler's production facilities in the city of Suzhou, near Shanghai, in 1998, where it began manufacturing elevator cables for Schindler. As Hans Ulrich Dätwyler remembers: "We benefited from Schindler in that we had a stable workload from the first day onwards."[40]

Hans Ulrich Dätwyler had never imagined that he would be the one to go to China. At first, the couple did not expect to stay very long, but "three months turned into three years." And, as Mr. Dätwyler asserts, "there were no young people around who were willing to go." His children, in turn, were already grown up and he found the idea exciting, so "I just blundered into it."

While in China, they lived in Shanghai. According to the Dätwyler couple, they did not have a "godparent" who introduced them to the easier, though isolated, expat life. Instead, they lived in a thirty-story apartment building in a Chinese neighborhood. Instead of having a private driver, they traveled in cabs. While he had a Chinese assistant, who interpreted and taught him the necessary cultural details, she regularly met with a language exchange partner and learned from other expat women. When taking a cab, she always took along a card with their Chinese home address in order not to get lost—"because the cab drivers did not understand my pronunciation of the address." In sum, says Ursula Dätwyler, "we were little prepared, but therefore experienced more."[41]

The move to China was arguably a bold one. During the planning phase, Hans Ulrich Dätwyler had met with numerous doubts from the parent company in Altdorf, because establishing a production site in China was a risky endeavor. It was helpful that he soon became the president of the Swiss-Chinese Business Forum (today's Swiss-Cham). That position helped him to network and get to know the expat employees of Swiss companies such as Nestlé, Novartis, Sulzer, and Roche. In addition, talks in front of Chinese Party and economic representatives increased the appreciation given him by the Chinese.[42]

Despite such conduits, however, the move towards the East has not always been easy. For one, the joint venture did not go well, due to conflicting interests: Zhongtian Cable was hoping to gain access to the European market (and later succeeded in Germany),[43] while the Dätwyler management was hoping to enter the Chinese market.[44] The headquarters in Altdorf were impatient and not satisfied with the results. Hans Ulrich Dätwyler had to demonstrate considerable effort at mediation and information to fend off skepticism, especially at home. In his words: "[I]t was almost more time-

40

Quoted in Lüönd and Zurfluh 2015, p. 189.

41

Hans Ulrich and Ursula Dätwyler, personal interview, September 17, 2019.

42

Lüönd and Zurfluh 2015, pp. 189–90.

43

ZTT, "ZTT International Limited," 2019, https://www.zttcable.com/ (retrieved December 12, 2019).

consuming to convince the company management in Switzerland of the correctness of the business in China than to get it going locally." [45]

The company finally took over the joint venture by buying out the Chinese share, and also set up its own factory in Shanghai. [46] The Dätwyler couple recalls how they had to start from scratch at the new location, buying their own folders and pencils and struggling to find staplers. Moreover, there was laundry hanging inside the office, because the migrant workers who constructed it also used it as living space. And when the government suddenly decided to construct a subway line there, the company had to move again. [47] Finally, in 2014, Dätwyler's two Chinese production sites were combined in a new factory in Taicang in the north of Shanghai. [48] By the end of the year 2000, Hans Ulrich Dätwyler had already returned to Switzerland. Looking back on his professional life, he says that "this was certainly one of the most interesting experiences."

While Dätwyler Cabling Solutions successfully entered the Chinese market, technology transfer did not occur in only one direction, of course. Today, different facets of a purported new Chinese modernity are also contributing to making Dätwyler part of a global digital Switzerland. These are occurring on both technical and social levels, whether with regard to specific technical components made in China and used by Dätwyler or with regard to collaborations with Chinese companies. For example, on a technical level, the stabilizing cores—also called "strength members"—of the bigger cables produced in Altdorf are directly imported from China. Two large, black Chinese characters referring to Shanghai Xiao-Bao FRP Co., Ltd. reveal the origin of these strength members, while they wait on bulky wooden reels to be processed on the Altdorf factory floor. [49] In other words, the thick optical cables that contain Chinese cores, American fibers, and Swiss coating technology, produced by workers from southeastern Europe, are thus really a multinational product spanning at least three continents.

On another, more social level, Dätwyler also cooperates with the Chinese firm Huawei, which produces components for networks. Mr. Müller states that Huawei was willing to cooperate with the much smaller Dätwyler Cabling Solutions for several reasons: because Dätwyler already had a Chinese crew, which would ease communication, and because Huawei was interested in establishing long-term relationships; both companies had long-term employees who had been collaborating with each other for years. Finally, he adds, both stand for high quality, and being a Swiss company in China generally works better than being an American one: "it's a question of trust!" [50] Accordingly, the comprehensive data center solutions offered by Dätwyler in

44

Johannes Müller, personal interview, April 29, 2019.

45

Quoted in Lüönd and Zurfluh 2015, p. 190.

46

Johannes Müller, personal interview, April 29, 2019.

47

Hans Ulrich and Ursula Dätwyler, personal interview, September 17, 2019.

48

Müller 2019; Dätwyler Cabling Suzhou, "德特威勒开业典礼成功举办 Deteweile kaiye dianli chenggong juban (Dätwyler Opening Ceremony Successfully Held)," 现代建筑电气 Modern Architecture Electric 5, no. 09 (2014), p. 69.

49

Dätwyler factory workers, personal interviews, and observations, October 14, 2019.

50

Johannes Müller, personal interview, April 29, 2019.

51

Wen 2017, p. 60.

Altdorf today also incorporate crucial Chinese know-how. Some decades ago, when the PRC was just on the verge of opening up, the fact that Chinese technology is now "modernizing" Swiss digital infrastructures would have been unthinkable. Yet companies such as Huawei have by now become an important part of digital Switzerland.

Huawei: From Shenzhen to Liebefeld

In the mid-1980s, around the same time that the fiber optic cable industry was emerging in Switzerland and elsewhere, a range of Chinese ICT companies began to appear as well. These included several enterprises that are now widely familiar, such as Huawei, ZTE, TCL, Lenovo, and Haier.[51] Among these, Huawei in particular has become a key player with regard to globalizing Switzerland's digital infrastructure. It now equips the Switzerland, which is well-known for its ascribed innovative capacity, with a new purported modernity made in China.

This would have been hard to imagine at the time when Huawei Technologies Co., Ltd. was founded in 1987—one year after Dätwyler began producing fiber optic cables in Altdorf. The story of the meteoric rise of Huawei has, by now, been told many times. Former People's Liberation Army engineer Ren Zhengfei founded the company with only six employees in Shenzhen, a city bordering Hong Kong in the southern Chinese province of Guangdong. In 1979, under the new leadership of political reformer Deng Xiaoping, the area became one of the first four Special Economic Zones. Since then, the city on the Pearl River Delta has undergone rapid transformation—from a former fishing village into the putative Silicon Valley of the East. In this special economic zone, private ownership, which had been prohibited in the Mao era, became possible in the high-tech sector in 1987. In the same year, eighty-five ICT companies, including Huawei, were established as so-called "people's enterprises" (renmin qiye). They deeply diversified the landscape of China's hitherto exclusively state-owned enterprises (guoyou qiye). Similar to the Chinese fiber optic companies, Huawei did not initially focus on developing its own components. Instead, the company mainly engaged in the telecom wholesale sector, trading with switches and other equipment.[52]

Over the course of recent decades, this has changed as Huawei has become a global ICT company. This rise is related to a unique framework of domestic and foreign policies. While the Chinese electronics industry had received special support since the founding of the PRC, the foreign firms that were allowed to enter the Chinese market during the period of reform also introduced new challenges to this industry. The result-

52

Ibid., pp. 64–65; Jin Sun 孙琎, "[1987] 华为之兴：如何离冬天远些 [1987] Huawei zhi xing: Ruhe li dongtian yuan xie ([1987] The Flourishing of Huawei: How They Moved Somewhat out of Winter)," 第一财经日报 First Financial Daily, September 30, 2007, http://finance.sina.com.cn/ chanjing/b/20070930/10514030947. shtml. (retrieved May 14, 2020). After the founding of the PRC, there were only limited exports of Chinese electronic products. Such export of radios, telephones, and electronic tubes to Hong Kong and Southeast Asia can be traced back to 1956. Wen 2017, p. 94.

ant fierce competition between foreign and Chinese firms as well as overcapacity in the Chinese market prompted Huawei to look for new overseas markets. This was facilitated by the PRC's foreign policy, which since the 1990s gradually changed from a strategy of "attracting in" foreign technology to one of "going out." In the early 2000s, the government encouraged Chinese companies through various instruments and forms of preferential treatment to go abroad and invest and set up operations in other countries. Huawei was one of them. Supported by these policies, the PRC surpassed Europe and the United States to become the main ICT-exporting country in 2004 and the largest exporter of telecom equipment in 2010.[53]

Huawei's move abroad began in the mid-1990s, at just about the time when Hans Ulrich Dätwyler first came to China. However, the strategies of the two companies differed. Dätwyler had gained its initial experience abroad three decades prior to Huawei, targeting economically well-off western European countries first. Huawei's approach, in turn, was similar to the strategy that founder Ren had initially followed within China, that is, to start from doing business in the economically poorer rural regions. Likewise, in going global, he first targeted the emerging markets in Asia, Africa, and Latin America. The first step was an office in Hong Kong, followed by an entry into the Russian market in the late 1990s, which considerably benefited from official strategic diplomatic relationships between the People's Republic and Russia. In 1998, Huawei managed to enter other countries in Asia through international bidding, and in 1998 and 1999 offices in Kenya and Brazil became the company's first offices in Africa and South America, respectively.[54]

Only after Huawei gained solid ground on these continents since the early 2000s did the company eventually expand to North America and western Europe. This trajectory was less smooth, however, and fraught with numerous difficulties and challenges due to inter-state and inter-capitalist competition. Huawei was markedly more successful in Europe than in the United States.[55] It benefited from the European recession that followed the burst of the Internet bubble in 2001. The downturn forced operators to procure cheaper yet high-quality equipment, which was something that Huawei could offer. Similar to the way companies such as Dätwyler initially approached the Chinese market, Huawei aimed first at establishing joint ventures with local companies in order to access the European market. In 2003, Siemens, a German company involved in fiber optics and one that had been present in China since 1872 and had good contacts with the Chinese government, agreed to sign a cooperative contract. The breakthrough came in 2004, however, when Huawei won major telecommunications bids in Sweden and the Netherlands.[56]

53
Wen 2017, p. 76, pp. 94–98.

54
Ibid. p. 76, pp. 94–98.

55
See Bruno Mascitelli and Mona Chung, "Hue and Cry over Huawei: Cold War Tensions, Security Threats or Anti-Competitive Behaviour?," *Research in Globalization* 1 (December 2019), pp. 1–6; Wen 2017, pp. 133–38.

56
Wen 2017, pp. 133–38.

Fig. 5

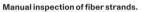
Manual inspection of fiber strands.

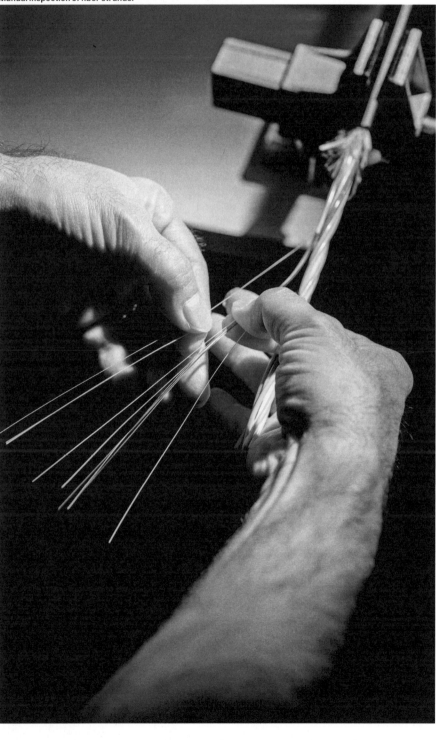

Fig 6 Loose tubes are being stranded together to form a cable, including strain relief and water-repellent protective coating.

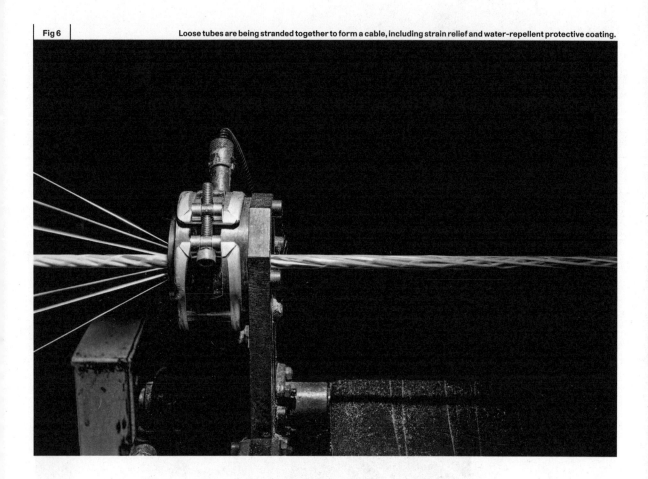

Fig. 7

Quality check: The cable is measured and labeled.

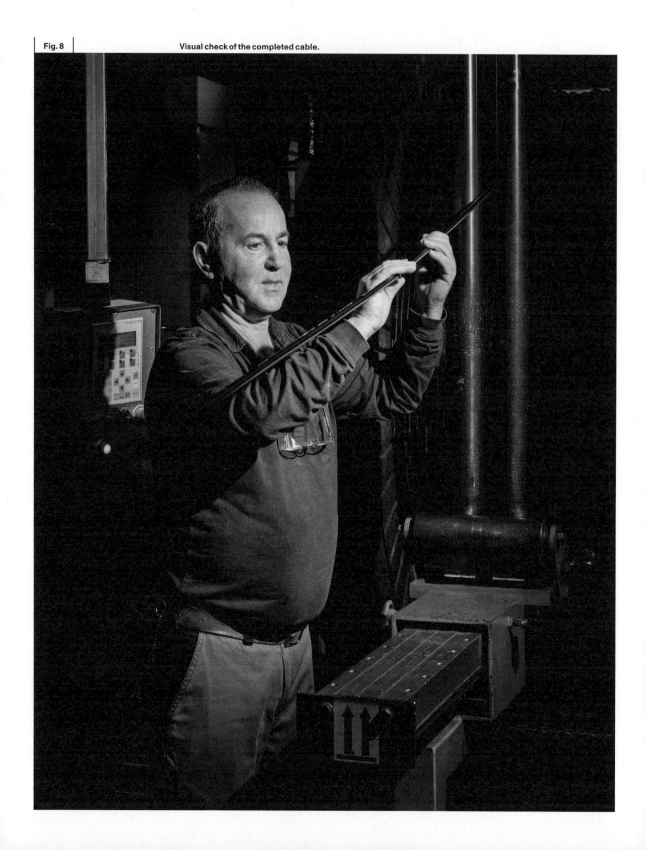

Fig. 8 | Visual check of the completed cable.

Fig. 9 Production plant in Altdorf with a view of the Uristock.

Huawei's official entry into the Swiss market—notably the last country in Europe where Huawei opened a branch[57]—is thus to be seen in this context of European market expansion. Around that time, the company was basically unknown in Switzerland. The company's first appearance in the Swiss Confederation was reportedly during an exhibition at the International Telecommunication Union's trade fair in Geneva in 1999. At that time, "[e]veryone was shocked that this sort of stuff was being made in China."[58] Nevertheless, only industry experts took notice of this.

In the following years, the company began to explore the Swiss market. According to Felix Kamer, Huawei Switzerland's vice president, who was part of the branch office's founding team, Switzerland initially did not have a strategic role in the company's business. Activities in Switzerland were first coordinated by Huawei's European headquarters in the German city of Düsseldorf and were later delegated to the Italian branch office in Milan.[59] From there, Toni Cheng (today the general manager of Alibaba's European cloud business) traveled to Switzerland regularly by car to sell Huawei Data Card, a product that could provide a Wi-Fi hotspot to mobile phones at a time when mobile phones did not yet properly support Wi-Fi.[60]

The turning point for a proper Swiss branch was in 2008, when the country's major telecommunications provider Swisscom planned to modernize its network on the basis of fiber optics. Vivian Gong Frey, Huawei Switzerland's chief technology officer, who was also part of the founding team, recalls the early beginnings of Huawei in Switzerland. Accordingly, Huawei was among several companies that were invited by Swisscom to make an offer and join the bid. However, the company did not yet have an office in Switzerland, and the colleagues from Swisscom initially did not know how to set up the contact. They knew Toni Cheng, however, and thus simply sent their request for information (RFI) to his hotel room when he was visiting Switzerland from Milan. At that time, people at Huawei hardly dared to dream that a seemingly high-end country such as Switzerland would even accept a Chinese vendor. However, says Mrs. Gong Frey, they presented a convincing, comprehensive, and solid network solution, which was developed directly in China.[61]

57

Felix Kamer, personal interview, August 23, 2019.

58

Quoted in Bruce Gilley, "Huawei's Fixed Line to Beijing," *Far Eastern Economic Review* (December 28, 2000), p. 96.

59

Felix Kamer, personal interview, August 23, 2019.

60

Vivian Gong Frey, personal interview and text communication on August 27, 2019 and December 10, 2019.

61

Vivian Gong Frey, personal interview, August 27, 2019.

62

Vivian Gong Frey, personal interview, August 27, 2019; René Schumacher and Said Rassouli, Swisscom, personal interview, September 23, 2019.

63

A telephone system consists of several hierarchical subsystems. Very roughly speaking, there are three layers. At the base, there is the local access network. The access network links individual telephones to local telephone switching offices or central offices (CO). These are located on the second layer, called the regional or metro network. Swisscom has 17 metro networks. The metro network connects the COs of cities, towns, and suburbs in a given region. Third, on top of the hierarchy, there is the long-distance network or backbone, which connects the different regional centers and major cities and, from there, provides links to the networks of different countries. Altogether, Swisscom has about 900 COs, including access COs, metro COs, and a few backbone COs. Huawei connected all of them, for example through technologies such as switches and multiplexing. As explained better in footnote 80, the former are technologies that ensure that our calls or e-mails are "switched" in the intended direction.

Yet, unlike Dätwyler Cabling, which was able to build upon the Chinese joint venture, Schindler, and its Swissness, Huawei first had to prove itself. After a test phase, the negotiations between Huawei and Swisscom began.[62] The first telecom equipment that Huawei sold to the latter in 2008 was high-capacity optical transport network (OTN) products to connect the various central offices (CO) across Switzerland.[63] Winning the Swisscom bid was the go-ahead for the company's business in Switzerland. A major requirement for being awarded the bid, however, was a local office. In setting up the business, they received strong support from the Bern Economic Development Agency.[64] Subsequently, in October 2008, Huawei registered an office.[65] Toni Cheng became its head, reporting to Italy. In March 2009, he began hiring a staff of four local and Chinese experts.[66] Among them was a senior local, Felix Kamer, who had previously worked at Swisscom and had received an offer from Huawei during a business trip to Shenzhen,[67] and Vivian Gong Frey, who was recruited as a senior network solution manager.

Mrs. Gong Frey recalls that she started to work at Huawei Switzerland rather by happenstance. She had been living in Switzerland since 2000 and spoke English as well as some German. Born in the Mao era, when women were supposed to "hold up half the sky," and being a telecommunications IT engineer with a degree from a top university in Beijing, she recalls that she was used to relative gender equality in technical fields. However, in this regard, Switzerland "was the biggest shock in my professional life!" At her first position in Switzerland, a managing role at a Canadian telecommunications company, "nobody talked to me unless they really needed to." Nevertheless, she reports, she went on, quitting the job only when she gave birth to her daughter and the industry was shaken by the burst of the Internet bubble.

Unexpectedly, on May 12, 2008, a major earthquake occurred in China's Sichuan Province. Mrs. Gong Frey registered as a volunteer to assist the victims. When one of the organizers heard about her telecommu-

64

Multiplexing enables a given telephone line to carry several signals at once by combining numerous signals into one higher-speed signal. Hecht 2017, p. 43, pp. 54–55; personal interviews with René Schumacher and Said Rassouli, Swisscom, June 27, 2019 and September 23, 2019; text and e-mail conversations with Vivian Gong Frey, Huawei, December 10–16, 2019.

65

Commercial Registry Office of the Canton of Bern, "Commercial Register of Huawei Technologies Switzerland AG" (Swiss Official Gazette of Commerce SOGC, October 14, 2008), https://shab.ch/api/v1/archive/4690286/pdf?tenant=shab (retrieved December 12, 2019); Economic and Commercial Office of the Embassy of the People's Republic of China in the Swiss Confederation, "华为落户瑞士 Huawei Luohu Ruishi (Huawei Set-

tles in Switzerland)," May 26, 2009, http://ch.mofcom.gov.cn/aarticle/jmxw/200905/20090506279707.html (retrieved April 23, 2020).

66

Vivian Gong Frey, personal interviews, August 27, 2019 and November 14, 2019.

67

Fabian Vogt, "'Komme an zweiter Stelle,'" Computerworld.ch (February 18, 2013), https://www.computerworld.ch/business/politik/komme-an-zweiter-stelle-1405564.html (retrieved December 12, 2020); Felix Kamer, "My Happy Ten Years at Huawei," Huawei People 1, no. 298 (2019), pp. 5–6.

nications background, she told her that Huawei was about to establish an office in Switzerland and put her in touch with Toni Cheng. Once Huawei officially launched its business in Switzerland, Toni Cheng invited her to join the team. She accepted the full-time position, although her friends from Switzerland, knowing that she was then the mother of a six-year-old, said: "Are you crazy?"[68]

As Felix Kamer remembers, the founding team of five people "established Huawei Switzerland from scratch."[69] With little time to find office space, they first started the business in a three-room apartment in Bern near Helvetiaplatz.[70] They had to set up everything by themselves, from buying their own laptops and traveling to Milan in order to get the right software from Huawei Italy, to going to IKEA and assembling the furniture purchased there, to improvising office curtains made from bedsheets.[71]

In addition to assembling these infrastructural materials, they had to develop intercultural understanding. As Felix Kamer notes, "Building trust is a challenge for any company, but it is much more demanding across cultural borders."[72] In the early years of working with Swisscom, says Vivian Gong Frey, "we had to act as a bridge to bring the two companies together." It was the first time they were using a Chinese product, and they had some doubts. The fact that the Huawei engineers could hardly speak English did not make things any easier. "We had to … do a cultural exchange and integrate body language," for example in intercultural workshops.[73] During these workshops, Felix Kamer recalls, the Swiss and Chinese sides "talked about culture, food … We sang 'Frère Jacques' and '*zhu ni shengri kuaile*' [Happy Birthday to You] in Chinese." The aspects of Switzerland that astonished his Chinese colleagues the most were the high cost of living, the impressive quality of services such as trains and buses always running on time, and public services, as well as the way the Swiss could eat heavy meals such as cheese fondue.[74] "I missed Chinese food," recalls Vivian Gong Frey. "At first I didn't know what to order at restaurants. I only knew spaghetti."[75]

68

Vivian Gong Frey, personal interview, August 27, 2019.

69

Kamer 2019, pp. 5–6.

70

Felix Kamer, personal interview, August 23, 2019.

71

Kamer 2019, p. 7.

72

Felix Kamer, personal interview, November 14, 2019.

73

Vivian Gong Frey, personal interview, August 27, 2019.

74

Felix Kamer, personal interview, November 14, 2019.

75

Vivian Gong Frey, personal interview, November 14, 2019.

76

Felix Kamer, personal interviews, August 23, 2019 and November 14, 2019.

77

Felix Kamer, personal interview, August 23, 2019.

78

Martin Zeller, Huawei Product Presentation, FTTH Forum Baden, May 7, 2019. Worldwide, Huawei has about 194,000 employees in more than 170 countries. Huawei, "About Huawei," 2020, https://www. huawei.com/ch-en/about-huawei (retrieved January 29, 2020).

79

IT Reseller, "Huawei baut Forschungszentren in der Schweiz," August 13, 2018, https://www. itreseller.ch/Artikel/87393/Huawei_ baut_Forschungszentren_in_der_ Schweiz.html (retrieved December 12, 2019); Tobias Marti, "Bern fürchtet den Zorn Amerikas: Chinas Entwicklungszentren in der Schweiz," *Blick* (July 5, 2019), https://www.blick.ch/news/ politik/weil-china-entwicklungszentren-in-der-schweiz-plant-bern-fuerchtet-den-zorn-amerikas-id15293817.html (retrieved December 12, 2019).

Nowadays, Huawei Switzerland no longer organizes intercultural workshops: "We have a better understanding of how Switzerland works, and the customers have also become more open." Nevertheless, Felix Kamer asserts that "the language is a barrier." While he spent one year in Shenzhen recently, practicing Chinese characters with flash cards in the evenings, his job kept him too busy to pick up more than rudimentary Mandarin.[76] To overcome such challenges, the staff of Huawei Switzerland is still made up of local, i.e. European, and Chinese employees, including people of Chinese origin with a Swiss passport. There is also a division of labor, with Chinese colleagues mainly being responsible for the technical side of the business and communication with headquarters.[77]

Today, Huawei Switzerland has about 350 employees of thirty-three different nationalities[78] working in offices near Bern, Zurich, and Lausanne. Despite the ongoing discussion about cybersecurity, the company continues to grow. Moreover, it is about to open one or two major research centers, likely to be linked to ETH Zurich and/or EPFL in Lausanne. In times of a trade war and in view of not wanting to endanger negotiations on a free-trade agreement with the United States, however, it seems that the negotiations on the research centers have been kept discreet.[79]

In practice, Huawei can already be found nearly everywhere in Switzerland's digital realm. Private consumers are addressed in advertisements for Huawei mobile phones on Switzerland's streets and in its train stations. Moreover, the company provides a range of network systems and devices for enterprises and telecommunications providers. These include switches and routers,[80] antenna components, wireless local area networks (WLAN), Internet of Things gateways, and security products. In the fixed telecommunications network, for example, Huawei provides crucial components that link Switzerland's older copper and coaxial networks to the fiber optic network.[81] Universities also use Huawei components; these include Switzerland's top technical university, ETH, which has distributed more than 3,000 of Huawei's WLAN access points across its campus. When traveling up mountainsides in the cable cars of Titlis Bergbahnen, skiers can now access Huawei's WLAN hotspots,[82] and the National Swiss Ski Alpine Team is currently competing in Huawei racing bibs.[83]

Swiss data centers rely on Huawei technology as well—although they are not always willing to talk about this in public. Such technologies include, among other things, servers, storage solutions, switches, and other network components, such as DWDM (Dense Wavelength Division Multiplexing).[84] In short, the range of technologies offered by Huawei is wide.

80

Very simply put, switches are devices that direct information through the right "pipes" or cables so they reach their intended destination. Switches basically do not pay attention to the content of the data they direct. After setting up a circuit, they "... leave it alone as long as it's carrying signals." Routers can perform a similar task of directing information. However, in contrast to switches, routers are more complex: They "... may bundle together packets that are going in the same direction, to be sorted and redistributed at their destination. In addition to reading the headers, routers monitor network conditions to establish the best routes for sending data packets." See Hecht 2017, p. 9, p. 402, p. 483. Interestingly, only a few decades ago, the PRC had to rely on imported switches, which was perceived as a national Chinese security concern. In 1994, Ren Zhengfei advised then president Jiang Zemin that "... switching equipment technology was related to national security. And if a nation did not have its own switching equipment, it was like a nation without its own military." Ren, in Eric Harwit, *China's Telecommunications Revolution*, New York, 2008, p. 148. Today, it seems that this situation has turned around, as Western countries express similar concerns with regard to employing Chinese technology.

81

Huawei, "Huawei Switzerland: Building a Fully Connected, Intelligent World," 2019, https://www.huawei.com/ch-en/ (retrieved December 12, 2019); personal observations and multiple interviews between March and November 2019, including with representatives from Swisscom, Cablex, Huawei, and Glasfasernetz Schweiz.

Accordingly, one data center IT engineer from the University of Zurich recalls that, after having gone through five hours of product presentations with Huawei engineers, "I just told them 'okay, just tell me what you don't have!'"[85]

While furnishing Swiss infrastructures with optical network components, Huawei's designers also draw inspiration from Swiss technologies—including in more unexpected ways. Huawei has invested 1.5 billion Swiss francs in the construction of its new Ox Horn campus near Shenzhen in southern China. By November 2019, more than 10,000 employees, mostly research and development staff, had already moved there. Once construction is complete, 25,000 people are expected to work there in twelve "cities" that will imitate various European cities and regions such as Paris, Verona, Oxford, Heidelberg, and Fribourg in Switzerland. An eight-kilometer rail network connects these places. The bright red, somewhat nostalgic shuttle trains that run there are modeled after the Jungfraubahn, a famous Swiss alpine train—an idea by Felix Kamer.[86]

In conclusion, Swiss-Chinese digital infrastructures are interwoven in complex, multidirectional, and multifaceted ways—not only by cables and network devices, but also by the people behind these infrastructures. Accordingly, the digital technologies involved can hardly be assigned clearly to a single nation. Throughout the last century, Chinese engineers have been adapting technologies and know-how from the Soviet Union, Western Europe, North America, and Japan, by studying abroad, learning from foreign experts, and importing technologies. They have developed these technologies into new Chinese versions, which are now finding their way back and promising a new modernity in their places of origin. At the same time, Swiss-made fiber optic technologies such as cables or plugs often contain components made in China or the United States. In addition, the people who work at Swiss and Chinese fiber optic companies in Switzerland and contribute their time, labor, and skills are often from many different backgrounds. In practice, it is therefore difficult to draw clear national boundaries, whether with regard to Chinese technology or when it comes to the making of digital Switzerland.

Acknowledgments

I am greatly indebted to all the interview partners who have made this research possible for sharing their time, knowledge, and personal experiences. I would also like to thank Olivier Keller for assisting me with the research for this chapter.

82

Huawei and Absolut Value Distribution, "Kundenreferenz: ETH Zürich setzt auf leistungsstarkes WLAN von Huawei," 2018, https://absolut-distribution.ch/wp-content/uploads/2018/04/Absolut_SuccessStory_ETH_2018.pdf (retrieved December 12, 2019); Huawei and Absolut Value Distribution, "Kundenreferenz: Titlis Bergbahnen steigern Gästeerlebnis durch leistungsstarkes WLAN von Huawei," 2018, https://absolut-distribution.ch/wp-content/uploads/2018/02/Absolut_Story_Bergbahnen_Titlis.pdf (retrieved December 12, 2019).

83

Swiss-Ski, "Huawei Schweiz wird offizieller Partner von Swiss-Ski," December 14, 2019, https://www.swiss-ski.ch/newsroom/news/huawei-schweiz-wird-offizieller-partner-von-swiss-ski/ (retrieved January 29, 2020).

84

Huawei, "Huawei Switzerland: Building a Fully Connected, Intelligent World"; DWDM is used to increase the bandwidth of existing fiber networks. It does so by "... transmit[ting] separate signals through the same fiber at many wavelengths." See Hecht 2017, pp. 10–11.

85

Swiss data center IT engineer, personal interview, May 27, 2019.

86

Matthias Müller, "Huawei bringt ein bisschen Jungfraujoch in den Süden Chinas," *Neue Zürcher Zeitung* (January 22, 2019), https://www.nzz.ch/wirtschaft/huawei-bringt-ein-bisschen-jungfraujoch-in-den-sueden-chinas-ld.1452614 (retrieved December 12, 2019); Villager/China, "Working in a Castle," *Huawei People* 11, no. 308 (2019), p. 34; Felix Kamer, personal interview, August 23, 2019.

Saanen

The Data Bunker
Is Not Just Anywhere:
Historizing and
Territorializing Flying
Machines, Data
and Men

Silvia Berger Ziauddin

Color Photos by
Yann Mingard

There's a sweeping view across the runway of Gstaad-Saanen Airport in the Bernese Highlands. Against the lovely backdrop of a mountain panorama, the private jets of well-to-do vacationers such as Bernie Ecclestone are landing, as are Air Glacier's red-and-yellow helicopters. In the summer, horses chase after little white balls at the Hublot Polo Gold Cup Gstaad. "The style, elegance and joie de vivre of the tournament is reflected by the offers provided by Gstaad Airport," says the airport's website, which I called up at the exclusive coffee bar in the newly opened terminal.[1] Right now I'm sitting several hundred meters away in the panorama lounge of a building of concrete and glass that is also adjacent to the runway. The operations and customer service center of the Mount10 company comprises an underground parking garage, a hangar with objets d'art, ultramodern office space, and a loft that includes an attic-like panorama lounge. Looking across the airfield at the facing cliffs, the contrast could not be greater: a rock face covered in peeling camouflage paint with a weathered concrete roof, to its left a discreet entrance gate. If one were to pass through the entrance and follow a winding system of corridors equipped with bulletproof individual entry checkpoints, one would be standing in the heart of the complex: the server room of the "data center fortress" known as the Swiss Fort Knox. Growing amounts—petabytes—of private and public customer data are stored here.[2] A tour of the mountain cannot be allowed for reasons of security and insurance, I was told shortly before my visit to the Saanenland region by Christoph Oschwald, the cofounder and CEO of SIAG (Secure Infostore AG), a subsidiary of Mount10. Whether aesthetics are of great value to him is a question I pose when we're finally sitting face-to-face in the panorama lounge. "Security is our aesthetic," Oschwald says, handing me a glass of water. "This is water from Gstaad, much better than anything from a bottle."[3]

In images that photographer Yann Mingard from francophone Switzerland has made of the Swiss Fort Knox, the data bunker's server room appears as a monofunctional, sterile place in which server racks are lined up in neat rows. It is a space that is shielded from view, which seems to exist in its own autonomous time zone, and in which no social relationships nor any relation to history are established. A non-place[4] kept in inconspicuous hues and dominated by codified ideograms, retinal scans, and cameras, which produces functionaries generated to fulfill the function of this space (see illustrations): the security guard who checks clients upon entry, the technician tasked with maintaining the servers, the supervisory staff at the company's headquarters in Zug who "proactively" monitor the goings-on inside the mountain and access to the data.

1
https://www.gstaad-airport.ch/en/ events (retrieved August 26, 2019). The community of Saanen contributed nine million francs to the construction of the luxurious new terminal, about a third of the total cost. Interview with Markus Iseli, Saanen, March 19, 2019.

2
"Tief im Berner Oberland lagern kostbare Daten," *blick.ch* (June 8, 2017).

3
Interview with Christoph Oschwald, Saanen, March 19, 2019.

4
On the concept and properties of a "non-place," which French philosopher Marc Augé described as the opposite of an "anthropological place," see Marc Augé, *Non-Places: Introduction to an Anthropology of Supermodernity*, London, 1995.

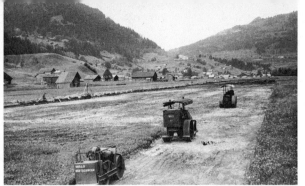

Fig. 2
Constructing a hard surface for the
runway: secret Saanen airfield
1943. (© Archiv MHMLW, Museum
und historisches Material der
Luftwaffe, Dübendorf)

In this essay, I'd like to give some historical, social,
and spatial depth to this supposed non-place inside a mountain by looking at
the people, materialities, and infrastructures that have played a critical part in
the emergence and specific contouring of the Swiss Fort Knox as the "most
secure" "data center fortress" in Europe.[5] The Swiss Fort Knox is, as I shall
demonstrate, intimately connected to Switzerland's military history in World
War II and the Cold War; it cannot be properly understood without a look at fly-
ing machines, data, and men, as well as the specific acquisition of this regional
terrain. I shall argue that the flying machines, data, and men have mobilized
Swiss cultural values, myths, and national symbols, which to this day remain
deeply inscribed in the material matrix and the arsenal of imagination of the
Swiss Fort Knox. The data bunker isn't located just anywhere.

Redoubt Airfield, A1790, and Covert Data in Flight

Seventy-five years ago, where the Swiss Fort Knox
stands today, aircraft were for the first time being moved away from prying
eyes and perilous attacks. These were airplanes of the Swiss Air Force which
were being placed in a camouflaged tunnel inside a massif in order to better
protect them from attacks by enemy bombers. During World War II, these taxi-
way tunnels (known as *Retablierungsstollen*) were excavated at many of the
secret airfields in Alpine Switzerland. Construction of the airfields became an
urgent matter when the airfields previously used by the Swiss Air Force came
to lie outside of the actual zone of defense as a result of the Army's retreat to
the *Réduit* (redoubt) starting in 1940. Army posts in the regions of the central
Alps and Alpine foothills were intended by the General Staff to create a deterrent
and result in decisive resistance in order to maintain Swiss independence and
neutrality toward the Axis powers.[6]

Construction of the airfield on common land along
the River Saane (there were expropriations as well), along with other redoubt
airfields being built in the Bernese Highlands (such as St. Stephan, Zweisimmen,
and Reichenbach), proceeded in strict secrecy.[7] After the runway was given
a hard surface,[8] a corps of airmen and the crew of an aviation division moved
into the aeronautically advanced military airfield, which was deemed politi-
cally to be well-situated—"bien au milieu" of the nation—in 1943.[9] A year later,
seven modest, decentralized airplane shelters (known as U43) were ready for
occupancy, as was the 46-meter-long, 11-meter-wide taxiway tunnel inside
the mountain,[10] which could accommodate up to seven airplanes (mostly
Morane, C-36 or Messerschmitt). Only "Swiss people of good Swiss convic-
tion" were allowed to dig the tunnel; the supervisors were required to keep the

Fig. 1

Fig. 2

5

https://www.mount10.ch/en/
mount10/ (retrieved August 26,
2019); https://www.mount10.
ch/en/mount10/swiss-fort-knox/
(retrieved August 26, 2019).

6

On the history of the redoubt stra-
tegy, see Hans Senn, "Réduit," *His-
torisches Lexikon der Schweiz
online*, https://hls-dhs-dss.ch/de/
articles/008696/2010-08-20/
(retrieved August 30, 2019); Jakob
Tanner, "'Réduit national' und Aus-
senwirtschaft," in: Philipp Sarasin
and Regina Wecker, eds., *Raubgold,
Réduit, Flüchtlinge. Zur Geschich-
te der Schweiz im Zweiten Weltkrieg*,
Zurich, 1998, pp. 81–103; Roberto
Bernhard, *Das Reduit. Mythen
und Fakten*, Biel, 2007.

7

Lukas Kappenberger, *Come Up,
Touch Down. Geschichte und
Geschichten zur Fliegerei im
Saanenland*, Gstaad, 2016, p. 34.

8

"Ausbau der Flugplätze im Reduit,
1940–1943; Geheim, Der Komman-
dant der Flieger- und Flieger-
abwehrtruppen an den Chef des
Generalstabs der Armee, betrifft:
Verbesserung der Flugplätze im
Zentralraum und Zerstörung von
Flugplätzen ausserhalb des Zentral-
raums, 1.3.1943" [Secret: From the
Commander of the Airborne and
Anti-Aircraft Troops to the Chief
of Staff of the Army, re: Improving
Airfields in the Central Area and
Destruction of Airfields Outside of
the Central Area, March 1, 1943],

Fig. 3
Wheel change by ground forces at
Saanen airfield during the Cold War.
(© Fred Mayer and Richard Schilliger)

Fig. 3

plans secret. The civilian population was forbidden to enter the airfield[11] or to photograph the infrastructure and airplanes. The runway was obscured on postcards, and neither the *Aero-Almanach* nor maps contained any references to the military airfield.[12]

In the early stage of the Cold War, the military occupancy of Saanen increased relative to that of World War II. Two flying squadrons with as many as twelve fighter planes absolved refresher courses in the Bernese Highlands, requiring a ground crew of some 500 persons around 1960.[13] In the mid-1960s, in view of the new threat of nuclear weapons, a large nuclear bunker complete with a command post was built into the mountain directly adjacent to the taxiway tunnel. This facility was intended to guarantee the coordination and supervision of flight operations in an anticipated nuclear war. Today this facility, which bears the military abbreviation A1790, harbors the racks and vaults of the data fortress known as Swiss Fort Knox.

The discreet entrance to subterranean facility A1790 reveals nothing of its more than 2,000-square-meter interior. In order to reduce the force of a nuclear blast wave, the long access tunnel was given various 90-degree angles. A control room at the entrance housing a security officer, as well as several massive, pressure-resistant, armored doors equipped with sensors, ensured strict control of access. Water tanks, electrical generators, and systems for filtering nuclear, biological, and chemical particles out of the air were to ensure the facility's survivability and self-sufficiency.

Even today, only a few kilometers from Saanen, at the St. Stephan airfield, an identical bunker and command post are found which reflect the architectural extension, technical installations, and furnishings from the time of the Cold War, nearly unchanged. Although I was prevented access to the server room of Swiss Fort Knox, I was able to explore the heart of the facility at St. Stephan: a two-story cavern built into the rock as an elongated tube at the end of a long, winding access tunnel. This cavern contains a

9

Swiss Federal Archives E27#
1000/721#16608*, vol. 3.

10

Kappenberger 2016, p. 35.

"Ausbau der Flugplätze im Reduit, 1940–1943; Tabelle Kostenberechnung für den Bau von Flugzeugkavernen, 17.4.1943" [Cost Calculation for the Construction of Aircraft Caverns, April 17, 1943], Swiss Federal Archives E27#1000/721#16608*, vol. 3. The cost of the taxiway tunnel in Saanen amounted to CHF 280,000.

11

Interview with Markus Iseli, Saanen, March 19, 2019.

decontamination room, diesel-powered back-up generators, a substation transformer, rooms for work and leisure, a command center, dormitories, toilet facilities, washrooms, a kitchenette, a quadradar facility and film room.[14]

At the Saanen military airfield, the infrastructure improvements and expansions undertaken during the Cold War included not only the construction of the A1790 bunker and command post, but also of a fortified tower from which activity on the field could be observed as well as a protected fuel depot and a shelter, capable of withstanding a nuclear blast, for the personnel working directly on the field. Setting up all these buildings and infrastructure proceeded, as during World War II, in strict secrecy. Even the excavation and sale of a total of 40,000 cubic meters of gravel[15] that accumulated in the mountain from construction of the facility was to be done so as to attract as little attention as possible.[16] Original plans of the former bunker and command post are impossible to find in the Federal Archives. A former Swiss Air Force intelligence officer surmises that the plans will remain inaccessible as long as other military facilities in Switzerland that are nearly identical in design are not declassified.

Strategies for maintaining secrecy, promises of military security and protection, discretion and advantages of location have thus been inscribed from the start in the bunker at the Saanen airfield, and these would play an important role in its later repurposing and, above all, marketing as a data center. But more on this later. First, it's necessary to explain the importance of covert data and flying men to the emergence of the subsequent data center known as the Swiss Fort Knox.

A military degradation of the Saanen site occurred, starting in the late 1960s, when larger and faster types of aircraft were introduced and the airfield's lack of large hangars with nuclear blast doors rendered it irrelevant.[17] The airfield and especially the A1790 bunker did, however, experience a second military heyday starting in 1982, when the parachute reconnaissance company informally known as the "Paras" was stationed there. Since its founding in 1969, Company 17, with its paratroopers and parascouts, who form an elite unit within the Swiss Army, repeatedly met with political resistance.[18] Not only did its reconnaissance and tactical operations in "enemy" territory before an actual breaching of the border threaten to claw at the Swiss

12

See Kappenberger 2016, p. 84 and interview with René Zürcher, Saanen, March 19, 2019.

13

Kappenberger 2016, p. 38.

14

I wish to thank René Zürcher and the Hunterverein Obersimmental for access to the facility and the excellent tour of St. Stephan. See https://www.hunterverein.ch (retrieved August 30, 2019).

15

Some of the excavated material was used for road construction in Gstaad. Flugplatz Saanen, Verkauf Stollenausbruchmaterial; Brief Direktor der eidgenössischen Militärverwaltung an Direktion der Militärflugplätze, Betrifft: Militärflugplatz Saanen, Stollenausbruchmaterial, 13.10.1965 [Saanen Airfield, Sale of Material Excavated from Tunnel; Letter from the Federal Military Administration to the Director of Military Airfields,

16

re: Saanen Airfield, Sale of Material Excavated from Tunnel, October 13, 1965], Swiss Federal Archives E5001 G#1979/56#1091*.

Interview with René Zürcher, Saanen, March 19, 2019.

17

Interview with René Zürcher, Saanen, March 19, 2019; "Die Auferstehung des Schweizer Bunkers," Der Bund online (August 23, 2018), https://www.derbund.ch/schweiz/die-auferstehung-des-schweizer-bunkers/story/23198504 (retrieved July 30, 2020)

Fig. 4

concept of neutrality; at the time of its founding, it was also regarded as a potentially hazardous element of a "state within a state" that could entice the military to "political coups de main."[19]

The parascouts stationed at Saanen and the units associated with them conducted their annual refresher courses in the Bernese Highlands, with a week dedicated to the actual maneuver. In preparation for such a mission, as many as ten teams, each consistent of four to five parascouts, were placed in complete isolation within the A1790 bunker, with an entire bunker company of around 120 persons responsible for security. Pilots used Pilatus Porters to fly the parascouts out of the facility at night to the theater of operations, where they silently dropped into the dark depths, each carrying a load weighing 30–40 kilograms. The parascouts encrypted and radioed back to the facility's communications center the information they collected "behind enemy lines" during the covert reconnaissance maneuver[20] and then attempted to struggle back to headquarters. The operations were led, evaluated, and monitored entirely from the bunker facility in Saanen. The results were relayed around the clock to the Armed Forces Staff in Bern.[21]

One of the flying parascouts relaying covert data who became familiar with the facility inside and out during his time of military service was Christoph Oschwald, the current CEO of SIAG. As a parascout in the 1980s, Oschwald attended refresher courses in Saanen each year. When he was no longer routinely making jumps, he spent a lot of time as commander of the company in the bunker's command center. In the late 1980s, when the overall geopolitical situation began to change, he realized that the A1790 facility was

18

An apologetic account of the Para-troop Company 17 was authored by Kaj-Gunnat Sievert, a former commander of the company. Kaj-Gunnat Sievert, *Die 17er. Die Fall-schirmaufklärer der Schweizer Armee*, Stuttgart, 2010. In Army circles, the "17" is considered an elite unit to this day. Ernesto Kägi, "Elite zwischen Himmel und Erde," *Schweizer Soldat* 92, no. 6 (2017), pp. 18–19. Promotional videos such as Touch the Limits,

intended to attract new applicants to the School of Recruits of the Special Reconnaissance Forces, fuel the mythos of an elite unit of the Swiss Army known for its adventure, patriotism, heroic masculinity, and strict selection criteria. See https://www.sphair.ch/sphair/para-film-touch-the-limits (retrieved August 29, 2019).

19

See "Umstrittene Fallschirm-grenadiere," *Thuner Tagblatt* (October 2, 1968); "Schweizer Paras unter Beschuss," *Thuner Tagblatt* (March 21, 1968); Sievert 2010, p. 49 (note 18).

20

In the event of war, an "infiltration of enemy territory," that is, foreign territory, as well as the "crossing of the combat zone" would have been part of the repertoire of a special reconnaissance mission. Ernst Frieden, "20 Jahre Fernspäher in der Schweizer Armee," *Schweizer Soldat* 64, no. 12 (1989), pp. 13–14, here p. 13.

21

Kappenberger 2016, p. 83.

22

Interview with Christoph Oschwald, Saanen, March 19, 2019; "Die Auferstehung des Schweizer Bunkers," *Der Bund online* (August 23, 2018), https://www.derbund.ch/schweiz/die-auferstehung-des-schweizer-bunkers/story/23198504 (retrieved July 30, 2020).

23

Beteiligung an Firma SIAG; Finanz-inspektorat PTT an GD II Stv, 8.5.1995 [May 8, 1995], Swiss Federal Archives E1050.3B#1998/209#747*.

24

Beteiligung an Firma SIAG; Brief Finanzinspektorat PTT an GD II Stv, Betreff: Beteiligung an der Firma SIAG Secure Infostore AG, München-chenstein, 25.10.1994 [October 25, 1994], Swiss Federal Archives E1050.3B#1998/209#747*.

actually only being used operationally for a one-week refresher course. By that time, he had founded his own computer company and felt, along with his partner Hanspeter Baumann, an electrical engineer, that the time was ripe for a combination of data storage and military security inside the mountain.

Lobbying, Marketing, and Stories Told after the Cold War

Starting in 1992, Oschwald and Baumann approached the Army. In the phase of upheaval following the Cold War, it wasn't easy at first to convince the Federal Department of the Military of the "business case" of a backup center inside a secret military bunker. Oschwald's impression was that the Army leadership was still too caught up in the Cold War.[22] In 1994, however, after two years of lobbying, he succeeded in arranging the first joint venture between a private company and the Swiss Army. In the spirit of a pilot project, the Department of the Military leased part of the bunker to Oschwald's private computer company for "one-time compensation at no charge." In exchange, however, the company was required to shoulder the operating costs of the entire military facility, which amounted to 400,000 Swiss francs annually.[23] With Baumann, Oschwald established SIAG, which operated as the leaseholder of the bunker rented by Oschwald's computer company and which employed soldiers from the bunker as security officers. They succeeded in getting Telecom PTT and the Telecommunications Agency in Zurich on board as the largest shareholders in the equity of this newly established company, which needed to "upgrade" the facility with computers (tape robots) and fiber-optic networks for data storage. According to files from the Federal Archives, they invested a couple of million Swiss francs in the company. Although this share corresponded to nearly 80 percent of the total equity, the PTT and Telecommunications Agency held less than a 30 percent share of the vote.[24] This discrepancy, along with the lucrative recurring interim profits from leasing the facility through Oschwald's private company to SIAG, prompted the Financial Inspectorate of the PTT as well as the Finance Delegation of the Swiss Federal Assembly to take notice in 1994 and 1995. After performing detailed evaluations, they criticized the PTT's stake as "speculative" and "sloppily drawn up." Involvement in SIAG, they said, had resulted in cost but little return. As a consequence of this and other experiences with the PTT's involvement with private firms, the state-owned enterprise enacted policies and guidelines for partnerships, stakes, and loans, and introduced steps toward effective investment controlling.[25]

The business of storing data in the bunker was, in fact, barely profitable at first, according to Oschwald. In 1996, a first client was

25

Beteiligung an Firma SIAG; Brief
Generaldirektor PTT an Finanzdele-
gation der Eidgenössischen Räte,
21.12.1995 [December 21, 1995],
Federal Archives E1050.3B#1998/
209#747*.

found, who personally brought his tapes to the data mountain that by this time was known as the Swiss Fort Knox. Beyond space in the storage machine, clients were able to rent 12-square-meter cells for the physical storage of data disks. Electronic transmission via fiber-optic cable was also possible (the maximum transmission rate at the time was 144 megabits/second), but clients hardly took advantage of this because of the high fees charged by PTT for transmitting the data to the Bernese Highlands.

At its start, the project had to contend with negative press. The *SonntagsZeitung* associated the data storage facility's location with the former bunker of the P-26 secret resistance organization near Gstaad and spoke of the storage of "sensitive data." After having had an information policy of announcing hardly anything to the public, SIAG launched a more active communication strategy starting in 1996. Oschwald approached *Der Spiegel* in Germany and invited journalists to tour the facility. When a fire at Crédit Lyonnais in Paris destroyed valuable data in spring 1996, the weekly Hamburg news magazine linked the story to SIAG's offer and published a favorable article about the potential and security of the "Fort Knox of data storage."[26] The *Frankfurter Allgemeine Zeitung (FAZ)* also published an article a short time later in which SIAG was able to accommodate its marketing message.[27] The PR done since then, says Oschwald, has been about finding a balance while "telling the same stories in a different way."[28] These "stories" include, as I shall explain below, not only the myth of Swiss security rooted in military defense readiness and the undisturbed landscape. The story of *Heidi* and the mobilization of the military history of the bunker, associated with secrecy and data transmission, has remained part of SIAG's narrative and visual marketing arsenal. Not least, references to scenes, characters, and the aesthetics of James Bond movies also permeate the company's promotional strategy.

In the 1990s, *Der Spiegel* told its readers that the data storage facility lay deep within a mountain where "the Swiss Air Force used to ensconce fighter jets." This was a military facility "able to withstand a nuclear blast" and guarded by "uniformed agents of a corps of bunker guards." Oschwald is quoted in the article as saying that only the Swiss "with their centuries-old paranoia" could have built such a bunker.[29] In brochures in the 1990s, SIAG referred to the "inviolability" of the fully operational military facility in times of peace as well as war. To the company, it was all about the "aura of fortified neutrality and security" that was good for business and that—as Oschwald told the *FAZ*—couldn't be sold better than in a military bunker.[30] The fact that bunker troops worked for SIAG underscored the direct relationship to the Swiss military and the military commitment to security.

26

"Für den Notfall," *Der Spiegel* 21 (1996), pp. 178–179.

27

"Ein Fort Knox für Computerdaten in der Schweiz," *Frankfurter Allgemeine Zeitung* (August 12, 1996).

28

Interview with Christoph Oschwald, Saanen, March 19, 2019.

29

"Für den Notfall," *Der Spiegel* 21 (1996), pp. 178–179.

30

"Ein Fort Knox für Computerdaten in der Schweiz," *Frankfurter Allgemeine Zeitung* (August 12, 1996).

Fig. 5 A guard waiting for the door to open.

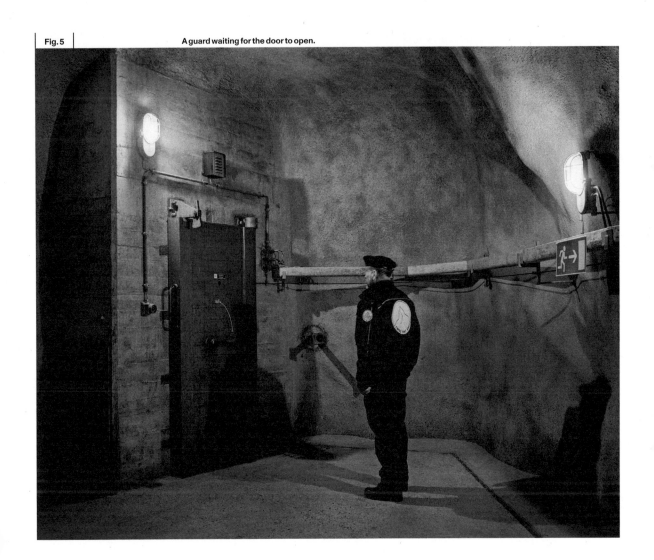

Fig. 6 Third entrance door of the vault.

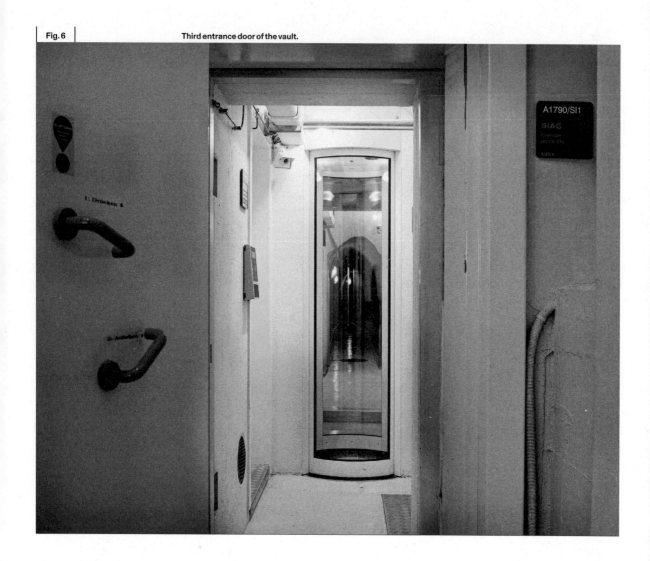

In an interview with the *Bund* newspaper in 1997, Oschwald emphasized how the merit of the remote Swiss landscape and the mountains would be particularly effective with international clients: "Look at this landscape. To a New York businessman who steps off a plane here, the mountains and the serenity convey a sense of security. I love Switzerland."[31] More than twenty years later, the New York businessman is still a topic in my conversation with Oschwald: "When you're standing in the middle of New York City—beep, beep!—and then you come here and are safe before you're even inside the mountain."[32] It's a no-brainer that the logo of the Swiss Fort Knox features a mountain and that the websites of SIAG and Mount10 make prominent use of various mountain motifs.[33]

A promotional film from 2004 offers a particularly vivid illustration of how SIAG links and superimposes the myth of the Swiss Alps and narratives passed down through the generations about autochthonous mountain individuals with the story of the parascouts transferring covert data during the Cold War and the aesthetic and settings of James Bond films.[34] To sounds of cowbells and mooing, the film begins with a tranquil scene in an Alpine meadow where Heidi and her bearded grandfather Alpöhi are having a conversation. Holding up a piece of cheese, blond, curly-haired Heidi asks: "Grandfather, why are there so many holes in the cheese?" Alpöhi replies: "Swiss cheese is like the mountains: it's full of holes." Then the film dispenses with the peaceful imagery: in rapid cuts, the viewer now follows a helicopter over dark, rugged mountaintops amid loud rotor noise and martial imagery. Heidi is heard asking: "And what's in the holes?" As the helicopter descends into the valley and the fortified tower of the airfield comes into view, her grandfather replies: "A lot of money!" The helicopter then lands next to a camouflaged rock face, the entrance to the Swiss Fort Knox. Heidi goes on: "My father says there are people who come with flying machines and have all the secrets of the world with them." While she's speaking, men in bright-colored overalls unload a metal suitcase from the helicopter. A tall woman in a tight-fitting suit leads them to the nondescript entrance in the rock face. There she activates a touchscreen and a facial sensor opens the gate. The camera follows her through a rock vein comprised of tunnels with the latest high-tech gates and retinal scans. A network of lasers has to be deactivated before they finally get "to the heart of the mountain," as Heidi narrates. At this point, the woman removes a data tape from her suitcase and places it in a storage machine. In the heart of the mountain, "all secrets come to rest," Heidi concludes. At the end, the SIAG signet appears next to the rousing slogan "Data storage in the massif!"

31

"Futuristischer Datensafe in alter Armee-Festung," *Der Bund* (November 11, 1997).

32

Interview with Christoph Oschwald, Saanen, March 19, 2019.

33

See https://www.mount10.ch (retrieved August 27, 2019); https://www.siag.ch/de/Default.html (retrieved August 27, 2019).

34

See https://www.youtube.com/watch?v=m492oFWyOkE (retrieved July 8, 2020).

Redundant Mountains and Deep Lakes in the New Millennium

The film, which not only emphasizes the location in a remote massif, but also recalls in the style of James Bond the dauntless missions of the parascouts in the Cold War, was produced a few years after the turn of the millennium. At that time, the business of data storage in the former military bunker turned profitable for the first time. Mount10 did have to declare bankruptcy when the Internet bubble burst in 2003, which led to Oschwald and Baumann buying the company themselves at a modest price.[35] However, the introduction of affordable broadband Internet access caused the financial hurdles in transferring data via the Internet to disappear almost overnight, Oschwald stresses in our interview. Large-scale modifications were indeed undertaken in the new millennium, mainly to improve air circulation, the true Achilles heel of any data center, but also the security systems. SIAG leased from VBS part of a second, still operational, bunker 10 kilometers away in Zweisimmen. This facility, put into operation in 2003 and capable of withstanding even an electromagnetic pulse (EMP) in the event of a nuclear attack, serves as redundant storage of the encrypted customer data at the Swiss Fort Knox. While the former bunker facility of the redoubt airfield in Saanen relied until the turn of the millennium on air circulation to remove heat, SIAG turned to a cooling system in 2008 that feeds groundwater from a 30-meter-deep gravel bed into the facility and sends it back into the depths when it has absorbed heat. The search for a technical solution that Oschwald says should be "highly efficient, scalable, and environmentally sound" proved not to be very simple. The hunch of an advising engineer suggested that water was available underground that could be used for cooling.[36] Test drillings confirmed this and eventually formed the basis for installing two cooling stations that pump in 8 °C groundwater from the gravel basin of the valley into the bunker and then pump out the heated water 500 meters downstream. How "environmentally sound" this procedure actually is and whether usage rights are affected below ground remains unclear.

In the graphical representation of the Swiss Fort Knox, the subterranean cooling system is presented spectacularly. An illustration of a cross section of the mountain and the underground terrain shows the components of the gated security systems of the Swiss Fort Knox, the server rooms, emergency generators, and air-filtering equipment as well as the "sabotage-proof high-performance cooling system" that consists of two tubes that lead deep into a water reservoir depicted as a subterranean lake.[37] In current media reports about the Swiss Fort Knox, this ostensible "lake" is reproduced unquestioningly,[38] although it is in reality just groundwater that accumulates in the gravel bed beneath the Saane Valley. Even Oschwald himself refers explicitly to

35

"Das Datenmeer im Bergmassiv," *Berner Zeitung* (October 14, 2008). According to a report in the financial magazine *Cash*, the Mount10 Service AG was already insolvent at the time of its founding. On this, see "Ärger um Ende der Schweizer Datenfestung," *Computerwoche.de* (February 21, 2003), https://www.computerwoche.de/a/aerger-um-ende-der-schweizer-daten-festung,1056477 (retrieved July 8, 2020).

36

Interview with Christoph Oschwald, Saanen, March 19, 2019.

37

https://www.swissfortknox.ch/infografik.html (retrieved August 28, 2019).

38

See "Sicher im Berg," *Sonntags-Zeitung* (September 7, 2008); "Das Fort Knox der Daten," *Der Bund* (January 5, 2009); "Gewaltiger Geheimnisträger," in: *GEO Special: Alpen Kompakt*, 120.

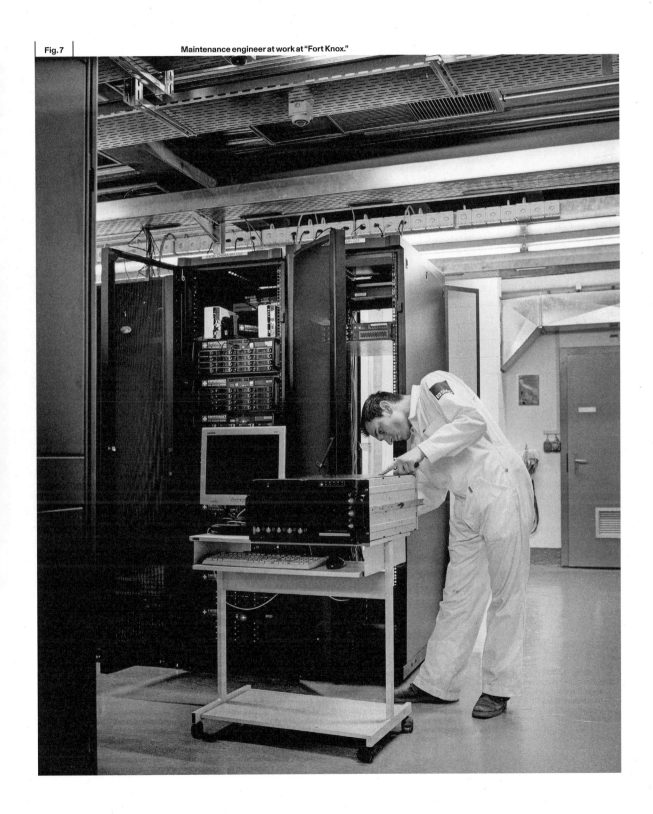

Fig. 7 Maintenance engineer at work at "Fort Knox."

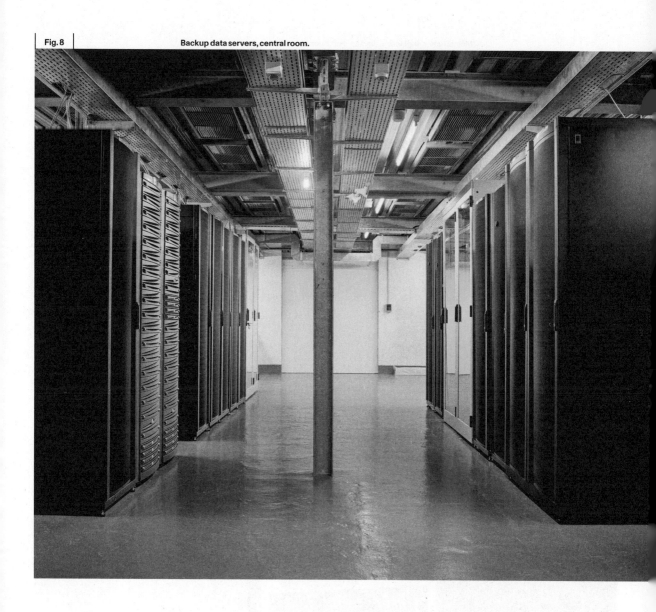

Fig. 8 Backup data servers, central room.

a lake when talking to the media: the bunker facility includes an "underground lake," he pointed out to the *Welt am Sonntag* newspaper in 2016.[39]

The illustration stylizes not only the cooling system, but also the mountain in which the data bunker is located, to great effect. The mountain is depicted as a tall, rugged massif with an impressive summit upon which satellite and radio communications equipment is perched. This representation cannot be reconciled with the rather unspectacular forested ridge found on site.

The Digital Time Capsule and the "New Gold"

Since 2015, ownership of the former Air Force bunker A1790 has been handed over completely to SIAG. The close linkage of the Swiss Fort Knox data center to the Swiss military's defense efforts during World War II, its linkage to persons, aircraft, and infrastructure of the Swiss Air Force during the Cold War, the exploitation of regional terrain, resources, and advantages of location of the remote luxury destination Gstaad/Saanen, all described in this essay, as well as the infusion of the data center with "Swiss" values, stories, and national symbols, seems to be paying off today. According to Oschwald, on the approximately 600 square meters available for data storage within the Swiss Fort Knox, corporate data from some 30 countries and approximately 40,000 servers are stored.[40] In 2008, according to the *Berner Zeitung*, clients included administrations, banks, and insurance companies, as well as small businesses and private individuals, yet only about 5 percent were large companies; of the remaining 95 percent, about two thirds were one-man businesses.[41] Storage of encrypted data inside the massif cost up to 100 Swiss francs a month, *Der Bund* reported. This made the data bunker a "luxury supplier among the data centers."[42] Oschwald, for his part, justified the price by citing the double security infrastructure and free customer support. The landing strip of the Gstaad-Saanen Airport, which was taken over by an airfield cooperative, is, according to Oschwald, an important part of the contingency plan for the Swiss Fort Knox: clients are able to retrieve a backup of their sensitive data by air.[43]

The data center houses not only the sensitive data of private individuals, however. For some years now, it also stores outmoded digital files and storage media. In May 2010, a consortium of European libraries, archives, universities, and corporations such as IBM and Microsoft brought a metal box named "Planets" to the bunker.[44] Its purpose is to preserve for posterity a selection of outmoded document formats and devices needed to store and view the data. "Planets" (Preservation and Long-Term Access through Networked Services) is, so to speak, a rescue mission for the global "digital

39

"In der Schatzkammer," in: *Welt am Sonntag*, November 27, 2016.

40

"Ein Panzerschrank im Bergmassiv," in: *Finanz und Wirtschaft*, August 22, 2018.

41

"Das Datenmeer im Bergmassiv," in: *Berner Zeitung*, October 14, 2008.

42

"Die Nummernkonten unserer Zeit," in: *Der Bund*, August 8, 2017.

43

Kappenberger 2016, p. 159.

44

See http://www.ifs.tuwien.ac.at/ dp/timecapsule/press/TimeCapsule_ Pressetext_180510.pdf; "Daten-Festungen im Schweizer Alpenmassiv," in: *swissinfo.ch*, July 5, 2010, https://www.swissinfo.ch/service/ search/ger/45809372?query= Daten-Festungen+im+Schweizer+ Alpenmassiv (retrieved July 30, 2020).

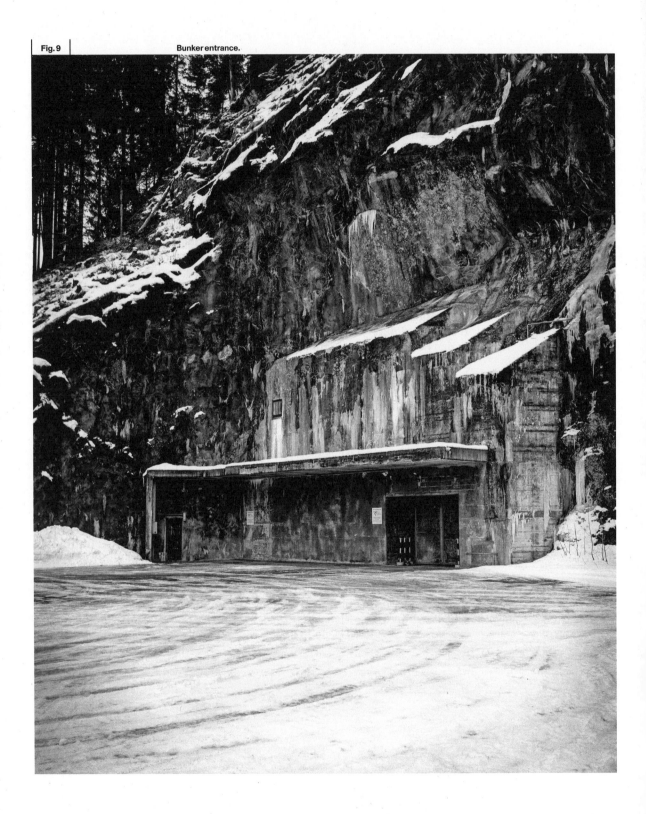

Fig. 9 Bunker entrance.

Fig. 10 A tower on the top of the vault for security and emergency exit. Former control tower.

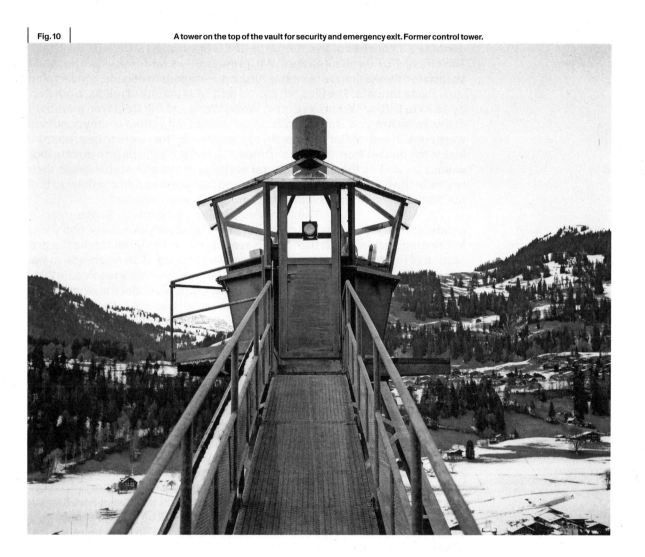

genome"; it consists of five formats—JPEG (image), HTML (website), Quick-Time (film), PDF (brochure), and Java (program)—as well as several thousand associated files which are to enable future generations to decode, convert, and view these formats. The files are stored on a wide variety of media, from floppy disks to DVDs.[45] Whereas during World War II and the Cold War, members of the Swiss Army, military aircraft, and classified data about enemy positions were considered "materials" worthy of preservation that were to be protected inside the bunker from all risks and hazards, today it's the data of private individuals as well as the digital cultural heritage of the planet that await their revival in the bunkered Swiss substrate and that will no doubt continue to fuel the "data bunker" as machinery of the imagination in the future.

The "Planets" project, with which Switzerland is establishing itself as a global repository for digital cultural assets, has some interesting parallels with the "Safe Haven" project. The latter tracks the protection of international cultural assets in Switzerland. With reference to the country's humanitarian tradition, the Swiss Federal Assembly resolved in 2014 that at a secure "place of safekeeping" in Switzerland, under the oversight of UNESCO, material cultural assets could be preserved that in their country of ownership are threatened by armed conflicts, catastrophes, or emergencies. A former Army munitions depot inside a mountain near Affoltern am Albis serves as a secure location for this purpose.[46]

The sun slowly sets on the Panorama Lounge of the operations center. Twilight bathes the site of the airfield in a warm glow. My thoughts remain with the name: Swiss Fort Knox. Its main purpose is to prevent a company from going bust as a result of vital data loss, Oschwald explains: "An essential business process called Data Defense."[47] This statement suits the recurring narrative of his company: data today is the most valuable commodity, the "new gold."[48] Whether real gold reserves such as in the eponymous Fort Knox in the US state of Kentucky are stored within the mountain is something Oschwald doesn't disclose. When the *SonntagsZeitung* reported rumors of a possible large-scale project for gold investors at the Swiss Fort Knox in 2010, he remained vague: "We won't rule out that we'll be giving more consideration to this idea in the near future."[49] To *Der Spiegel* in 2011, he remarked ambiguously, "If you're going to ask me about gold, you could just as well ask the Israeli army about the atomic bomb."[50] In the village of Saanen, people say that a bit more than data is stored inside the mountain. These statements are, of course, all off the record. Discretion and secrecy appear to remain intact. And thus I finish my water from Gstaad that my host has poured from a gold-plated faucet, and bid farewell.

45

Hung-Hui Hu, *A Prehistory of the Cloud*, Cambridge, 2015, p. 104; "Wie sich digitales Wissen aufbewahren lässt," in: *FUZO-Archiv*, http://www.fuzo-archiv.at/artikel/1648247v2 (retrieved August 29, 2019).

46

"Aus der Session," in: *Neue Zürcher Zeitung*, March 14, 2014; "Ein sicherer Hafen für Kulturgüter," in: *Neue Zürcher Zeitung online*, March 15, 2013, https://www.nzz.ch/schweiz/kulturgueterschutz-kulturgueter-save-haven-schweiz-1.18047556 reduced=true (retrieved July 30, 2020); Cornelia Wegerhoff, "Der sichere Fels bei Affoltern," radio segment in Deutschlandfunk Kultur, July 16, 2015; Barbara Inglin, "Bundesrat schlägt Alarm – die kleine Schweiz will das Weltkulturerbe retten," in: *Luzerner Zeitung*, March 8, 2019.

47

Interview with Christoph Oschwald, Saanen, March 19, 2019.

48

"In der Schatzkammer," in: *Welt am Sonntag*, November 27, 2016.

Acknowledgments

I'd like to thank Sascha Deboni for the valuable assistance provided in review-
ing sources and literature, organizing excursions, and recording and tran-
scribing interviews for this essay.

Yann Mingard's photography makes infrastructural spaces and structures visible. In the "Deposit" series, which
was published in book form, he photographed spaces in which data, material, and species are stored between 2009
and 2013, seeking access to archives and laboratories that are otherwise closed to visitors. In his project, the Swiss
photographer puts the unconditional belief in technology up for discussion. He photographs the architecture of
these deposits, the landscapes, the people who work in them, and the preserved objects, and captures the para-
doxical character of these places. Mingard's work is represented in collections, including the Fotomuseum
Winterthur. His work has been displayed in exhibitions at the Folkwang Museum in Essen, Germany; the Fotomuseum
in Antwerp, Belgium; and the Pasquart in Biel.

49

"Reduit für Reiche," in: *Sonntags-
Zeitung*, May 30, 2010.

50

"Almrausch und Höhenkoller,"
in: *Der Spiegel*, September 12, 2011.

Wait, My Data Goes Where?

Perceptions of a Secretive Industry as Revealed by a Representative Sample Survey

Renate Schubert
Ioana Marinica

We all rely heavily on data centers for carrying out our daily activities, from sending text messages to managing our finances, using social media, or storing our pictures. Yet are we aware of the fact that all of this information must ultimately be stored somewhere? Are people aware of the fact that data centers are involved in, for example, the route a text message follows from one's smartphone to that of the recipient? What do people actually know about data centers, their locations, basic functionality, and ownership? What are their perceptions of data security inside these facilities? And how do they feel about the privacy of their data? In this paper, we will give evidence-based answers to these questions.

The data center industry seems notoriously "blackboxed,"[1] meaning that the questions above are hard for the public but also for researchers to answer. Having been referred to as "invisible infrastructures,"[2] data centers and their involvement in the process of information transfer widely remain an enigma for at least two reasons. On the one hand, the data center industry itself makes an effort to keep its operations away from scrutiny, for reasons ranging from profit maximization to data privacy and national security. Even if this industry decides to publish some pictures of their physical infrastructures, little to nothing is revealed with respect to their software and processes. On the other hand, we all struggle with understanding how data travels, simply because of the lightning speed of the processes. Speed has turned information transfer into a highly abstract, invisible process that more often than not escapes human perception.[3] Data center companies' marketing strategy of calling the network of data centers "the cloud" just adds another layer of abstraction.[4] This paper explores which perceptions people report when prompted to actively consider data transfer processes in which they are often involved, with the ultimate goal of promoting a critical view of the industry's way of handling transparency.

We ran an online survey on a representative sample of the Swiss population[5] in order to answer questions pertaining to three main topics. First, we are interested in data center representation. We want to find out whether people can specifically indicate at least one data center. We are also interested in their opinions of what such a facility would look like and which types of data they think are stored inside. In a second thematic cluster, in light of the political and economic relevance of the subject matter, we cover questions related to the ownership of data centers. We are particularly interested in a potential discrepancy between who people believe run data centers and whom they would like to do so. Lastly, a third set of questions taps into people's perception of data security[6] with regard to data centers, as well as into their willingness to pay for security. We will relate this willingness to pay to people's privacy concerns.

1

Jennifer Holt and Patrick Vonderau, "'Where the Internet Lives': Data Centers as Cloud Infrastructure," in *Signal Traffic: Critical Studies of Media Infrastructure*, edited by Lisa Parks and Nicole Starosielski, Urbana et al, 2015, p. 74.

2

SHARE Foundation, "Invisible Infrastructures: The Exciting Life of Internet Packet." Share Lab, February 5, 2015, https://labs.rs/en/packets/ (retrieved January 7, 2020).

3

Ibid.

4

Holt and Vonderau 2015, p. 72.

5

823 respondents from the German-speaking part, 243 respondents from the French-speaking part, and 144 respondents from the Italian-speaking part.

6

Throughout the chapter, we use the terms "data security" and "data safety" interchangeably. Although there is a subtle difference in meaning between the two, it could not be preserved when translating the survey into German, French, and Italian. Both data security and data safety should be understood as protection against data loss, as well as against unauthorized access.

Is That a Data Center?

Given the fact that the Swiss population has not previously been subject to a prominent inquiry about the data center industry, we do not have a benchmark for our study. Our survey is performed on a representative sample of the Swiss population. Yet whether our results would resemble results from similar surveys performed in other countries or at an earlier point in time is unclear. Thus we cannot report on a tendency of improved or worsened insights of the Swiss population. Instead, we simply present a status-quo report, which hopefully might motivate other researchers to replicate the study either in another country or in a few years' time.

At the outset of our survey, respondents were provided with only a loose definition of what a data center is: "a data center is a facility housing computer systems." While participants received this definition in either German, French, or Italian, according to their place of residence, all respondents were additionally informed that these facilities are sometimes also called "data centers," using the English expression, even for Switzerland. Data centers were referred to using the term *Rechenzentren* in the German version of the survey, *centres de données* in the French version, and *centri di calcolo* in the Italian version. We purposely designed the definition in a way that did not nudge respondents into imagining a data center as a facility with specific predefined characteristics in terms of size, purpose, business model, and/or owner.

We then asked the respondents whether they know the name of a data center. If they did know one, they were prompted to specify it. We found that an overwhelming majority of the participants in our representative sample (76%) could not name a specific data center (see | Fig.1 |). People above the age of thirty-five, men, and residents of the Italian-speaking part are more likely to be able to name a data center than younger people, women, and residents of the other two parts of Switzerland. The difference between regions is particularly striking, with the probability of a resident of the Italian-speaking part knowing the name of a data center being four times as high as one of residents of the other regions.

Regarding the actual data center names that were to be provided by the participants, our expectations were modest. Since we knew that data center locations are oftentimes purposely obscured by the owners[7], particularly in the case of data centers run by private companies, we did not expect the respondents to provide us with accurate information about the facilities' official names

7

Holt and Vonderau 2015, p. 75.

Fig. 1
**Do you know the name
of a data center?**

Yes
16.1%

No
76.4%

don't know
5.1%

se

or precise locations. Indeed, as shown in | Fig.2 |, survey participants mostly named a company or institution that owns one or more data center facilities.

Going back to the particularly large regional difference in familiarity with a data center, the likely explanation for this finding is that the Italian-speaking part of Switzerland hosts what we found to be the most popular data center in Switzerland: the Swiss National Supercomputing Center (CSCS) in the city of Lugano. | Fig.2 | displays the names of the data centers that respondents mentioned.[6] Undoubtedly, CSCS enjoys the greatest popularity by far, followed by the Green and Swisscom facilities.

In addition, we presented our respondents with a series of pictures of buildings, asking them to indicate which of them they believe to host a data center. We included both pictures of actual data centers and pictures of buildings serving other purposes. The pictures were of a great variety: from structures resembling warehouses to churches and offshore facilities.

In general, people were found to hold stereotypical views on what a facility hosting a data center would look like. Unsurprisingly, our respondents were more likely to identify monolithic, warehouse-like buildings as data centers. These are the typical images that the industry giants release whenever they wish to advertise their facilities.[9] At the same time, participants did not identify more "exotic" settings, such as churches or abandoned offshore structures, as data center shelters. Yet the Uspenski Cathedral in the Finnish capital of Helsinki, for example, which was also shown to the respondents, actually hosts a data center inside its underground system of caverns.[10] Similarly, until 2006, a former anti-aircraft deck built off the coast of the UK during World War II hosted the servers of HavenCo, an anti-establishment company regarded in the early 2000s as a data haven.[11] Only 2.5% and 5% of our survey respondents identified the Uspenski and the HavenCo buildings, respectively, as facilities hosting data centers.

We also found that Swiss people are familiar with the outward appearance of one of the Green data center buildings. Seventy percent of the respondents in our sample were able to recognize the building as a facility serving data center purposes when faced with the series of images.

People's familiarity with the particular Green data center picture they were shown might be attributed to two main factors. First, the company owning this particular facility (Green. ch) is one of the largest Internet service providers in the country and might therefore be more visible than data centers hosting rather "invisible" services such as business-to-business or business-to-customer data storage and processing. Most likely, it is the Internet, telephone and television bundles offered by

8

Responses were manually aggregated for the cases in which participants refer to the same facility under different names. For example, the Swiss National Supercomputing Centre (CSCS) also appears in the responses under the names Centro di Calcolo Lugano, Centro Svizzero di Calcolo Scientifico, and simply Lugano. Responses were also translated, where necessary, from either German, Italian, or French into English.

9

See, for example, Holt and Vonderau 2015, p. 75, and A.R.E. Taylor, "The Data Center as Technological Wilderness," *Culture Machine*, vol. 18 (2019), https://culturemachine.net/vol-18-the-nature-of-data-centers/the-data-center-as/ (retrieved January 10, 2020).

10

"ABB Provides Power Distribution for 'World's Most Energy Efficient' Data Center," https://www.digitimes.com/news/a20111221PR201.html?chid=9 (retrieved May 4, 2020).

11

Adi Robertson, "Sealand's Failed Data Haven: Why HavenCo Was Doomed from the Start," *The Verge* (March 28, 2012), https://www.theverge.com/2012/3/28/2909303/sealand-havenco-doomed-data-haven-history (retrieved August 30, 2019).

32
green

13
swisscom

7
google

5
bedag, ibm, swift

4
cdrom, cern, gais, oiz, six, ubs

tahub, eth, infomaniak, kantonale verwaltung, uni

xas, amazon, apple, avaloq, brainserve, facebook, interxion, iwb, postfinance, rtc, swiss~fort~knox, titanic

a, agno, aruba, athenry, bancadati, bank, bbt, birrfeld, bison, brugg, bussigny, centris, cervellone, ciges, ckw, cpu, datacenter, dataroom, datawire, alde, equinix, globaz, gondo, hard, icloud, itris, iway, k20, luzern, moresi, nestle, netrics, novartis, ovh, reso, rrzn, safehost, schurter, shelter, st. gallen, cation, vrsg

the company that boost its popularity, including as a data center provider, since these bundles are directly used by and are useful to the broader public. Second, Green facilities may have benefited from media coverage at the time, when the company was bought for several hundred million Swiss francs.[12] The importance of media coverage and marketing to people's perception of firms is also manifested by the fact that 70% of our respondents identified correctly that a processing facility owned by a renowned Swiss manufacturer of cough drops is not hosting a data center.

Is That Where My E-Mails Go?

In addition to people's ability to name specific data centers and identify them visually, we also inquired into which types of information respondents think is stored inside such facilities. | Fig. 3 | shows the possible responses provided: banking data, e-mails, geolocation information, medical data, social media data, surveillance camera footage, governmental archives, and data recorded by telecom companies such as text messages, which are not transmitted via the Internet. The most striking observation was that about 50% of the respondents did not believe that e-mails and social media data are being stored inside data centers.[13] Yet the question of where they thought such information was actually being stored remains open. At the opposite end of the spectrum, a majority of respondents correctly answered that one can find banking data and governmental archives in data centers. Equally noteworthy is the fact that a non-negligible 7% of survey participants declared that they did not know which kind of information data centers are hosting.

The public's lack of knowledge about information storage inside data centers does not come as a surprise. As already mentioned, the respective industry is not transparent about what it is doing in data centers, and the high speed of data processing further contributes to the lack of transparency to the broader public.

12

"Green.ch bekommt einen neuen Besitzer," *Neue Zürcher Zeitung* (December 1, 2017), https://www. nzz.ch/wirtschaft/greench-bekommt-einen-neuen-besitzer-ld.1334572 (retrieved August 30, 2019).

13

Older people, less educated people, women, and residents of the Italian-speaking part of Switzerland were slightly overrepresented in this group.

Fig. 3

Which of the following types of information do you think are being stored inside data centers?

Governmental
archives
82%

Banking data
76%

Medical data
65%

Telecom data
62%

Surveillance camera footage
59%

Social media data
56%

Geolocation data
50%

E-mails
49%

Multinational corporations
82%

Multinational corporations
44%

Federal authorities
81%

Federal authorities
79%

Universities
66%

Universities
61%

Cantonal authorities
51%

Cantonal authorities
47%

Local companies
43%

Local companies
36%

Local authorities
18%

Local authorities
19%

Others
11%

Others
6%

Fig. 4
**Who do you think runs
and who do you think
should run data centers
in Switzerland?**
■ Who runs DCs
☐ Who should run DCs

It's the Corporations!

Concerning the public perceptions of data centers, another aspect we explored was the question of ownership. Who do people think runs data centers in Switzerland? Whom would people want to run data centers? Is there a discrepancy between the two sets of entities?

The results of our inquiry are reported in | Fig. 4 |. Respondents among our representative sample believed that data centers are mostly run by multinational corporations, the government, or universities. More strikingly, the respondents were not happy with multinational firms operating data centers. Only half of the respondents who thought that data centers are run by multinational corporations also supported the idea that corporations should do so. In contrast, people generally seemed happier with federal authorities and universities running data centers.

Most data centers in Switzerland are, in fact, run by private Swiss companies. Nevertheless, a large share of the data traffic going in and out of the country is ultimately hosted on servers abroad, in which these companies hold shares. This may entail additional security risks, and these risks might become even more relevant in the future. With such firms as Amazon Web Services (AWS), Google, and Microsoft already having stated their intention to open local facilities in various countries, there is no guarantee that Swiss companies will manage and control the storage of Swiss data in the future.[14]

The Swiss public cloud market is dominated by AWS, Microsoft, SAP, and Google. From 2013 to 2017, it grew by 35% on an annual basis, reaching 1.3 billion Swiss francs in 2017. Companies save millions in infrastructure by outsourcing their computationally intensive processes to cloud providers. Hence, cloud corporations are likely to step up their efforts to convince even more Swiss companies to store and analyze data on their servers, be they Swiss-bound or located in a different country.[15] However, switching from a company's own servers to the cloud also implies opportunity costs. For instance, larger companies have to additionally incur the costs of selling or retiring their own data storage and processing facilities before switching to the public cloud. Yet for startups that have never run their own data centers, cloud storage seems to be a sound decision.[16]

In addition to opportunity costs, there is another issue with the adoption of cloud storage in Switzerland: the shared perception among cloud providers appears to be that Swiss companies value local data storage more than their counterparts in other countries.[17] However, our sur-

14

Bastian Heiniger and Karen Merkel, "Die Schweizer Cloud-Pläne von Amazon, Google und Microsoft," *Handelszeitung* (March 11, 2019), https://www.handelszeitung.ch/digital-switzerland/die-schweizer-cloud-plane-von-amazon-google-und-microsoft (retrieved August 30, 2019).

15

Heiniger and Merkel 2019.

16

Zero Cool, "Oil is the New Data," *Logic*, no. 9 (2019), https://logicmag.io/nature/oil-is-the-new-data/ (retrieved January 8, 2020).

17

Heiniger and Merkel 2019.

vey responses paint a different picture for individual data owners. Only one third of Swiss citizens would, for instance, be prepared to pay a monthly commission for their banks to store their financial data at a Swiss data center and not at a data center located in a different country. By comparison, 42% would pay a commission for their data to be stored under "safer conditions."

At the global level, opportunity costs are the main reason why the cloud providers have so far managed to capture only 30% of the total addressable market.[18] Nevertheless, the public cloud services market is forecast to total USD 266.4 billion in 2020. That is a 17% increase in revenue compared to the previous year, driven mostly by modern applications and workloads demanding standards of infrastructure that traditional data centers can no longer meet.[19]

Worldwide, there is already evidence of a concentration of power in the hands of a few players. Their servers have already begun to host even critical public sector data. In the United States, for example, the CIA, the Department of Defense, and the Federal Reserve employ the services of AWS[20] for storing their relevant data. Recently, this has become a matter of public and even electoral debate. US presidential candidate Bernie Sanders picked up on the topic as part of his 2020 campaign, advocating government regulation of Internet providers and universal access to the Internet as a public good.[21] Similarly, in the UK, the Labour Party promised in 2019 to ensure free, universal broadband access, funded by a new tax on tech giants, should the party win the general election.[22]

But Is My Data Safe?

In our survey, we also investigated the participants' perceptions of data security and protection inside data centers. | Fig. 5 | displays the answers to the question "Would you say your data is rather safe or rather unsafe inside data centers?" Participants believed their data to be relatively safe, with the mean of responses situated at 6.3 on a scale from 0 to 10, where 0 means very unsafe and 10 means very safe. Nevertheless, 10% of the respondents, with twice as many women than men, admit that they simply do not know how safe their data actually is. Relating these findings back to the results in the previous section, it appears that people might have reasons other than security for wanting to see limits on the power of international corporations. Disapproval of an international corporate monopoly on data remains a possible, albeit untested, explanation.

18

Cool 2019.

19

Gartner, Inc. "Gartner Forecasts Worldwide Public Cloud Revenue to Grow 17% in 2020." Press release, November 13, 2019, https://www.gartner.com/en/newsroom/press-releases/2019-11-13-gartner-forecasts-worldwide-public-cloud-revenue-to-grow-17-percent-in-2020 (retrieved January 21, 2020).

20

Holt and Vonderau 2016, p. 84.

21

Cat Zakrzewski, "The Technology 202: Bernie Sanders Just Made Internet Providers a New 2020 Target," *The Washington Post* (December 9, 2019), https://www.washingtonpost.com/news/powerpost/paloma/the-technology-202/2019/12/09/the-technology-202-bernie-sanders-just-made-internet-providers-a-new-2020-target/5ded5991602ff1440b4ddcdb/ (retrieved January 10, 2019).

22

Mark Scott, "Labour Wants to Nationalize Broadband. Be Careful What You Wish for," *Politico* (November 15, 2019), https://www.politico.eu/article/labour-party-nationalization-broadband-internet-infrastructure-jeremy-corbyn/ (retrieved January 10, 2019).

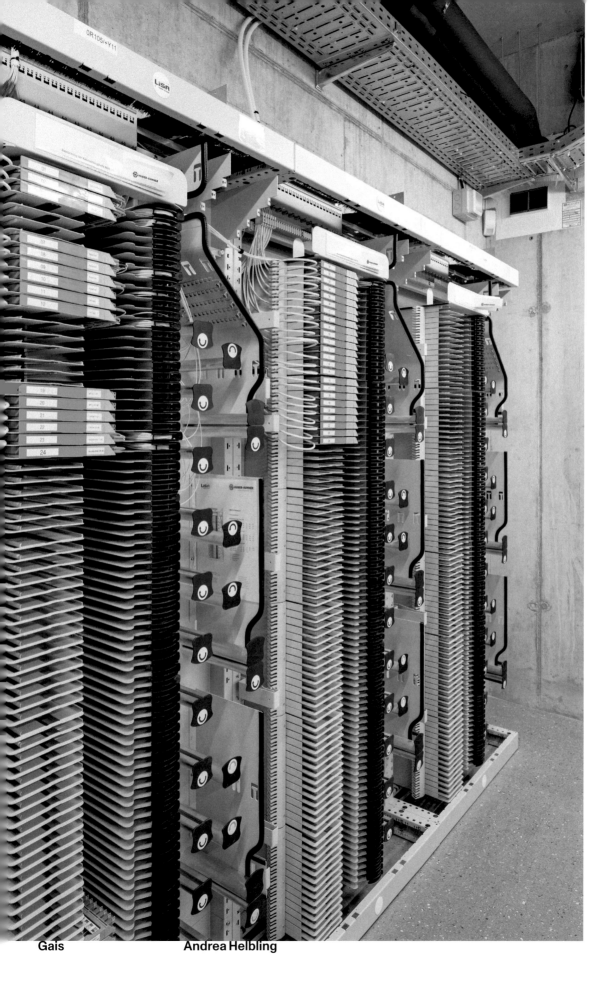

Gais Andrea Helbling

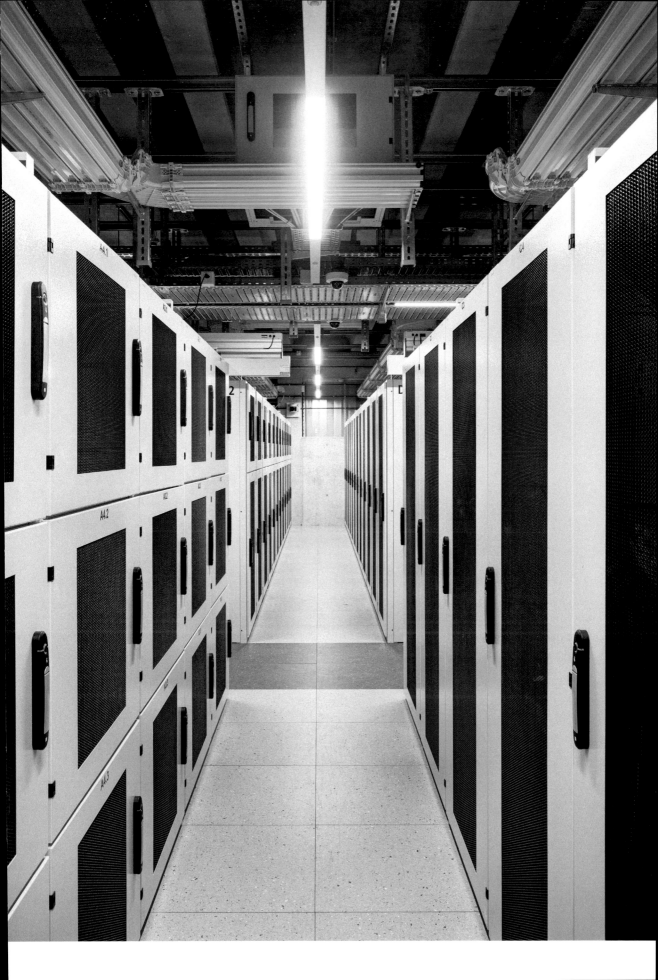

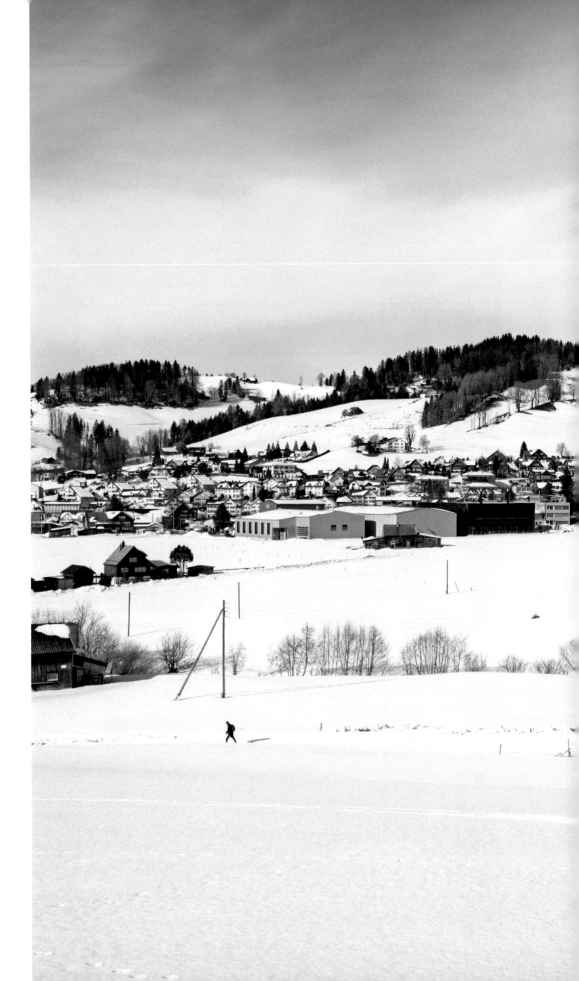

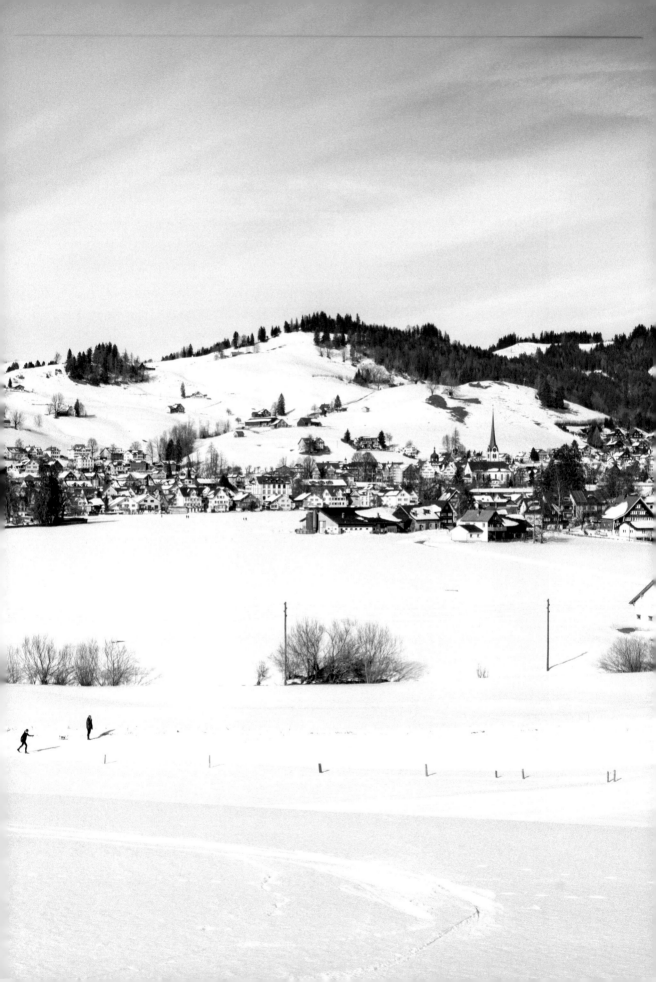

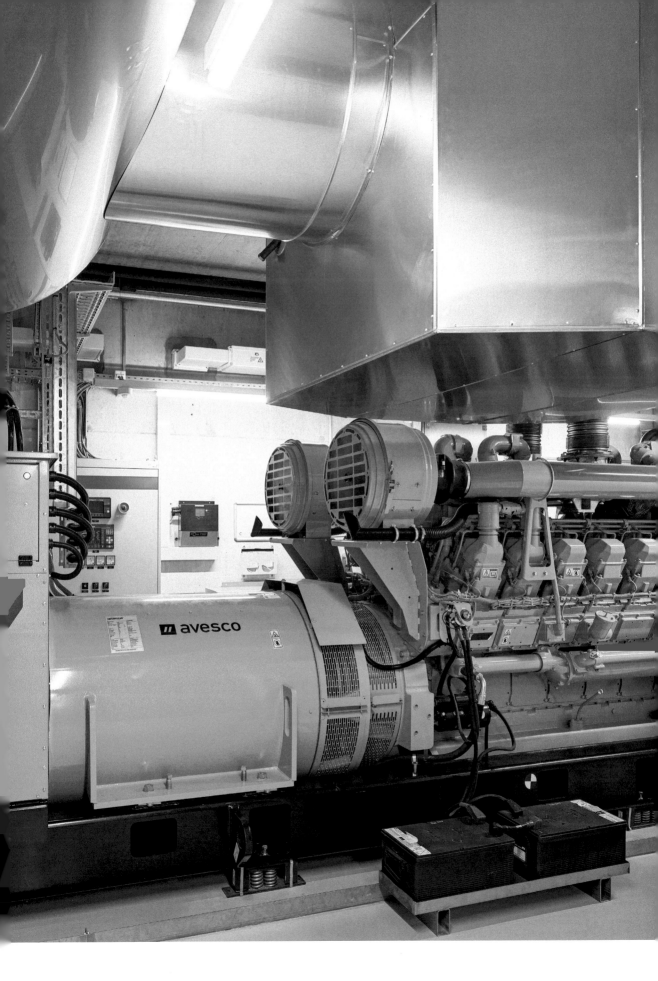

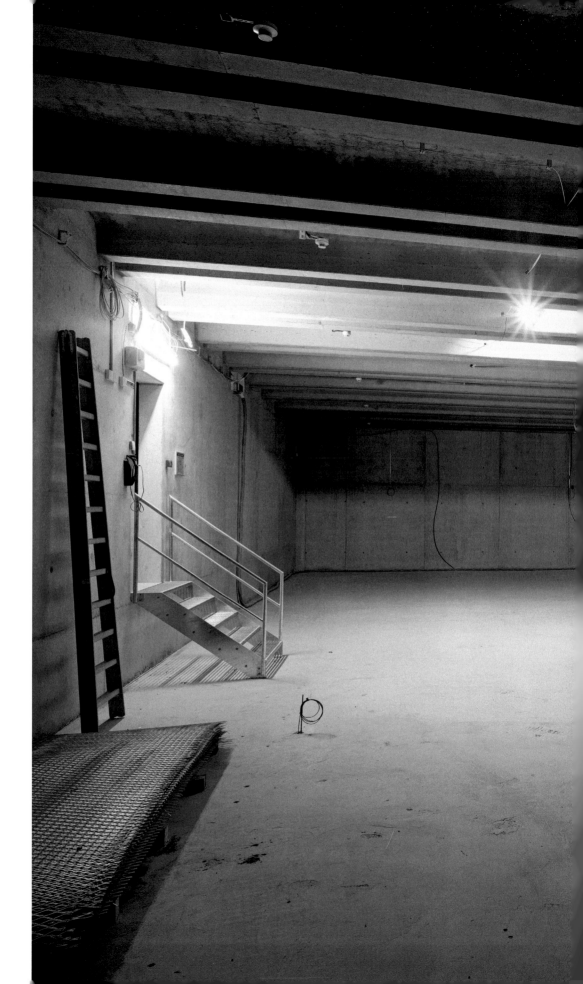

Diving deeper into demographic differences, we found that people under 35, the so-called "digital natives," show higher levels of concern with respect to safety. As ⎸ Fig. 6 ⎸shows, their estimate of data privacy inside data centers tends to "unsafe," whereas people who are older than 65 tend to be more trusting. On the same scale from 0 (my data is very unsafe) to 10 (my data is very safe), the mean value for the under-35 group is 6, that for the over-65 group is 6.75, and that for the remaining respondents, aged between 35 and 65, is 6.26.

At the same time, higher levels of concern do not translate into a greater willingness to pay for improved security measures. We asked our survey participants the following question: "If you had the option, would you be willing to pay a higher commission to your bank so that it stores your financial information in a data center which has certifiably higher data safety standards? If so, how much would you be willing to pay per month?" As many as 42% of our respondents would be willing to pay a commission for improved data safety. The average amount they would be prepared to pay is 9.7 Swiss francs (approximately USD 10) per month, with a minimum of 1 and a maximum of 200 francs.[23]

As shown in ⎸ Fig. 7 ⎸, people younger than 35 are the ones willing to pay the least for storing their financial information in data centers with high security standards, despite the fact that their income[24] is not lower compared to that of the other age groups. At first glance, this result seems inconsistent—we saw above that they are the population group most concerned about security. Yet evidence of such inconsistent behavior is ubiquitous when it comes to data privacy. In the literature, this phenomenon is known as the "privacy paradox."[25] The privacy paradox refers to the disparity between people's self-reported privacy concerns and their actual behavior with regard to privacy. People frequently claim to be very concerned about the privacy of their data, and yet they continue to reveal personal information for even the smallest rewards.[26]

Previous studies provide additional evidence of precisely the inconsistency between concerns and willingness to pay for safety which we found in our data. Athey et al, for instance, analyze the behavior of digital natives. They observe that when choosing between different cryptocurrency wallets, individuals default to the option listed first, regardless of that option's guarantees of privacy and regardless of the individuals' previously stated privacy concern levels. Options offering enhanced privacy but appearing further down the list are not chosen even if the additional cost of better privacy is very small: essentially, merely reading one more line of text.[27] Similarly, in another experiment featuring

23

An outlier of CHF 1,000 has been removed from the analysis.

24

Income was measured at household level.

25

Barry Brown, *Studying the Internet Experience*, Publishing Systems and Solutions Laboratory, HP Laboratories Bristol, HPL-2001-49, 2001, 1.

26

Despite the ubiquity of the privacy paradox, we cannot fully exclude the possibility that digital natives' low willingness to pay might actually be related to them having less disposable income. Unfortunately, we are not in a position to formally test this hypothesis due to the lack of availability of data.

27

Susan Athey et al, *The Digital Privacy Paradox: Small Money, Small Costs, Small Talk*, NBER Working Paper no. 23488 (2017), p. 12.

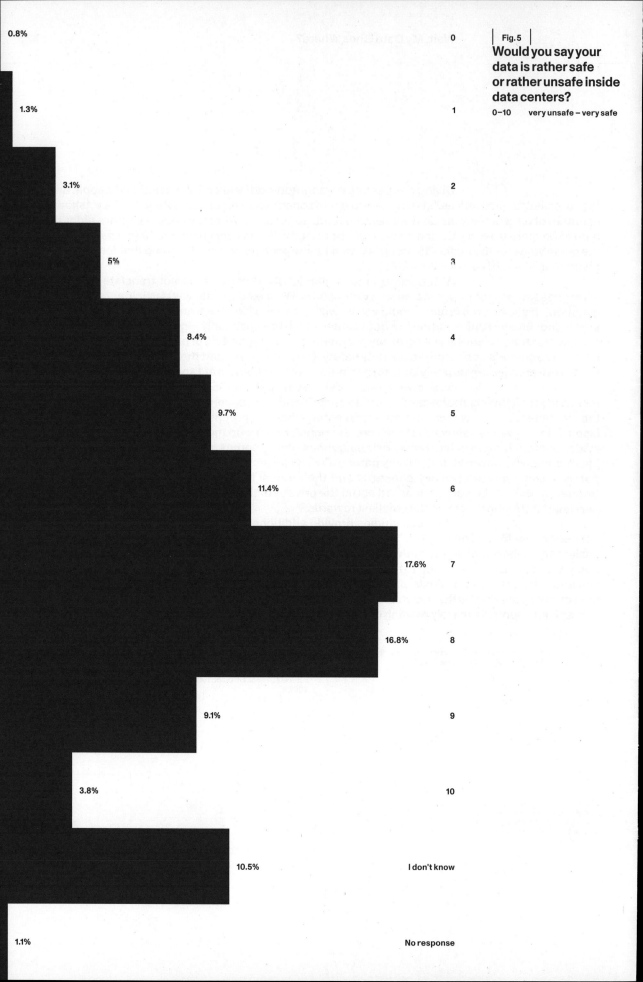

0.8% 0

| Fig. 5 |

**Would you say your
data is rather safe
or rather unsafe inside
data centers?**

0–10 very unsafe – very safe

1.3% 1

3.1% 2

5% 3

8.4% 4

9.7% 5

11.4% 6

17.6% 7

16.8% 8

9.1% 9

3.8% 10

10.5% I don't know

1.1% No response

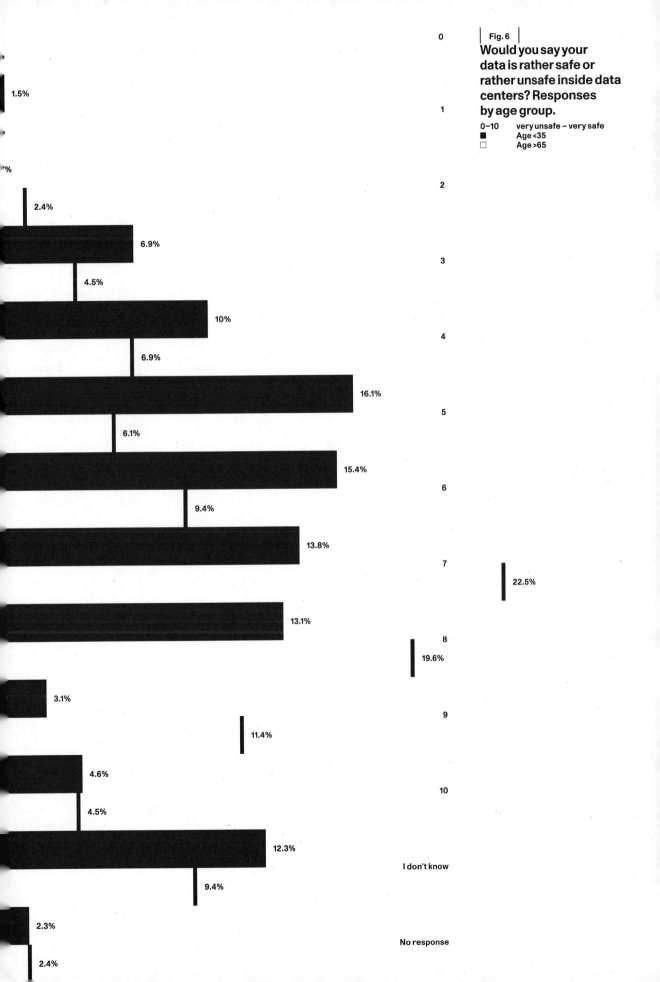

Fig. 6

Would you say your data is rather safe or rather unsafe inside data centers? Responses by age group.

0–10 very unsafe – very safe
■ Age <35
□ Age >65

0

1.5%

1

2.4%

6.9%

4.5%

2

10%

6.9%

3

16.1%

6.1%

4

15.4%

9.4%

5

13.8%

6

22.5%

13.1%

7

19.6%

8

3.1%

11.4%

9

4.6%

4.5%

10

12.3%

I don't know

9.4%

2.3%

No response

2.4%

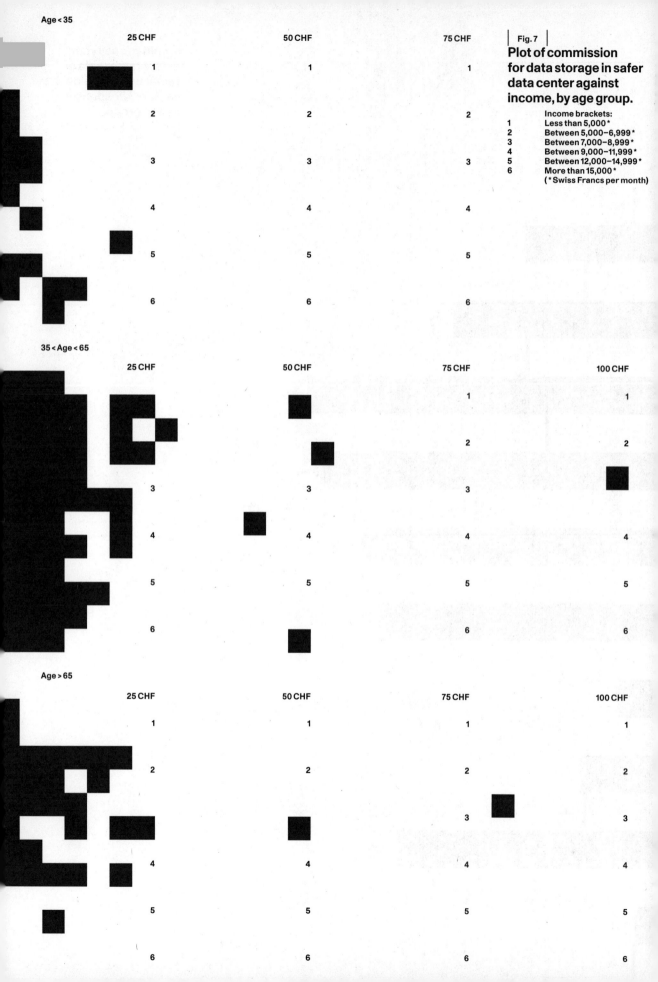

Age < 35

| 25 CHF | 50 CHF | 75 CHF | Fig. 7 |

Plot of commission for data storage in safer data center against income, by age group.

Income brackets:
1 Less than 5,000*
2 Between 5,000–6,999*
3 Between 7,000–8,999*
4 Between 9,000–11,999*
5 Between 12,000–14,999*
6 More than 15,000*
(*Swiss Francs per month)

35 < Age < 65

| 25 CHF | 50 CHF | 75 CHF | 100 CHF |

Age > 65

| 25 CHF | 50 CHF | 75 CHF | 100 CHF |

young participants who profess a strong interest in privacy protection, Beresford et al found that people reveal their monthly income in order to obtain a price discount as low as one euro when making an online purchase.[28] In other words, adding even a very small cost to individuals' decisions can divert people's privacy choices towards reduced privacy standards, even though they actually prefer higher standards.

It is interesting to see that residents of the French-speaking part of Switzerland have higher levels of concern compared to their German- and Italian-speaking counterparts. Nevertheless, their willingness to pay for increased data safety is lower than that of the residents of the other two regions, regardless of their income. This difference might be linked to a general tendency of French-speaking Swiss to strongly rely on government measures.[29] It seems possible that a francophone Swiss would be reluctant to pay for improved data safety standards out of his or her own pocket not because he or she does not deem data protection important, but because he or she expects the government to regulate companies in order to enforce appropriate data security measures.

The size of the commission that people would be prepared to pay for improved data security, including data privacy, does not appear to be related to their income. Somewhat surprisingly, people in the lower income brackets, for whom one would expect that expenses related to data privacy are not necessarily a priority, are willing to pay more or less the same amount as people in the upper income brackets (see| Fig. 7 |).

Discussion

Our findings shed some light on the Swiss population's perceptions of what data centers are, what they do, and whom they should belong to. They also provoke a series of further questions that would be worth exploring in future analyses.

People's knowledge of the existence of specific facilities as well as their understanding of data centers' functionality seem to be limited. This is at least in part due to the data center industry's lack of transparency. It is interesting to ask whether individuals need to have (extensive) knowledge of the structure of this sector. Almost instinctively, and along the lines of the "knowledge is power" mantra, one would answer "yes." Data centers host and process information of utmost sensitivity, such as medical data or financial information, with potentially crippling consequences should it land in the wrong hands, be lost, or be made public. Hence, the manner in which such information is handled should be of prime interest to all citizens. Yet research has shown that people, even when provided with sufficient

28

Alastair R. Beresford et al, "Unwillingness to Pay for Privacy: A Field Experiment," *Economics Letters* 117 (2012), p. 26. For an exception to this pattern of findings see Janice Y. Tsai et al, "The Effect of Online Privacy Information on Purchasing Behavior: An Experimental Study," *Information Systems Research* 22, no. 2 (2011), p. 264. In their experiment, people were willing to pay a premium in order to purchase from online stores that would better protect their privacy. However, their sample does not focus on digital natives only, but is drawn from the general population.

29

Christophe Büchi, "Das gewisse Etwas," *Neue Zürcher Zeitung* (July 14, 2016), https://www.nzz.ch/schweiz/sprachgrenze/die-deutschschweiz-und-das-welschland-das-gewisse-etwas-ld.105611 (retrieved August 30, 2019).

information, do not always make rational decisions, but instead sometimes make choices that may have suboptimal consequences for themselves and for society.[30] Indeed, the coexistence of people's great willingness to accept small rewards in exchange for private information and their low willingness to pay to protect their data seems to generate a real conundrum, since the same people show great concern about violations of privacy.

If we think that individuals should retain autonomy and be in a position to protect the privacy of their data in the long run, novel ways of delivering data protection education could be a way forward. It seems worthwhile to invest in early education aimed at making consumers aware of the long-term consequences associated with the short-term benefits gained by giving away personal data. Both privacy-focused and environmental studies have shown that there is insufficient detailed information about current decisions. In this sense, there might be value in overemphasizing future risks in order to counteract consumers' myopic behavior of ignoring future consequences. Yet studies in the area of the environment in particular show that better information seems necessary but not sufficient for more rational decisions. Hence, using means such as nudging, which have the advantage of guiding people toward more rational decisions while leaving them the freedom of choice, could be a viable alternative. For example, people could be nudged into better protecting the privacy of their data by having the privacy settings on their mobile and Web apps being set to the most protective level by default. People could opt out of this strong privacy protection, but would not have to invest time or energy to be better protected.

Moreover, there is a necessity for more thorough discussions about who should be held responsible for ensuring data security and protection inside data centers. The data center industry's culture of secrecy is undoubtedly problematic from the consumer's perspective, yet it is aligned with these companies' economic interests. Unless the industry faces more pressure from either consumers or governmental forces, a paradigm shift is unlikely to happen. Thus far, there is little in the way of these companies carrying on with their opaque practices. Legislation lags behind technological development, governments are interested in cooperating with these firms, and consumers readily trade the safety of their personal data in exchange for discounts.

30

Athey et al 2017, p. 14.

Conclusions

In a world in which most activities inevitably connect us to a blackboxed data center industry, it is highly relevant to find out what people think happens to their data once they click "Send," "Upload," or "Yes, I agree to my data being processed." To this end, we empirically studied Swiss people's perceptions of what data centers are, what types of data are being stored inside, who runs them, and how safe the data is once it is hosted on data centers' servers.

Surveying a representative sample of 1,210 Swiss citizens revealed that most respondents hold broadly realistic views of what a data center building looks like, namely like a monolithic, warehouse-like structure. Only a tiny minority of respondents (16%) could name a specific data center, while half of the participants did not think information such as e-mails or social media data were stored in such facilities. Swiss citizens would like to greatly limit data center ownership by corporations; they also tend to think that the safety of their stored data is rather high. Only one age group shows relatively high levels of concern when it comes to data privacy: the "digital natives." However, in a perfect exemplification of the privacy paradox, the highly concerned people prove at the same time to be the ones with the least willingness to pay for improved safety standards.

Are paradoxical behavior and a lack of knowledge about digital infrastructures' functionality problematic? If individuals' privacy is at stake, it would be hard to argue otherwise. Yet taking into account that processing and storage of data is complex, opaque, and rapidly changing, consumers cannot be expected to have near-perfect knowledge of the data center industry. Once the data center industry becomes more transparent about its practices and governmental bodies more strongly prioritize the public interest, consumers might become better able to make more rational decisions related to processing and sharing data. More rational decisions could yield a higher level of welfare in this area.

The figures in this chapter have been stylized, leading to minor deviations from their statistically accurate version. The readers are welcome to contact the authors to request a copy of the data used for creating the graphs.

Scherwin M. Bajka

is a research associate and doctoral candidate at the University of St. Gallen (GOVPET Leading House). He received his master's degree in political science from the University of Zurich in 2019. Throughout his studies, he specialized in the fields of international political economy and statistics while working as an intern for the statistics unit of the Swiss National Bank and as a research assistant at the Collegium Helveticum (ETH Zurich) and the Immigration Policy Lab (ETH Zurich & Stanford University). He is particularly interested in the effects of globalization, digitization, and migration on labor market integration as well as in the interrelationship between education and political behavior.

Silvia Berger Ziauddin

teaches as an assistant professor of history at the University of Bern. In August 2020 she will assume the chair of Swiss and Contemporary History at the University of Bern. She has researched and taught at the University of Zurich, the Federal Institute of Technology Zurich, the Max Planck Institute for the History of Science in Berlin, the University of Basel, and Columbia University in New York City. In 2019, she finished the manuscript of her second book, entitled *Überlebenszelle, Territorium, Bordell. Bunker/Schweiz im nuklearen Zeitalter*. Her research interests include the transnational history of Switzerland in the Cold War, the historical anthropology of gendered spaces and emotions, the history of knowledge, the underground, vertical perspectives, mobilities and resources (nineteenth – twenty-first century), the history of civil defense, and the history of epidemics in the nineteenth and twentieth centuries.

Sascha Deboni

has been a student assistant at the Collegium Helveticum since 2018. He is currently pursuing a bachelor's degree in general history at the University of Zurich. His research interests include the history of right-wing movements and political think tanks. With his minor in computer science, he is interested in the technical as well as social aspects of digital and interconnected data and its infrastructure.

Monika Dommann

is a professor of modern history at the University of Zurich. She has researched and taught at the International Center for Cultural Technology Research and Media Philosophy (IKKM) in Weimar, the German Historical Institute (GHI) in Washington, the Max Planck Institute for the History of Science in Berlin, and elsewhere. Topics in Dommann's research and teaching are the intertwining of the Old and New Worlds (especially Europe, North America, and the Caribbean); media, economic, and legal history; the history of knowledge and science; and the methods of historical science. Her particular focus is on the history of material cultures, immaterial goods, logistics, and data centers.

Kijan Espahangizi

is a historian and scientific coordinator at the Center for the History of Knowledge (ETH & University of Zurich). He studied physics and history at the University of Cologne (Germany) and the University of Seville (Spain). He received a Ph.D. in history of science and technology from the ETH Zurich in 2011. He teaches at the History Department of the University of Zurich. His recent research has been on the history of the concepts of migration and integration after World War II, with a focus on knowledge production. He has been a member of the German Council on Migration since 2015 and has collaborated with the IMISCOE Standing Committee on Reflexivities in Migration Studies since 2019. He is also cofounder of an independent "post-migrant think & act tank" called Institute New Switzerland (INES).

Andrea Helbling

is a photographer who specializes in architecture. She does photography for architectural offices, magazines, and the public sector in the field of building construction and civil engineering. Her images are published in books, trade journals, and magazines. Helbling is also a freelance architectural photographer who pursues her own independent photographic projects under the name Arazebra. In 2017, the monograph *Representatives of the House*, which included images from her long-term "Houses and Conglomerates" project, was published by Scheidegger & Spiess. She is represented by these images in the collection of Fotostiftung Schweiz. Also in 2017, she received the Swiss Photo Award in the category of architectural photography. She completed her training as a photographer at the Schule für Gestaltung Zürich (now Zurich University of the Arts) in the specialist class for photography from 1987 to 1991.

Lena Kaufmann

is a postdoctoral researcher at the Department of History and an associate lecturer at the Department of Social Anthropology and Cultural Studies (ISEK), both at the University of Zurich. She studied social anthropology and China studies in Berlin, Rome, and Shanghai, before obtaining her Ph.D. in anthropology in Zurich. She has been a consultant in Sino-German development cooperation and a research and teaching assistant at the University of Zurich's Ethnographic Museum. Lena Kaufmann has spent nearly four years in the People's Republic of China and is a founding member and deputy speaker of the German Anthropological Association's China working group. Regionally, her research focuses on both mainland and transnational China. Thematically, she engages with the anthropology of technology, work, digital infrastructures, and migration.

Marc Latzel

was born in 1966 and lives and works in Zurich. His works are published internationally. After earning a Matura Type B in Zurich in 1986, he studied photography at the Ecole des Arts Appliqués in Vevey from 1989 to 1993. From 2000 to 2005 he was a member of the Lookat Photos agency, and from 2004 to 2009 a founding member of the lookatonline.com agency. Since 2008 he has led workshops at the Centre d'Enseignement Professionnel in Vevey (CEPV), from 2006 to 2008 at the Ecole Cantonale d'Art de Lausanne (ECAL), and since 2009 at the Swiss Media Training Centre (MAZ), Lucerne. Since 1995 his career has produced numerous exhibitions and awards. In 2011 he held a scholarship from the Landis & Gyr Cultural Foundation in London, and in 2015 he was honored in the context of the European Architectural Photography Prize. He has been part of the 13photo photo agency in Zurich since 2015 and head of the F+F specialist photography class since 2020.

Moritz Mähr

is a research assistant at the Chair of the History of Technology at ETH Zurich and at the Collegium Helveticum. He studied history and the philosophy of knowledge, computer science, and banking and finance in Zurich and Berlin. He is currently working on a dissertation on the history of information privacy and on the digitization of the migration authorities in Switzerland. This study is part of the SNF-funded "Trading Zones" project. His research interests include computer history, migration studies, and digital history. He is an advocate of open access and open source.

Ioana Marinica

is a scientific collaborator at the Collegium Helveticum. She holds a master's degree in comparative and international studies from ETH Zurich and the University of Zurich. In her previous affiliation with the National University of Political Studies and Public Administration in Bucharest, she was involved in research projects on electoral behavior and contributed to the first Romanian edition of a behavioral economics handbook. Most recently, Ioana Marinica conducted large-scale experimental and survey-based analyses of privacy concerns and privacy behavior. She is particularly interested in the privacy implications of human-technology interaction.

Fatih Öz

is a risk analyst at the Swiss National Bank and a co-lecturer on commodity trading at the University of Zurich. He received his bachelor's degree in banking and finance from the University of Zurich. He contributed to Prof. Schubert's fellowship project "Who Owns Data? The Possibilities and Implications of Enforceable Property Rights" at Collegium Helveticum. Currently, Fatih Öz is finalizing his master's thesis in banking and finance/quantitative finance at the University of Zurich. His main interests are economics and technology.

Hannes Rickli

is a visual artist who has held a professorship at the Zurich University of the Arts since 2004. Born in Bern in 1959, Rickli studied photography, the theory of art and design, and media art in Zurich and Karlsruhe. From 1988 to 1994, he was a freelance photographer for various newspapers and magazines. Since 1991, he has staged visual art exhibitions in Switzerland and abroad. In 2004, the Swiss Federal Office for Culture awarded him the Meret Oppenheim Prize. His teaching and research focus is on the instrumental use of media and space as well as media ecology. His research project "Computer Signals: Art and Biology in the Era of Digital Experimentation," 2012–2015 and 2017–2021, was funded by the Swiss National Science Foundation (SNSF).

Giorgio Scherrer

is a graduate student of contemporary history and political science at the University of Zurich. His interests include the history and political economy of higher education as well as global and media history. He was a research assistant on the "Digital Infrastructures" project at Collegium Helveticum (ETH Zurich, University of Zurich, University of the Arts Zurich) from 2017 to 2018. He also works in the newsroom of Swiss Radio and Television (SRF) and as a freelance journalist.

Renate Schubert

is a professor of economics at ETH Zurich and a principal investigator at the Singapore ETH Center (SEC) in Singapore. She did her doctoral dissertation at the University of Tübingen and her habilitation at the Technical University of Darmstadt. For many years, she was a jury member at the Swiss and German National Science Foundations. Furthermore, she headed several governmental advisory committees, including the German Advisory Council on Global Change (WBGU). Renate Schubert's research focus is on behavioral economics as applied to environmental and energy-related topics. In addition, she has been investigating social resilience as well as data privacy issues and the value of data. Her data-related work has essentially been done at the Collegium Helveticum in Zurich, where she has been a fellow since 2016.

Max Stadler

is a postdoctoral researcher at ETH Zurich (Science Studies and Collegium Helveticum). His Ph.D. was in the history of science, technology, and medicine from CHoSTM, Imperial College, London. Prior to coming to ETH, he was a pre- and post-doctoral fellow at the Max Planck Institute for the History of Science; more recently, he co-directed the research project "Augenarbeit – Visual Performance and Visual Design" at Eikones, NCCR Bildkritik, and cofounded intercom Verlag, Zurich, an academic publishing collective. His research interests center on the history of high tech, labor, and the human sciences.

Andrés Villa Torres

is a Mexican artist and designer active internationally since 2010 in the fields of new media and computer and algorithmic arts. As a solo practitioner and with the Labor 5020 art collective, he explores issues of politics, society, philosophy, media, and technology through artistic practice and research. He works mostly with algorithms, computational processes, data, networks, public space, sound, light, live coding, and the Web. Currently he is part of the scientific staff of the Interaction Design Research Group at the Zurich University of the Arts. He is writing his dissertation on algorithmic agency and social machines at the Graduate School of the Arts and Humanities at the University of Bern.

Emil Zopfi

is a writer based in Zurich. He has published several novels, nonfiction books, children's books, radio plays, short stories, and articles for magazines and newspapers. His works have earned him several awards, including from the city and canton of Zurich, a cultural award from the canton of Glarus, another from the Swiss Alpine Club, the King Albert II mountain award, the Landis & Gyr Foundation, and a Swiss award for children's books. His first profession was electronic and computer engineering. He earned his degree from the Department of Electrical Engineering and Control Systems at Technikum Winterthur, now the ZHAW School of Engineering, in 1967. He was a research assistant at the Laboratory for Physical Chemistry, ETH Zurich, then a systems engineer and programmer for Siemens Germany, Siemens-Albis Zurich, and IBM Switzerland. His first novel, *Jede Minute kostet 33 Franken*, was published in 1977. Outside of his freelance writing, he has been an adult educator in computer science and creative writing. www.zopfi.ch

DATA CENTERS
EDGES OF A WIRED NATION

Editors	Monika Dommann, Hannes Rickli, Max Stadler
Authors	Scherwin Bajka, Silvia Berger Ziauddin, Sascha Deboni, Monika Dommann, Kijan Espahangizi, Lena Kaufmann, Moritz Mähr, Ioana Marinica, Fatih Öz, Giorgio Scherrer, Renate Schubert, Max Stadler, Andrés Villa-Torres, Emil Zopfi
Project Coordination	Christian Ritter
Assistance	Sascha Deboni, Ann-Kathrin Eickhoff, Olivier Keller, Giorgio Scherrer, Andrés Villa-Torres
Editorial assistance	Martin Schmid
Translations and copyediting	Mike Pilewski
Coordination (publisher)	Maya Rüegg
Proofreading	Stephanie Shellabear
Photography	Andrea Helbling, Marc Latzel
Digital Image Editing (Helbling)	Regula Müdespacher
Design	Hubertus Design (Jonas Voegeli, Kerstin Landis, Lea Fischlin, Felix Plate)
Production	Martina Mullis
Lithography, printing and binding	DZA Druckerei zu Altenburg, Germany
Paper	Magno Star, Holmen Trend 2.0
Typeface	Monument Grotesk (Kasper-Florio, Dinamo)

DATA CENTERS. Edges of a Wired Nation was created as part of the
fellowship period "Digital Societies" (2016–2020) at Collegium Helveticum,
the joint institute for advanced studies at the University of Zurich,
ETH Zurich and the Zurich University of the Arts. www.collegium.ethz.ch

© 2020 Lars Müller Publishers and Collegium Helveticum

Photography
© Andrea Helbling (pp. 7–28, 45–56, 81–92, 117–128, 185–196, 321–332)
© Historisches Museum Olten, Photographer: Roland Schneider (pp. 168–180)
© Marc Latzel (pp. 244–283)
© Yann Mingard (pp. 299–307)

Lars Müller Publishers is supported by the Swiss Federal Office of Culture
with a structural contribution for the years 2016–2020.

Lars Müller Publishers
Zurich, Switzerland
www.lars-mueller-publishers.com

ISBN 978-3-03778-645-1

Distributed in North America by ARTBOOK | D.A.P.
www.artbook.com

Printed in Germany